TRAP
DOOR

Critical Anthologies in Art and Culture
Johanna Burton, series editor

.

Mass Effect: Art and the Internet in the Twenty-First Century,
edited by Lauren Cornell and Ed Halter

Public Servants: Art and the Crisis of the Common Good,
edited by Johanna Burton, Shannon Jackson, and Dominic Willsdon

Trap Door: Trans Cultural Production and the Politics of Visibility,
edited by Reina Gossett, Eric A. Stanley, and Johanna Burton

TRAP DOOR

TRANS CULTURAL PRODUCTION AND THE POLITICS OF VISIBILITY

EDITED BY REINA GOSSETT, ERIC A. STANLEY, AND JOHANNA BURTON

The MIT Press / Cambridge, Massachusetts / London, England

This book was set in Chaparral and PF Din by The MIT Press. Printed and bound in the United States of America.

Library of Congress Cataloging-in-Publication Data is available.

ISBN: 978-0-262-03660-3

10 9 8 7 6 5 4 3 2 1

CONTENTS

Between 1984 and 2004, the New Museum produced six anthologies under the series title "Documentary Sources in Contemporary Art." Initiating these books was *Art After Modernism: Rethinking Representation* (1984), a volume that, more than thirty years after its appearance, continues to stand as a model for what it looks like to consider and reflect upon a historical moment even as it unfolds. Indeed, the pivotal nature of that book, and those that followed, evidenced a new model for scholarship within the purview of a contemporary art museum. Taking the art sphere (and its attendant discourses) as a nodal point by which to investigate larger culture, *Art After Modernism* gave shape and visibility to an arena of debate. The broad questions being considered—Were modernism's effects truly waning? What movements or reorientations were replacing its foundation?— found provocative, pointed answers in wide-ranging texts by equally wide-ranging authors. In today's much-changed context, the seminal arguments that appear in *Art After Modernism* are often discussed as having produced their own foundation, now itself in the process of being productively overturned.

Our decision to reinvigorate the series in the year 2015, under the new rubric "Critical Anthologies in Art and Culture," came out of discussions with museum and academic colleagues, with students, and with artists, all of whom expressed a hunger for platforms that equally prioritize debate and experimentation. Rather than focusing on topics around which there is already broad consensus, these books aim to identify and rigorously explore questions so salient and current that, in some cases, they are still unnamed, their contours in the process of being assumed. To that end, the series aims less to offer democratic surveys of themes under consideration and rather hopes to stage arguments and offer conflicting, even contrasting, viewpoints around them.

The role of art has substantially, perhaps fundamentally, shifted in the last several decades. What has not changed, however, is its ability to channel,

magnify, and even alter the ways we approach the world around us. The increasing speed and density of cultural information ironically create an even greater need for the kind of rigorous and sustained engagement that the Critical Anthologies volumes set forward as their ultimate priority. These books serve to underscore the importance of intellectual endeavors as political and ideological acts. We hope they will become, like their predecessors, invaluable documents of our histories as we come to make them.

.

Johanna Burton, Series Editor
Keith Haring Director and Curator of Education and Public Engagement

Questions of identity have always had a place in art. One can scarcely think of a time or an instance in which the role of subjectivity has not, overtly or inadvertently, been raised by an object created by one person and looked at by another. Yet subjectivity as a topic unto itself has a shorter history, one that coincides, not incidentally, with a larger cultural awareness of the roles race, gender, sexuality, and class play in social life and the formation of identity. Contemporary art's intersections with feminism, postcolonial theory, Marxist thought, and institutional critique demonstrate that artists have been questioning the structures in which they live, work, and make their art for decades.

The effects of such intersections were—and continue to be—felt within art institutions, too. In some cases, museums battened down the hatches, insisting even more strongly on historical canons that mostly excluded artists who were not white and male. But many more institutions actively questioned histories that were taken for granted, and more than a few institutions opened their doors specifically to facilitate discussions around these and other emerging dialogues. The New Museum was one such institution, established in 1977 to provide, as founder Marcia Tucker put it, "a forum for dialogue, controversy, and visual provocation—a place where artists, public, and professionals of all kinds can once again become engaged in contemporary art in an active and meaningful way."[1]

Over its now forty-year history, the New Museum has regularly presented exhibitions that question subject positions and the politics of identity, such as "Difference: On Representation and Sexuality" (1984–85), "HOMO VIDEO: Where We Are Now" (1986–87), and "Bad Girls" (1994), among many others; and books like *Out There: Marginalization and Contemporary Cultures* (1990) and *Talking Visions: Multicultural Feminism in a Transnational Age* (1998), both of which are volumes from the earlier incarnation of our Critical Anthologies

series. The New Museum's commitment to providing time and space for artists to consider their own and others' place in art and the world is formidable. *Trap Door: Trans Cultural Production and the Politics of Visibility* continues this tradition and feels absolutely vital for this moment.

Trap Door provides a platform for emerging thinking and theories around transgender cultural production. As the editors point out in their introduction, the representation of queer and trans bodies is at an all-time high, in both art and popular culture, manifesting what seems to be a great curiosity about gender nonconforming subjects and an insatiable hunger for images of transgender bodies. Yet violence against trans people, particularly people of color, is also at an all-time high, showing how starkly such "interest" plays out.

Trap Door examines the paradox of this moment: seeming embrace paired with violent rejection. Debates around trans representation take on a special urgency in the current political climate, with its escalating violence, daily rollback of rights, and increasing discrimination. The book's contributors delve into issues as wide-ranging (and yet ultimately connected) as trans archives, mainstreaming, beauty, performativity, technology, fashion, craft aesthetics, collectivity, police brutality, and chosen family. By considering these matters, the volume inherently asks that institutions—art museums among them—consider their own roles and responsibilities in the context of new cultural constellations, reflections, and terminologies. Moreover, *Trap Door* hopes to ignite a conversation beyond trans culture per se, insisting that while these debates and dialogues are, of course, specific, they nevertheless have great relevance for all readers invested in the ethics of visual culture.

The publication of this anthology marks the third in our revival of a series that was active between 1984 and 2004, during which time six seminal volumes were coproduced by the New Museum and the MIT Press. The partnership marks a shared commitment to the field of contemporary art as a primary platform for scholarship, intellectual exchange, and the evolution of new ideas. The first volume to appear under this reignited collaboration was *Mass Effect: Art and the Internet in the Twenty-First Century* (2015), edited by Lauren Cornell and Ed Halter, which offered a singular meditation on how art has responded to technology since 2000. The second volume was *Public Servants: Art and the Crisis of the Common Good* (2016), edited by Johanna Burton, Shannon Jackson, and Dominic Willsdon; that book explored art's evolving relationship to activism and the contemporary public sphere. We expect that future volumes, like this one, will similarly examine and further dialogues around the most pressing questions of our time as they emerge both in art and in culture at large.

For his belief in the need for this series and his commitment to it, our sincere thanks go to Roger Conover, Executive Editor at the MIT Press. Roger helped steer the first series of books we produced together, and we so value his partnership both then and now. We are also enormously grateful to the Andrew W. Mellon Foundation and its President, Earl Lewis, and Executive Vice President for Programs and Research, Mariët Westermann, for their generous support of these books and the crucial related research around them. Further support for this publication was provided by the Shelley & Donald Rubin Foundation and the New Museum Council for Artists Research and Residencies.

Johanna Burton, Keith Haring Director and Curator of Education and Public Engagement, is the series editor for our relaunched Critical Anthologies as well as one of the coeditors of this volume. Her initiative, intelligence, and dedication in conceiving the structure for these books and overseeing every aspect of their production are fundamental to their realization.

My deepest thanks go to Johanna, as well as to activist, writer, and filmmaker Reina Gossett and to Eric A. Stanley, Assistant Professor in the Department of Gender and Sexuality Studies at the University of California, Riverside—the three coeditors of this truly groundbreaking volume. As the editors note in their introduction, central to the volume is the very question of whether and how gender nonconforming subject positions retain—or resist—legibility within a larger context that threatens to repress or appropriate anything that challenges the status quo. The rich roster of texts collected and commissioned for inclusion within these pages reflects directly on this paradox, asking that we understand art as always in dialogue with other institutions—from schools to prisons, hospitals to courthouses—that administer and control the way subjects are recognized and accounted for, if at all.

Many other members of the New Museum's staff have been fundamentally and enthusiastically involved in every step of this book's publication, contributing not only sheer labor power but unquantifiable brainpower, excitement, and belief as well. Particularly deserving of thanks are Jeanne Goswami, who served as the patient and thoughtful editor for this volume; Kaegan Sparks, Publication Associate, Critical Anthologies; and Kate Wiener, Education Associate. Without Jeanne's, Kaegan's, and Kate's tireless and committed work on every aspect of this publication, this project would simply never have come to be. We also wish to thank Olivia Casa, who stepped in to assist on the editorial front during the final stretch of production.

Still others within the New Museum lent support to the volume in crucial ways. Karen Wong, Deputy Director, was instrumental in advancing discussions

about reviving this series, and Massimiliano Gioni, *Edlis Neeson Artistic Director*, and Dennis Szakacs, Associate Director, Institutional Advancement, contributed to the realization of this volume as well. At the MIT Press, in addition to Roger Conover, we extend our thanks to Matthew Abbate and Victoria Hindley, with whom we have worked with great synergy on the preparation of the manuscript, as well as Emily Gutheinz for her design for this and all other volumes in the series. To Faith Brabenec Hart, we offer appreciation for her excellent and thorough indexing. We also extend our gratitude to Paula Woolley, who contributed to this volume in substantial ways.

Finally, we are most grateful to the artists, organizers, theorists, historians, activists, critics, curators, and collectives represented in this volume, all of whom, in addition to contributing texts, dialogues, roundtables, dossiers, images, and other materials, were distinctly invested in seeing the discussions in which they are engaged brought together here. The individuals and groups who produced new work and those who agreed to have previously published texts contextualized within this new framework provide inestimable contributions toward furthering this rich dialogue and making it visible. The materials brought together here engage in an urgent contemporary exchange by asking a number of vital questions whose very importance lies in the possibility that they may not find immediate answers.

.

Lisa Phillips
Toby Devan Lewis Director

NOTES

——

1. Marcia Tucker, "The New Museum: A Forum for Dialogue, Controversy, and Visual Provocation," *Art Journal* 37, no. 3 (1978): 244.

Reina Gossett, Eric A. Stanley,
and Johanna Burton

*An image is powerful not necessarily because of anything specific it offers the viewer,
but because of everything it apparently also takes away from the viewer.*
—Trinh T. Minh-ha, "Beware of Wolf Intervals"

TRAPS

We are living in a time of trans visibility. Yet we are also living in a time of
anti-trans violence. These entwined proclamations—lived in the flesh—frame
the conversations, interventions, analyses, and other modes of knowing that
are captured in *Trap Door: Trans Cultural Production and the Politics of Visibility*.
Consequently, we come to this project with a deep sense of possibility that also
exists in an interval of anxiety. All three of us, in different yet sometimes overlap-
ping capacities, and via different yet sometimes overlapping self-identifications,
utilize and are imbricated in the production, presentation, and circulation of
visual culture. At the same time, we know that when produced within the cos-
mology of racial capitalism, the promise of "positive representation" ultimately
gives little support or protection to many, if not most, trans and gender non-
conforming people, particularly those who are low-income and/or of color—the
very people whose lives and labor constitute the ground for the figuration of
this moment of visibility.[1]

This is the trap of the visual: it offers—or, more accurately, it is frequently
offered to us as—the primary path through which trans people might have access
to livable lives. Representation is said to remedy broader acute social crises rang-
ing from poverty to murder to police violence, particularly when representation

is taken up as a "teaching tool" that allows those outside our immediate social worlds and identities to glimpse some notion of a shared humanity. To the degree that anyone might consider such potential to exist within representation, one must also grapple and reckon with radical incongruities—as when, for example, our "transgender tipping point"[2] comes to pass at precisely the same political moment when women of color, and trans women of color in particular, are experiencing markedly increased instances of physical violence.[3] Many of the essays, conversations, and dossiers gathered in Trap Door attempt to think through this fundamental paradox, attending to implications for the political present and the art historical past, particularly with regard to persisting—if incomplete—legacies of representation.

Perhaps inevitably, such a perspective on representation is deeply rooted in our personal experiences, which render the questions at hand less "contemporary" than historically insistent, and less abstract than emphatically concrete. Indeed, when first approaching this project—considering how art, fashion, and other image-based works more generally function in culture—Reina was immediately reminded of an invaluable lesson learned early on as a community organizer: that immense transformational and liberatory possibilities arise from what are otherwise sites of oppression or violent extraction—whether the body, labor, land, or spirituality—when individuals have agency in their representation.

Through such a lens, one may recognize more clearly the living stakes for current representations of trans culture, insofar as they are necessarily a kind of extraction and instrumentalization—if not outright recoding—of the artwork and experiences of marginalized peoples and communities. In this regard, the very terms of representation should not be considered apart from public life and its regulation. Consider how Seymour Pine, the New York Police Department officer who led the raids at the Stonewall Inn that preceded the uprising of 1969, would later speak about the city's moralizing penal code, which he was enforcing on the night of the Stonewall riot. In a 1989 interview, he observed that these statutes, which formed the basis for New York's anti-cross-dressing laws, specifically targeted people in public spaces; as a result, the laws underscored the power of being together and of fashion's potential to destabilize the state-sponsored morality underpinning the gender binary and, moreover, the basis for who should or should not appear in public.[4] In other words, to violate the state-sponsored sanctions—to render oneself visible to the state—emphasizes that there is power in coming together in ways that don't replicate the state's moral imperatives. Fashion and imagery hold power, which is precisely why the state seeks to regulate and constrain such self-representations to this very day.

REINA GOSSETT, ERIC A. STANLEY, AND JOHANNA BURTON

The politics of such a turn are not monolithic, however, and if there is one trap in representation's instrumentalization, so is there another in its figuration and, more precisely, its simplification. This issue has persisted since the very beginnings of the gay and trans movements in the United States. Notably, in the shadow of the gay political landscape that developed after the Stonewall uprising, a group of street queens—including Sylvia Rivera, Marsha P. Johnson, Bubbles Rose Marie, Bambi Lamor, and Andorra Martin—started organizing together under the name Street Transvestite Action Revolutionaries (STAR). STAR engaged a particular set of issues generally overlooked by the white middle-class gay movement, whose realization was so encapsulated by the momentous events at Stonewall. Put more bluntly: although their life, fashion, and labor shared the same constitutional ground on which the entire early gay rights movement was built, poor people, mostly of color, as well as trans people who were sex workers did not find their own issues addressed or accommodated by the larger movement. The members of STAR gathered enough resources to rent an apartment in the Lower East Side, calling it STAR House. This small, personal act of resistance and refusal created space for those unruly to the demand of assimilation to come together and to support one another. At a time of heightened violence, just by hanging out with and taking care of one another, the members of STAR were doing revolutionary work.

STAR's example, and the ultimate fate of its endeavor, bridges the gap between representation and reality in stark terms. As writer Arthur Bell outlined at the time in "STAR Trek: Transvestites in the Streets," published in the *Village Voice*, STAR was evicted from its tenement brownstone when the landlord decided to turn the building into a gay hostel. This was an example, Bell asserted, of how gay New York was being gentrified and whitewashed, while people who were poor or of color were being pushed out of the newly recognized and politically defined nomenclature. Significantly, STAR's landlord, Mike Umbers, owned a gay bar on Christopher Street (called Christopher's End) that became commercially successful during the rise of the gay liberation movement.[5] In fact, Umbers later became a sponsor of the 1973 Gay Pride rally—the infamous and first "nonpolitical" iteration—during which Rivera broke out onstage to remind people about their gay brothers and sisters who were still in jail,[6] despite the progress being made in the larger cultural context. At least in part, *Trap Door* aspires to similarly resist resolution.

DOORS

Being mindful of how representation can be and is used to restrict the possibilities of trans people flourishing in hostile worlds, we persist. This anthology takes seriously the fact that representations do not simply re-present an already existing reality but are also doors into making new futures possible. Indeed, the terms of representation require novel critical attention today precisely because of their formative and transformative power. Put simply, if we do not attend to representation and work collectively to bring new visual grammars into existence (while remembering and unearthing suppressed ones), then we will remain caught in the traps of the past.

Trap Door utilizes the most expansive examples of art and visual culture we can imagine. Resistant to the canonization of trans art (although we have included many artists who might appear in such a project), we want to radically undo the boundaries of cultural production so that the category can come to include modes of self-fashioning, making, doing, and being that fall outside the properly "artistic." Partly this approach arises from our own divergent creative practices, which include artistic, activist, critical, and curatorial endeavors. Yet our individual approaches should be taken to underline our collective desire for a different visual grammar.

For example, Eric's film *Homotopia* (2006) and its sequel, *Criminal Queers* (2016), codirected with Chris E. Vargas, respond to conversations in trans/queer contemporary politics and utilize camp and humor to unfold difficult and knotty issues. *Homotopia* is a radical queer critique of the institution of gay marriage. As both a theoretical commitment and a material limit, it was made with no budget and no grants. All the actors on-screen were friends, lovers, or exes who worked collectively, writing their own scripts and developing their characters. *Criminal Queers* was, in turn, a kind of response to questions audiences would pose at screenings of *Homotopia*. People would often ask, "If we shouldn't put all our time and energy into gay marriage, then what should we fight for?" While not wanting to be overly prescriptive, Eric and Chris suggested, through *Criminal Queers*, that prison abolition might be one of the many struggles that trans/queer and gender nonconforming communities should work toward.

Importantly, in both films, gender and trans identities are left unstable. Eric and Chris knew that they did not want to traffic in the dominant visual economies of trans images. There were no binding scenes, no "undressing," no visual cues that might lead the viewer to assume they "know" who these characters "really are." In contrast, they let the actors work with and convey their gender however they felt: the actors might well have developed an on-screen persona

who is more or less similar to who they are in their daily lives, or perhaps they developed a character who is more adjacent. In effect, Eric and Chris chose to center a trans/GNC universe without giving the viewer the visual satisfaction of "discovery." This has led individuals who have watched the *same* film to variously ask, "Why do you have only cis people in your films?" and, "Why do you have only trans people in your films?" While the majority of the people in both films identify as trans, Eric and Chris have left the question of gender open in order to see in what other directions we all might take such projects.

Reina's film *Happy Birthday, Marsha!* (2018), codirected with Sasha Wortzel, tells the story of Marsha P. Johnson in the hours leading up to the Stonewall riots. The film stars Mya Taylor as Johnson, a disabled Black trans artist and activist who was one of the first people to resist the police raid at the Stonewall Inn on the night of the riots. Beyond simply portraying a time when trans people of color were oppressed or acted exceptionally, the film tells a much more complex story that challenges the hierarchy of intelligible history and the archive that keeps our stories as trans and gender nonconforming people from ever surfacing in the first place. Following Saidiya Hartman, *Happy Birthday, Marsha!* enables a story to emerge "that exceed[s] the fiction of history...that constitute[s] the archive and determine[s] what can be said about the past."[7]

Through making the film, Reina came to realize that aesthetics and image matter deeply and can exist against the current instrumentalization of trans visibility as an advertisement for the state. *Happy Birthday, Marsha!* achieves its goals by focusing on Marsha's beauty and the beautiful ways that she and her fellow street queens made life and meaning out of the world around them, outside of the gaze of the state. The film shows something not normally seen on screen: a trans life, with its intimate sociability and relationships. What is visible in the film exists as fugitive to both the rational and the moral: how Marsha and her friends came together, laughed and worked together, made meaning of the world together, and, thanks to Marsha, how they dreamed together.

One of the scenes in *Happy Birthday, Marsha!*, not coincidentally, was filmed at the New Museum—not in its exhibition spaces, but in its adjacent building, a floor of which currently houses working studio space for artists in residence. Via Sasha (who was then working as an educator at the New Museum), Johanna was introduced to Reina and to the extraordinary film project in process. That encounter began a dialogue about institutional responsibility and chains of affiliation, about the politics of alliance, friendship, and platform-building. And that encounter eventually led to a conversation about this book.

Johanna's own longstanding commitment to education and pedagogy, manifested within the museum and academic contexts, bridges engagements

with representation in art with those being articulated in discourse, viewing present circumstances in historical perspective. Seeking alternative approaches to representation—or perhaps better said, clarity around the stakes of representation—has defined her curatorial and discursive projects, which have always been moored in feminism and its continuously necessary expansions and self-evaluations. Yet, recognizing the historical specificity and limits of dialogues devoted to subjectivity, and juxtaposing contemporary developments in art and culture with previous efforts, may now allow for an elaboration and a recasting of critical language. The altered landscape for arts institutions, artistic production, and even identity in a swiftly changing political climate lends real urgency to such considerations—to say nothing of the need to commit to projects dedicated to resisting increasingly complex modes of incorporation and repression. While our cultural moment feels, in this way, quite precarious, it also opens up to radical new possibilities, and these are what we most hope to foreground here.

To this end, we have included reflections by contributors who take up aspects of self-styling, drag, direct action, voice, sound, care and protection, technology, documentation, and labor, among many other topics. In every case, the question arises of whether visibility is a goal to be worked toward or an outcome to be avoided at all costs. Indeed, this question—unresolved and unresolvable—shapes discussions that, however varied, share an urgency that might be named existential. In other words, many of the contributors reflect on what it is to *be*, and then, what it is to reckon that *being* with structures that either refute or appropriate it (and sometimes do both at the same time). Our gambit is that in the face of such a paradox, we must challenge the very notion of *being* itself and name (though not codify) new modes of recognition, identification, and collective endeavor. As authors Morgan Bassichis, Alexander Lee, and Dean Spade have asserted elsewhere—and as Jeannine Tang reiterates in the final lines of her essay—"Impossibility may very well be our only possibility." Bassichis, Lee, and Spade continue provocatively, "What would it mean to *embrace*, rather than *shy away from*, the impossibility of our ways of living as well as our political visions?"[8] Such impossibility, however, should be seen not as dire nor as a state of crisis but, rather, as a radical invitation to fantasize and to dream otherwise. This book aims to point unflinchingly to a cultural context that has little use for the impossible and yet is forced to grapple with its existence and persistence.

Gathered in these pages are twenty-one contributions that take various forms: individually authored and collaboratively written essays, historical and contemporary illustrated dossiers, and transcribed roundtables and dialogues. Most were produced specifically for this volume and, as such, might be understood as consciously participating in an evolving discourse whose very contours should

REINA GOSSETT, ERIC A. STANLEY, AND JOHANNA BURTON

be and are questioned here. To this end, even those texts that take up the task of providing a historical framework for today's trans landscape offer versions of the past rather than postulating master narratives of it. For instance, in plumbing the radical politics of several historical organizing groups, Abram J. Lewis's "Trans History in a Moment of Danger: Organizing Within and Beyond 'Visibility' in the 1970s" explores the complex and sometimes opposing strands driving these groups' activities and thinking—from anti-patriarchal feminism to interspecies animal communication to pagan magic. "Out of Obscurity: Trans Resistance, 1969–2016," a companion piece by Grace Dunham, surveys and analyzes contemporary activist organizations in relation to their 1970s forebears, paying particular attention to prison abolition and health care. In "The Labor of Werqing It: The Performance and Protest Strategies of Sir Lady Java," Treva Ellison explores the life and work of historic 1960s performer Sir Lady Java in order to issue a critique of racial capitalism that easily extends its reach to our present moment. And, in "Cautious Living: Black Trans Women and the Politics of Documentation," activists Miss Major Griffin-Gracy and CeCe McDonald similarly reflect on the perils of representation—and day-to-day life—that they have each negotiated for decades, in a conversation organized by journalist Toshio Meronek.

Such negotiations are at the heart of texts focusing specifically on artistic production: Roy Pérez's "Proximity: On the Work of Mark Aguhar" examines the late artist's decision to make her body her art and asks where representation begins and ends in such a configuration. In "Dynamic Static," Nicole Archer also pushes back on the notion that one can locate something like a queer or trans "aesthetic," and posits, through a close reading of several artists, a mode of pattern-jamming that has roots in older models of institutional critique. Jeannine Tang takes institutions themselves to task in "Contemporary Art and Critical Transgender Infrastructures," demanding from them a new awareness of their imperatives, which tend to exclude (or to absorb) trans practitioners. In "Introducing the Museum of Transgender Hirstory and Art," on the other hand, Chris E. Vargas uses satire and biting humor to call for real changes and alternative models for showing and contextualizing trans art.

A shared thread running through many of the pieces here is, not surprisingly, the archive—or, perhaps better, the archives (plural). In Stamatina Gregory and Jeanne Vaccaro's "Canonical Undoings: Notes on Trans Art and Archives," the authors assess the current structural impasse many feel when writing histories that have effectively been refused or erased. They, like Morgan M. Page in "*One from the Vaults*: Gossip, Access, and Trans History–Telling," propose alternative models of retrieving and disseminating the past. But in both of these texts, archives stand for much more than repositories of history: the archive is seen as

an active, present site, one that undergirds and supports the very people who seek it out and, in doing so, contribute to its evolving contents. To this end, Mel Y. Chen's "Everywhere Archives: Transgendering, Trans Asians, and the Internet" considers the ways in which user-generated archival structures such as YouTube tags can remap gendered and racial identifications.

Two roundtables take up the relationship between histories and futures. "Representation and Its Limits," moderated by Tavia Nyong'o and with participants Lexi Adsit, Sydney Freeland, Robert Hamblin, and Geo Wyeth, focuses on the pitfalls of visibility and trans representation within institutions that continue to operate in exclusionary, violent ways. "Models of Futurity," moderated by Dean Spade and with participants Kai Lumumba Barrow, Yve Laris Cohen, and Kalaniopua Young, focuses on contemporary instances of structural violence, while speculating on potential futures and alternatives that operate outside of their logic.

The current landscape, however, is stark with such violence, and as many contributors to this book note, art's operation within the symbolic has limits. micha cárdenas's "Dark Shimmers: The Rhythm of Necropolitical Affect in Digital Media" meditates on the ways we are increasingly unable to escape the physical and psychic effects and affects of technologically driven violence. In "Blackness and the Trouble of Trans Visibility," Che Gossett addresses how the legacy of racial slavery inflects contemporary anti-Black and anti-trans violence, as well as the interventions of Black radical thinkers to destabilize human/animal and gender binaries. And Park McArthur and Constantina Zavitsanos poetically take up the fragility of bodies and the strength of collaboration, while considering ideologies of ableness in "The Guild of the Brave Poor Things." Various modes of affinity and alliance are explored—and questioned—in Heather Love's "The Last Extremists?," which considers mainstream media's embrace of queer and trans content in the face of an increasingly conservative gay mainstream. Relatedly, in "An Affinity of Hammers," Sara Ahmed analyzes the ways in which feminism, which is often seen as aligned with trans and queer politics, is wielded by trans-exclusionary radical feminists as a violent tool against trans women.

In "Existing in the World: Blackness at the Edge of Trans Visibility," a conversation between Juliana Huxtable and Che Gossett, Juliana suggests that existing and persisting are acts not only of resistance but also of interference. This idea resonates with Eva Hayward's "Spiderwomen," in which the author explores the possibility that corporeality embodies a kind of sensuous transaction not only between body and environment but also between species in an encounter that changes both parties—an idea with immense political ramifications. "All Terror, All Beauty," a conversation between Wu Tsang and Fred Moten, concludes that in

nonbinary thinking, conclusions themselves are a moot point, though this hardly means reverting to relativism. As Fred says, "The absoluteness is in the attempt, not in the achievement."[9]

The biggest effort for this volume—its absoluteness, if that exists—is to allow the paradox of trans representation in the current moment to find form in conversations that don't attempt to smooth the contradictions. In order to facilitate an open network of resonances and to allow through-lines to emerge among the texts—for instance, the figures of the threshold and the trap, the reconfigured parameters of the archive and the institution, and claims to beauty and glamour as modes of trans worlding—we have resisted grouping them into thematic categories. Issues of representation inevitably summon questions of self-representation, and to that end, we wish to be forward about the terms we bring to the subject. (In this regard, we should note that we have elected not to standardize terms that allow for self-determination; for instance, the words "Black" and "trans" and their affiliates appear in many variations here, as requested by the writers using them.) In today's complex cultural landscape, trans people are offered many "doors"—entrances to visibility, to resources, to recognition, and to understanding. Yet, as so many of the essays collected here attest, these doors are almost always also "traps"—accommodating trans bodies, histories, and culture only insofar as they can be forced to hew to hegemonic modalities. This isn't a new story; various kinds of "outsider art" have historically been called upon by an art market or academic cadre that utilize them to advance dominant narratives before pushing them back out. Yet, in addition to *doors* that are always already *traps*, there are *trapdoors*, those clever contraptions that are not entrances or exits but secret passageways that take you someplace else, often someplace as yet unknown. (It is precisely this ambiguity between seeing and knowing, between figure and the new ground that thresholds open up, that initiates McArthur and Zavitsanos's text: "What about a door is a trap when it's known, or known to be unknown?")[10] Here is the space we believe exists and a third term that acknowledges the others but refuses to be held to them.

THRESHOLDS

———

Trap Door, then, is offered as an imperfect experiment. We do not claim to be the first voice, or even a definitive one, on the many ways "trans" and "art" might collide. In this respect, we must note that the bulk of the people gathered

here, with important exceptions, are based in or primarily work in the United States. The scope of the book is thus geopolitically limited. At the same time, from the beginning of the project, we felt committed to including the voices of emerging artists and cultural producers recognized mostly outside of the art world. Given that gender always lives in the idiom of race (to say nothing of disability, sexuality, class, and so on), we wanted to work to disrupt the assumed whiteness of both trans studies and visual culture. Also, while we point to political roots for the present dialogue, we must underline that this collection has been compiled in a time of specific struggle. From prison abolition work to #BlackTransLivesMatter, we have wanted to continue to center the ways in which the question of the visual is always also a question of the political. For that reason, as noted previously, we have included the work of numerous activist collectives, as we know their work to be a vital intervention of its own. But we would hasten to add that art itself can and should be seen as activist, and we do not wish to mark any clear-cut division between what counts as "political" and what as "artistic," even as we certainly see some people put themselves at far greater immediate risk in their activities.

A central aspect of this book, even while it meditates on the unthinkably difficult terms of our contemporary moment, is to insist on pleasure, self-care, beauty, fantasy, and dreaming as elements key to sustained radical change. Therefore, we consider the efforts of those included in this book as exhibiting some combination of artistic and activist impulses, conceived via both deeply researched and wildly speculative thought. In putting such an extraordinary range of making and imagining into the world, we hope we have enabled others to do the same and more. In fact, the present volume demands responses and further dialogues from readers and the larger public: if we offer here another image of trans experience and culture, it is necessarily to the exclusion of so much else at hand. The very problems of representation we seek to engage are reproduced in the making of this volume, and yet we continue to name and unname the known and the unknown, without guarantees, toward the aesthetics—which is to say the materiality—of trans flourishing.

EDITORS' NOTE, MARCH 2017

The questions of art are always posed in relation to the shifting terrain of the social world, and such a counterpoint is, in fact, the explicit and historical purpose of the New Museum's Critical Anthologies in Art and Culture. Accordingly, when this volume was conceived in 2015, and its contents gathered and produced

REINA GOSSETT, ERIC A. STANLEY, AND JOHANNA BURTON

during the better part of 2016, the editors sought to grapple with a structured contradiction in which—as the title *Trap Door* suggests—trans people were at once gaining unprecedented representation in the mass media while remaining subject to explicit forms of prejudice and violence. The urgency of understanding this double bind has been heightened in the intervening time. While the texts in this volume were commissioned and assembled during the American presidential election season, our endeavor was not conceived with the election of Donald Trump in mind, to say nothing of the immediate actions of his administration. Less than two months after his inauguration, the few legal protections that existed for trans people have been stripped by executive order. We might, then, understand this moment as both radically rearticulated and as yet another iteration of US settler colonialism, which is to say white cis normativity. It is our hope that the writings in this publication will go some distance toward generating a deeper analysis of the deadly constrictions many trans people are compelled to survive while also revealing the beautiful force of cultural production and the people that bring it into the world. Indeed, when the brutality of US empire floats closer to the surface, as it now is, we must reaffirm that art, in its most expansive definition, is central to our collective liberation.

NOTES

1. Donald Trump's 2016 presidential campaign is worth discussing with regard to this point. A number of recent texts point out that Trump's rise is explicitly tied to deeply held white supremacist ideologies and circles in America. See, for example, the Editorial Board, "Donald Trump's Alt-Right Brain," *New York Times*, Opinion Pages, September 5, 2016, http://www .nytimes.com/2016/09/06/opinion/donald-trumps-alt-right-brain.html; Donald Nieman, "Donald Trump Is Taking a Page From Reconstruction-Era White Supremacists," *U.S. News & World Report*, October 12, 2016, http://www.usnews.com/news/articles/2016-10-12 /donald-trump-is-taking-a-page-from-reconstruction-era-white-supremacists; Peter Holley, "Top Nazi leader: Trump will be a 'real opportunity' for white nationalists," *Washington Post*, August 7, 2016, https://www.washingtonpost.com/news/post-nation/wp/2016/08/07 /top-nazi-leader-trump-will-be-a-real-opportunity-for-white-nationalists/?utm_term=. d5c3f530d77e; and Paul Holsten, "Experts say white supremacists see Trump as 'last stand,'" PBS Newshour, August 11, 2016, http://www.pbs.org/newshour/rundown/experts -say-white-supremacists-see-trump-last-stand/.

2. Katy Steinmetz, "The Transgender Tipping Point: America's next civil rights frontier," *Time*, May 29, 2014, http://time.com/135480/transgender-tipping-point/.

3. For more information, see Human Rights Campaign and Trans People of Color Coalition, "Addressing Anti-Transgender Violence: Exploring Realities, Challenges and Solutions for Policymakers and Community Advocates" (Washington, DC: Human Rights Campaign, November 2015), accessed October 11, 2016, http://hrc-assets.s3-website-us-east-1 .amazonaws.com//files/assets/resources/HRC-AntiTransgenderViolence-0519.pdf; and

National Coalition of Anti-Violence Programs, "Lesbian, Gay, Bisexual, Transgender, Queer and HIV-Affected Hate Violence in 2015" (New York: New York City Gay and Lesbian Anti-Violence Project, Inc., 2016), accessed October 11, 2016, http://www.avp.org/storage /documents/ncavp_hvreport_2015_final.pdf. These important studies demonstrate the unprecedented rise in violence against LGBT communities in 2015. See also Haeyoun Park and Iaryna Mykhyalyshyn, "L.G.B.T. People Are More Likely to Be Targets of Hate Crimes Than Any Other Minority Group," *New York Times*, June 16, 2016, http://nytimes.com /interactive/2016/06/16/us/hate-crimes-against-lgbt.html; and Jos Truitt, "Transgender People Are More Visible Than Ever: So Why Is There More Anti-Trans Legislation Than Ever, Too?," *The Nation*, March 4, 2016, https://www.thenation.com/article/transgender-people -are-more-visible-than-ever-so-why-is-there-more-anti-trans-legislation-than-ever-too/.

4. See Reina Gossett, "Sylvia Rivera & NYPD Reflect on Stonewall Rebellion," blog post, *Reina Gossett*, February 23, 2012, http://www.reinagossett.com/sylvia-rivera-nypd-reflect-on -stonewall-rebellion/. In her post, Gossett pulls an excerpt from a 1989 discussion recorded by Sound Portraits titled "Remembering Stonewall," which originally aired on NPR. The audio piece, featuring Pine, Marsha P. Johnson, and *Village Voice* reporter Howard Smith, was publicly available when Gossett linked to it in 2012. At the time of this writing, the link, via Sound Portraits, had been disabled.

5. See Arthur Bell, "STAR trek: Transvestites in the street," *Village Voice*, July 15, 1971, https://news.google.com/newspapers?id=UslHAAAAIBAJ&sjid=7YsDAAAAIBAJ&pg=2943 %2C838144; and Arthur Bell, "Hostility comes out of the closet," *Village Voice*, June 28, 1973, https://news.google.com/newspapers?id=mtRHAAAAIBAJ&sjid=_YsDAAAAIBAJ&dq =hostility-comes-out-of-the-closet&pg=3148%2C6605538. Notably, after Bell profiled STAR, several of its members, including Johnson and Rivera, were arrested one by one while they were working. Johnson reflected on this moment in an interview, noting that for the article "we all gave our names ... and [then] we all went out to hustle, you know, about a few days after the article came out in the *Village Voice*, and you see we get busted one after another, in a matter of a couple of weeks. I don't know whether it was the article, or whether we just got busted because it was hot." Marsha P. Johnson and Allen Young, "Rapping with a Street Transvestite Revolutionary: An Interview with Marsha Johnson," in *Out of the Closets: Voices of Gay Liberation*, ed. Karla Jay and Allen Young (New York and London: New York University Press, 1992), 112–20.

6. For footage of Rivera's comments, see "Sylvia Rivera—'Y'all better quiet down' (1973)," YouTube, video, 4:08 min, accessed October 10, 2016, https://www.youtube.com/watch ?v=9QiigzZCEtQ.

7. Saidiya Hartman, "Venus in Two Acts," *Small Axe* 26, no. 2 (June 2008): 9.

8. Morgan Bassichis, Alexander Lee, and Dean Spade, "Building an Abolitionist Trans and Queer Movement with Everything We've Got," in *Captive Genders: Trans Embodiment and the Prison Industrial Complex*, ed. Eric A. Stanley and Nat Smith (Oakland, CA, and Edinburgh: AK Press, 2011 and 2015), 36. For Jeannine Tang's invocation of Bassichis, Lee, and Spade's work, see "Contemporary Art and Critical Transgender Infrastructures" on page 363 of this volume.

9. Fred Moten, "Interview with Wu Tsang and Fred Moten," *356 S. Mission Road*, accessed October 8, 2016, http://356mission.tumblr.com/post/150698596000/interview-with-wu -tsang-and-fred-moten; and "All Terror, All Beauty" on page 339 of this volume.

10. See "The Guild of the Brave Poor Things" by Park McArthur and Constantina Zavitsanos on page 235 of this volume.

THE LABOR OF WERQING IT:
THE PERFORMANCE AND PROTEST STRATEGIES
OF SIR LADY JAVA

Treva Ellison

"Werq Queen!" "Yaaaas!" "Slay!" These terms, which have become mainstream in US popular culture, circulate through Black queer and trans culture and social life to affirm and express excitement over a performance and praxis of existence that exceed the commonsense of normative categories of social being like gender, race, class, and sexuality. In the house and ball scene, the declarative "Werq!" asserts the sartorial, the expressive, the performed, and the embodied over the biologic, the state record, the birth certificate, the checkbox; it affirms the potential and creativity in being surplus and the potential of reworking and repurposing the signs, symbols, and accoutrements of Western modernity. Werqing it is a relational gesture of world-making at the spatial scale of both the body and the community that aligns sender and receiver in a momentary network of fleshly recognition. That is to say, werqing it and having that werq seen, felt, or heard is a power-generating praxis, a force displacement in and over time, that arises from Black queer and Black trans culture, performance, and politics and through the re/production of Black trans social life. It reminds us that under racial capitalism, all Black life is trans, transient, transductive, and transformative. To werq is to exercise power through the position of being rendered excessive to the project of the human and its dis/organizing social categories: race, gender, sexuality, and class. Werqing it deforms, denatures, and reforms the very categories in which werqers can find no stable home.

As an act of making power, werqing it has become attractive; it's trending.[1] We are in a moment in which everyone wants to "werq werq werq werq werq," from Young Thug to Jaden Smith to Beyoncé, each of whom has adopted either sartorial strategies, terminology, or other performative elements arising from Black queer and trans culture and presented them to more mainstream audiences. A 2014 issue of *Time* magazine that features Laverne Cox on the cover

termed this current moment a "transgender tipping point,"[2] a historically significant time of representational saturation of transgender people, identity, and struggles in popular culture, media, and public discourse and debate. The visual economy of the so-called transgender tipping point is driven by Blackness and Black femme embodiment. Black women have become emblematic of and instrumental to the tipping point narrative: they are the representational figures of transgender issues and politics and the martyrs of political struggles for civil rights for trans people—a hyper-present absence. The facts that trans is trending and that Black trans performance, embodiment, and politics are desirable are tempered by the images of spectacular violence against transgender people, particularly Black trans women. Black trans women like Cox, CeCe McDonald, and Janet Mock have named and resisted the exceptionalism/death binary that pervades popular culture narratives of transgender rights and transgender vulnerability, insisting on visibility and representation as limited and partial strategies for transgender people of color that do not challenge structures and systems of violence and oppression.

This essay thinks through the labor of werqing it—the practices, performances, and protests that constitute Blackness, queerness, and transness as relational and para-identitarian approaches to existence, knowledge, and power. To do this, I focus on the protest and performance strategies of Sir Lady Java, a Los Angeles–based Black femme performer who rose to national and international acclaim in the 1960s. As Java ascended to local and national prominence, the Los Angeles Police Department (LAPD) began to track and monitor her performances: they sent plainclothes officers to observe her performances; they attempted to strip search her to confirm her "real" gender; they sent a police battalion to intimidate her and other Black femme performers; and, in October 1967, they even attempted to get her off the stage by filing an injunction against one of the bars that regularly employed her. Using archival documents and excerpts from an April 2015 conversation I had with Sir Lady Java and C. Jerome Woods, founder and director of the Black LGBT Project,[3] this essay outlines Java's strategies in the context of her struggle against LAPD harassment, the burgeoning gay liberation movement, and the rise of Black middle-class power.

Java's struggle against the LAPD elucidates the labor of werqing it: both the labor politics of being a Black gender nonconforming woman and entertainment industry worker in postwar Los Angeles and the liminal labor of insisting on and inventing an undercommons for Black and queer social life through and under the oppressive forces of racial capitalism. Her protest and performance strategies evince a nuanced, nimble analysis of the position of Black femme embodiment in the postwar Los Angeles political economy. Java's fight as a Black

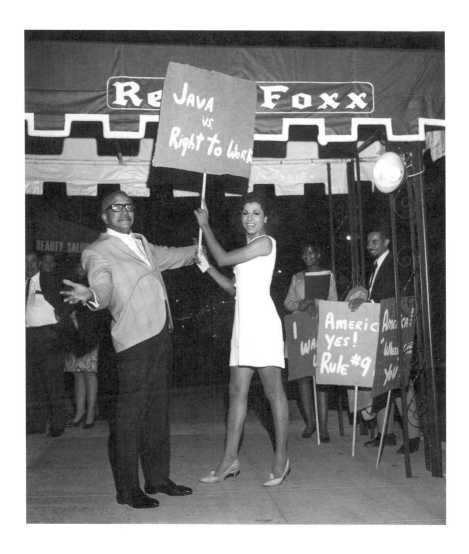

Sir Lady Java and Redd Foxx in front of the Redd
Foxx, October 21, 1967. Originally published in
Jet 33, no. 6 (November 16, 1967): 37. Courtesy
Johnson Publishing Company, LLC. All rights
reserved. Photo: Howard Morehead

femme performer and her fight against the LAPD emphasize that under racial capitalism, visibility is a flexible capacity whose motive potential is derived from the conjoining of subjection and subjectification.[4] Gender studies scholar Grace Kyungwon Hong argues that the political and intellectual formations of women of color mark the violent transition between US capital's national phase and its global phase after World War II. Hong argues that before World War II attempts to resolve contradictions between the abstract labor needs of racial capital and the coherence of the nation-state hinged on abstraction. The universal citizen-subject of US democracy is defined by a capacity for ownership of self and of objects, but racial capital operates precisely by dispossessing racialized subjects of land, property, and the capacity of self-actualization and self-possession.[5] After World War II, Hong explains, attempts to resolve contradictions between global racial capital and an increasingly delocalized nation-state started to hinge not on the abstraction of difference but on the fetishization of difference, which she calls "flexibility."[6] This formulation of flexibility riffs on the concept of flexible accumulation, which marks a transition from a Fordist model of production characterized by the incorporation of labor into highly formalized production processes, to a post-Fordist model characterized by the integration of informal production processes alongside formal processes. We can witness the expansion of flexibility as a cultural project or as a logic that organizes postwar US social and political subjectivities in the growth of voluntary sector governance and community policing, for example. The cultural project of flexibility is also exemplified in the War on Poverty's community empowerment programs and the extent to which they instrumentalized racial, class, gender, and sexual difference to reproduce governance and re-territorialize state power.[7] The development of these kinds of political, social, and cultural institutions integrate semiskilled or unskilled laborers and more informal networks of political and social action, such as grassroots political groups, into formal processes and structures of governance and management. As a logic that underwrites the articulation of subjectivity, flexibility is, in part, a response to the long arc of anti-imperialist and Black freedom struggles in the US that threw the abstract citizen-subject of the US racial state into crisis. Flexibility is itself an abstracting logic because it repositions the racial state as the purveyor and guarantor of racial, class, gender, and sexual citizenship and demands a constant forgetting of the exclusions and erasures that imbue race, class, gender, and sexuality with the appearance of stability and coherence.

Flexibility facilitates the consolidation of normativity as an epistemology of progress and a method of building class power. Both Sonia Song-Ha Lee and Christina Hanhardt detail how the rise of the War on Poverty's Community

Action Agencies in New York led to the creation of internal fissures among groups using the categories of race, gender, class, and sexuality to challenge state power and the distribution of resources.[8] Both note that the escalating professional requirements coming from the federal government, the limited availability of resources, and caps on wages for workers in Community Action Agencies created hierarchies and fractures within political groups organized around racial, ethnic, gender, or sexual identities. Federal requirements privileged professionalism, training, management, and rationality, qualities that are themselves raced, gendered, and classed. Flexibility, as a logic of the post-Keynesian racial state, overwrites oppositional social formations with propriety and attempts to position self-possession and self-actualization as the end goals of social movements. It is a mechanism of subjectification via strategic disavowal. Under the logic of flexibility, sex workers, people who are regular drug users, people with mental illnesses, people with disabilities, and people who in general cannot perform a hegemonic ideal of professionalism or rationality become re-thingified. As an expression and accretion of racial progress or class power, they become the objects of recovery, renewal, and remediation, often by people who claim an identitarian commonality with them. To follow Hong's argument, in racial capitalism's flexible phase, political and cultural visibility and representation, which were never not commodifiable to begin with, find new and multiple pathways for commodification and instrumentalization. Java's struggle calls our attention to those rendered surplus even to oppositional social movements, and reminds us that Black women's political and intellectual formations are capacious terrains that facilitate the coherence of race, gender, class, and sexuality as social and political categories. This, then, is what is encapsulated in the phrase "the labor of werqing it": Black femme embodiment and labor act as the fulcrums of racial capital's flexible capacity in the articulation of politics and culture. That is to say, Black femme embodiment is one point of passage through which subjection and subjectification reach a dynamic (and often deadly) equilibrium via mechanisms of power and social sedimentation, including visibility, recognition, legibility, and representation.

In the hegemonic visual and political culture of the United States, Black femme embodiment appears as that which flits in and out of sight and sound, that which can be simultaneously erased and affirmed, enlivened with vitality and agency or rendered void in order to tell someone else's story. Understanding Java's struggle in relation to the burgeoning gay liberation movement in Los Angeles and the context of the rise of the Black middle class throughout the 1960s underscores the limits of visibility as a tool of political power, as both of these groups instrumentalized Black femme embodiment and labor to build

political power but failed to disrupt the relationships and logics that undergird Black femme precarity.

I am using the terms "Black femme" and "Black femme embodiment" to describe Java because, while she never labeled herself or identified her gender during the course of our interview, she lived her life as a woman. I am also using "Black femme" in a similar vein to critical studies theorist Kara Keeling to think about how Black trans and gender nonconforming femme labor, politics, and cultural production pose challenges to social and identity categories that were themselves constructed as a response to racism, sexism, and homophobia.[9] Keeling writes that the Black femme as a figure "exists on the edge line ... between the visible and the invisible, the thought and the unthought. ... [I]t could be said that the Black femme haunts current attempts to make critical sense of the world along lines delineated according to race, gender, and/or sexuality. Because she often is invisible (but nonetheless present), when she becomes visible, her appearance stops us, offers us time in which we can work to perceive something different, or differently."[10] Sir Lady Java's protest and performance strategies ask us to think different and differently by putting pressure on the normative categories and epistemologies of progress that both scholars and activists use to build power— terms and ideas such as transgender, the transgender tipping point, transgender history, and the Black community. It is my humble hope that the telling of this story offers time and space to think different and differently about the terms and narratives through which we envision and articulate political struggle, LGBT history, transgender studies, and Black studies.

SIR LADY JAVA AND RULE NO. 9

Sir Lady Java was born in New Orleans, Louisiana, in 1940, the eldest of six children. Java climbed through the ranks of the entertainment industry working as a go-go dancer at a club in Hemet, California, doing stand-up comedy and female impersonation (the term used at the time). Java has described her stage act as combining the humor of Pearl Bailey, the facial beauty of Lena Horne, and the sartorial style and presence of Josephine Baker.[11] The fact that Java lived her everyday life as a Black woman but earned her living as a female impersonator and performer made "passing" an incoherent framework for her. She instead leveraged passing as a source of livelihood while using her performances to poke fun at and question the coherence of gender. During her performances, Java would often come on stage dressed in a full suit, portraying a debonair gentleman, and

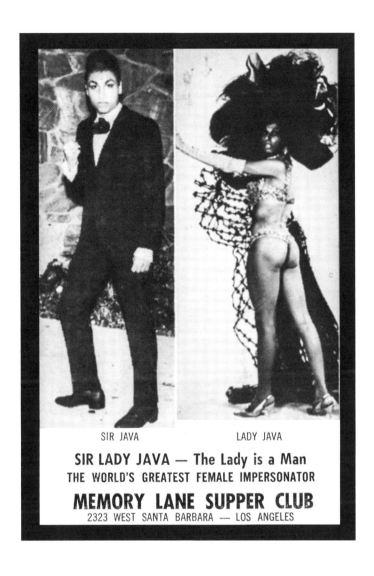

Flyer for Sir Lady Java's regular performance at
Memory Lane, Los Angeles, ca. 1970. Courtesy
Division Leap and Sir Lady Java

take the audience through her gender transition over the course of her stage act, metamorphosing first into a femme in the style of Horne or Baker and ending her shows in a sequined bikini. Java's stage act challenged viewers' trust in gender as a visually verifiable trait. While many drag performers of the era wore elaborate gowns, suits, and costumes, Sir Lady Java performed primarily in bikinis, which allowed her not only to stand out, but also to invoke the spectacle of her body as a challenge to the audience's faith in the rigidity of gender: "I came in a bikini. That's what made me famous. [Knocks on the table.] Even at the drag shows, when they had a ball, the girls wore such outlandish gowns that I couldn't compete with. So I'd come in chiffon and floral prints and a bikini on where they could see it. You know, and that would win the ball. All the time."[12] Reviews of Java's performances made continual reference to how spectacular and unbelievable her appearance was,[13] and Java has recounted that employers and co-performers (notably Richard Pryor) voiced disbelief and overzealous interest upon learning that she was not a cisgender woman. Java's ability to earn a living as an openly gender nonconforming performer troubles today's tipping point narrative and asks us to think about public interest in and discourse around gender and sexuality as iterative and connected to conflicts or crises of economic, social, and political capital. For example, at the turn of the twentieth century, gender impersonation was considered family entertainment, and the conservative capitalist elite of Los Angeles—the Merchants and Manufacturers Association—used to sponsor a huge gender-bending party in Los Angeles called All Fools' Night, which was celebrated as a successful tourist event until the growing Protestant merchant class decried its immorality and had the party outlawed in 1898.[14]

As a Creole woman, Java also troubled racial boundaries and emphasized throughout our interview that she "chose" to be Black, as she could have passed as Latina in the racial visual economy of Los Angeles at the time.[15] Java's ability to slip between identities was always tempered by the possibility of harassment and violence from employers or obsessed audience members.[16] Although she emphasized that she did not "walk in fear," Java recounted experiencing and witnessing multiple incidents of anti-Black racial profiling and anti-Black gendered violence throughout her young adult years.[17] Java actively built community with Black trans and gender nonconforming femmes, whom she refers to as her sisters, and hosted an annual Halloween ball that flexed her personal notoriety and connections to create a performative and labor undercommons for other Black femme performers to hone their craft.[18]

As Java gained local and national prominence, the LAPD began to target her by sending plainclothes and uniformed officers to monitor her performances

TREVA ELLISON

Advertisement for Sir Lady Java's performance
at the Mermaid Room, Los Angeles, ca. 1970.
Courtesy Division Leap and Sir Lady Java

It is interesting to note that the image on the
left is the same photo the LAPD has on file in
the investigator's report about Java's performance
at the Redd Foxx, October 8, 1967.

Opening Wednesday, April 9th

The Beautiful

SIR LADY JAVA

The Sensation Dancer of Dances

Critics have billed Java as America's loveliest
female impersonator of today. This entertainer
has the following statistics: age 24, eyes green,
skin olive, height 5' 7", bust 35", waist 22",
hips 37", has never shaved. He is indeed one of
the World's seven wonders. His acts are full of
pulsating and provacative impressions including
a wardrobe that stuns the imagination. You can't
afford to miss this limited engagement. Make
your reservations. From Coast to Coast, wherever
she is engaged, there is standing room only.

SHOWS
11:30 1:30 3:30

MERMAID ROOM

Ph. 272-9677

and to warn bars against employing her. This harassment reached a fever pitch in October 1967, when the Los Angeles Police Commission (LAPC) filed an injunction against the Redd Foxx, a Black-owned bar that employed Java, demanding that the bar cancel all of her upcoming performances or risk losing its business license. Before filing the injunction, an LAPC investigator went to the Redd Foxx and attempted to strip search Java to confirm her "true" gender, but Java refused to comply. The LAPC claimed that by employing Java, the Redd Foxx was in violation of one of the commission's rules governing public entertainment venues, Rule No. 9, which read: "No entertainment shall be conducted in which any performer impersonates by means of costume or dress a person of the opposite sex, except by special permit issued by the Board of Police Commissioners."[19] Java responded by staging a picket outside of the Redd Foxx on October 21, 1967, and later, with the help of the American Civil Liberties Union (ACLU), filed a lawsuit against the LAPD.[20] The LAPD's harassment of Java and other femme of color queens and werqers occurred in a climate in which gender nonconforming people could be arrested for "masquerading," or dressing as the "opposite" gender. Java's struggle against the LAPD and the LAPC is a powerful story in the unkempt and unruly archive of the labor of werqing it.

LGBT studies scholars have been quick to fold Java's struggle against Rule No. 9 into genealogies of male-to-female transgender activism, gay history, and struggles over queer spaces without acknowledging that her protest was, at its core, a response to anti-Black racism.[21] In news articles and interviews at the time, Java framed her struggle against the LAPD and Rule No. 9 as a workplace discrimination issue: "It's discrimination, allowing some people this privilege and not others. ... It's got to stop somewhere, and it won't unless somebody comes forward and takes a stand. I guess that's me."[22] But, reflecting on the incident in 2015, Java framed her fight with the LAPD as a struggle against anti-Black and gendered racial profiling:

> We didn't know of any establishment that was white that they [the LAPD] were stopping [from employing impersonators], but they were definitely targeting me, because I was queen of the Black ones and they feel that they had more trouble out of the Black ones. You see, we didn't have places to go to, places to eat, and they would not allow us in the places and it was against the law to wear women's clothing, you know that? They could arrest you if you walk down the street in women's clothing [if you were being read as biologically male], in male clothing [if you were being read as a biologically female].[23]

Java felt that the LAPD chose to suspend the Redd Foxx's business license rather than the licenses of the numerous other venues where she performed across the city because the bar's owner, Redd Foxx, stood out in the area as one of the few Black club owners on the Westside. LAPC records corroborate this: the investigator's report about Java's scheduled performances at the Redd Foxx notes that other venues had been "warned about employing this individual"; warned, but not threatened with the loss of livelihood.[24] Also, Java was granted a permit from the Police Commissioner to perform for a charity benefit at the Coconut Grove, a club with a mostly white patronage, weeks after the incident at the Redd Foxx.[25] Java recalled that the performance at the Coconut Grove was the first time she had performed in front of a majority white audience.[26] She links the LAPD's effort to make female impersonators unemployable to larger issues of employment for gender nonconforming people and the criminalization of sex work, noting:

> You have to understand that we didn't have jobs, because they wouldn't hire us and those that would dress, the pioneers ... it hurts to talk about it ... We could not ... But they wouldn't let us work, so we had to turn tricks to work. And, baby, that was so-called "our job" and we'd get ready to work at night, and baby, we was come out! Police or no police, we was coming out, snapping our wrists, flirting, walking down the street. ... I told them [the American Civil Liberties Union] that we have no place to work and the only place we can work is at night in the club. We had no right to work. [When] we come to work, we had to come as men [because it was illegal to dress as the "opposite" gender on the street] and then transform ourselves into women when we get on stage. Well, that was hard to do both. I won the fight for us to appear on stage, but I didn't win the fight for us to walk the streets.[27]

When Java asked the ACLU of Los Angeles to sue the LAPC after the commission tried to pull Redd Foxx's business license, she ran into difficulty. While Rule No. 9 targeted drag performers, it made the bar owner the *subject* of the law. Thus, Java's civil suit required a bar owner willing to be the named plaintiff. Her case could not be heard in a court of law with Java as the sole plaintiff and was eventually rejected by the courts on these grounds. So, while the LAPD could track Java from venue to venue under the guise of Rule No. 9, she had little recourse to challenge the LAPD. Unable to legally challenge Rule No. 9, Java effectively subverted it by finding a way to adhere technically to its requirements: she tested the threshold of its stipulation that performers must wear at least three items

of "properly gendered attire" by incorporating a wristwatch, a bowtie, and men's socks into her act. This became a strategy, according to Java, that other performers mimicked: "They [other female impersonators] say: We're able to work, and we're all going [to] work the next day, and we're going to put on the three male articles [of clothing], and they did the same thing I did: socks and the wristwatch and the bowtie if they wore bikinis; if they wore gowns, they wore little bowties, some of them were jeweled."[28]

The transgender tipping point narrative suggests that public interest in transgender people, transgender representation, and transgender power is progressive and has reached an apotheosis in our current time. Even critical counter-narratives of the tipping point stage their arguments by remarking that despite advances in visibility and representation, violence against trans people has reached a climax today.[29] Besides being hard to verify, both of these narratives also miss the way that the visibility and containment of gender and sexual nonconformity are cyclical and related to crises in capital. By framing her challenge to Rule No. 9 and LAPD harassment as a labor issue informed by anti-Black racism, and by connecting unemployment for gender nonconforming people to the criminalization of sex work, Sir Lady Java calls our attention to the linked histories of containing gender nonconformity and criminalizing sex work in Los Angeles and how these histories intersect with the racialization of space and ruptures in capital.

THE LABOR OF WERQING IT:
CRIMINALIZING BLACK FEMME EMBODIMENT IN LOS ANGELES

Public interest in and discourse around gender and sexual nonconformity in Los Angeles have been iterative and related to dramatic, qualitative changes in the organization of economic, political, and social life. For example, in 1942, when faced with the threat of the disintegration of the nuclear family and traditional gender roles because World War II production needs had shuffled the gendered division of labor, then-mayor Fletcher Bowron petitioned the city council to make it illegal for women employees to wear pants in city hall.[30] And slightly earlier than that, in the late 1930s, policing gender and sexual deviance became a way to resolve a political fissure between middle-class reformers and organized labor on one side and the mayor and the LAPD on the other. Middle-class reformers and organized labor pointed to the unchecked spread of sex work, gambling, and the immorality of night life as evidence that

the LAPD and mayor were under the control of commercial vice organizations. However, the racialization of space served as a primary organizing trope for the criminalization of gender and sexual deviance, as Bowron's predecessor, Mayor Frank Shaw, and the LAPD responded to reformers' critiques by punishing the most vulnerable people in the social hierarchy, reinforcing race- and class-based spatial containment strategies such as redlining, racially restrictive covenants, and vigilante violence. The LAPD responded by increasing the number of arrests of Black and Mexican women for sex work and by establishing a Sex Crimes Bureau in 1937 to fingerprint, study, and contain so-called sexual criminals.[31] Earlier, between 1932 and 1933, the LAPD had responded to the increasing popularity of impersonation by raiding the pansy clubs where impersonators performed.[32] Raiding drag venues and criminalizing women of color were convenient ways to temporarily resolve a political crisis without actually disrupting the more powerful commercialized vice conglomerates that had already paid off the LAPD and city hall. Sir Lady Java's insistence on her struggle as an issue of gendered racial discrimination is an insistence that we not forget that the racialization of urban space is a structuring phenomenon for queer and trans criminality. It's not surprising, then, that after winning office on an anti-vice platform, Bowron would try to ban women from wearing pants in an effort to stave off gender inversion, which he saw as a consequence of wartime labor needs.

Throughout the late 1960s, LGBT activists in Los Angeles increasingly used visibility as a strategy to build political power. Activists held touch-ins and kiss-ins at public parks and bars, led public consciousness-raising circles in the new Gay Community Services Center (now the Los Angeles Gay and Lesbian Center), held political forums for local politicians to meet with the "gay electorate," and organized marches and protests against LAPD harassment. However, as a political strategy, LGBT visibility became increasingly anchored to the neighborhoods of West Hollywood and Hollywood. Even when the acts of police harassment and deadly police violence that cohered LGBT as an oppressed cluster targeted racialized LGBT people outside these two neighborhoods, gay liberation groups in Los Angeles still mostly failed to understand how the racialization of space and the criminalization of cross-dressing and sex work underpinned the criminalization of sexual deviance. Gay Liberation Front Los Angeles, for example, had internal fissures develop both around including trans people in the group—especially trans women—and around taking up issues that impacted people who were not cisgender men.[33] At the same time, Gay Liberation Front and other groups struggled to welcome and retain trans and gender nonconforming femmes, lesbians, and people of color.

While gay liberation organizations in Los Angeles failed to see the criminalization of sex work and trans and gender nonconforming people as structuring components of queer criminality, Black middle-class activists fought to curb sex work in certain sections of Los Angeles throughout the 1960s and '70s. In October 1960, a group of Black businessmen led by Cecil B. Murrell formed the Council of Organizations Against Vice (COAV), which sought to eradicate prostitution in the West Adams neighborhood of Los Angeles.[34] Murrell, one of the cofounders of the famed Golden State Mutual Life Insurance Company, the first Black-owned insurance company established west of the Mississippi, led an effort to increase punitive fines for sex workers, not to penalize those soliciting sex work. Murrell worked with the LAPD and city council to increase the fine for sex workers from $50 to $100, and he lobbied municipal judges to sentence sex workers for the maximum possible 180 days instead of the average ten-day sentence in 1960.[35] Even the Los Angeles Sentinel criticized Murrell's and COAV's approach as shortsighted, arguing that police resources should not be used to entrap Black women and should instead be directed toward arresting white male motorists, who residents complained would come through the neighborhood and proposition and harass any Black woman walking down the street.[36] Although COAV noted that sex work was pervasive throughout Los Angeles and that the Central and Newton districts had the "worst" prostitution, they focused their energy on Westside, whose Black communities have historically been more middle class. COAV saw eradicating sex work as a part of a larger self-help politics of racial equality and progress. A review of LAPC records throughout the 1960s shows similar instances of Black residents petitioning the police commission for LAPD intervention to curb prostitution, burglaries, and other proclaimed nuisances in South Central and West Adams.[37]

Leveraging Black middle-class political power as a way to curb prostitution was based on the idea that Black people have the same right to safety, protection, and a say in policing priorities as middle-class whites. COAV's anti–sex worker activism rerouted a real communal concern about racist sexual harassment in West Adams into a script of gender and sexual conformity as a method of building class power. This framing of equality and identity-based class power rendered Black femme sex workers outside of the terrain of Black middle-class neighborhood politics and disregarded the extent to which gender and sexual deviance function as the staging grounds for Black fungibility. Gay and lesbian activists, on the other hand, disavowed the centrality of race and racism in the production of sexuality-based criminalization. Understanding Java's struggle as both surplus to the gay liberation movement and excessive to Black middle-class activism and Black middle-class visions of Black neighborhoods and communities, we can

see how flexibility—as a cultural logic underwriting subjectivity in racial capital's global phase—manifests itself in social and political formations organized around race, class, gender, and sexuality. For Los Angeles–based gay and lesbian institutions like Gay Liberation Front and the Gay Community Services Center, the local expansion of voluntary sector governance initiatives under the Bradley mayoral administration and the Nixon presidency created opportunities for activists to fund survival programs, which they modeled on those of the Black Panther Party. The professional requirements of these funding initiatives, however, privileged the skills and expertise of middle-class and educated gays and lesbians; thus, activists increasingly positioned sex workers, drug users, raucous partiers, people with mental illnesses, gays and lesbians of color, and working-class trans people as excessive to the project of gay Los Angeles. For the Black middle-class activists in COAV, civil rights–era gains created an opportunity for Black middle-class activists to cohere Blackness around middle-class performances of gender and sexual conformity, property ownership, and racial uplift.

Java's praxis of producing social life—creating an undercommons for Black queer labor, performance, and desire—and her hesitance around transgender as an identity offer us so much to consider. First, Java's story issues a warning against investing in transgender as the penultimate horizon or new frontier of social difference. Her struggle has been rendered through the language of trans activism, MTF activism, and LGBT history. What does it mean to recover this story as an episode in the production of transgender history, when, from Java's perspective, so much of her understanding of herself as a woman—the kinds of labor she performed as a lover, a daughter, and a friend—and her framing of her struggle with the LAPD are both anchored in a strident critique of anti-Black racism? Considering Java's life story on her own terms delivers a word of caution to the burgeoning field of transgender studies: transgender studies becomes a scene of the subjection and instrumentalization of Blackness when scholars and proponents of the field use the lives and stories of Black people to make transgender cohere as a category of analysis and a field of inquiry without a full acknowledgment of how the racialization of space dis/organizes the articulation and production of queer and trans culture and politics.

For Java—to riff on poet and playwright Ntozake Shange—there wasn't enough for her in the world she was born into, so she made up what she needed.[38] She flexed her hyper-visibility as a gender nonconforming woman as a source of livelihood. She worked to create an undercommons for Black femme labor and expression. Her capacity to do so (her act sold a lot of tickets)—her ability to buy a home for her family with the money she made as a performer in the 1960s and to rent out ballrooms in downtown Los Angeles to host balls that featured

only Black femme performers—exposes precisely the lies and abstracted labor that constitute white life, civil society, and Black middle-class propriety. During our 2015 conversation, Java shared a story of negotiating her gender performance with her mother as a young woman: "I'm nineteen years old, and I act like a woman; I look like a woman. I say [to my] Momma: 'I didn't ask to come here.' She say, 'Stay in your place.' I was making my own place, and I was breaking the rules, but I didn't know I was breaking the rules. I just know it was not right to do Black people like they do."[39] This quote emphasizes the para-subjective and para-identitarian movement of the labor of werqing it. Java's formulation of her femininity is grounded in her relationships to Blackness, Black people, and the ways racial capitalism attempted to circumscribe Black life via the racialization of space. At the same time, as exemplified by the work of COAV, Black politics and Black political power offered no stable home for Black femmes like Java. Her story emphasizes that Black femme embodiment and performance are a constant crossing between, a flight in and out of, legibility and recognition.

Java's life and praxis also offer an alternative approach to thinking about Blackness and theories of Blackness and of Black ontology that posit social death as an axiom or universal law of Black existence—namely, Blackness as a relation of ontological death. Such theorizations dismiss the ways that Black femmes, in particular, and Black people, in general, create and exercise power through the production of social life and social underworlds that are always already denaturing and deforming the "world as we know it." The over-representation of social death as an axiom of Blackness also relies on a dismissal of gender and sexuality as one of the staging grounds of Black fungibility. The idea that Blackness is related to death relies on the reality of natal alienation for enslaved Black women as a defining characteristic of "Blackness as social death," but then twists that fact to render anti-Blackness as the primary structuring mode of the human project, relative to gender and sexuality, which, under this framework, become strategic modes of oppression. This logic de-particularizes and abstracts gendered anti-Black violence to do the work of rendering anti-Blackness as a universal or axiomatic theory of Blackness. For example, Black communal violence against gender and sexually nonconforming Black people, as outlined by Black feminist scholars like Beth Richie and Cathy Cohen, becomes reduced to a case of "borrowed institutionality," or white man mimesis,[40] instead of opening a space and a time to critically reflect on how racial capitalist logics reproduce themselves within oppositional political-intellectual formations precisely through the frameworks of gender and sexual conformity.[41] What does it mean to relegate Blackness to the position of social death, when, as Java's life and times suggest, Blackness itself is uncertain, as it is both a medium and relation of social death

and social life? Black is; Black ain't; Black is in flux between is and ain't. This tension is what is summoned in naming the labor of werqing it: the power and potential in creating underworlds and undercommons for Black social life and its collision with logics and strategies of subjectification that rely on Black femme subjection, abuse, and premature death. Naming the labor of werqing it incites and stokes tension and uncertainty because flexibility, as a cultural and epistemological logic of racial capitalism, does try to position Blackness as fungible. At the same time, flexibility is also a Black femme method of cultivating the undercommons, the unkempt, and the unrulable—the very potentialities that drive social and political transformation and threaten the coherence of civil society and the world as we know it.

. .

"The Labor of Werqing It: The Performance and Protest Strategies of Sir Lady Java" by scholar Treva Ellison was written in 2016 for this volume.

. .

NOTES

———

1. See Manuel Arturo Abreu, "Transtrender: A Meditation on Gender as a Racial Construct," *Newhive*, April 18, 2016, https://newhive.com/b/transtrender-a-meditation-on-gender-as-a-racial-construct/. Abreu raises similar questions about the instrumentalization of transness, writing: "Trans is trending, which may or may not help, but most likely hurts, actually-existing trans people. A concrete institutional definition of trans is still 'under construction,' itself having undergone various 'queerings.' But both above and under the carnival of signifiers and the circulation of theoretical concepts, trans people, especially of color, still inordinately suffer and die. Our voices are still unheard and ignored, even as aspects of the condition become generalized and hypervisible. The world cheers on as we agonize. Statistics about trans people of color get subsumed into the general trans struggle to intensify empathy. What, precisely, is this necropolitics of conceptualization whereby trans pain, particularly the pain of Black trans people, continues to transmute into metaphors, generalities, theoretical developments, queerings, coping mechanisms for people who think they were 'born into the wrong race,' and much more, but basic human rights and even expectancy of life itself still elude many in the global trans community? When did queerness become a post-critical theory clickbait machine?"

2. Katy Steinmetz, "The Transgender Tipping Point: America's next civil rights frontier," *Time*, May 29, 2014, http://time.com/135480/transgender-tipping-point.

3. The Black LGBT Project, founded and directed by C. Jerome Woods, is the largest and, perhaps, only archive in existence dedicated to preserving the history of the Black LGBT people of Los Angeles and their partners. Woods, a retired Los Angeles Unified School District

teacher, started the archive from materials he had collected over the years and creates local exhibitions of archival materials. The Black LGBT Project consists of over one thousand photos, over one hundred books, thousands of paper documents, and several hundred pieces of ephemera relating to Black LGBT life in the United States, with the bulk of the materials focused on Black LGBT life in Los Angeles.

4. Several recent books in ethnic studies and gender and sexuality studies theorize how processes of material and ideological subjection animate and capacitate processes of producing and rendering subjects in the context of US racial capitalism. Jodi Melamed terms this contradiction "represent-and-destroy," or the incorporation of the management of difference into the aegis of the post–civil rights US state, alongside the creative destruction of racial capitalism evinced in the buildup of the prison industrial complex at state, federal, and global scales beginning in the late 1960s; see Jodi Melamed, *Represent and Destroy: Rationalizing Violence in the New Racial Capitalism* (Minneapolis: University of Minnesota Press, 2011). Chandan Reddy names this contradiction "freedom-with-violence" to underscore the productive tension between the expansion of sexual citizenship alongside the expansion of racialized carceral violence; see Chandan Reddy, *Freedom with Violence: Race, Sexuality, and the US State* (Durham, NC: Duke University Press, 2011). Lisa Marie Cacho uses the term "unprotectability" to identify the gap between the socio-spatial multiplicity that criminality indexes and the particular embodiments that become reified through the production of identity-based political subjects. Cacho argues that when one is rendered unprotectable, the interpretive violence of the law attempts to make one politically, economically, and socially illegible. Additionally, she argues that these modes of representation and subjectification (the law, law enforcement, and political representation) *work* and are reconstituted precisely through the very endurance of unprotectability as a mode of existence, the disciplinary double to political subjecthood; see Lisa Marie Cacho, *Social Death: Racialized Rightlessness and the Criminalization of the Unprotected* (New York: New York University Press, 2012), 5. These scholars illustrate, in different ways, how the fungibility of criminality marks both the potential and limits of identity-based political formations.

5. Grace Kyungwon Hong, *The Ruptures of American Capital: Women of Color Feminism and the Culture of Immigrant Labor* (Minneapolis: University of Minnesota Press, 2006), 2, 9.

6. Ibid., 110. Other scholars of race and racial capitalism might disagree with Hong's periodization of capital into two major phases in the twentieth century: nation-state and global. Certainly, we can find many examples of global racial capital before World War II. Katherine McKittrick, Denise Ferreira da Silva, and Sylvia Wynter, for example, all chronicle the formulation of the onto-epistemological creation of "Man" (white, cisgender, able-bodied, propertied) as the corollary project to the world-organizing strategies and projects of racial capitalism: enclosure, extraction, colonialism, and transatlantic slavery. What is helpful to me about Hong's formulation is that she identifies flexibility as a logic that organizes culture, politics, and subjectivity and manifests alongside the shift in modes of capital accumulation from more formal, production-oriented modes to more multi-varied ones. Today, even work once thought of as informal, like domestic work, cleaning, personal assistance, sex work, food delivery, and even gifting, can be integrated into formal, corporate modes of accumulation. Companies such as Google, Airbnb, Facebook, Instacart, Tumblr, and PayPal fold all kinds of informal labor into a formal corporate chain of production. Hong asks us to consider how flexibility as a mode of accumulation for racial capital manifests in our cultural, social, and political formations.

7. Christina Hanhardt and Sonia Song-Ha Lee explain how War on Poverty programs were sites of rupture for coalitions and grassroots groups organized around racial justice and gay liberation in New York City. While Lee examines how the changing rules and regulations governing Community Action Agencies dictated by the federal government created tensions and hierarchies within political coalitions between Blacks and Puerto Ricans, Hanhardt explains how the competition over resources and the discourses of racial liberalism and rational choice theory align LGBT social formations with racist policing agendas. See Christina Hanhardt, *Safe Space: Gay Neighborhood History and the Politics of Violence* (Durham, NC: Duke University Press, 2013); and Sonia Song-Ha Lee, *Building a Latino Civil Rights Movement: Puerto Ricans, African Americans, and the Pursuit of Racial Justice in New York City* (Chapel Hill: University of North Carolina Press Books, 2014).

8. Hanhardt, *Safe Space: Gay Neighborhood History and the Politics of Violence*, 35–80; and Lee, *Building a Latino Civil Rights Movement: Puerto Ricans, African Americans, and the Pursuit of Racial Justice in New York City*, 131–64.

9. Kara Keeling, *The Witch's Flight: The Cinematic, the Black Femme, and the Image of Common Sense* (Durham, NC: Duke University Press, 2007), 2.

10. Ibid.

11. Sir Lady Java, interview by C. Jerome Woods and Treva Ellison (unpublished transcript), April 19, 2015, 1.

12. Ibid., 12.

13. See, for example, Gertrude Gibson, "Lady Java Unbelievable," Candid Comments, *Los Angeles Sentinel*, January 13, 1966, B6; Gertrude Gibson, "World's Greatest: Farewell L.A. Appearance of 'Lady Java' Monday," Candid Comments, *Los Angeles Sentinel*, May 11, 1967, B7; Gertrude Gibson, "Lady Java Gets a Double," Candid Comments, *Los Angeles Sentinel*, December 29, 1966, B5; and Gertrude Gibson, "Lady Java Fantastic," Candid Comments, *Los Angeles Sentinel*, February 13, 1975, B7, which reads: "Sir Lady Java ... did it again, packing them in at Larry Hearns' Memory Lane displaying the 'topless' look. One spectator got so carried away she spilled a whole table of drinks on the floor. The unbelievable 'Female Impersonator' has them standing on their feet to watch the great show. First show at 9 p.m."

14. Lillian Faderman and Stuart Timmons, *Gay L.A.: A History of Sexual Outlaws, Power Politics, and Lipstick Lesbians* (New York: Basic Books, 2006), 15–17.

15. Sir Lady Java, interview by Woods and Ellison, 2.

16. Ibid., 17.

17. Ibid., 2–5, 17.

18. Archival data suggests the annual ball happened at least several times. A 1974 promotion for the ball in the *Los Angeles Sentinel* reads: "Unbelievable ... but it's true. THE LADIES ARE MEN and represent some of the prettiest 'female impersonators' in the business. Monday night at Memory Lane Club, you will see a bevy of other performers on hand for the Pre-Halloween Ball with Sir Lady Java crowning the beautiful queen." The promo article shows pictures of Java and two Black femme performers: Tawny Tann and Sahji. See "Pre-Halloween Ball Monday Night," *Los Angeles Sentinel*, October 24, 1974, B8.

19. "Board Rules Governing Café Entertainment," Minutes of the Board of Police Commissioners, City of Los Angeles, June 24, 1964, 452, available at the Los Angeles City Archives, Erwin C. Piper Technical Center.

20. James Gilliam, "Pride: Sir Lady Java and the ACLU/SC," *ACLU of Southern California*, December 17, 2010, https://www.aclusocal.org/pride-sir-lady-java-and-the-aclusc/.

21. The GLQ Archive: Members of the Gay and Lesbian Historical Society of Northern California, "MTF Activism in the Tenderloin and Beyond, 1966–1975," *GLQ: A Journal of Lesbian and Gay Studies* 4, no. 2 (1998): 365, doi:10.1215/10642684-4-2-349; and Monica Roberts, "Sir Lady Java: Trans Civil Rights Warrior," blog post, *TransGriot*, December 9, 2010, http://transgriot.blogspot.com/2010/12/sir-lady-java-trans-civil-rights.html.

22. "Sir Lady Java Fights Fuzz-Y Rule Nine," *Advocate* 1, no. 3 (November 1967): 2.

23. Sir Lady Java, interview by Woods and Ellison, 4.

24. "Los Angeles Police Commission Investigative Report: Redd Foxx Enterprises," Meeting Minutes of the Los Angeles Police Commission, October 3, 1967, 3, available at the Los Angeles City Archives, Erwin C. Piper Technical Center.

25. "Sir Lady Java Fights Fuzz-Y Rule Nine," 2.

26. Sir Lady Java, interview by Woods and Ellison, 1.

27. Ibid., 10.

28. Ibid., 3.

29. In the past year, several articles have suggested that violence against transgender people is at its highest point in US history. See, for example, Cleis Abeni, "Two Black Trans Women Killed in 48 Hours," *Advocate*, February 23, 2016, http://www.advocate.com/transgender/2016/2/23/two-black-trans-women-killed-48-hours; and Zach Stafford, "Transgender Homicide Rate Hits Historic High in US, Says New Report," *Guardian*, November 13, 2015, https://www.theguardian.com/us-news/2015/nov/13/transgender-homicide-victims-us-has-hit-historic-high.

30. Faderman and Timmons, *Gay L.A.: A History of Sexual Outlaws, Power Politics, and Lipstick Lesbians*, 93–94. This is doubly interesting knowing that Fletcher Bowron was elected mayor in a recall election aimed at ousting mayor Frank Shaw, who was accused of corruption and of having mob ties. The coalition of organized labor and progressive middle-class reformers who pushed for Bowron pointed directly at vice as a sign of the decaying morality in Los Angeles.

31. Treva Ellison, "Towards a Politics of Perfect Disorder: Carceral Geographies, Queer Criminality, and Other Ways to Be" (PhD dissertation, University of Southern California, 2015), 73; and Kaitlin Therese Boyd, "The Criminalization of Black Angeleno Women: Institutionalized Racism and Sexism in Los Angeles" (PhD dissertation, University of California, Los Angeles, 2012).

32. Daniel Hurewitz, *Bohemian Los Angeles and the Making of Modern Politics* (Berkeley: University of California Press, 2007), 120–21.

33. The GLQ Archive, "MTF Activism in the Tenderloin and Beyond" summarizes the struggles that Angela Douglas, a trans woman who is an active member of Gay Liberation Front Los Angeles, has had with the patriarchy within the organization. Gay Community Alliance, another Los Angeles–based gay group that organized against homophobic policing in the early 1970s, defined its work as explicitly for gay men only and made a specific point to exclude transgender and transsexual women in its printed materials inviting people to join the organization; see "An Invitation to Participate in Activities of the Gay Community Alliance," May 10, 1971, Gay Community Alliance Collection, Coll. 2011-045, ONE National Gay and Lesbian Archives at the USC Libraries, Los Angeles.

34. See "Westside Businessmen Organize Fight Against Dope, Prostitution: Vice Council Formed," *Los Angeles Sentinel*, November 3, 1960, A1; "Prostitution Resurgence Noted in Southwest L.A.: Vice Crusader Calls for Help, Gives Partial Blame to Municipal Court Judges," *Los Angeles Sentinel*, November 19, 1961, C10; "Vice Meeting Tonight at Golden State Los Angeles Sentinel," *Los Angeles Sentinel,* December 1, 1960, A1; and Cecil B. Murrell, "Anti-Vice Organization Lauds Los Angeles Police Department," *Los Angeles Times*, August 2, 1962, A5.

35. "Prostitution Resurgence Noted in Southwest L.A."

36. "Policemanship," *Los Angeles Sentinel*, November 17, 1960, A6; and Paul Coates, "Vice Casts Its Shadow on West Adams District: White Men on Prowl for Negro Streetwalkers," *Los Angeles Times*, April 11, 1965, B.

37. "Western-Adams Residents Seek Public Vice Action," *Los Angeles Times*, January 30, 1961, 2; and Walter Ames, "Problem of Prostitution Never Ending for Police: Arrests, Difficult …," *Los Angeles Times*, April 12, 1965, 3.

38. Ntozake Shange, *Sassafrass, Cypress and Indigo: A Novel* (New York: Macmillan, 1996), 4.

39. Sir Lady Java, interview by Woods and Ellison, 1.

40. For a detailed and excellent deconstruction of the articulation of anti-Black racism as a paradigm of emasculation, see LaKeyma King, "Inversion and Invisibility: Black Women, Black Masculinity, and Anti-Blackness," *Lies: A Journal of Materialist Feminism* 2 (August 2015): 31–48. King demonstrates how Black women and Black femme embodiment are instrumentalized to do the work of rendering narratives of anti-Blackness that hinge on racial castration or the idea of anti-Blackness as a flattening ontology in relation to gender (anti-Blackness negates gendered difference among Black people and Black women get treated "like men"). King argues that "theories of racial castration are fused to a narrative about racial authenticity that leaves Black women politically isolated from the overarching Black community, their efforts to survive attacked as forms of race-betrayal, their struggles within and without their homes elided" (32).

41. See Beth E. Richie, *Arrested Justice: Black Women, Violence, and America's Prison Nation* (New York: New York University Press, 2012); and Cathy J. Cohen, *The Boundaries of Blackness: AIDS and the Breakdown of Black Politics* (Chicago: University of Chicago Press, 1999).

CAUTIOUS LIVING:
BLACK TRANS WOMEN AND THE POLITICS
OF DOCUMENTATION

Miss Major Griffin-Gracy and CeCe McDonald in Conversation
with Toshio Meronek

Miss Major Griffin-Gracy and CeCe McDonald are conjurers. For many decades, trans and queer people have gathered around Major, creating a family of mutual aid in which she mothers us all. Similarly, the international struggle to free CeCe from prison after she survived a racist and transphobic attack has built an underground network of abolitionists whose work has strengthened the link between trans liberation and the end of prisons. Both women inspire real actions with the vibrations and words they put out into the world, which are, at their core, about rendering people's lives more livable and exorcising the world of all oppression.

Their lives are at once individually extraordinary and extraordinarily common for trans women of color in the United States. Major's and CeCe's stories capture the dehumanization of trans women of color that materializes as intense physical and psychological violence; they also help us imagine ways to endure and thrive under the most precarious of circumstances.

CeCe and Major are the subjects of the recent documentaries *Free CeCe!* (2016) and *Major!* (2015), respectively. These films were both released in the context of increased visibility for trans women of color; with this visibility, there has been a pointed increase in violence against this same community. As on-screen protagonists, Major and CeCe exist both as actors shaping their own histories and as documents of time.

I write as someone who became inspired by both women via their public reputations around 2010, but it was not until the fall of 2014 that I spent any meaningful amount of time with them. As a member of the makeshift road crew for their speaking tour of Southern California, I arranged for taxis and took photos on cell phones handed to me by event attendees who were likewise transfixed by CeCe's and Major's brilliance. Though I've since called on them time and again to share their insights for other journalism projects, this is the first time we've talked formally about the recent rise in visibility for them and for trans people at large.

Leslie Feinberg, Leslie Feinberg and CeCe
McDonald at Hennepin County Jail, May Day,
2012. Digital photograph. Courtesy Minnie
Bruce Pratt. Image: © Leslie Feinberg

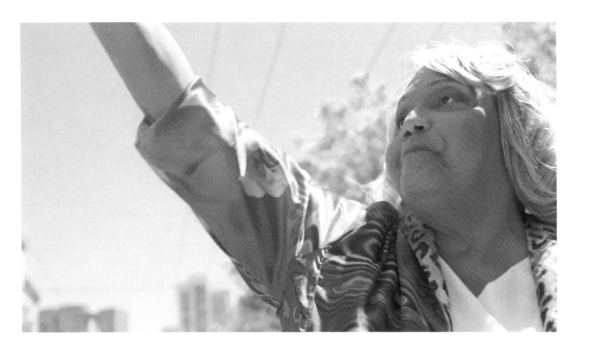

Annalise Ophelian, *Major!*, 2015 (still).
Feature-length documentary film. HD digital
video, sound, color; 95 min. Courtesy Annalise
Ophelian. Image: © *Major!*, 2015

TOSHIO MERONEK: The documentaries about each of you came out at this moment when trans people are more visible than ever in the mainstream media. How do you think this visibility translates in the real world?

MISS MAJOR GRIFFIN-GRACY: There's a backlash. It's a very wonderful thing that Laverne Cox was on the cover of *Time*—it's a monumental thing.[1] Before today, occasionally a person would get mainstream attention—like Christine Jorgensen—but this is the first article that was geared toward *us* as a community. She's a black woman, and she's trans, and she's in what people consider *the* profession—she's an actress. But with that newfound visibility, there's always a reverse reaction.

People all around the world were amazed by Laverne's cover story. However, for the girls who have to live on the streets and off their wits, this was not something that was beneficial to their existence. What I have noticed, since that happened, is that there are more girls being murdered or beaten up because the people who want to do these harmful things can't get to Laverne Cox. She's in a world that they can't even dream about approaching; she's basically out of their reach, with the security that she has.

Girls like me—we don't have that security. So somebody can really dislike the fact that trans is gaining acceptance and think, "Oh, there's a trans girl on the cover of *Time*; oh, there's one of those trans bitches there," and go and kill her. Another trans woman pays the price for what the media is applauding and the world is getting all happy over. There are two sides to every fucking coin; nothing is as simple as it appears to be. Now, how to negotiate that, or mediate it carefully, is hard to do.

CECE MCDONALD: I feel like trans women are being acknowledged and are in the spotlight in ways that are not just about depicting trans women as stereotypes. We're human beings.

But this trans visibility also puts trans women in unsafe positions. With the height of trans visibility has also come the height of trans violence and murder. And so it's very important for people to acknowledge that yes, it is important to see these figures in the spotlight, but it is also necessary to recognize that this "trans tipping point" is bringing an unsettling rate of violence toward trans women.

TOSHIO: So, the concept that mainstream media depictions of queer and trans people are making queer and trans peoples' lives easier offscreen is false?

MAJOR: We are always going to have to look over our shoulders. Just being black, you're the dirt that everything else is built on. So people are like, "Fuck you. And then you have the nerve to be a transgender person, too?"

I don't believe that the documentary that they did about me is something that is going to get worldwide acclaim, because it's not of interest to everybody. People really don't care about our existence, or how we navigate through society, or how we live, acquire friends, create a social network, develop a sense of family—because our blood families tell us to go and fuck off. We have a lot to do to build up who we are, so we can have a sense of pride in ourselves and behave with some sense of *dignity* and *style*. And then, with that, have the comfort of being safe where we're at. Usually, we're never feeling safe. There's always that one person who looks at you funny ...

For years I wouldn't go to restaurants, and when I did, I'd have to sit somewhere with my back against the wall, where I could see the front door, so no one could just come in and whip on me. And it's hard to live your entire life like that—always paying attention to people coming past you and how they look at you, worrying that once they go behind you, they are going to turn around and come back at you.

So you learn to look in reflections—off of store windows, or windows on cars—just to be sure, because you never know. And so, in that regard, what winds up happening as we're going through this, we become bitter, distrustful, and crusty, because we're like a cheeseball with nuts all around it: you can't get to the cheese, bitches, until you deal with the other bullshit that happens around that.

And even then, we still have to be careful, because a lot of times, someone that we're living with, some man that we're seeing or what have you, will get violent. See, he has to get high or have a drink to be with us, or his religion tells him this is sinful, so after he goes to bed with us, he must repent. Well, his repentance means he has to hurt us. "Go repent outside, and better yet, *don't come back in.*"

We want male company, so sometimes to have that, we have to give up some of our safety. That puts us in this state of constantly having to be aware of our surroundings. Our only respite is sleeping, and hopefully having dreams that aren't going to drive us crazy. And how do you live waiting to go to bed so that you can relax?

TOSHIO: Major, you were recently interviewed for a TV segment honoring trans liberation fighters Marsha P. Johnson and Sylvia Rivera, who were being given awards posthumously.[2] All of the other awardees were gays and lesbians

who are still alive. What will it take for trans, queer, and gender nonconforming people to get recognition while they're still living?

MAJOR: Right now, we're the flavor of the month—we're the Neapolitan—but mainstream gays and lesbians still don't care about us; they're not doing things to help keep us safe or to help promote us. They spent millions and millions of dollars [lobbying] for the right to get married. "Oh yay, let's get married." OK, what about taking some of that billion dollars you spent and using it to set up programs to get kids through school without [being bullied], to help transgender people keep it together through all the stuff that they have to suffer and get the help that they need to become stable.

I don't want an award; I'm not in this for all that shit. I'm here to make sure that my girls avoid the crap that I had to go through; you don't have to turn a trick and suck dick and sell drugs to survive. So, I would have wanted the award's producers to at least show that they care about us. Marsha, Sylvia, and I were friends, and they're calling me to speak on film, but posthumous awards are not the same as care.

We've earned the right to go to college, to go to trade school, get a job, be paid fairly, and pay taxes. We didn't really have the chance to do any of those things until AIDS came along and started wiping these fags out left and right. Then, no one wanted to touch them, be around them, or look at them, because the person they used to know, visually, that person wasn't there anymore. Well me and my girls, we didn't care; we knew in a crisis, you help.

But when I started applying for clinic jobs, the first thing they wanted to know was, how big were my titties, and how long was my dick. Well, since you're not going to be sucking on my titties, and you're going to leave my dick alone because I wouldn't stuff you with a pole, it's none of your damn business. "Oh, so you don't get the job." And hospitals wouldn't hire us, because we had no work history. I don't need a work history to wipe down some guy with AIDS when no one else wants to bathe him; just give me the damn job.

It took a long time to get past all that. Gays and lesbians with influence are trying to claim that they started this movement. But it's like: Where were you then? Oh, you weren't born.

TOSHIO: Even with increased visibility in the media, it must occur to you that you may be the first trans woman that many people in these audiences can knowingly identify as trans. And so, in a way, you might be forced into this role of representing for the entire trans-women-of-color community. What is that experience like for you?

CECE: I'm glad that if I am the first, then at least I'm not the stereotype that the mainstream media would portray. But a part of me isn't quite ready for all that.

MAJOR: What I've noticed because I'm older is that people are really leery of asking stuff. After a speech, someone's *got* to have a question. But no one asks me anything until I'm leaving on my way to the transportation I'm taking out of there, then people come up. And I'm like: So why didn't you ask me in front of the audience? Oh, because you're ashamed of it. I'm not—you should ask me then.

It's OK; I know that they don't understand. I'd rather they ask and weren't as ignorant as they were before I got there. *That* would be nice.

TOSHIO: Do you see a difference between the women you are depicted as in these films or on stage and who you perceive yourselves to be?

CECE: In the documentary, that's me; that's genuinely me. But that's not to say that I don't have multiple personalities, which I do. You know, you've got CeCe; you've got Chrishaun; you've got HoneyBea; and they all have their own personalities. I feel like you got a sense of all of those people in the documentary. It's kind of like Beyoncé's Sasha Fierce factor. We all have this person—HoneyBea is the person that is the outspoken and, you know, very *in your church* personality, and then you've got CeCe, who is just chill, and Chrishaun, who is just a powerhouse.
[Friend in background: CeCe got real issues.]
[CeCe to friend: This is who I *am*! Accept it!]

TOSHIO: You feel that CeCe, Chrishaun, and HoneyBea were appropriately represented in the film?

CECE: Yes, because life isn't edited. Even though in the case of the film, a lot of the footage that was captured for the documentary didn't make the cut; it was two or three years of tape put into one ninety-minute film.

TOSHIO: Major, you're outspoken about your life as a sex worker. Sex work almost invariably involves an element of performance.

MAJOR: With sex work, you gotta be *on*.
I don't think of the film or public speaking like that, but what I notice is, the people that I'm going to speak to are expecting that type of thing. Because of my

age and how long I've been around, they have all these ideas about how I'm going to present, about who I am, and what I'm going to say.

Even after they've seen the documentary, they still have all these preconceived ideas. And the thing is, in the documentary, that's exactly how I am. This isn't a mapped out thing; this isn't a book where you can say, Oh, this is the beginning; this is the middle; this is the end. She fell in love; he died; her poor heart, she's broken, still in love with him. In the end, that's crap.

For me, the most important thing is making sure that I represent my community from my unique position. Because I've been around seventy-four fucking years, and you can't say anything that's going to shock me or have me running into a corner. People don't think about that when they think about me. They forget that I have all this history in my head and with me; on any given subject, we can sit and discuss *whatever*, and I can have an opinion on it. Just because I'm trans doesn't mean I don't think, or that my brain has been on hiatus since 1962, but they do think that. I had to get to seventy-four to feel like the token nigger, transgender bitch. That's a lot to take on.

And so, I want to make sure that if you're going to work me, I'm going to get what I need out of it to be OK. Because I've *earned* this; I got here, and it wasn't an easy trip. And getting paid to make appearances didn't start fifteen or twenty years ago—this *just* started.

I didn't do this documentary for me; I know what I've been through. I did it for the younger trans girls, so they can understand that they can get here. But there's a lot of negotiating; there's a lot of finagling through this society and this world; and there's a lot of cautious living to do. It's kind of like living your life walking on eggshells. So you have to get through all this crap and wake up at the other end. Things are *not* fine; things are always up in the air, and we are always struggling and being aware of and trying to be conscious of things that are going on.

We're getting shit from our families, from schools, and from the people who do not want to hire us for jobs, especially during my period of growing up. So some transgender girl gets beat up, and the media goes, "Oh, 'Man Who Wears a Dress' Got Murdered." *She* got murdered, not a "man who's wearing a dress."

And then the family gets involved and decides, "Let's bury her in a suit." Meanwhile, these girls have had work done and breasts done and their faces redid, and they're going to stick them in a men's suit? Oh yeah, *that* was made for her body. Even if the girl has taken the time out to make sure what her wishes are for her last rites, they ignore them. They say, "Well, I'm the family, and I can do what I want to do." That is the grossest form of disrespect. Their entire life ... They've just taken the girl's entire life and said, "Well, fuck her."

TOSHIO: So, specifically in the film, you didn't change your persona?

MAJOR: No, because as an older trans person, I don't have time for all that excess drama and bullshit. That is exactly how it is, and what happened at the time, what I remember.

TOSHIO: Do you have an ideal audience for the films, or for when you speak?

MAJOR: My community—young girls who are just coming out or feeling as if they are the only ones in the world, or that no one out there could ever know what they've gone through …
 For them … I just want them to be aware that there's a culture here. We have a history as trans people that didn't just start with me, or with Laverne Cox being on the cover of *Time*; it started *years* ago.

TOSHIO: Do you feel like you perform differently in front of different audiences?

MAJOR: I'm more comfortable if I'm dealing with other trans folks, because I don't have to explain a whole lot to them; they know where I'm at, what I've been through, and how I got here. So in talking and being with them, it's like having friends over to have tea, and we just sit and chat, which is a good thing. Now, some places you have to go through Trans 101 …

CECE: I love to talk to trans women because there's a lot of transphobia, even within the trans community. But cis men of color, they also need to know how important it is for trans women to have the support of their community.
 I'm not saying that communities of color don't support us, but we're living in a society that just has it out for all of us because of our gender, our class, or whatever the case may be. I want to have dialogue—I actually want to start a project for cis men who have killed trans women and look at what drove them to that kind of violence. It's the "trans panic" effect. I want to ask them: What does trans mean to you?
 The "trans panic" defense—that you were made to believe that this person was a different gender than they are—I think it's something that's deeper; it's an intersectional thing that is part of violence toward women in general, and society's got to be accountable for building this type of fear.
 And trans panic doesn't just affect sexual relationships; I'm talking about *any* type of relationship: cousins, brothers, fathers, mothers, whatever the case may be. Even on Facebook, posts warning cis men, "Fellas be careful" or "Don't

be tricked"—*that is violence*. People don't *understand*. That is what's gassing up these people to be violent toward trans people, because now they have this idea that trans people are deviant, that we trick people. It's not the case at all.

People won't have any kind of relationship with trans, queer, or GNC people based on not wanting to be shamed in public. In the end, that's why I really want to talk to cis men about how we need to build our communities together so that we can end violence against trans women of color, so that we can end the intersectional components that are transphobia, class, white supremacy, and misogyny.

TOSHIO: Can you speak more to the idea that the misogyny that trans women experience is the harshest form of the misogyny that *all* women experience?

MAJOR: For years, there's been this unspoken separation between trans women and trans men, and this is because trans men pass so much easier. My girls are not going to pass that easy. Most of us are larger than the average bear, you know what I mean? OK, I'm five-eleven; I'm six-two; I'm six-five—OK, girl. We don't have that acceptance quota about us, because a man can be anything. He can be five-feet tall, and as long as he has a little stubble or a deep voice, he's good to go. Women, even the cis women, have all these criteria that they have to meet to be OK. Any model has had to be stick-thin. At least up until the heavyset girls who have started to model lately, and even then, some other women have said, "I think that's disgusting having that cow wear that shit." Oh, really? Your mother was a cow, bitch, and you're headed there. Wake up!

It comes down to dick and pussy. You got a dick, the world is: "Yay! Work that thang, it spits cum, and how wonderful."

But you have a pussy, and the world is: "Well, that's OK ..." There's so many straight guys who just can't *stand* having to deal with women and their pussies, but they do it because it's the acceptable thing, while in the back of their brains, they hate women. If they didn't, they wouldn't be chasing my trans girls down low and having them, then getting upset when somebody finds out.

So, going through all of that shit, what winds up happening to the trans person: if you were born a male, and you want to be a female, or look like a female, you're a sick, demented, twisted loser. But, if you were born with a vagina and you want to have a dick, how wonderful for you to realize the power of the penis. And this world is based on that. There are so many smart, intelligent women out there who are never going to get the chance to be in the type of control and position that they should be in, which is what got a lot of the girls, including me, involved in the women's movement. Because I always thought, if they get going, I can get on that bandwagon. But then a couple of them decided, "Oh no, you

want to rape me." Miss Thing, I wouldn't want to use someone else's dick to rape you; you don't understand.

CECE: I feel that as a person coming up from the hood, what you're giving is the black girl's feminist perspective and not the white woman's feminist perspective; they're different things.

And a lot of white women have been debating whether or not Cardi B or Amber Rose or Beyoncé should be considered feminists because of whatever rhetoric [white women may have] that is somewhat still upholding white supremacy. It's like there's a certain [correct] type of feminist, and it's the one that's aligned with white women's fantasies. Like, "You should get out of here, girl; stop talking about Amber Rose." But what Amber Rose is giving me is what I need in my life!

TOSHIO: For the films, I assume you wouldn't have trusted just anyone with your stories?

MAJOR: There was trust with Annalise and Storm.[3] Storm had started working with TGIJP [the Transgender, Gender Variant, and Intersex Justice Project] while I was still its Executive Director. And when Storm was bringing Annalise around the office, she had me in a film she did called *Diagnosing Difference* [2009], and we just hit it off. She's straightforward; you never get the feeling that she's up to something, or trying to slip something past you.

And so, I was talking to her, and told her that people had been asking me to do something for years, but I've seen some of the documentaries they do about the girls, and they don't treat them right. These documentaries can be very sensationalizing, "Oh, let's show her shooting up drugs, and hanging out with her dick out." *No.*

So in talking with Annalise, she mentioned to me that we could avoid that, and let's work out how we would want it—What would be its purpose? Why was I willing to do it now, when I hadn't been willing to do it before? And I was willing to do it now because of her. And after seeing it, I'm there crying with everybody else, because it was me, and I lived all that—but that doesn't mean the emotions that happened along with it are gone.

For me, it kept me in touch with who I am. And I don't want to be bitter and tired and annoyed and frustrated and angry. I still want to feel the hurt when a girl dies that shouldn't have; I still want to cry when something happens that is devastating to one of my girls' or guys' lives. And I want to cry tears of joy when something good happens. When they find love, and they really believe in

it—that it's the true thing. I wish them well, and hope that they have found it. A lot of times we don't, you know?

CECE: I feel like my correspondence with Laverne, which was before she even got the role for *Orange Is the New Black*, helped.[4] She was a part of this show called *In the Life*, which Jac was producing at the time.[5] I was just gonna be a little segment piece in the TV show, and then the show lost funding.

It's been a long process, so over time, I've been able to get to know who these people are. Of course I loved working with Laverne; when she approached me, and she was a trans woman of color, that really kind of helped me get comfortable with doing the documentary.

TOSHIO: Having a trans woman of color involved in the project played a part in you saying "yes"?

CECE: Yes, definitely. Also, Jac, being a white cis woman, knows that she has this privilege—knowing that, and that she could have had anybody do the documentary, and previously working with Laverne, really sealed the deal for me.

TOSHIO: You are two of the most well-known trans women in this niche trans/queer world. CeCe, your case was championed around the world; people were tagging "Free CeCe!" in places like London and Paris. Major, you have a building in New York named after you; the Stonewall statues in Greenwich Village were painted brown in your honor. People have taken action in your names, outside of your knowledge, and beyond your control. It seems that these things would qualify you as "public figures." Do you accept that title?

CECE: I don't know; I feel like I'm just me, and how people see me is how they see me.

I have a roommate; I'm barely making it. I don't want people to think that I'm living lavishly—that's not where I'm at right now. If I'm a public personality, or whatever the case may be, that wasn't my intention.

What I *am* is a black trans woman who is an activist, who is fighting to help uplift the most marginalized, the most targeted ... Being the person that I've always been, who is this person who's been there for community, who's been there for family, who's been there to support people. That's what I want people to understand. I'm not trying to produce some public image, or be a "celebritay," or any of that. Because there's more to me than just being pretty.

I'm still struggling; I have bills; I gotta pay rent. But I'm here for my community, and I'm going to do what I can.

TOSHIO: That brings up the concept that being a public figure does not necessarily translate into the things that people associate with it, like material wealth. Why aren't you both living in mansions somewhere?

MAJOR: Well, for one, I'm the wrong color [laughs]. It would be nice, but I don't think it's going to happen. I'm a grassroots person; I don't want to be in management; I don't want to decide where this girl is or that girl is. When they painted the Stonewall statues, I was so tickled; I was running around here like Snoopy at suppertime, child, because it was so cute.

Then, of course, I found out the city government washed them down and repainted them white. And the statues were brass! That's brown—leave them brown! "Oh no, white again." Alright, how about we blow the bitches up?

CECE: Of course I'm being fiscally responsible—making sure that I can pay my bills and do stuff like that—but nine times out of ten, I'm helping out other people, which isn't an issue for me; I wish I could do more, but I'm only doing what I can with the financial privilege that I have. A lot of people are like, "That's crazy; that's your hard-earned money," and things like that. But how can I be a person who talks about community, and talks about poverty, and talks about equal pay, and employment rights, and things like that, and then have all this money and be stingy with that? Isn't that why people are rich, right? People are rich because they hoard money.

I feel like it's my duty to help my community. If my friend says she needs to get help on bail, and she has no way to do that, and the resources that she has aren't helping her, then I'm going to help her. If I have it, *I will give it to you*. Isn't that what community is about?

And that's also something that is helping me grow to understand the person that I am. I recently got into a debate with someone about giving a homeless person some money, and they were like, "Well, they don't do nothing but spend it on liquor," and it's like, even if they did spend it on liquor, I mean, look at the situation that they're in.

I remember a time when I was homeless ... And to numb the pain of not having stability and not having employment and not being able to support yourself and only being able to afford a two-dollar bottle of vodka, or whatever the case may be ... You can't judge somebody for the state that they're in. And also, it's not my place to say what you do with the money once it leaves my hands. You

said you needed it for something, and I was there to help you. However you took advantage of that situation, that's up to you. I'm doing this out of the kindness of my heart because I know what it's like to be in that kind of predicament.

TOSHIO: Do you ever envision there being a mainstream media where trans women of color have real agency and get to tell their own stories?

MAJOR: Things are getting better, but they're not where they should be. I'm hoping maybe it's going to get better during the time that I'm still alive. I did this [documentary] so that the younger generation could know that they're not alone; we spent a lot of years in the beginning trying to figure out what to do, where to go, who to trust. I want them to know that, first of all, they can trust themselves—that they're not this abomination that people try to tell them they are. They're not stupid.

You can follow your heart. I don't think it's going to lead you wrong. It's going to be bumpy; it's going to be rough; nothing is fucking easy for anybody, but if you stick to your guns, it's going to be OK at the end of the day, you know? I want them to say, "She went through a lot of shit, but she's still OK." I feel that the film builds to such a powerful message with the community. "Yes, we're still fucking here."

And I want them to realize that, and for the community to take that with them when they leave. And for the people who are not a part of our community to realize, "Well, they're a tough bunch of bitches; they went through a whole lot of shit; they should be commended and respected for the choices that they've made, and what we have put them through unnecessarily," because that's exactly what they've done. So if they happen to run into a girl somewhere, they at least give her that respect.

CECE: I feel like we are getting to that point. But of course, in a mainstream media that is geared for the white gays, and that is conducted through white supremacy, we can only maintain so much of the voice we have, without it being altered to stroke the egos of these people in society to make them feel better about our narrative, right?

And so, I feel that if there were more trans, queer, and GNC people of color having agency in mainstream spaces, then our narrative definitely could change. Because the stereotypical narrative and the rhetoric that plays out with it soothes society, which then acts out in ways that can be even more violent, or transphobic, or homophobic, or queer-phobic, toward our communities. Or the

media helps non-trans people say to themselves, "I didn't understand, and now I still don't understand, but I'm a good person because I watched this movie."

Our narratives aren't really for those people, you know what I'm saying? They're not for them to consume in such a way that makes them feel better about themselves. Our narratives should make them get their shit together, not be like, "Oh, trans people exist—how fascinating!" Like, yeah, dumbass—Captain Obvious, we've been around for all of human existence, so why wouldn't we be here?

Once there is control over that type of space, where trans, queer, and GNC people of color can have that type of agency, then definitely our narrative could change. We're getting there—we're just not necessarily there yet.

. .

"Cautious Living: Black Trans Women and the Politics of Documentation" transcribes a conversation between journalist Toshio Meronek and activists Miss Major Griffin-Gracy and CeCe McDonald that was conducted in San Francisco on June 13, 2016, for this volume.

. .

NOTES

1. See Katy Steinmetz, "The Transgender Tipping Point: America's next civil rights frontier," *Time*, May 29, 2014, http://time.com/135480/transgender-tipping-point/. The cover of the magazine features a photograph of Laverne Cox accompanied by the title of Steinmetz's article.

2. Johnson and Rivera were honored during Logo TV's "Trailblazer Honors" awards, which aired on Logo and VH1 on June 25, 2016. See JamesMichael Nichols, "Marsha P. Johnson and Sylvia Rivera Honored by Modern Day Trans Heroes," *Huffington Post*, June 25, 2016, http://www.huffingtonpost.com/entry/marsha-johnson-sylvia-rivera-logo_us_576da1a2e4 b0dbb1bbbaa257.

3. The documentary *Major!* was directed by Annalise Ophelian and produced by StormMiguel Florez ("Storm").

4. Laverne Cox coproduced and appears in *Free CeCe!*

5. Jac Gares directed *Free CeCe!*

EXISTING IN THE WORLD:
BLACKNESS AT THE EDGE OF TRANS VISIBILITY

Che Gossett and Juliana Huxtable in Conversation

The following conversation between scholar, activist, and archivist Che Gossett and artist Juliana Huxtable took place on May 18, 2016, at the New Museum.

CHE GOSSETT: I saw this really great quote that somebody had made into a .gif. Someone asked you in an interview, "What's the nastiest shade you've ever thrown?" And you said, "Existing in the world." I wrote it down, and I was like, okay, this is so powerful, you know? It struck me. It made me think about black trans politics and Afropessimism[1] and the will to live.

JULIANA HUXTABLE: That was at a photo shoot that I was doing. I was kind of apprehensive about doing a video thing because, at first, it seemed like they were trying to get everyone to perform in this way that I wasn't in the mood for at the time, the sort of performance that Black queers are often asked to embody—to over-identify with performativity. And so I didn't know what they were going to ask me. When they asked me that question, I was like, "Oh, that's actually a really difficult question. I'll process that."

And then I thought about it, and I said, "Existing in the world," because that's generally how I approach the more ostensibly "politicized" aspects of my being in the world—sort of like being the shade—trying to exist in a way where I don't even need to state the validity or the invalidity or the absurdity of your discomfort, or whatever it is. At that moment in my life I was dealing with a lot of explicit transphobia. That was earlier in my hormonal transition. And so I think that's why that idea resonated with me at that moment.

GOSSETT: Do you feel that there is a black trans radical tradition? And how might it be defined?

HUXTABLE: Well, it's weird because, to me, the word "tradition" implies a handing down, or rituals, hand-me-downs, and traced languages, and documentation of all that. To me, that's what tradition goes hand in hand with. And so, I find it hard to say whether or not there's a black trans radical tradition. I think that there are—that there have always been—radical Black trans people and lives and work. But I feel like, at least up until recently, there wasn't necessarily a tradition. I think in the moment we're in, with social media, that's one of the advantages in terms of the visibility question. There are platforms and profiles dedicated to archiving what's happening in the present, and to uncovering and highlighting these moments in the past—even if they were disguised until the contemporary moment. I'm thinking of model Tracey "Africa" Norman here as a prime example. She was hidden in plain sight as a transgender woman breaking barriers before she could be credited for doing so ... I think social media is expanding the possibilities for both archiving the present and finding ways of revisiting and rereading the past so that we can try to form something that we could perhaps analyze and use to approximate a "tradition."

When I was blogging, that was my outlet. I was using my blog as a way to try to document and mine books and websites and media and then share them. And it was actually hard for me to find basic documentation of Black trans people. You know, you have *Paris Is Burning* [1990], but at that point, I was like, *Oh my god*, if I have to talk about *Paris Is Burning* again ... That's the only documentation of what exists? And so, I really feel that a black trans radical tradition is only being deciphered now.

Paris Is Burning and the ballroom community at large represent a culture that does, very literally, have a tradition. There's a history; you can trace it and explore it in the archive. And there's documentation. There are figures I've kind of become obsessed with. But I was also like, What does it mean? Where are the other Black trans intellectuals? Where are the Black trans activists? Where are the Black trans musicians and artists? They are very difficult to find. When asked, there are people that I can think of like Vaginal Davis and Connie Fleming. I learn more as I go along. But I feel like the tradition is still in the process of being discovered and articulated.

GOSSETT: I think it's always a retrospective project to create a tradition, and then it gets documented.

HUXTABLE: There's definitely nightlife. Connie Fleming was one of my trans idols. When I first moved to New York, just being able to live in this way, against all the expectations of what people presume, especially as a Black, trans, general

femme-spectrum person, felt radical. Connie and Honey Dijon were some of the first people who really demanded presence and respect in this way … I think that's why I was attracted to nightlife, because there was not a tradition, per se, but figures I felt proximate to.

GOSSETT: That's interesting. Monica Roberts has a blog called *TransGriot* that pushes back against historical erasure.

HUXTABLE: Yes, *that* I love.

GOSSETT: Roberts found that *Ebony* and *Jet* used to cover balls in the '50s and '60s, and because of that, the magazines perform as black trans archives. I thought that was really interesting. And then other people were like points of light for me and for so many of us—like the incredible Miss Major.[2] There's still work happening to excavate more of that history. … There's another person, Mary Jones, who was the first Black trans woman to get locked up for sex work in New York in the 1830s; I first learned of her through Tavia Nyong'o's book *The Amalgamation Waltz: Race, Performance, and the Ruses of Memory* [University of Minnesota Press, 2009].

HUXTABLE: I love that it goes that far back—not that the persecution does, but that the first documentation of a Black trans sex worker was in the 1830s.

GOSSETT: Yes! I was so interested in her story that, after reading Nyong'o's book, I ordered a copy of a court transcript where the judge asks Jones, "How long have you dressed like this?" And she says, "I've always dressed this way with people of my own color."

The "always" is really interesting because it holds, you know; it spans. Jones was from New Orleans, so her story made me think a lot about black trans genealogies of resistance and resilience. I think that there's definitely a black trans radical politics that is also always a plural form of politics. And I think that in the so-called age of visibility—neoliberal visibility—your work and other trans artists' work that pushes at the critical edges in ways that subvert and, as Gayatri Spivak might say, "affirmatively sabotage"[3] is really powerful.

How do you think about this new, neoliberal, spotlight moment?

HUXTABLE: Right, this zeitgeist moment?

GOSSETT: Yes, the zeitgeist moment. How do you work within it, or how do you problematize it?

HUXTABLE: I think, in some ways, I have a chip on my shoulder about the whole thing. It's gotten to the point where there's this toxic assumption that one would transition in order to be in the spotlight, in order to gain media visibility—literally, just being visible to sell an idea, like there's something to gain, or maybe to monetize. It's frustrating because I think that type of visibility is really strictly monitored.

GOSSETT: It's like surveillance.

HUXTABLE: It's total surveillance. I think there is an actual moment of dynamic and, in many ways, powerful visibility, and perhaps there are reasons why it's happening that we can point to. I think there are a lot of cultural factors in terms of gender variance that are hot-button issues now. I think, in terms of larger fantasies and narratives around social progress, visibility just fits into an ideal of where we would be at this moment; it's the next logical step from third wave feminism or cyber culture or the juridical advancements of mainstream LGBT rights.

But it's an empty gesture in a lot of ways. And it's a gesture that I'm always questioning. Are they—meaning the audiences obsessed with and consuming media about transness—tapping into a derivative pornographic obsession with transgender bodies? Or are they putting me on display as a circus freak show, in a "We're all secretly laughing at you" sort of way? That's the anxiety that I've gotten from the whole situation, because I think that the policing and the violence against trans people have a direct relationship to that increase in visibility. The people who gain visibility—those whom the media deem to be relatively "passable" in one sense or another—end up being used as examples to police trans people generally.

There's this rift that opens between gender variance and transness as an idea. And I think that's part of the trap of what's happening in terms of visibility. I didn't know how to engage the term "trans community": "Are you are speaking for the trans community? Are you doing this for the trans community?" And I was like, I don't know what that term means. I have no clue what the hypothetical community is that you're speaking of. I am developing my own sense of a community as time unfolds, but when I first started to transition—medically at least, to establish a point of reference—I didn't really have a community. I felt like there was no community ... Maybe online, on Tumblr, but that was just

under the umbrella of queerness more broadly. At that time, I felt isolated in my experience as a trans woman. I didn't even have trans friends. Someone I dated around that time was the first person close to me who was also trans.

When I would meet older trans women, I would be like, Oh my god, how do you do it? Oh my god, what about hormones? Oh my god, what about your sex drive? How have you supported yourself? There was a kind of apprehension, almost a distance or a dismissive attitude toward me, when I would ask those questions. And I didn't understand that. But I think it's because so many people of an earlier generation had to go through so much. To have someone who, from their perspective, just decides to take estrogen one day and assumes that those experiences have a shared commonality with what they went through was almost insulting to these women. They were like, "You have no clue what I've had to do just to be able to exist in this way."

I feel like I'm having a sort of similar response in relation to the visibility moment because I don't know what this community is. I don't know. And I think a lot of what people speak about in terms of visibility now is literally press coverage—articles, photo shoots, interviews—and I don't want that to outpace what I'm doing in my life, because I got to the point that I'm at without that moment. And so, it's complicated. And it's also fueling such an intense backlash because we haven't collectively thought through what the idea of a trans community is. What is the trans community of the United States?

I feel like that community is way more ambiguous and undefined than the Black community, even knowing that that community has so many manifestations. But there's a history, and there's documentation, and there's a relationship to media. Just promoting the idea of visibility is getting ahead of really dealing with the intricacies of what it means to create a community within ourselves, to create a community that then engages the outside world with a sense of cohesion (or not). And that lack of an infrastructure is creating this self-replicating media cycle. But most people don't know what the term "trans community" means.

I see the people in my family, for example. I have members of my family from the South who, if I weren't their family member, would probably beat the shit out of me if they met me in a bar, you know? I know that. I'm living in that reality. And so, it's crazy to function in the mode of visibility.

But I do think it's good in some ways. Like in my relationship with my family, visibility lends an air of legitimacy to people who are like me. My family is operating in a world where they're like, "We don't really know or understand what you're doing"; "We're presuming that your behavior is insanely risky and problematic"; or "You have daddy issues." There's a whole list of things that they just presumed because I operated in a realm that wasn't accessible to them. But once

it got to the point where I was in a *Vogue* article, so many of my family members were like, "Oh, it's legitimate now." And so, I guess visibility can offer something productive in a compromised way, considering that so many people, especially people of color, don't necessarily have the education or political context to really break down what visibility in the neoliberal context means.

GOSSETT: People seem to be appropriating the moment. I feel like a lot of the trans political pedagogy happening now is coming from trans women of color who are using this moment when the world is watching.

HUXTABLE: Right.

GOSSETT: The criminalization of the musician Big Freedia made me think about the moments of trans visibility under racial capitalism—the limits of trans visibility and how visibility still doesn't challenge the hierarchical and racialized distribution of resources and/or criminalization within the regime of racial capitalism. And yet, people are sabotaging visibility.

HUXTABLE: Yes, and I think the art world functions so explicitly as a product of violent and impulsive capitalist motives because it's funded by private collectors. That's what fuels … that's what permits visibility, even career stability for many artists. If I didn't have a collector who bought my artwork to gift it to the Guggenheim, I would not be in that museum—it's all funded by a system of people who are making money in hyper-capitalist ways.

And so, what's interesting is the way visibility is being used to sabotage actual engagement with real questions of structural negligence and discrimination and violence. It's promoting problematic hegemonic ideas about what bodies are or are not legitimate. For instance, I did this panel at Art Basel in 2015 called "Transgender in the Mainstream." And I told the moderator in an email, I don't like this title. I don't want this. This is so disgusting. They used the title anyway. And I flipped out at the moderator because he sent the email to the other panelists. And during the panel, there was a moment when everyone had to *read* the organizer. But that's actually what people think—that we are "in the mainstream" because of visibility.

I think the circulation of Frank Benson's sculpture of me from the New Museum's 2015 Triennial exhibition "Surround Audience"—just how widely circulated that work was—gives people an idea that art is having a trans moment. But there are so few trans artists, it's actually insane. There's Zackary Drucker, Vaginal Davis …

GOSSETT: Chris Vargas, yes!

HUXTABLE: The idea that we could plausibly make a list right now between the two of us—that we could probably make a pretty representative list—and yet I have to deal with someone literally saying "transgender in the mainstream" is crazy to me. I think it's more extreme in the context of the art world because, at this point, I think the art market is seeking out the consumption of marginality.

There was a period, which most people will probably dismissively or patronizingly refer to as the "identity politics" period, during the '90s and maybe into the early 2000s, when notions of diversity and marginality—which were linked to critical antagonism toward certain structures—were so prevalent in academic dialogues and in culture. But now, it's crazy because so many real discussions of race and things like that have been swept to the side, or people assume, "We dealt with that already." And so, we're in this moment now when I think people are actively seeking the next margin, the next type of work that undermines the system of mainstream artistic production. And I'd rather it be trans than what was happening for a while, when these nihilist, pseudo-Marxist white boys were mocking, jeering, and squandering opportunities, while claiming these approaches were "critical stances."

But it's weird, because if you look from the outside, you would think that I'm a very successful artist. People write about my work; it's distributed. But since the Triennial, no one has purchased any of my artwork. People are not buying. The images that don't present me as sexualized in some way, like *Untitled in the Rage (Nibiru Cataclysm)* and *Untitled (Psychosocial Stuntin')* [both 2015], which are way more difficult to read as seductive, don't sell.

This situation is such a clear example of this moment that's happening. And that's a form of sabotage to me. People don't actually want to deal with the idea that they're innately uncomfortable and that their entire lives are built around reinforcing really strict structures of sex equals gender, you know what I mean? And, the sabotage is to invite two trans artists to an event, to post the image on Instagram, to share the Facebook article, and to not actually deal with the structural assets.

GOSSETT: Yes. It makes me think of visibility as a deadlock, you know? It's representation, sort of, but not really. It's a scattering of people without any redistribution of power. That's why I think Chris Vargas's MOTHA [Museum of Transgender Hirstory and Art] is so brilliant—it functions as a biting institutional critique of the museum and of the politics of representation and visibility, while at the same time lifting up trans artistic theory, knowledge, and power.[4]

It's intense, what you're saying. I really appreciate your point about the mainstream "pornographic obsession with transgender bodies," which, as a Black trans femme, makes me think about Hortense Spillers and what she calls the "pornotroping"[5] of Black bodies under racial slavery's scenes of subjection and how that carries forward to the "afterlife of slavery,"[6] to use Saidiya Hartman's brilliant political grammar.

HUXTABLE: Yes. It's been really interesting to navigate that whole experience. Now I worry, If I don't have the press, will my work just disappear? And that kind of sucks. But, I feel like any trans person who works in a field that is creative—in the sense that they're making things that you can link back to them in an authorship-type of way—inevitably has to deal with these questions. There's no way of escaping them.

GOSSETT: That's true ... I was going to ask you what you're working on now. Hearing you read at the Poetry Project and looking at your work, there's so much there around what we could call "black trans radicalism." You also deal with the archive of slavery, which makes me think about how blackness is gender trouble and how blackness troubles gender. You talk about history as cosplay. And I feel like there is a blur, where you're bringing together a lot about politics with stuff around Grindr and SCRUFF. How do you see your work as being in dialogue with a black trans radical tradition, with black trans radical aesthetics—or how do you shape that? And then, what do you think about for the future? If the visibility moment is ephemeral and fleeting, and we can maneuver within it but there's a limit to it, what do you think is next?

HUXTABLE: Well, maybe psychologically it's from growing up and always being an outcast in a lot of ways. I remember I had this poster in my room from *DIS* magazine called "W4W Buzz."[7] And the essay that the poster was linked to wasn't so clear, but it was thinking through the idea of a lesbian aesthetics and what haircuts signified as markers of queerness. It was like a fake index of barbershop haircuts with a grid of different options on different models. I was thinking about the semiotics of the subtleties of how you cut your hair or how you carry yourself, or how the way that you speak sort of frames your face, and thinking about the idea of a marker of lesbian identity as being, in a way, related to cruising or seeking out communities.

I think it's difficult now because the visible markers of difference are so quickly consumed and marketed. A lot of times, I honestly couldn't tell you the difference between someone who is a queer punk and someone who is a ballroom

queen because the aesthetics related to these communities—haircuts, clothing, or styles of text—are so mutable. Even in the context of the art world, artists create fake names just so that they can pretend to be a Black female artist. But the markers of identity, or what might be thought of as a real grounding, I think, have disappeared in a lot of ways. That's part of what's really difficult for me to process. But I think the way that I navigate is through seeking out different types of avant-garde or radical traditions. Like when I discovered free jazz and what that signified culturally, that was super powerful to me in a lot of ways. Or when I discovered the realm of porn and sex-worker academic-type feminist writing ...

GOSSETT: Whose work do you remember from that genre?

HUXTABLE: Nina Arsenault's work in this field has really activated my thinking.

GOSSETT: I'm really interested in Mireille Miller-Young's book *A Taste for Brown Sugar* [Duke University Press, 2014] right now. Miller-Young is thinking about black feminist porn studies and interviewing Black women who have worked in porn since the '70s. She says that people have written about porn and Black women, but they haven't talked to the Black women who were actually in porn. So, it's like an ethnography. It's really good. And it's critiquing or grappling with some of the iconic figures of the black feminist radical tradition who were anti-porn, acknowledging them, and saying we can still take up their work, but that we can also expand it.

HUXTABLE: For me, writing has been really powerful, particularly writing for the purpose of performance or live sound, because I think that working in the visual realm is so complicated at this point. When I did the New Museum project, I was thinking of how I could code images, in a way.[8] I was inspired by images of black household art; you know, a Negroid woman in a jungle holding a presumably West African sphere, with black panthers lounging behind her under the moonlight. She's maintaining a seductive and anatomically impossible pose, and her butt is *huge*—you know, the type of thing that I see in my own family's house.

I was also thinking of black radicalism in the '60s and the '70s and how the activist arms of these organizations were suppressed. At one point, it was like Harlem was on fire. Southern Baptists were on the picket line, protesting. There was an energy—the idea that Black existence went hand in hand not just with being politicized or racialized, but with explicitly engaging in juridical structures and social change. And I was thinking of the decimation of a lot of lives and energies. I believe that crack was ... The crack epidemic and the mass incarceration

related to it were direct attacks on black activism, black consciousness–raising, and a pivotal moment for black liberation. And whether or not the government was directly involved, or whether they just turned a blind eye and watched it flourish—either way, movements were literally destroyed. And Black people became trapped in new systems of control.

But a by-product of that, which I've seen—and a lot of this is coming from my experience with my own family—is a backlash against the idea of being radical. Like when I would come back from school having just read Frantz Fanon, and my mind was blown, my family would say things like, "Oh, you're like Malcolm X." "Oh, you're like Angela Davis"—somewhat as a joking compliment, but also kind of implying, "Oh, that's *your* thing." I felt like a lot of that black household art was actually taking explicitly political impulses and mutating them into visual symbols. The prevalence of black panthers in relation to solitary Black women in these images was actually about romanticizing and almost subverting the image of the Black Panther and what that symbolized—to have an emblem of radical activism become something that you could have in your house. Even if you're not processing it consciously, it's nonetheless always a totem of black liberation.

And so, for the New Museum project, I tried to think about how I could create images that abstracted a political impulse into symbols—but symbols that still retained clear political associations. In that series [*UNIVERSAL CROP TOPS FOR ALL THE SELF-CANONIZED SAINTS OF BECOMING* (2015)], I took a kind of black tradition and loaded it with references to science fiction and to the aesthetics of body modification—injections, like butt injections—which I think of as very trans, and I totally morphed the image of my body. Well, I made my butt really big in *Untitled (Nibiru Cataclysm)*.

I was also thinking about how these images might circulate. Like, could I get these images on a Hotep blog? But I was also thinking about all of the baby trans on Tumblr who could see this and feel activated ... And the work was successful in a lot of ways. But then I encountered this problem because no one wants to buy work that doesn't seem seductive, and the literal visibility—in terms of criticism and publicity—surrounding my other works, which are less obviously seductive, was stunted. So it made me wonder: Is the reception or the distribution of that work actually about what I intended it to be? How has the body of work itself been augmented by the desires of collectors, by their desire to sexualize me?

To me, writing and performance are really immediate ways to dictate the terms on which I'm establishing my own history. And a lot of my writing is about history. I reference language that's specific to trans people in New York, like plucking and tucking and binding, and Antony and the Johnsons' "You Are My

Sister," and I try to use text as a way of creating these references. But I'm the one dictating them; I'm the one who's performing them. And that feels a bit more intentional than an image does at this point. Not that I want to abandon images, but, for me, performance and writing feel like very relevant ways to deal with a lot of the questions surrounding trans people or how to represent them in this moment.

How do I engage the idea of a black trans radical tradition in my artwork? I don't necessarily know how to do that visually in a way that doesn't reduce, that isn't documentary. I think documentary work is really important. But I think it's also really important that as a Black trans woman I have the right not to be documentary, to not have to be literal, to not have to be factual. You know, that I can be a sort of fantasy. I don't really know what the way out is, but right now performance and text feel like ways of dealing with that, because the visual history is a lot harder to convey.

GOSSETT: Yes. It makes me think of fugitivity and maroon movement and of escaping this moment, or of *Guarded Conditions* [1989] by Lorna Simpson, where it's about a concealed form of visibility so that you control your image while still being under the cis and white-supremacist gaze.

HUXTABLE: Right.

GOSSETT: Like a politics of evasion and refusal.

HUXTABLE: In my work, I am generally author and subject, yet I've also started to move away from that a bit. But that's my ground; my practice is grounded in me as a vessel for expressing the ideas that I want to use. Questions of community are so murky, especially when it comes to making physical art. You really have to do it in the right way, because if I work with my friends and we create a piece together—let's say I shoot them in a portrait—but that image ends up taking on a different life, in terms of context, reception, or accumulation of financial value, it becomes complicated in a way that I don't really know if there's an infrastructure for dealing with at this point.

GOSSETT: I so appreciate the way you use refusal as a critical feeling. Rage is so necessary, and as Audre Lorde said, "Anger holds information and power."[9] I think it's interesting and important to think about the institution of the museum or of the art world and about the commodification of trans aesthetics or

Black trans life. You saw what happened to visual stuff. You're still a part of the art world, but you're trying to dictate the terms. And you appear here.

HUXTABLE: There's a gap. I don't think it's coincidental that most of my visibility ... most of my larger visibility in an art world context is the result of institutions, because I think sometimes institutions are actually ahead of what's happening socially in the art world.

I think part of the reason why I feel like visual work is really difficult to navigate is because most artists are the beneficiaries of tacit social organizing—there are group shows, and artists, gallerists, and curators put their friends in group shows, and everyone hopes to come up together, but it's also a way of articulating the boundaries of what art is and what communities can make art, and they're almost always white. There's a whole circuit independent of the museums. But generally, the institutional reception of me and my work has been way ahead of that social world. Socially, the New York art world is so white. And it's terrified of—before you even get to transness—blackness. The members of this world are terrified of that. A lot of younger galleries have programs that you could consider left-leaning. But they don't show a single Black artist or a single Black image.

Most people develop the formal qualities of their work in dialogue with those whom they consider to be their peers. And I know, like, three younger trans girls, none of whom is Black. And so I put my work in group shows, but it would be great if there was one other Black trans person, one other person who wasn't written-off as political, because that's the other trap.

GOSSETT: What do you mean by that? What happens?

HUXTABLE: I think you have to be really strategic, which is why performance is great for me because I can establish the entirety of the context. If someone reads your work as political, it's always derogatory in the contemporary art context. When it's verbalized, it's always dismissive. And it presumes that you are dealing with questions of politics usually related to a first-person idea of an existence in the world and speaking of your relation to structures. And that is perceived to be simplistic, dated, and harking back to a previous "political" artistic epoch. When I was in school, in a lot of art classes I was told, "Oh, you're trapped in your identity." Or people will ask, "Why are you still having this moment? It's conceptually stunted." There is this prevailing expectation that ideally you will get to the point where you can just be an artist. "But you're so obsessed with being a Black artist." I think that is a patronizing, racist, and strategic way of promoting a few Black

artists in their forties and fifties who have established careers and are now just promoting their objects. I think there's an actual gap right now. I think there's an absence of young people of color, especially Black and Latino people, in the art world. It's really crazy to me.

GOSSETT: What you're saying about the devaluation and delegitimization of political work reminds me of the reactionary dismissal of much of black thought and black feminism, especially intersectionality as a form of "identity politics."

You deejay, too ... How did you start doing that? How do you see that relating to your work, because you do it with multimedia, basically, in different forms?

HUXTABLE: When I first moved to New York, I was working as a legal assistant. That's how I supported myself. And it was good money. I was also really clinging to the idea that I needed to have a respectable job, maybe as part of my parents' brainwashing me or whatever. But nightlife was really welcoming. It was a space that was diverse—way more diverse than any other self-identified creative, left-of-center space, you know? There were a lot of Black people, a lot of queer people. It felt really free, like a space for experimentation. I've always wanted to be an artist. But I suppressed that urge because I didn't think it was possible. Nightlife became a way to experiment and to feel like I had space to pursue myself, to pursue my work as an extension of myself.

At first, the way I would dress to go out was a necessary act of self-expression. Sometimes, I would dress up for a party, and then I would make a video of myself in the outfit at the party. And later, I would start writing a piece based on what I felt, you know? That's how I sort of fell into nightlife. And it was also a very supportive community. But, at one point, I was just hosting parties, selling molly, and doing dominatrix work after I quit my day job. And then I thought that I needed to have a more involved relationship with nightlife. I didn't want to just be at parties anymore. I was constantly thinking about how I could create a world, think through references and play them out, and create a space for my own experiments.

I've always been obsessed with music. And I always had the good playlists at the parties. And then deejaying opened up this whole new way of dealing with things because I could take certain lyrics or references from different genres and stitch them together. Every set is an experiment. Just playing a set where the majority of the vocals are female vocals creates a certain energy. And I think it's almost better that people are unaware of it, you know? They're really into the energy.

GOSSETT: There's a whole soundscape that you create when you're doing that.

HUXTABLE: Yes.

GOSSETT: I think that's fascinating because you don't know. You can't predict.

HUXTABLE: Right. I'm also a fan of intoxication for multiple reasons. I think states of intoxication are really productive for transgression.

GOSSETT: I mean, that's super cool. I was reading this article in the *New Inquiry* called "The Ego's Death Trip" by Natasha Young.[10] It's about one form of intoxication, one substance like acid, and basically about how it de-subjectivizes you. People are calling it "ego death." You know that group, The Internet? They have a song called "Ego Death." I don't know if there's a relationship ... your self-consciousness dissolves at different points; it's an ontology. And it's almost like, "I think, therefore I am" becomes "I trip, therefore I am," you know?

HUXTABLE: It's like different ways of being.

GOSSETT: Yes! Yes! Different modalities and relation.

HUXTABLE: I think intoxication is a space where desire is able to operate in a way that's much more liminal. I started deejaying at my own parties, so I was both creating the sound and throwing the party. It was a really intentional way to engender a dynamic. And it felt *possible*. So many things felt possible. It was also a means of support. It was an alternative to doing other things. I didn't really want to sell molly; it actually scared me every time that I was going with, like, five grams of molly to a club and there were police coming in, you know? I didn't really want to be doing dominatrix work. Was it fun? Sure. But I didn't want to have to do that for money. And nightlife became a pretty sustainable way to have an outlet for experimentation and to be able to support myself. And now a lot of what I'm doing is more in an art context. I'm glad that I'm not just in nightlife because it has its own limitations and its own expirations.

GOSSETT: It makes me think about how you can create these ephemeral "temporary fabulous zones"[11] as a process of what I would actually call "underworlding," in which you are thinking about imaginaries and creating parallel spaces and sustaining underworlds beneath the world of the status quo. What do you see as the limits and/or expirations of nightlife?

HUXTABLE: At a certain point, I want the option of operating during the day. That's one part of it. And, then, the other part of it is that I don't want to be a

nightlife person because that comes with its own traps. Luckily, nightlife is a space where there are trans women older than me who I can look up to and see how they've navigated. There are Black trans women who have navigated. But you can get trapped in nightlife. It's very easy to get trapped because it can be great in a lot of ways, like states of intoxication around people who are having a great time. But I have aspirations outside of that. And, unfortunately, part of having to be strategic about everything I do is knowing that if I become a night-life person, people will engage my work less. I also think it's important for me to take my other work seriously. I think I'll be deejaying for a long time. But I think some people have a necessary cut-off point. I just want to make sure that I have other options. And it feels necessary at this point. I'm happy that I've been able to start that process.

GOSSETT: What art are you interested in creating now?

HUXTABLE: I am still figuring that out, actually. The way that I make work is that I basically need to disappear into myself. And then I do a lot of reading, a lot of writing, and figure out what sort of idea sets I want to work with, and then navigate from there. Right now I've been focusing a lot less of my energy on what work I want to make, and more on how I want to be positioned as a person, and how I want to carve out the space necessary for me. At this point, before I get to the question of what work I want to make, I'm asking, What context is this going to be presented in? What are the structures dictating how it is or isn't perceived?

I have a show coming up. Whatever it is, it will simultaneously continue the tradition of how I imagine the world and try to craft a kind of fantastical uni-verse. But it will also critique what's going on around me because, in the context of the art world, I feel really isolated a lot of times. That isolation is exacerbated by gallerists and artists and curators who are surrounded by white people all the time, and they don't question it at all. Being in that context has been really in-tense for me, and right now, I'm thinking through how I'm going to grapple with that in my work, whether it's about where the show is, or whether there's text that goes along with it. I'm thinking through those questions right now more than what form the work will take.

The other day I started thinking about what passing culture signifies specifi-cally for Black trans women. Passing is a means to safety, the ability to navigate the world with a bit of rest. It's so very different from what a lot of white trans people experience. I think sometimes it's easier for them to operate in a sort of genderqueer/genderpunk way, but as a privilege. You're allowed to operate in

the space of gender variance. But that space for us can really be—and feel—like a prison. I went through that stage of genderqueerness. And now I find little ways to hold on to my refusals. But I think it's actually really radical to insist on an idea of beauty. I think that's really radical, but also not hiding away from transness. And so, I was thinking about that and about makeup and clothes and how those things might relate.

GOSSETT: Yes. I want to ask you more about that. I like what you just said about the radical act of insisting on a type of beauty.

HUXTABLE: That's one thing I think is cool about a lot of older Black trans women. They are these beacons of beauty and of traditional ideas of what beauty is, but in a really intense way. I think their beauty, their insistence on and mastery of it, is radical, actually, especially coming from a Black woman.

..

This conversation was conducted at the New Museum on May 18, 2016, for this volume.

..

NOTES

1. On Afropessimism, see Frank B. Wilderson III, *Red, White & Black: Cinema and the Structure of U.S. Antagonisms* (Durham, NC: Duke University Press, 2010), 58.

2. See Miss Major Griffin-Gracy and CeCe McDonald in Conversation with Toshio Meronek, "Cautious Living: Black Trans Women and the Politics of Documentation," on page 23 of this volume.

3. See Brad Evans and Gayatri Chakravorty Spivak, "When Law Is Not Justice," Opinion Pages, *New York Times*, July 13, 2016, http://www.nytimes.com/2016/07/13/opinion/when-law-is -not-justice.html?_r=1.

4. See Chris E. Vargas, "Introducing the Museum of Transgender Hirstory and Art," on page 121 of this volume.

5. Hortense J. Spillers, "Mama's Baby, Papa's Maybe: An American Grammar Book," in *Black, White, and In Color: Essays on American Literature and Culture* (Chicago: University of Chicago Press, 2003), 206.

6. Saidiya Hartman, *Lose Your Mother: A Journey Along the Atlantic Slave Route* (New York: Farrar, Straus and Giroux, 2007), 107.

7. "The W4W Buzz Lesbian Visibility Barbershop Poster," and Katerina Llanes, "A Hair Piece," *DIS*, accessed August 30, 2016, http://dismagazine.com/dysmorphia/beauty/10144 /the-w4w-buzz/.

8. Huxtable is referring to her project for the New Museum's 2015 Triennial: "Surround Audience," which also featured Frank Benson's sculpture of the artist.

9. Audre Lorde, "The Uses of Anger: Women Responding to Racism" (June 1981), *BlackPast.org Blog*, accessed September 25, 2016, http://www.blackpast.org/1981-audre-lorde-uses -anger-women-responding-racism.

10. Natasha Young, "The Ego's Death Trip," *The New Inquiry*, May 9, 2016, http:// thenewinquiry.com/essays/the-egos-death-trip/.

11. Che Gossett, "Pulse, Beat, Rhythm, Cry: Orlando and the queer and trans necropolitics of loss and mourning," blog post, *Verso*, July 5, 2016, http://www.versobooks.com /blogs/2747-pulse-beat-rhythm-cry-orlando-and-the-queer-and-trans-necropolitics-of -loss-and-mourning.

TRANS HISTORY IN A MOMENT OF DANGER: ORGANIZING WITHIN AND BEYOND "VISIBILITY" IN THE 1970S

Abram J. Lewis

The historical archive of trans activism—much like trans activism's archive of the present—is at once expansive, unruly, and at times (perhaps at its best), downright strange. Across the United States and beyond, the years following the 1969 Stonewall riots saw a flurry of organizing on behalf of transsexuals, transvestites, intersex people, and other nonbinary communities. Increasingly, some of these historical efforts are gaining recognition in progressive queer and trans cultures today. In particular, thanks to the work of public and scholarly historians alike, radical groups like Street Transvestite Action Revolutionaries (STAR), founded in New York City in 1970 by Sylvia Rivera, Marsha P. Johnson, and others, have become a source of inspiration for a new generation of trans activists, artists, and community members.[1] Activist forerunners like Rivera and Johnson have especially been invoked by contemporary advocates working to imagine a world beyond today's neoliberal and homonormative social justice landscape.[2]

But STAR, of course, was one voice among many in the push for trans liberation during the 1970s; and in turn, trans activism during these years emerged amid a larger, complex, and shifting milieu of national political developments around gender identity and expression. This dossier surveys a handful of notable trans groups formed during this historical moment, including not only STAR but also the Queens Liberation Front (QLF), founded in 1969 in New York City; Radical Queens in Philadelphia; the Transvestite Legal Committee (TLC) in Chicago; the Erickson Educational Foundation (EEF), based mainly out of Baton Rouge, Louisiana; and the Transexual Action Organization (TAO), a multi-chapter group founded in Los Angeles in 1970, and then based out of Miami Beach, Florida, starting in 1972.[3] Those of us working toward gender justice today—during a moment sometimes hailed as unprecedented in trans politics— have a great deal to learn from the resonances we share with these longer legacies

of resistance and world-making. And yet, in their efforts to contend with both the affordances and the vulnerabilities produced by trans "visibility" during a period of sexual and gender liberation, trans activist cultures of the 1970s have at least as much to offer us in their striking discontinuities with trans activism in the present. It is, in fact, in their divergences from contemporary orthodoxies of political organizing that 1970s trans cultures proffer an especially powerful model of gender justice developed outside of liberal and state-sanctioned logics of representation, recognition, and civil rights.

Within and beyond activist communities, the 1970s threw trans issues and identities into the national spotlight. During this decade, trans activists became leaders in gay and women's liberation movements, and they were important contributors to an expansive Left print culture.[4] In the popular arena, trans characters hit the big screen in major motion pictures like *Myra Breckinridge* (1970) and *Dog Day Afternoon* (1975). The rising fame of rock icons like David Bowie and Alice Cooper further bolstered popular culture's enthusiasm for gender transgression. In 1976, tennis player Renée Richards made headlines as the first openly trans professional athlete—the 1977 New York Supreme Court ruling that upheld her right to compete as a woman would become a watershed cultural moment of trans recognition as well as a major legal precedent for trans advocacy in athletics.[5] At the local level, widespread municipal laws against cross-dressing, before largely unquestioned, were quickly becoming untenable during these years, as courts found themselves at odds with the basic fashion trends of the counterculture. And in 1975, the city of Minneapolis, Minnesota, passed the country's first legislation that explicitly banned discrimination based on gender identity and expression.[6]

"This planet will soon be ours." Cover of TAO's *Moonshadow* newsletter, September 1973. Artwork by Vanessa Wolfe. Courtesy Charles Deering McCormick Library of Special Collections, Northwestern University Libraries

Indeed, virtually all of the most perceptible developments in trans politics during this period—unprecedented inroads in cultural representation, major legal gains, and a rapidly expanding and connected activist milieu—anticipate the much-touted "tipping point" of our contemporary moment.[7] And although "transgender" would not emerge as an umbrella term for non-normative gender forms until the 1990s, '70s activists also recognized—and sought to build coalitions with—a wide range of marginalized gender and sexual communities. Arguably, this longer history of trans hyper-visibility and resistance belies the novelty and vanguardism sometimes accorded to trans politics of the twenty-first century, even within some activist circles.

Furthermore, just as commentators today have been quick to point to backlashes against recent political gains—in particular, a national spate of anti–trans bathroom bills, and the unabated, appalling incarceration and murder rates faced by trans women of color—so too did trans communities in the 1970s contend with the unpredictable stakes of their own newfound visibility. As the '70s progressed, many feminist and gay activists became more vocal in their denunciations of trans issues. In 1973, only a few months before lesbian feminists in New York City attempted to bar Sylvia Rivera from the Christopher Street Liberation Day March, Robin Morgan delivered an excoriating screed against trans women in her keynote address at the West Coast Lesbian Feminist Conference.[8] Advocates attempting to push through the first major gay anti-discrimination bills during these years (like INTRO 475 in New York City) quickly adopted language specifying that sexual orientation protections did not include gender expression.[9] Reflecting on burgeoning anti-trans sentiment in gay and feminist groups, QLF member Bebe Scarpi would later affirm the early 1970s as the beginning of exceptionally "dark times" for politicized trans and cross-dresser communities.[10] Official trans exclusion from other forms of legal, medical, and cultural support also became quickly formalized as the '70s progressed. By 1981, a federal report developed in consultation with anti-trans advocate Janice Raymond advised that gender-affirming surgeries be considered strictly "experimental," thus helping to decisively establish trans health care exclusion as a national standard.[11]

In short, these years, like today, comprised moments of both great possibility and great violence and precarity for trans lives. It was a period in which trans communities' collective power to act upon and alter their worlds grew exponentially, and a period in which those same communities also suffered unprecedented attacks and rollbacks. The activist groups featured in this piece varied significantly in their constituencies, ideologies, and organizing strategies. TAO and STAR were arguably the most successful at developing an intersectional, coalition-based

politics that centered especially vulnerable trans populations: their member-ships were mainly composed of low-income and homeless transfeminine people of color, immigrants, and sex workers. The issues they prioritized reflected those constituencies. Radical Queens, like the San Francisco–based countercul-tural troupe the Cockettes, adopted much of the revolutionary rhetoric and militant, anti-conformist ethos of the New Left, albeit with a somewhat more mixed-class membership base. The group was also quite racially mixed—Cei Bell, an African American woman, was a cofounder along with Tommi Avicolli Mecca, a working-class, white, femme-identified, gay person.[12] In contrast, QLF and EEF—the latter funded singlehandedly by millionaire transsexual philan-thropist Reed Erickson—are more easily characterized as "liberal" organizations, in the sense that they readily articulated investments in institutional reform. (Always frank in her assessments, TAO founder Angela Douglas backhandedly characterized QLF's publications as "excellent, if non-radical.")[13] Nonetheless, as the documents collected here elicit, even these seemingly more traditional organizations exhibited great creativity and imagination in their approaches to movement-building. Indeed, across all these groups, a great deal of their most innovative work can be located in forms of thinking and acting that do not easily map onto today's commonsense notions about the proper scope and content of trans politics. And although the relationships these groups built with each other were at times riddled with clashes and infighting—accusations of mental insta-bility and, worse, of acting as government informants circulated promiscuously—these documents can help us trace important throughways in their collective trans imaginary.[14]

Perhaps one of the greatest resources that 1970s trans communities offer to our conditions of neoliberal austerity in the present is their effort to theorize and effect trans justice outside of the limitations of mainstream reform institutions—institutions from which trans people found themselves increasingly excluded as the '70s progressed. Self-determination and coalition work, in contrast, emerge recurrently as organizing priorities. Few of these groups, in fact, invested in legal or policy reform, even as trans law and policy debates were percolating nationally (its name notwithstanding, the TLC appears mainly to have been a community-organizing group and probably did not do any actual legal work). While they worked to be a resource of information for trans communities nationally and globally, some of these groups also evinced skepticism about efforts to expand sanctioned access to institutions that they saw as inexorably oppressive—and not just toward trans people, but toward all marginalized groups. As Douglas noted, for instance, "psychiatrists and psychologists ... are some of the worst enemies of transsexuals and gay people and women."[15]

Much like radical queer and trans activists today, activists in the '70s centered critiques of policing, incarceration, and other forms of state violence—TAO declared organizing against police and prisons "one of TAO's most important efforts"—and they generally declined strategies that sought to build better relationships with law enforcement.[16] The TLC, formed in response to the 1970 police murder of James Clay, a black transgender person, meticulously reported on and condemned treatment of gay and trans prisoners in Chicago jails.[17] In New York City, STAR members adapted anti-carceral critiques to the politics of institutionalization, organizing against the involuntary confinement of trans people in Bellevue mental hospital.[18] And although TAO, QLF, and EEF members appeared as speakers at public events, efforts at mainstream education and recognition were not always paramount to their work. Often, rather than seeking to expand trans access to existing social support structures, many of these activist leaders exhibited extraordinary commitments to building survival services and networks of care within trans circles. Sylvia Rivera and Marsha P. Johnson were well known for the maternal roles they took on toward the city's queer street youth. They developed the group's East Village "STAR House" into a space where they could provide their many "children" with free shelter, meals, hustling tips, and a safer environment in which to use drugs.[19] Scarpi would recall Lee Brewster's unflagging generosity toward trans community members over the course of decades—not only through formal work with QLF, but also in more quotidian acts like hosting Thanksgiving dinners, or later, giving away free clothes to friends and acquaintances with AIDS.[20] It would be difficult to overstate the importance of the relations of intimacy, support, and caretaking that 1970s trans communities cultivated with each other, particularly during a time that saw such mounting hostility from other sectors of society. As Scarpi later reflected on the friendships developed during those years, "there was hardship, but out of the hardship, there was a certain magic."[21] And likewise, the documents reproduced here form part of an extensive trans print culture that highlights these activists' dedication to privileging trans communities—often more so than mainstream society—as primary interlocutors in their communication, thinking, and movement-building.

At the same time, in both their solidarity work and their critiques, many trans activists also prioritized relationships with other radicals in women's, gay, and antiracist movements. STAR, for instance, appeared at demonstrations with the Young Lords and Communist Parties and Sylvia Rivera proudly recalled her encounter with Black Panther leader Huey Newton on a number of occasions—as Leslie Feinberg recounted, Rivera emphasized that Newton had already heard of her when they met at a Black Panther convention in Philadelphia, exclaiming,

"Yeah, you're the queen from New York!"[22] Tommi Avicolli Mecca underscored that the vitality of Radical Queens stemmed largely from close working relationships with local radical feminist and black gay organizers.[23] Mecca indicated, in fact, that their strong ties to lesbian separatist factions like the DYKETACTICS probably helped lesbian and trans communities in Philadelphia avoid the acrimony that affected other coastal cities.[24] In a similar vein, TAO often directed attention to developments in women's liberation communities, alternately expressing its allegiances to feminist politics and its criticisms of growing transmisogynistic sentiments. Collectively, the very fact that these cultures tended to value developing conversations among themselves and fellow radicals is but one reason that they often lack immediate visibility from the vantage point of mainstream publics and histories today.

And yet, these investments in working with—and demanding accountability from—other progressive movements also helped produce some of trans activism's most nuanced theorizations of interlocking structures of power. Facing increasingly strained relationships with gay and feminist movements nationally, trans activists redoubled their efforts to more complexly articulate connections between misogyny, heterosexism, and transphobia. In this respect, Radical Queens and TAO in particular might be hailed as forerunners of transfeminism. Radical Queens' writings often emphasized the need to center femmephobia in queer, feminist, and Marxist analyses. "Gender," the group proposed, "is the caste system by which male-dominated society designates Women and effeminates as inferior"—an articulation that rendered the oppression of cis women, trans women, and femme gay men as mutually imbricated.[25] Radical Queens insisted on the repudiation of male patriarchal power as a precondition for trans and gay social justice: their newsletter proclaimed itself the "magazine of the non-man." TAO, likewise, produced analyses that anticipated queer theory's conception of "heterosexism" as a system reliant on interconnecting norms of both sexuality and gender. In 1974, UK-based TAO member Brooklyn Stothard coined the term "hetsism" to grapple with the complex interplay of misogyny and sexual and gendered normativities. As Stothard noted, "Hetsist systems of social relations lay down that people should play out gender roles appropriate to their biological sex, as social males or females, and maintain heterosexual relations. … [S]exism, as a term, is inadequate, since it suggests that the oppression of women by men is the sum total of sexist relations."[26] Making the insights of second-wave feminism central to trans political analyses also generated some positions quite unfamiliar to trans activism today. For instance, rather than advocate for institutional reform that would make it easier for trans people to formally change their first names in alignment with their gender identities,

Radical Queens exhorted trans people to drop their last names, in solidarity with feminist critiques of patrilineage.[27]

But while trans activists in the post-Stonewall years developed intersectional and abolitionist critiques that continue to circulate today, their investments in self-determination and organizing outside of liberal reform also generated a number of unexpected—even unusual—techniques for building power and organizing capacity. Indeed, at times, these activists' most imaginative experiments in social change work look very little like viable or "serious" activism at all, especially from the vantage point of today's logics of nonprofit reform. By all appearances, for instance, many of these activists envisioned themselves as part of an expansive, interdependent community that not only included other marginalized human groups, but also other species and beings. Many trans activists, for instance, looked to the animal kingdom for inspiration around the possibilities of sexed transformation. Radical Queens lauded annelid worms for their protean sex systems, and TAO praised jewfish as "the sex changes of the undersea world."[28] Both of TAO's newsletters, Moonshadow and Mirage, featured remarkable and strange psychedelic artwork, mostly contributed by member Suzun David, which depicted trans women interacting with butterflies, sea horses, and other creatures. And along with the funding he provided to gender identity researchers like Harry Benjamin, Reed Erickson also invested for years in John C. Lilly's research into interspecies animal communication, particularly with dolphins and whales. One of Erickson's closest companions was his leopard, Henry, who lived with him in his mansions in Baton Rouge and, later, Mazatlán, Mexico.[29] EEF's newsletter reported regularly on advances in research into mind-altering substances, and Erickson commissioned at least one research trip to retrieve a "hitherto-unknown" hallucinogenic mushroom from Mexico (Erickson eventually relocated permanently to Mexico after fleeing drug indictments related to his ketamine use in the United States).[30] TAO echoed EEF's optimism around using psychoactive organisms to alter both mind and body outside of official medical institutions—its newsletter approvingly noted studies linking "excessive" marijuana use to gynecomastia. Douglas opined that the studies seemed "highly correct," and quipped, "Although many transsexuals use marijuana, most transsexuals discovered their transsexuality long before they discovered marijuana."[31] For these groups and others, creating a more livable world for trans people required attunement to and contact with a much larger ecology of human and nonhuman life.

Beyond even the earthly realms of plants, animals, and fungi, 1970s activists also turned to enchanted and otherworldly entities in their pursuit of gender justice. EEF regarded paranormal phenomena as integral to their mission to expand

　　　　　　　　　　　　　　　　　　　　　　ABRAM J. LEWIS

human potential otherwise limited by social constraint: its newsletter offered regular comments on research around parapsychology, telekinesis, and extrasensory perception. The *Radical Queen* newsletter ran a regular "Pagan Page," offering extended ruminations on uses of magic and witchcraft to serve feminist, trans, and gay communities. Of all of these groups, TAO was probably most committed to mining otherworldly forces as social change tools. Its newsletter ran a regular UFO/ESP/occult feature, and Douglas repeatedly upheld the centrality of magic and spirits to TAO's mission.[32] Colette Goudie, a Cuban immigrant who served as TAO's president for several years, was a committed occultist and *bruja* who developed an eclectic repertoire of magical techniques for trans organizing, drawing variously from Satanism, Santería, Vodou, and other witchcraft traditions. Responding to Robin Morgan's venomous treatise against trans women at the West Coast Lesbian Feminist Conference, TAO revived a strategy it had used against an abusive police force in Miami Beach and gathered to place a hex of restraint and education on the feminist leader (the action occasioned a remarkable headline in the national gay newspaper, the *Advocate*: "Transsexuals Hex Robin Morgan").[33] Interviewed for one of TAO's newsletter pieces, Goudie commented that black magic "can be very helpful to transexuals who need really strong protection in this world from their many, many enemies."[34] Douglas, in turn, had a lifelong fascination with ufology. In her self-published autobiography, she reflected at length on her friend and fellow activist, Randy Towers, who revealed to her that she was in fact a trans extraterrestrial, sent to earth to aid groups like TAO.[35] Douglas speculated on a number of occasions on the resonances between extraterrestrial and human transsexual experience, and declared TAO's intent to "welcome extraterrestrials as liberators."[36] TAO used its newsletter to solicit an extraterrestrial invasion of earth and issued an organization-wide directive "to all officers and members ... to protect and assist extraterrestrials, UFO crews and their vehicles should the situation arise."[37]

Occurring at a time that saw not only a national backlash against the major radical movements in the US, but also growing animosity toward trans communities from former allies in women's and gay liberation, these groups' willingness to think and act beyond normative parameters of reform—at times, even beyond dominant conceptions of the "rational"—can make their work challenging to reckon with today. Not surprisingly, many of these activists' views and tactics have been dismissed, even by allied historians, as symptoms of mental illness—as paranoid, delusional, or psychotic. And of course, some of the forces these activists most valued for their ability to act upon their worlds—like spirits, orishas, and "space people"[38]—are not recognized by secular civil society as having the capacity to be social agents at all. These communities often drew from

techniques of change so marginalized that their activism can be altogether illegible *as* activism. Furthermore, inasmuch as they declined urban protest marches, litigation pursuits, and other familiar reform strategies in favor of whispered incantations and transcendent psychotropic experiences, these groups are poorly served by the mandates to visibility and recognition that permeate LGBT politics in the present. But in our own negotiations with escalating visibility today, 1970s trans communities may have much to teach us about the uncharted powers of the obscured, the esoteric, and the mysterious. And they may serve as an equally invaluable model in their commitment to demanding the unreasonable and the impossible. In this moment of heightened memory around trans activism, a time in which, as Walter Benjamin might put it, history flashes up to us in a moment of danger, it especially behooves us to attend to these variegated and unexpected legacies of survival.[39]

25¢

JULY, 1972 THE TRANSVESTITE LEGAL COMMITTEE
 NEWSLETTER VOLUME LL NO.2

L Am
serial

2/28/23

Cover of the Chicago-based *Transvestite*
Legal Committee Newsletter 2, no. 2 (July 1972).
Courtesy Charles Deering McCormick Library
of Special Collections, Northwestern
University Libraries

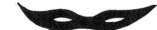

THIS CAN AND DOES HAPPEN !

want it to happen to you? it can!

Even comparatively "liberal" groups like QLF viewed organizing against incarceration and police violence as paramount to trans politics.

Queens Liberation Front, "This Can and Does Happen," pamphlet, ca. 1969. Courtesy Bebe Scarpi and Manuscripts and Archives Division, The New York Public Library, Astor, Lenox and Tilden Foundations

editorial

Club Gay

Go Away Little Girl

Vicky

This image from Drag *magazine critiques masculinism and femmephobia in gay cultural spaces. As the campy depiction of the "butch" men in the club elicits, most of these groups were well aware of the provisional and performative status of all gender, and they objected to allegations that drag queens and trans women were inappropriately "mimicking" genders that could only properly be inhabited by cis women.*

Vicky West, "Go Away Little Girl," *Drag* 1, no. 3 (1971): 4. Courtesy Digital Transgender Archive and Bebe Scarpi

tv humour

"No, it isn't the margerine darling.
I just won first prize at the Drag Ball."

"tv humour," *Drag* 1, no. 3 (1971): 10. Courtesy
Digital Transgender Archive and Bebe Scarpi

ABRAM J. LEWIS

"MADAME! THIS FRAGRANCE WILL MAKE MEN FLIP THEIR WIG."

Drag 1, no. 1 (1971): 29. Courtesy Digital Transgender Archive and Bebe Scarpi

Lee and Kay at Gay Pride
demonstration in Central
Park, 1971.............

QLF founder Lee Brewster (left) with Kay Gibbons at the 1971 Christopher Street
Liberation Day March. Brewster often appeared at actions with the quirky slogan
featured on this sign: "We're only No. 2 and we do try harder ... 2nd class citizens, that
is!" The Radicalesbians banner visible in the background ("Women's Liberation is a
lesbian plot") locates this scene in the immediate post-Stonewall years, before
animosity between trans and feminist leaders in New York City rapidly escalated.

Photograph published in *Drag* 1, no. 4 (1971):
inside cover. Courtesy Digital Transgender
Archive and Bebe Scarpi

SISTERS AND BROTHERS,
 PLEASE COME TO OUR

OPEN HOUSE

CAKE

SALE

SATURDAY
MARCH 20th
1 PM - 8 PM

STREET TRANSVESTITE ACTION
 REVOLUTIONARIES
213 EAST 2nd STREET
 APTS. 2A + 3A

In their work to support the safety and self-determination of trans communities outside of state-based service structures, groups like STAR used small-scale and local strategies for resource building, like this "cake sale."

STAR "Cake Sale" flyer, 1971. Courtesy Manuscripts and Archives Division, The New York Public Library, Astor, Lenox and Tilden Foundations

TRANSVESTITE AND TRANSSEXUAL LIB.

The oppression against transvestites and transsexuals of either sex arises from sexist values and this oppression is manifested by homosexuals and heterosexuals of both sexes in the form of exploitation, ridicule, harassment, beatings, rapes, murders, use of us as shock troops, sacrificial victims, and others.

We reject all labels of "stereotype" "sick" or "maladjusted" from non-transvestic and non-transsexual sources and defy any attempt to repress our manifestation as transvestites and transsexuals.

Trans Lib began in the summer of 1969 when "Queens" formed in New York and began militating for equal rights. The Transvestite-Transsexual Action Organization (TAO formed in Los Angeles, the Cockettes in San Francisco, Street Transvestites Action Revolutionaries (STAR) in New York, Fems Against Sexism, Transvestites and Transsexuals (TAT) also formed in New York; Radical Queens formed in Milwaukee–all in 1970. "Queens" became "Queens Liberation Front."

Transvestism - transsexualism - homosexuality are separate entities. Sexist values incorrectly classify any male who wears feminine attire as a homosexual, and to a lesser degree, any female who wears masculine attire is classified as a homosexual.

DEMANDS

1. Abolishment of all crossdressing laws and restrictions of adornment.
2. An end to exploitation and discrimination within the gay world.
3. An end to exploitative practices of doctors and psychiatrists who work in the fields of transvestism and transsexualism. Hormone treatment and transsexual surgery should be provided free upon demand by the state.
4. Transsexual assistance centers should be created in all cities of over one million inhabitants, under the direction of postoperative transsexuals.
5. Transvestites and transsexuals should be granted full and equal rights on all levels of society and a full voice in the struggle for the liberation of all oppressed people.
6. Transvestites who exist as members of the opposite anatomical gender should be able to obtain full identification as members of the opposite gender. Transsexuals should be able to obtain such identification commensurate to their new gender with no difficulty, and not be reqired to carry special identification as transsexuals. There should be no special licensing requirements of transvestites or transsexuals who work in the entertainment field.
7. Immediate release of all persons in mental hospitals or prison for transvestism or transsexualism.

WE SHARE IN THE OPPRESSION OF GAYS AND WE SHARE IN THE OPPRESSION OF WOMEN.

Trans Lib includes transvestities, transsexuals and hermaphrodites of any sexual manifestation and of all sexes - heterosexual, homosexual, bisexual, and asexual. It is becoming a separate movement as the great majority of transvestities are heterosexual, and many transsexuals (postoperative) are also heterosexual, and because the oppression directed towards us is due to our transvestism and transsexualism and for no other reason. We unite around our oppression as all oppressed groups unite around their particular oppression. All power to trans liberation.

QLF Box 538 NYC NY 10009
TAO Box 261 Coconut Grove, Fla.
STAR BOX 410 NYC NY 10011
COCKETTES Box 408, Berkeley, Calif. 512 4
FAS Box 410 NYC NY 10011
RADICAL QUEENS Box 5457 Milwaukee, Wisc. 53211

This statement was prepared by members of STAR, TAO and FAS and does not signify approval by the Radical Queens, QLF or the Cockettes. A national conference of all trans lib groups is being planned for this spring.

OUT OF THE CLOSETS AND INTO THE STREETS
COME VERY TOGETHER

This statement is noteworthy in both its resonances with contemporary trans activist critiques and its commitment to collective thinking and coalition building across trans groups nationally.

"Transvestite and Transsexual Liberation," image and statement from the *Gay Dealer: The Rage of Philadelphia*, 1971, page 9. Courtesy Manuscripts and Archives Division, The New York Public Library, Astor, Lenox and Tilden Foundations

ABRAM J. LEWIS

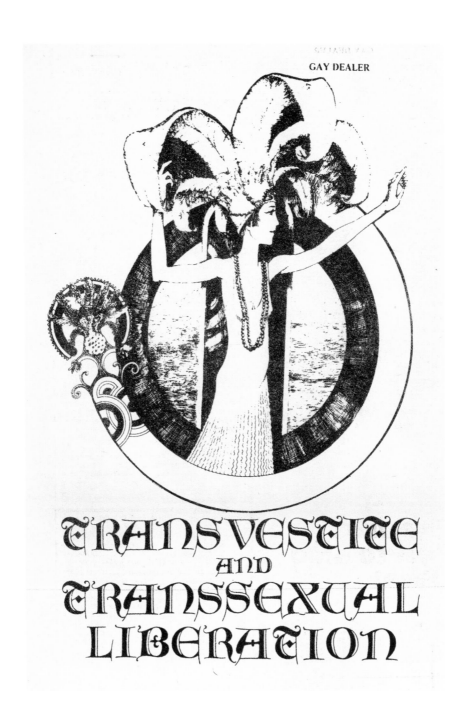

GAY DEALER

TRANSVESTITE
AND
TRANSSEXUAL
LIBERATION

STREET TRANSVESTITES ACTION REVOLUTIOARIES

The oppression against transvestite of either sex aries from sexist values
and this oppression is manifested by hetrosexuals and homosexual of both
sexes in form of exploitation, ridicule,harrassment,beatings, rapes,
murders.

Because of this oppression the majority of transvestites are forced into
the streets we have have framed a strong alliance with our gay sisters
and brothers of the street. Who we are a part of and represent we are;
a part of the revolutionaries armies fighting against the system.

1.We want the right to self-determination over the use of our bodies;
the right to be gay, anytime, anyplace; the right to free physiological
change and modification of sex on demand; the right to free dress and
adornment.

2.The end to all job discrimination against transvestites of both sexes and
gay street people because of attire.

3.The immediate end of all police harrassment and arrest of transvestites
and gay street people, and the release of transvestites and gay street
people from all prisons and all other political prisoners.

4.The end to all exploitive practices of doctors and psychiatrists who work
in the field of transvestism.

STAR's platform not only anticipated contemporary trans advocacy around ID documents and gender-affirming medical care, but also linked trans justice to issues of incarceration and medicalization, as well as to struggles for decolonization, women's liberation, and racial and economic justice.

Statement of STAR's political platform, ca. 1970.
Courtesy Manuscripts and Archives Division,
The New York Public Library, Astor, Lenox and
Tilden Foundations

5. Transvestites who live as members of the ppposite gender should be able to

 Obtain identification of the opposite gender.

6. Transvestites and gay street people and all oppressed people should have
 free education, health care, clothing, food, transportation, and housing.

7. Transvestites and gay street people should be granted full and equal rights
 on alllevels of society, and full voice in the struggle for liberation of all
 oppressed people.

8. An end to exploitation and discrimination against transvestites within
 the homosexual world.

9. We want a revolutionary peoples' government, where transvestites, street
 people, women, homosexuals, blacks, puerto ricans, indians, and all oppressed
 people are free, and not fucked over by this government who treat us like
 the scum of the earth and kills us off like flies, one by one, and throws
 us into jail to rot. This government who spends millions of dollars to go
 to the moon, and lets the poor Americans strave to death.

<div align="center">

POWER TO THE PEOPLE

S. T. A. R.

</div>

SYMPOSIUM PROGRAM *(Continued)*

Chairman (P.M.): M. Mehl/ U.S.A.

Transsexuals—Some Further Legal Considerations:
J. Holloway/ U.S.A.
Transsexual Problems in a Correctional Setting:
G. Sturup/ Denmark
Change of Names of Transsexuals in Sweden:
H. Forrsman/ Sweden
**A Proposal for a New Law Concerning Sex Reassign-
ment of Transsexuals in Sweden:** J. Walinder/
Sweden
**A Humanistic Approach to Community Tolerance for
Sexual Difference:** M. Mehl/ U.S.A.

Sept. 14: **POSSIBLE ETIOLOGICAL FACTORS IN
TRANSSEXUALISM**

Chairman (A.M.): H. Forssman/ Sweden

**Prenatal Androgen and Masculinization of Behavior
in Females:** A. Ehrhardt/ U.S.A.
**Production of Pituitary Gonadotrophins and Uptake
of Testosterone in Male Transsexuals:** A. Gil-
lespie/ England
**Peripheral Plasma Testosterone Concentrations in
Female Transsexuals:** J. Jones/ U. S. A.

Chairman (P.M.): R. Green/ U.S.A.

**The Epidemiology of Male and Female Transsexu-
alism:** J. Hoenig and J. Kenna/ Canada
Genetic Factors in Transsexualism: O. DeVaal/
Holland
Male Transsexualism: Two Cases in One Family:
B. Hore/ England
**Behavior Antecedents of Transsexualism: The Pre-
Transsexual Child:** R. Green/ U.S.A.

ADDITIONS TO ADVISORY BOARD

. . . We are pleased to announce the addition of
two distinguished new members to the EEF Advisory
Board: Dr. Benito Rish of New York City, plastic
surgeon, who was a panelist at our recent seminar
on transsexualism at Fairleigh Dickinson University.
. . . W. Dorr Legg, M.L.D., has been Director of
ONE Institute of Homophile Studies since 1956, and
Chief of Educational Research of the Institute for
the Study of Human Resources since 1964, both
Los Angeles-based organizations. He has given
courses in the sociology of homosexuality, lectured
widely here and abroad, and published a number
of articles on aspects of male and female homo-
sexuality. His extensive experience in counseling
is the basis for the book, **Counseling Homosexuals:
A Manual,** now in preparation.
. . . Zelda R. Suplee, EEF Assistant Director, has
been appointed to our Board of Directors.

PROGRESS

The EEF referral file of physicians from whom
transsexuals may expect the skilled and sympathetic
treatment they deserve now includes some 250
names, nationwide. We appreciate the cooperation
we have received in this effort from Dr. Harold
Lief, Director of the Center for Sexual Studies at
the University of Pennsylvania, whose question-
naires directed to the 56 medical schools associated
with the Center have helped to add many names
to our list.

The number of gender identity units in the western
hemisphere has been growing by leaps and bounds.
Some of these are engaged only in research and
evaluation so far, others are preparing to or have
performed surgery for transsexuals.

When you are successfully living in the gender
of your choice and ready for reassignment, releas-
able information will be made available to your doc-
tor or you upon receipt of written request.

WHAT'S IN AN S?

Followers of the Newsletter, and of the medical
literature, may be asking themselves: Do you spell
it transsexual or transexual? Since both spellings
appear on these pages, we owe you an explanation.
All the early publications on the subject, and some
current ones too, use the double-s spelling; so when
we mention these papers, we follow the authors'
choice. But, as Dr. John Money of Johns Hopkins
University Hospital points out, the correct spelling
when combining the prefix "trans" with a root be-
ginning with "s" uses only the one "s". As, for
example, transubstantiation, transcribe, transistor,
and so on, therefore our choice is "transexual."

MEXICAN RESEARCH MUSHROOMING

John Lilly, Jr. reports on the rich harvest of his
EEF-assisted field research into the little-known
cultures of the remote sierras of south-central Mex-
ico. An aduio-visual chronicle, perhaps the most
complete ever obtained of the folkways of these
ancient tribes, includes: research films, some 1500
color transparencies, 50 wool paintings, an exten-
sive herbarium, tapes of religious music and cere-
monies, and interviews with tribal priests. Of spe-
cial interest is the ritual gathering, preparation and
use of medicinal and vision-inducing plants, includ-
ing the hallucinogenic mushroom and peyote. Some
of the EEF-commissioned wool paintings revealed
the hitherto-unknown existence of a powerful hallu-
cinogen, the use of which is described on tape.
Another notable tape, recorded on the night of the
first moon landing, captures the reactions of men
from the remote past to modern technological
achievement. They just refused to believe it!

*EEF integrated support for trans justice with inquiries into psychotropics,
parapsychology, animal communication, and techniques for inducing altered states
of consciousness. The newsletter elicits a view of these disparate issues as key to
building power and potential not only among marginalized human groups, but
across an array of species and entities.*

Erickson Educational Foundation Newsletter 4,
no. 3 (1971): 2. Courtesy the Transgender
Archives, University of Victoria Libraries, Victoria,
British Columbia. Image: © University of Victoria

This image, filed among EEF's organizational brochures, attests to EEF's integration of multiple life forms in its funding priorities. Although the image might have been created by Reed Erickson, it may also be one of John Lilly's hallucinogen-inspired works commissioned by EEF in 1975.

Untitled (Don't Compromise Compassion for Science;
We Are One), n.d. Acrylic on paper, 8 ½ × 11
in (21.5 × 28 cm). Courtesy the Transgender
Archives, University of Victoria Libraries, Victoria,
British Columbia. Image: © University of Victoria

WHAT"S HAPPENING IN THE WHITE HOUSE HONEY!IT'S THE SAME OLD JUNK. You know Wasnington, D.C. never had a dress code, so we are organizing and fighting the lottering and vagrancy framed-up charges, without the help of the felous female imperson-ators from Female Mimic's nor the magizine neither (who looks down at us cause we are not in their class, and they are not Tranvestites nor Transexuals, besides they have a famale support, their famorite saying. Female Mimic's is the biggest selling magazine in the country, they make over a million dollars a year off of Transvestites along, ($5. a magazine-90, full of female impersonators) refuses to help or support us in ANY KIND OF WAY." Well other than that their talking about the next moon shot sometime in April--. three men...two on moon for 72 hours, honey, but let me tell you something girl."Next year" Skylab! Big capsule orbiting the earth for weeks, girl..but that ain't all girl their going to be experimenting, studying space around the planet and I know down here,too. But what's going to be happening on the surface , honey. "A fresh burst of activity for aerospace, girl, the new space shuttle, girl. Boon to Calif. and Wash, jobs, girl, from prime contractor to the subcontractors. All sorts! Of lines, girl, some that badly need a lift! "Yes, Sister!" There going to the moon! well they better some place, honey; cause we've tired of them down here!!! You know, buses on interstate routes, girl, no smoking rules to be enforced in certain sections of buses, starting April 17. Similiar to airlines,. Most airlines segregate smokers, but gov't doesn"t requtre it......

Like a number of other trans writings from this activist milieu, pieces by the Transvestite Legal Committee were variously playful, outraged, meandering, and at times difficult to follow. TLC issued at least one directive to its readers to join the Ku Klux Klan—probably as a joke, although it is difficult to know for certain.

Excerpt from the irregularly published
Transvestite Legal Committee Newsletter 2, no.
2 (July 1972): 18, probably authored by Tony
Johnson. Courtesy Charles Deering McCormick
Library of Special Collections, Northwestern
University Libraries

ABRAM J. LEWIS

Like some members of Radical Queens and TAO, Reed Erickson emphasized attunement to an array of unseen energies and forces in his autobiographical writings.

Reed Erickson, Erickson Educational Foundation memo, 1983. Typescript on paper, 8 ½ × 11 in (21.5 × 28 cm). Courtesy the Transgender Archives, University of Victoria Libraries, Victoria, British Columbia. Image: © University of Victoria

Angela Douglas and Colette

TAO members Angela Douglas and self-identified bruja *Colette Goudie. Douglas interviewed Goudie in* Mirage *when Goudie stepped in as president of the group. Asked by Douglas, "What does TAO do at present?" Goudie replied, "Oh, we place curses on our enemies and teach each other a lot of things. We make referrals to doctors and attorneys."*[40]

Image of Angela Douglas (left) and Colette
Goudie (right). Originally published in
Mirage 1, no. 4 (Winter 1974): 11. Courtesy
Charles Deering McCormick Library of Special
Collections, Northwestern University Libraries

TAO's extraordinary psychedelic newsletter artwork by Suzun David features trans women as robots and extraterrestrials, with nonhuman creatures, and with various inhuman physical characteristics.

Reed Erickson signed this self-portrait, "Love Joy," and the inscription on the back reads, "I am fire, I am Wind, I AM BEING All that YOU IS SEEING." Like Erickson's other paintings, which depict demons, monsters, animals, and angelic figures, his self-portrait experiments with indeterminacies between the human and nonhuman and suggests sensitivities to cosmic and geological forces. In these regards, Erickson's work recalls TAO's newsletter artwork from around the same time.

Reed Erickson, *I am fire, I am Wind, I AM BEING All that YOU IS SEEING*, ca. late 1970s–early 1980s. Acrylic on canvas, 36 × 24 in (91.5 × 61 cm). Courtesy the Transgender Archives, University of Victoria Libraries, Victoria, British Columbia. Image: © University of Victoria

Reed Erickson with his leopard companion Henry von Weber Erickson, who lived with him from the mid-1960s until the leopard's death in 1981. Erickson described Henry as his "protector."

Reed Erickson with Henry, n.d. Photographic print, 5 × 4 in (12 × 9 cm). Courtesy the Transgender Archives, University of Victoria Libraries, Victoria, British Columbia. Image: © University of Victoria

UFOs, TSs, and Extra-Ts —

Excerpt from the UFO Sightings Newsletter: "TRANSEXUAL ACTION ORGANIZATION ALLIES WITH EXTRA-TERRESTRIALS". Miami Beach-In late August, a group of transexual lib-erationists headquartered here published another issue of their monthly publication Moonshadow, which is distributed free. Under direction of their president Angela K. Douglas, a cartoon was drawn depicting a transexual contacting Venus with a walkie-talkie with the caption "come in Venus-we should have no trouble taking over here-I've been living with one of "them" for two years...they're pathetic...this planet will soon be ours." As the magazine was being published, UFO sightings began to come in from the northern part of Florida and the Miami News reported that "five telephone poles were reportedly knocked down by a group of UFOs in Fort Lauderdale (just north of Miami Beach)". (The TAO had earlier run into physical confrontation with employees of Southern Bell telephone, at one point resulting in the arrest of President Douglas on a charge of assault during a fight with two Southern Bell truckdrivers.) The UFO flap spread quickly thru the South to Alabama, Georgia, Mississippi, Tennessee, then Ohio, Eastern Seaboard states, the Midwest and the West Coast. Meanwhile the TAO issued a directive to all officers and members (about 500 people belong to the organization) to protect and assist extraterrestrials, UFO crews and their vehicles should the situation arise. Douglas spoke on WBUS radio here and said that "certain oppressed minority groups would welcome extraterrestrials as liberators" and would "probably ally with them", contrary to suggestions that the people of Earth might unite to fight "invaders from outer space." As editor-publisher of UFOSN I also give all readers and members of my organization the same directive. I expect all of you to protect and assist all Space Beings whom we have determined are friendly. Further I ask that all heads of UFO groups contact me and work with me to work out a nationwide UFO friends network;we must all let the Space People know we are willing to work with them and they are most welcome to live with us.

TAO shared with Radical Queens, EEF, and other activist groups a fascination with trans politics' connections to the magical and otherworldly. Angela Douglas speculated often on the "similarities of prejudice against both transexuals and extra-terrestrial beings." She was optimistic that creatures from other planets could be important allies to human trans activists: as she put it, "it would appear that someone up there may like us."[41]

Suzun David, illustration accompanying "UFOs, TSs, and Extra-Ts," *Mirage* 1, no. 1 (March–April 1974): 24. Courtesy Charles Deering McCormick Library of Special Collections, Northwestern University Libraries

..

"Trans History in a Moment of Danger: Organizing Within and Beyond 'Visibility' in the 1970s" is a dossier compiled and contextualized by scholar Abram J. Lewis in 2016 for this volume.

..

NOTES

———

1. On Rivera, Johnson, and STAR, see, for example, Jessi Gan, "Still at the Back of the Bus: Sylvia Rivera's Struggle," *Centro: Journal of the Center for Puerto Rican Studies* 19, no. 1 (2007): 124–39; Stephan Cohen, *The Gay Liberation Youth Movement in New York: "An Army of Lovers Cannot Fail"* (New York: Routledge, 2007), 89–164; Leslie Feinberg and Sylvia Rivera, "Leslie Feinberg Interviews Sylvia Rivera: 'I'm Glad I Was in the Stonewall Riot,'" *Workers World* (1998), accessed September 19, 2016, http://www.workers.org/ww/1998/sylvia0702.php; and Reina Gossett, "Ten Posts for Sylvia Rivera's Ten Year Memorial," blog post, *Reina Gossett*, July 31, 2012, http://www.reinagossett.com/ten-posts-for-sylvia-riveras-ten-year-memorial/.

2. On STAR's work as an antithesis to contemporary neoliberalized nonprofit structures, see, for example, Reina Gossett, "Sylvia Rivera Kicking Ass On Stage …," blog post, *Reina Gossett*, July 10, 2012, http://www.reinagossett.com/sylvia-rivera-kicking-ass-on-stage-after-some/; and Che Gossett, "We Will Not Rest in Peace: AIDS Activism, Black Radicalism, Queer and/ or Trans Resistance," in *Queer Necropolitics*, ed. Jin Haritaworn, Adi Kuntsman, and Silvia Posocco (New York: Routledge, 2015), 42. Perhaps more famously, the Sylvia Rivera Law Project, named in Rivera's honor, has become one of the most vocal LGBT activist critics of nonprofitization. See Rickke Manzala and Dean Spade, "The Nonprofit Industrial Complex and Trans Resistance," *Sexuality Research and Social Policy* 5, no. 1 (March 2008): 53–71.

3. The documents collected here are drawn from special collections at the New York Public Library, Northwestern University's LGBT Periodicals, the Digital Transgender Archive, and the Transgender Archives at the University of Victoria, British Columbia. Remarkable holdings on trans history, however, can also be found at the GLBT Historical Society in San Francisco; the Sexual Minorities Archives in Holyoke, MA; the ONE National Gay and Lesbian Archives at the USC Libraries; the Lesbian Herstory Archives in Brooklyn, NY; the Kinsey Institute at Indiana University; the Human Sexuality Collection at Cornell University; and the National Transgender Library and Archives, Labadie Collection, University of Michigan, to provide an incomplete list.

4. For overviews of trans activism and politics during this period, see Joanne Meyerowitz, *How Sex Changed: A History of Transsexuality in the United States* (Cambridge, MA: Harvard University Press, 2002); and Susan Stryker, *Transgender History* (Berkeley, CA: Seal Press, 2008).

5. Joseph Randall, "A Changing Game: The Inclusion of Transsexual Athletes in the Sports Industry," *Pace I.P. Sports & Entertainment Law Forum* 2, no. 1 (Spring 2012): 199.

6. The ordinance, which banned discrimination on the basis of "having or projecting a self-image not associated with one's biological maleness or one's biological femaleness," expanded an existing ordinance banning discrimination based on sexual orientation. The legislation reportedly passed with little notice during a "general flurry" of liberal legislation pushed through just before the city turned over to a newly elected conservative mayor. See Minneapolis, MN, Code of Ordinances, tit. 7, ch. 139, § 139.20 (2000); and Paisley Currah and Shannon Minter, *Transgender Equality: A Handbook for Activists and Policy Makers*

(New York: Policy Institute of the National Gay and Lesbian Task Force and National Center for Lesbian Rights, 2000), 19.

7. Katy Steinmetz, "The Transgender Tipping Point: America's next civil rights frontier," *Time*, May 29, 2014, http://time.com/135480/transgender-tipping-point.

8. On the clashes between lesbian feminists and trans activists in New York City, see Dudley Clendinen and Adam Nagourney, *Out for Good: The Struggle to Build a Gay Rights Movement in America* (New York: Simon and Schuster, 1999), 171–73. For video footage of remarks denouncing trans women at the march made by Jean O'Leary, then a leader of Lesbian Feminist Liberation, see "Jean O Leary Lesbian Feminist Liberation 1973 Pride Rally," posted by Reina Gossett, *vimeo*, accessed September 19, 2016, https://vimeo.com/57691610. For more on Robin Morgan and the West Coast Lesbian Feminist Conference, see Stryker, *Transgender History*, 183–88.

9. When INTRO 475, which failed to pass, was reintroduced as INTRO 554 in 1974 (spearheaded mainly by the Gay Activists Alliance), the bill included a new clause stipulating that "nothing in this definition [of sexual orientation] shall be construed to bear upon standards of attire or dress codes." Int. no. 554, City Council of New York, June 20, 1974, 2. Box 99, folder 15, National Gay and Lesbian Task Force Records, Human Sexuality Collection, Cornell University, Ithaca, NY.

10. Bebe Scarpi, in discussion with the author, August 30, 2016.

11. Janice Raymond gained repute in the late 1970s as a champion of anti-trans radical feminism. Her research indicted transsexuality as a patriarchal effort to invade and "violate" women's spaces and bodies. Her eventual book, *The Transsexual Empire* (1979), is today recognized as a founding text of trans-exclusionary radical feminism; in the view of the federal government at the time, the book also established her as a distinguished authority on trans issues. See Janice Raymond, *The Transsexual Empire: The Making of the She-Male* (1979; repr., New York: Teachers College Press, 1994); and Janice Raymond, "Paper Prepared for the National Center for Health Care Technology [NCHCT] on the Social and Ethical Aspects of Transsexual Surgery, June 1980," manuscript in National Transgender Library and Archives, Labadie Collection, University of Michigan Library, Ann Arbor. The government report for which Raymond was consulted in turn became the basis for the Department of Health and Human Services' policy determination to exclude gender-affirming surgeries from coverage under Medicare, which remained in effect until being overturned in May 2014. See Department of Health and Human Services, Appellate Division, NCD 140.3, Transsexual Surgery, No. A-13-87, May 30, 2014, http://www.uilgbtqclinic .com/uploads/2/7/5/8/27587983/dab2576.pdf.

12. Susan Stryker, "Radical Queen: An Interview with Tommi Avicolli Mecca," in "Trans/ Feminisms," special issue, *Transgender Studies Quarterly* 3, no. 1–2 (May 2016): 278–84.

13. Angela Douglas, "Transexual Action Organization Publications, 1972–1975," 116, materials held at the GLBT Historical Society, San Francisco.

14. As one example, New Jersey–based *Female Impersonator News* editor Sandy Mesics set off an in-print debate with TAO founder Angela Douglas after questioning whether Douglas suffered from "paranoid schizophrenia." Mesics's indictments evidently did not deter Douglas from her conviction that Lee Brewster and Reed Erickson secretly worked for the FBI and CIA. See *Female Impersonator News* 1, no. 2 (n.d.): 3; Douglas, "Transexual Action Organization Publications," 116; and Meyerowitz, *How Sex Changed*, 240.

15. Douglas, "Transexual Action Organization Publications," 9.

16. In contrast, TAO leadership noted their success in using spells to restrain Miami Beach police from harassing local trans communities; see, for example, "Transsexuals Hex Robin Morgan," *Advocate*, July 18, 1973, 21.

17. See "Homosexuals in Cook County Jail," *Transvestite Legal Committee Newsletter*, July 1972.

18. Arthur Bell and Sylvia Rivera, "Gay Prisoner in Bellevue," *Gay Flames*, November 14, 1970, 1.

19. See "Street Transvestite Action Revolutionaries (S.T.A.R.)" in Cohen, *The Gay Liberation Youth Movement*, 89–164.

20. Scarpi, in discussion with the author.

21. Ibid.

22. Leslie Feinberg, "Early Left Wing Liberation: Unity with all the Oppressed," *Workers World*, October 5, 2006, http://www.workers.org/2006/us/lavender-red-75/.

23. Stryker, "Radical Queen," 281–83.

24. Ibid.

25. *Radical Queen*, no. 4 (n.d.), back cover.

26. Brooklyn Stothard, "Transsexualism and Women's Liberation," *Mirage* 1, no. 2 (1974): 24.

27. Tommi Avicolli Mecca, "Focus," *Radical Queen*, no. 4 (n.d.): 24–26.

28. Douglas, "Transexual Action Organization Publications," 7.

29. Aaron Devor, "Reed Erickson (1912–1992): How One Transsexed Man Supported ONE," in *Before Stonewall: Activists for Gay and Lesbian Rights in Historical Context*, ed. Vern Bullough (New York: Haworth Press, 2002), 385.

30. *EEF Newsletter* 8, no. 1 (1975): 8; and Stryker, *Transgender History*, 146.

31. Angela Douglas, "Marijuana Usage Linked to Gynecomastia," *Moonshadow* (January–February 1974): 4.

32. Angela Douglas, "Occult Aspect," *Moonshadow* (January–February 1974): 12.

33. Goudie noted that the curse was only a "mild" one, but reassured the *Advocate* that Morgan "will suffer because of her attacks upon transsexuals, without a doubt." "Transsexuals Hex Robin Morgan," 21.

34. "Tisha Interview," *Mirage*, no. 4 (February 1975): 10.

35. Angela Douglas, *Triple Jeopardy: The Autobiography of Angela Lynn Douglas* (self-published, 1983), 55, 72; copy on file with the GLBT Historical Society.

36. Angela Douglas, "UFOs, TSs, and Extra-Ts," *Mirage* (March–April 1974): 24.

37. Ibid.

38. Ibid.

39. Walter Benjamin, "Theses on the Philosophy of History," in *Illuminations* (New York: Schocken Books, 1969), 255.

40. "Tisha Interview," 11.

41. Angela Douglas, "Editorial," *Mirage* (March–April 1974): 4.

OUT OF OBSCURITY:
TRANS RESISTANCE, 1969–2016

Grace Dunham

The photographer Alvin Baltrop spent a decade, from 1975 through 1986, documenting the West Side Piers—a network of dilapidated former shipping terminals on Manhattan's Hudson River frontage. "The Piers," as they were colloquially referred to, were a nexus of the city's queer underground, a place where gay men, trans people, and sex workers all gathered to participate in social, sexual, and political life. The Piers provided a refuge away from NYPD surveillance, which specifically targeted low-income queer and trans people and trans people of color. (Even after the Stonewall Inn riots of 1969, the state continued to criminalize the survival of queer and trans people of color; namely, their reliance on the sex trades for money.) Separated from the West Village and Chelsea by the elevated West Side Highway and a strip of industrial buildings, the Piers provided a cover of obscurity, drawing communities that otherwise faced rampant surveillance and the constant risk of arrest.

The fugitive potential of the Piers was not only social and sexual, but also political; at the Piers, a community of youth, sex workers, the homeless, and trans people—and, of course, those at the intersection of these identities—collectively cared for, educated, and protected one another. This particular account of the Piers was not, at the time, as well recorded as the alternate interpretation of the Piers as a Dionysian, though potentially deadly, playground for a predominantly white, gay male population.[1] No doubt, these worlds existed simultaneously and were intertwined—but the latter has been canonized (in the work of white gay artists like Robert Mapplethorpe), while the former has remained largely invisible.

The lack of documentation, both visual and archival, of trans life at the Piers is, in no small part, informed by a specter of death: if they survived until the '80s and '90s, many of those who populated the Piers were then wiped out during the

Graffiti was a primary visual feature of the Piers; wall-based works by David
Wojnarowicz and the street artist Tava, among others, were lost when the Piers
were demolished. The text in the background of Alvin Baltrop's untitled photograph
reads, "Pick up a Free Pier Newsletter: tell your friends the truth about the Piers."
This image is the only visual documentation of a community-run Piers newsletter,
which has never been corroborated in more formal histories. Though the text is
difficult to make out, Baltrop deciphered the writing prior to his death. He shared this
information with Randal Wilcox, who manages his estate.

Alvin Baltrop, Untitled (n.d.), from the series
The Piers, 1975–86. Gelatin silver print, 8 × 10 in
(20.3 × 25.4 cm). Courtesy The Alvin Baltrop
Trust. Image: © 2010, The Alvin Baltrop Trust
and Third Streaming. All rights reserved

GRACE DUNHAM

AIDS crisis. And while New York's white gay population received little governmental support, the Black and Latinx people impacted by HIV/AIDS benefited from even less. The AIDS epidemic, as well as ongoing violence against Black and Latinx trans people, resulted in massive losses of both life and collective memory. With so many trans people disappeared and forgotten, few remained alive long enough to carry accounts of resistance into canonical histories.

The riots at Stonewall, which took place two decades before the Piers were demolished, have benefited from retroactive scholarship and, as such, their significance has only increased with time—which is to say, on that evening in June of 1969, no one present narrated the riot as the beginning of the modern gay rights movement; this narration has shifted and been catalyzed by a mainstream, state-sanctioned gay agenda that seeks to absorb the riots into its narrative of progress, even as surviving participants in the riots work to correct that narrative.[2]

Scholars have attempted to excavate accounts of antipolice riots that took place before Stonewall, such as the Compton's Cafeteria riot in San Francisco in 1966[3] or the Cooper's Donuts riots in Los Angeles in 1959[4]—both were primarily initiated by queer and trans people of color, many of whom were homeless and enjoyed little institutional or organizational support. The Piers, then, were at their height in the aftermath of Stonewall, at a time when far fewer formal organizations served and recorded the political work of trans people, and those that did—like Street Transvestite Action Revolutionaries (STAR) and the other groups referred to in "Trans History in a Moment of Danger: Organizing Within and Beyond 'Visibility' in the 1970s" by Abram J. Lewis (see page 57 in this volume)—had no support from the state, universities, or foundations. Trans political life was not born out of institutions; it rubbed up against and resisted them. In fact, for most of the twentieth century, before the rapid growth of the nonprofit sector, trans political organizing primarily occurred at the level of the community itself—organizations were less important than the friendships and familial or sexual relationships that constituted community.

One of Baltrop's lesser-known photographs from his time at the Piers (his most widely viewed works are voyeuristic, distant shots of queer sex) is a wide-frame shot of a wall scrawled with graffiti that reads, "Pick up a Free Pier Newsletter: tell your friends the truth about the Piers." This image, untitled and undated, indicates the existence of a newsletter which has not been confirmed or corroborated in any existing scholarship. Yet, the image alludes to a structure for both the dissemination of information and community education. With little additional context, Baltrop's image raises a series of logistical questions: What group was responsible for this newsletter? Where was it printed? Who organized the funds for its printing? Whose voices were included in the newsletter,

and who read it? Additionally, did this newsletter exist in a material way, or was its medium simply the walls of the Piers, where it could be viewed and read by the hundreds who passed by every week?

Baltrop's image allows us to glimpse the contours of political work without knowledge of how that work was structured or who was responsible for it. It briefly lifts the veil of obscurity, revealing political intention and a political agenda that existed outside of and away from what would be remembered. The fact that this newsletter—a formation of trans political and social life—was revealed ex post facto neither legitimizes nor validates the impact of that political work; the "newsletter" existed with or without historical memory and cast political reverberations. No doubt, we have no visual proof of most trans political work from that era.

.........

In the decades after Stonewall, as the assimilationist turn continued and the gay rights movement grew more visible, a multitude of factors changed the relationship between the so-called gay, lesbian, and trans communities and the state. On the one hand, white gays and lesbians continued to build their platforms around such normalizing agendas as marriage rights, employment security, and the general tenets of equality. At the same time, the US government grew more effective at managing a symbiotic relationship between its institutions and its opponents. This symbiosis is perhaps best exemplified by the rise of the nonprofit: a model wherein advocacy groups, service providers, and community organizations work in the gaps left by shrunken social services, mitigating the effects of state violence while depending on the state and its corporate allies for funding. This critical analysis has been well documented by scholars and activists both within and outside of the nonprofit sector.[5] It poses a set of contextual concerns without blaming those individuals working within the system itself. Broadly speaking, the increased institutionalization of political struggles within the nonprofit model has offered employment to populations that were previously barred from most opportunities for an annual salary and benefits.

In the late 1990s and early 2000s, a group of organizations began taking shape that explicitly worked on behalf of, and to build leadership among, queer communities that had long been overlooked and even maligned by mainstream gay rights groups. Organizations such as the Audre Lorde Project, the Sylvia Rivera Law Project (SRLP), BreakOUT!, FIERCE, Black & Pink, and Transgender, Gender Variant, and Intersex Justice Project (TGIJP), among a handful of others, were founded on and continue to utilize the nonprofit model to create formalized

community organizations for low-income queer and trans people of color who face ongoing violence from police and a continued lack of access to resources. A network of organizations in cities across the country, as well as some explicitly rural organizations—like Southerners On New Ground (SONG)—sought to create a coalition that would offer a different queer agenda, rooted equally in racial and economic justice and geared toward the abolition of police and prisons and the prioritization of those facing urgent and intersecting forms of violence. These groups do not foreground the potential of LGBTQ people to be American citizens; rather, they radiate out of the experience of trans people of color as a way of criticizing the very premise of citizenship.

One primary way that these organizations have challenged notions of respectable citizenship is by centering the struggle of queer and trans prisoners, and the problem of prisons in general. Whereas mainstream LGBTQ organizations glossed over the impact of prisons on queer and trans people, groups like TGIJP, based in San Francisco, and Black & Pink, based in Boston, work to foreground the relationship between prisons and gender- and sexuality-based oppression. This work has sought to correct that erasure of incarcerated peoples that emerged after Stonewall (e.g., Sylvia Rivera's ejection from the stage of the 1973 Gay Pride Parade in New York City after she criticized the gay rights movement's neglect of incarcerated trans people).[6] Black & Pink, a network of "LGBTQ prisoners and 'free world' allies,"[7] runs chapters throughout the country that send letters, care packages, and a monthly newspaper to incarcerated community members; simultaneous to this work, Black & Pink has developed curricula and strategies for educating organizers about the prison industrial complex, its impact on LGBTQ people, and the legacy and goals of prison abolition. Black & Pink has also been responsible for the largest to-date surveys of LGBTQ prisoners, which enlist thousands of participants to answer questions about their identities, their treatment by prison staff, and their mental, physical, and sexual health inside of prisons.[8] Up against a carceral system which asserts that criminalized people are undeserving of freedom, Black & Pink models a movement in which queer and trans prisoners are not just acknowledged, but listened to and followed. Their structure for solidarity—free allies in ongoing dialogue with unfree peers—undermines a hierarchy of value in which free people's needs and demands are treated with more urgency than incarcerated people's.

While Black & Pink and TGIJP work to facilitate and follow the leadership of people inside of or recently freed from prisons, organizations like BreakOUT! and FIERCE have built their work on protecting queer and trans youth from the systems of violence and surveillance that land them in cycles of incarceration. Both organizations are led by queer and trans youth of color,

who disproportionately navigate homelessness and the policing that necessarily follows. These organizations not only go up against the structures of white supremacy and transphobia that inform policing and incarceration, but also assert that youth—particularly, youth facing the most surveillance—have the capacity and knowledge to structure their own political movements. This, no doubt, carries forward the legacy of earlier efforts in trans resistance, like the riots at Stonewall, Compton's, and Cooper's, which were all initiated by queer and trans youth living without familial or institutional support.

Amid an ever-expanding police and carceral state, and the isolation that follows, organizations led by trans and queer people of color have worked to build structures and networks for connection. SONG, which describes itself as a "regional Queer Liberation organization made up of people of color, immigrants, undocumented people, people with disabilities, working class and rural and small town, LGBTQ people in the South,"[9] organizes across a large geographic area to build community among marginalized people navigating both spatial and social isolation. While the work of SONG continues to be deeply rooted in the regional identities and barriers of the South, organizations—like BreakOUT!, FIERCE, or the Audre Lorde Project—work in particular to address the urban trans and queer of color experience. In cities like New York, New Orleans, and San Francisco, gentrification (and the displacement and policing that follow) has been a primary focus of organizing.[10] These groups work to maintain community spaces despite increased rent and evictions, to develop tactics for community accountability outside police involvement, and to educate community members about how to advocate for themselves when being stopped by police or held in jail;[11] at the same time, these groups create festivals and celebrations that offer alternatives to white, corporate-sponsored gay events. The Audre Lorde Project, for example, organizes annual events like Trans Day of Action and Bed Stuy Pride (see flyer, page 103), both of which partner with local, non-gentrifying businesses and center the legacies and resistance of people of color. In addition, these events oppose the idea that police are needed for security and instead train community members to maintain safety.

The constellation of these groups, in conjunction with their organizing and policy work, has been responsible for spreading analyses that, until recently, rarely entered popular discourse or mainstream media. In the spring of 2016, in the aftermath of the massacre at the Pulse nightclub in Orlando, Florida, groups including TGIJP, BreakOUT!, and the Audre Lorde Project—despite their minimal funding—forcefully critiqued the state's promise to increase security on behalf of LGBTQ people.[12] It was this network of organizations that challenged the state's militarized response to the massacre and made decisions to directly opt out of and

counter the state's supposed protection.[13] In keeping with their record of anti-policing initiatives, both BreakOUT! and TGIJP pulled out of Pride events in their respective cities after police departments announced heightened security. These groups used media channels to rigorously emphasize the police's role as oppressors of trans people, not protectors.[14] This discourse affirmed the fact that, whatever the pitfalls and complications of the nonprofit structure, the aforementioned groups are still the primary voices in the nonprofit world working to legitimize counterproposals for what a queer and trans politics might look like.

Unsurprisingly, the efforts against oppression and violence taken on by these groups—to say nothing of the communities themselves—continue to suffer from a profound lack of financial support. While visibility for trans people has increased in the media in the past two years, a recent report from Funders for LGBTQ Issues reveals that less than 1 percent of LGBTQ funding goes to trans issues and less than 1 percent of LGBTQ funding goes to criminalized populations (the obvious intersection is Black trans people, who are criminalized and incarcerated at the highest rates of any identity group).[15] Despite their widely impactful work, both in terms of policy and discourse, the organizations discussed here—particularly those with minimal state grant funding—continue to run on funding that pales in comparison to that of corporate advocacy groups, which predominantly employ white, cis gays and lesbians and seek more normative goals.

It seems essential to describe the last decade of trans political life without reducing the impact of the nonprofit structure to net-positive or net-negative outcomes. The pitfalls of state and corporate funding are obvious and widely stated: state sponsorship often means state influence; the very institutions that harm and neglect trans people have the most power to determine who is respectable enough to be funded and served. But, within and against that matrix, a coalition of organizations with minimal funding has attempted to center and transform a system of violence that is rarely, if ever, prioritized or even acknowledged in mainstream politics.

The most common criticism of nonprofits is that they have eroded the foundation of trans political resistance, pulling people into a formal labor agreement with the state and, in turn, foreclosing the possibility of an antistate (and thus anti-prison and antipolice) political agenda. But such a conclusion assumes that a complicated institutional structure requires the complicity of those inside that institution; it overlooks the demands of income and stability that lead people to this kind of labor in the first place, and the work they do that goes undetected by the surveilling apparatuses of the state—namely, structures of care and dependency which are not legible as monetized or productive labor.

Rather than seeing nonprofits as an entirely new formation, a continuous thread might be drawn from the anonymous newsletter of the Piers to the social reach of these organizations, many of which disseminate information through social media. Channels like Instagram, Facebook, and Tumblr allow organizers and community members from across the country to share analyses, boost events, offer one another support, exchange tactics, and collectively articulate a politics of resistance. Employment, benefits, and grant writing: these complicate and inflect trans political work, but do not destroy it. Trans justice politics doesn't begin and end at the nonprofit—nor does it require it or entirely fail because of it. The nonprofit will not exist in perpetuity; just as it came to prominence within and against the sociopolitical context of the past half century, there will be new models—formed by the imaginative resistance of activists, as well as by the compromises those engaged in resistance are forced to make. Already, organizers who have spent the last decade working inside the nonprofit system are experimenting with potential new models that seek funding from individuals, as opposed to state or corporate foundation support; that propose more direct channels for the redistribution of wealth; and that distance political work from the binds of salaried wage-labor.[16] Any organizational structure is but one context for the ongoing and far-from-complete struggle that is trans liberation—a commitment to the possibility of a world without oppressive institutions even as the state develops increasingly advanced strategies to foreclose that possibility. Trans liberation is not rooted in the longevity of any one institution or in the efficacy of one organizational model; trans liberation is born out of and continually renewed by the labor and resilience of the communities that continue to push toward possibility.

*The queer, trans, and gender nonconforming protesters who participated in the
1959 riot at Cooper's Donuts in Los Angeles were arrested and imprisoned in
the Lincoln Heights Jail, then referred to as the "Fruit Tank." The Lincoln Heights
Jail was the designated facility for "cross-dressers" and "transvestites" during the
reign of William H. Parker, the LAPD chief who created vice squads to target queer
nightlife and social culture. Today, the "Fruit Tank" sits empty under a highway
next to the Los Angeles River, one of the few remaining landmarks of the largely
undocumented 1959 riot.*

View of Lincoln Heights Jail, Los Angeles, 2001.
Digital photograph. Courtesy the Center for Land
Use Interpretation

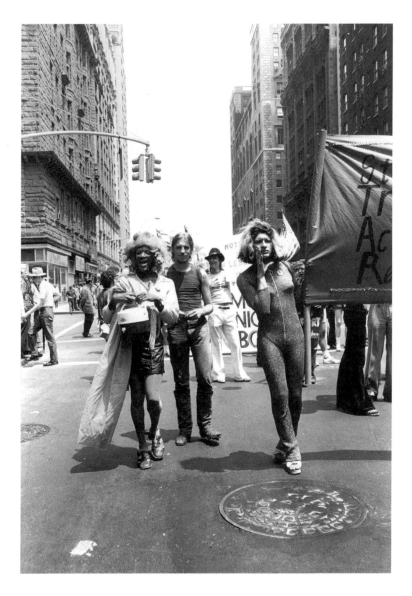

*STAR members marching in the Christopher Street Liberation Day Gay Pride
Parade in New York, on June 24, 1973. Sylvia Rivera (on the right), holds a "Street
Transvestite Action Revolutionaries" banner; the same day, she was pulled off
the Pride Parade stage for confronting the burgeoning gay rights movement about
its erasure of trans women and incarcerated community members.*

Micah Bazant's portraits depict trans movement leaders, both living and dead. Bazant's work centers trans people navigating intersecting forms of violence: disabled activists, undocumented activists, and Black and indigenous activists. Their work contributes to the visual culture of a trans abolitionist political movement by portraying people who have often been disappeared by the state and rendering them as leaders and legends. This particular image, which depicts two trans people of color surrounded by prison bars, centers the experience and struggle of trans prisoners.

Micah Bazant and Audre Lorde Project, *Remember Trans Power, Fight for Trans Freedom*, 2016. Poster, 11 × 17 in (27.9 × 43.2 cm). Courtesy Micah Bazant and Audre Lorde Project

This image was made in conjunction with the decision by TGIJP to pull out of San Francisco Pride, after it was announced that the event would be subjected to increased policing in the aftermath of the massacre at the Pulse Nightclub in Orlando, Florida. Janetta Johnson, the subject of this portrait, is a formerly incarcerated Black trans activist who has fought against gentrification and criminalization in the Bay Area and across the country for decades.

Micah Bazant and TGIJP, *Police Out of Pride*, 2016, from the *Trans Life & Liberation* series (February 2016–ongoing). Graphite, watercolor, and Photoshop, 12 × 12 in (30.5 × 30.5 cm). Courtesy Micah Bazant and TGIJP

Every year, the Audre Lorde Project plans multiple community events in New York, including Bed Stuy Pride, Trans Day of Remembrance, and Trans Day of Action (TDOA), which this flyer promotes. TDOA, which takes place on the Christopher Street Piers, coincides with the week of the city's Gay Pride Parade. The event offers a counter-narrative to the history espoused by the mainstream gay rights movement: TDOA centers queer and trans people of color and commemorates the decades of organizing and social life that have occurred along the West Side Piers.

Audre Lorde Project, Trans Day of Action poster, 2014. Courtesy the Audre Lorde Project

The Safe Party Toolkit is an ongoing labor of love and necessity, first imagined and implemented in 2007 by members and staff of the Safe OUTside the System Collective.

Many thanks to the members and staff who came before us, imagined a vision, and built safety outside of state systems.

For the most up-to-date Safe Party Toolkit online, visit http://bit.ly/SafePartyToolkit.

One of the primary aims of the Audre Lorde Project is to provide resources to community members. These resources range from instructions for how to safely navigate encounters with the police to "toolkits" for health care and safe parties. This image is from the Safe Party Planning Tool Kit, collectively written and illustrated by ALP's Safe OUTside the System Collective.

Audre Lorde Project and Safe OUTside the System,
The Safe Party Planning Tool Kit, 2007–ongoing.
Digital pamphlet

SONG'S VISION, MISSION AND HISTORY

VISION

SONG imagines a sustainable South that embodies the best of its freedom traditions and works towards the transformation of our economic, social, spiritual, and political relationships. We envision a multi-issue southern justice movement that unites us across class, age, race, ability, gender, immigration status, and sexuality; a movement in which LGBTQ people – poor and working class, immigrant, people of color, rural – take our rightful place as leaders, shaping our region's legacy and future. We are committed to restoring a way of being that recognizes our collective humanity and dependence o the Earth.

MISSION

SONG is a home for LGBTQ liberation across all lines of race, class, ability, age, culture, gender, and sexuality in the South. We build, sustain, and connect a southern regional base of LGBTQ people in order to transform the region through strategic projects and community organizing campaigns developed in response to the current conditions in our communities. SONG builds this movement through leadership development, intersectional analysis, and organizing.

HISTORY

The first conversations about forming Southerners On New Ground came about in 1992, when a multi-racial group of six Southern lesbians came together at Creating Change in Durham, NC, and dared to talk about LGBTQ people and economics in the same breath. Many told them that talking about things like poverty, racism, and solidarity between oppressed people worldwide was a "waste of time," but the group insisted that these conversations were critical LGBTQ issues, vital to the South, and could not be ignored. Their insight, courage, and belief that every human being matters and that we are part of one another led to the founding of SONG in 1993.

Since that time, SONG has been known both regionally and nationally for its organizing and training work across issues of race, class, gender, culture and sexuality with both LGBTQ people and allies. SONG works to build and maintain a Southern LGBTQ infrastructure strong enough to combat the Southern-specific strategy of the right wing to divide and conquer Southern oppressed communities. During SONG's 20-year existence, it has served as a hub and an igniting force for many organizing, political analysis, and leadership development projects. The organization is currently moving forward with greater focus on campaign work than ever before, and with a renewed push to build power through the recruitment, expansion and retention of a base of Southern LGBTQ organizers and visionaries.

WHY IS SONG A REGIONAL ORGANIZATION? WHY DO WE HAVE A REGIONAL STAFF?

SONG believes that the South is a key region for building movement power in the 21st century, as it has been in other times. Oppressive forces have had a regional strategy for the South—so we have one, too. That means that instead of pitting state against state, or Appalachia against the Deep South, we seek to build leadership, base, alliance and organizing in sites and between them. While it is very difficult to build and resource a regional infrastructure, our time, conditions, and communities need one in order to achieve the kind of change we believe necessary.

3

SONG is a regional queer liberation organization that connects people of color, immigrants, undocumented people, people with disabilities, and working-class, rural, and small-town LGBTQ people in the South. These pages from SONG's membership guidebook offer a window into the group's principles, goals, and relationship to l egacies of Southern resistance.

SONG PRINCIPLES:
BELIEFS OUR WORK IS BASED ON

- Every person is worthy of dignity and respect.

- We are all part of one another.

- People are experts on their own lives, and have the right to self-determination. It is through people's stories that we learn the conditions needed for change, hope, resiliency, and survival.

- Community Organizing is the best way we know to build power for oppressed people. SONG supports organizing that builds collective power and leadership among all involved and that begins with people who are most targeted by injustice.

- Race, Class, Culture, Gender and Sexuality are intrinsically connected. Oppression is systemic and inter-sected, as are its methods and the people targeted by it. Alignment and solidarity among those who experi-ence injustice provide the possibility of broad-based social change.

- Unjust power divides and harms us. Shared power and resources are the foundation of liberation built on justice. As Gandhi said: "Every step towards liberation must have liberation in it."

- There is no liberation, not even survival, in isolation. Our liberation depends on us coming together across lines of difference. Our hope for change is bringing people together in multi-issue, multi-cultural com-munity organizing.

- As people, we are often asked to fragment our multiple identities. We believe everyone should be able to bring their full selves to this work.

- In LGBTQ organizing, people of color, women, trans people, rural people, immigrants and low-income people are often marginalized. We believe WE must be central.

- Attacks on LGBTQ people threaten the entire social change agenda, and we work to put LGBTQ issues into a rightful place. Likewise, as classism, racism and ableism threaten the LGBTQ movement, we work to put all of these social justice issues in their rightful place.

- Rural areas and small towns are integral to building a strong movement and we work to bring appropriate resources and strategies to these areas, as they are traditionally under-resourced.

- SONG develops holistic spaces and practices that welcome each person's whole self, create a culture of hope, encourage the development of one's best self, and inspire vision for the combined individual and collective good.

- Our work is about transformation. We seek to build a just, fair, and liberated society that meets the needs of its people. SONG chooses to organize around longing, desire, and hope before anger and fear. Some-times we are angry and heart broken, but our work comes forth from a place of celebration and love for our communities.

4

SONG, Membership Guidebook, page 4, April 2015. Courtesy Southerners On New Ground.
© Southerners On New Ground

STILL WE RISE:

A Resource Packet for Transgender and Gender Non-Conforming People in Prison

**TRANSGENDER
GENDER-VARIANT
& INTERSEX
JUSTICE PROJECT**

TGIJP works with trans, intersex, and gender nonconforming prisoners and formerly incarcerated people in the Bay Area of California. Its work has influenced organizers across the country, offering an organizational model wherein incarcerated people and formerly incarcerated people act as the leaders of their own movements.

TGIJP, "Still We Rise: A Resource Packet for Transgender and Gender Non-Conforming People in Prison," 2012/16. Digital and print pamphlet. Courtesy TGIJP

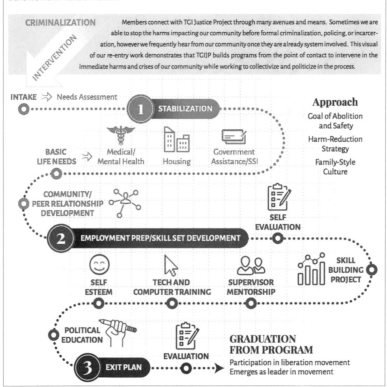

MELENIE ELENEKE
Grassroots Re-Entry Program

Every person has a unique recipe for successful re-entry, and at TGIJP we create space to equip our community with the skills and support they need to cook up the next phase of their lives. The programs namesake, Melenie Eleneke showed the world how to love, welcome home, work with and fight for trans women. Mahalo Melenie!

CRIMINALIZATION Members connect with TGI Justice Project through many avenues and means. Sometimes we are able to stop the harms impacting our community before formal criminalization, policing, or incarceration, however we frequently hear from our community once they are already system involved. This visual of our re-entry work demonstrates that TGIJP builds programs from the point of contact to intervene in the immediate harms and crises of our community while working to collectivize and politicize in the process.

INTERVENTION

INTAKE ⇒ Needs Assessment

1 STABILIZATION

BASIC LIFE NEEDS ⇒ Medical/ Mental Health Housing Government Assistance/SSI

Approach
Goal of Abolition and Safety

Harm-Reduction Strategy

Family-Style Culture

COMMUNITY/ PEER RELATIONSHIP DEVELOPMENT

SELF EVALUATION

2 EMPLOYMENT PREP/SKILL SET DEVELOPMENT

SELF ESTEEM **TECH AND COMPUTER TRAINING** **SUPERVISOR MENTORSHIP** **SKILL BUILDING PROJECT**

POLITICAL EDUCATION

EVALUATION

3 EXIT PLAN

GRADUATION FROM PROGRAM
Participation in liberation movement
Emerges as leader in movement

This flow chart is one example of the types of resources that TGIJP collectively writes and shares with other organizers and educators.

TGIJP, flow chart from the "Melenie Eleneke Grassroots Re-Entry Program," TGIJP Annual Report, 2015. Courtesy TGIJP

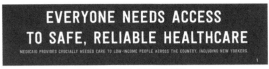

EVERYONE NEEDS ACCESS TO SAFE, RELIABLE HEALTHCARE

MEDICAID PROVIDES CRUCIALLY NEEDED CARE TO LOW-INCOME PEOPLE ACROSS THE COUNTRY, INCLUDING NEW YORKERS.

DID YOU KNOW?

- **15%** OF TRANSGENDER PEOPLE ARE LIVING IN POVERTY

 COMPARED TO

- **4%** OF THE GENERAL POPULATION

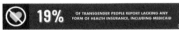

19% OF TRANSGENDER PEOPLE REPORT LACKING ANY FORM OF HEALTH INSURANCE, INCLUDING MEDICAID

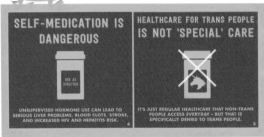

SELF-MEDICATION IS DANGEROUS	HEALTHCARE FOR TRANS PEOPLE IS NOT 'SPECIAL' CARE
UNSUPERVISED HORMONE USE CAN LEAD TO SERIOUS LIVER PROBLEMS, BLOOD CLOTS, STROKE, AND INCREASED HIV AND HEPATITIS RISK.	IT'S JUST REGULAR HEALTHCARE THAT NON-TRANS PEOPLE ACCESS EVERYDAY – BUT THAT IS SPECIFICALLY DENIED TO TRANS PEOPLE.

COVERING THE HEALTH CARE NEEDS OF TRANS PEOPLE IS AFFORDABLE

MANY INSURANCE PROVIDERS COVER TRANS HEALTH NEEDS – WITHOUT RAISING PREMIUMS.

WHEN TRANS PEOPLE GET THE CARE THEY NEED

OVERALL MENTAL HEALTH IMPROVES
78% OF TRANS PEOPLE HAD IMPROVED PSYCHOLOGICAL FUNCTIONING AFTER RECEIVING GENDER-CONFIRMING TREATMENT.

SUICIDE RATES DROP DRASTICALLY
FROM A RANGE OF 29% TO 19% BEFORE GENDER-CONFIRMING TREATMENT, TO A RANGE OF 6% TO .8% AFTER TREATMENT.

MEDICAID MONEY IS SAVED
TRANS PEOPLE WHO RECEIVE GENDER-CONFIRMING TREATMENT HAVE FEWER MENTAL HEALTH AND SUBSTANCE ABUSE COSTS, WITH HIGHER RATES OF EMPLOYMENT.

HELP REPEAL MEDICAID EXCLUSIONS FOR TRANSGENDER PEOPLE IN NEW YORK. VISIT SRLP.ORG

 glaad.org

SYLVIA RIVERA LAW PROJECT

1. American Psychological Association Council of Representatives "APA Policy Statement: Transgender, Gender Identity, & Gender Expression Non-Discrimination" http://www.apa.org/about/governance/council/policy/transgender.aspx.
2. National Center for Transgender Equality, National Gay and Lesbian Task Force "Injustice at Every Turn Executive Summary. A Report of the National Transgender Survey" transequality.org/PDFs/Executive_Summary.pdf
3. National Center for Transgender Equality, National Gay and Lesbian Task Force "National Transgender Survey Report on Health and Healthcare October 2010" transequality.org/PDFs/NTDSReportonHealth_final.pdf
4. National Center for Transgender Equality, National Gay and Lesbian Task Force "Injustice at Every Turn Executive Summary. A Report of the National Transgender Survey" transequality.org/PDFs/Executive_Summary.pdf
5. National Center for Transgender Equality, National Gay and Lesbian Task Force "Injustice at Every Turn Executive Summary. A Report of the National Transgender Survey" transequality.org/PDFs/Executive_Summary.pdf
6. Human Rights Campaign, "Transgender-inclusive benefits for Employees and Dependents" www.hrc.org/issues/workplace/benefits/transgender_inclusive_benefits.htm
7. National Center for Transgender Equality, National Gay and Lesbian Task Force "National Transgender Survey Report on Health and Healthcare October 2010" transequality.org/PDFs/NTDSReportonHealth_final.pdf

SRLP, in New York City, offers legal aid to trans and gender nonconforming people facing criminalization. SRLP has led major legal battles in New York State, including campaigns to get medical transition and gender self-determination covered by New York State health care.

SRLP and GLAAD, Trans Health Care infographic, from the campaign for health care for trans and gender nonconforming people, 2014. Courtesy SRLP and GLAAD. © SRLP and GLAAD

SRLP, as well as other trans-led abolitionist organizations, proposes prison abolition as a practice that is not solely about ending jails, prisons, and detention centers, but also about transforming intimate and interpersonal relationships.

SRLP and Rabi Cepeda, "Every Day Abolition" poster, 2015. Courtesy Rabi Cepeda and SRLP

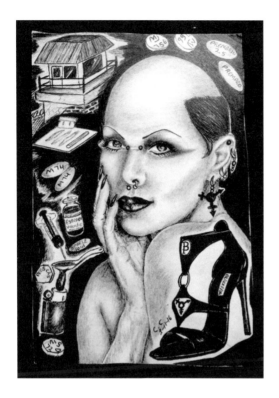

*Black & Pink, a national community of LGBTQI prisoners and their allies, keeps
a large archive of artwork and writing by queer, trans, and gender nonconforming
prisoners. Black & Pink helps overcome and reduce the harm of the physical and
emotional isolation created by incarceration. Prisoners are able to access information
and work by their peers through the organization's monthly newspaper.*

C.C., portrait, 2016. Pen on paper. Courtesy the
artist and Black & Pink

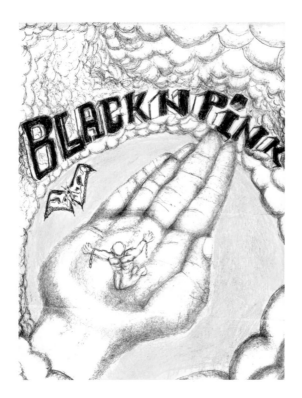

Many of Black & Pink's members spend large portions of their sentences in solitary confinement, a punishment that is disproportionately imposed on trans and gender nonconforming prisoners. For many Black & Pink members, the letters they write back and forth with their pen pals are the primary social contact to which they have access.

Christopher, Black & Pink hand prayer, 2016.
Black pen and highlighter on paper, 9 × 13 in
(22.9 × 33 cm). Courtesy the artist and
Black & Pink

GRACE DUNHAM

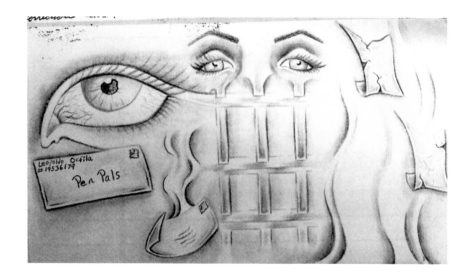

Much of the artwork archived by Black & Pink is drawn on envelopes and letters—the medium for communication with friends, family, allies, and comrades outside prison walls.

Leopold, illustrated envelope, 2016. Pencil on standard-size legal envelope, 4 ⅛ × 9 ½ in (10.5 × 24.1 cm). Courtesy the artist and Black & Pink

●●●●● AT&T 📶 12:18 AM 99% ▰▰▰

〈 **Photo** ↻

youthbreakout •••

A PAT DOWN OR FRISK IS DIFFERENT FROM A SEARCH. OFFICERS CAN PAT YOU DOWN TO MAKE SURE YOU DON'T HAVE ANY WEAPONS. BUT THEY SHOULD HAVE PROBABLE CAUSE FOR A SEARCH (GOING IN YOUR POCKETS, BAG, ETC.)

#GETYRRIGHTS

♡ ◯ ↪

♥ **17 likes**

youthbreakout Happy Carnival! While you're out enjoying parades today, remember! Never resist a search but say loudly and clearly, "I do not consent to this search" and check to see if the officer's body cam is on. (This can help you later in court if it was a illegal search.) #MardiGras #GetYrRights

⌂ 🔍 📷 ♡ 👤

BreakOUT!, FIERCE, and Streetwise and Safe (SAS) have staged multiple national #KnowYourRights campaigns to make sure criminalized queer and trans youth of color have access to the information they need to navigate situations involving police harassment. This information has been primarily disseminated through social media.

Screenshots of BreakOUT!'s #GetYrRights
social media campaign on Instagram, 2016.
Courtesy Youth BreakOUT!, New Orleans

youthbreakout
New Orleans French Quarter ❯ ···

THERE IS NO LEGAL LIMIT TO THE NUMBER OF CONDOMS YOU CAN CARRY- IF POLICE THREATEN TO USE CONDOMS AS EVIDENCE OF PROSTITUTION, FILE AN ANONYMOUS COMPLAINT WITH WOMEN WITH A VISION OR BREAKOUT!

#GETYRRIGHTS

♡ ◯ ↗

♥ 32 likes

youthbreakout @wwavnola and @youthbreakout can both take complaints on behalf of the NOLA Independent Police Monitor #GetYrRights #MardiGras #mardigras2016

FEBRUARY 6

••••• AT&T 📶 12:19 AM 99% 🔋

❮ Photo ↻

youthbreakout
New Orleans, Louisiana ❯ ···

POLICE ARE LIKE VAMPIRES- THEY HAVE TO BE INVITED INTO YOUR HOME UNLESS THEY HAVE A WARRANT. IF A COP COMES TO YOUR DOOR FOR A 'KNOCK & TALK,' SIMPLY STEP OUTSIDE TO SPEAK WITH THEM (& PULL THE DOOR CLOSED BEHIND YOU) OR TALK TO THEM THROUGH THE DOOR.

#GETYRRIGHTS #MARDIGRAS2016

♡ ◯ ↗

♥ 20 likes

youthbreakout #KnockAndTalk #GetYrRights #mardigras2016 #MardiGras

FEBRUARY 7

 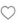 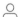

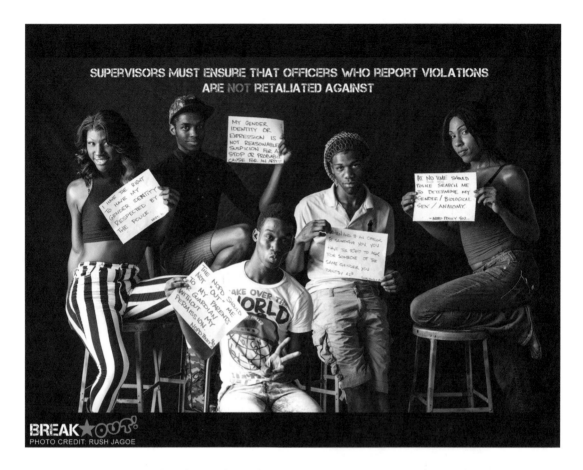

This 2013 photo shoot by Youth BreakOUT! features community members and activists and provides easily shareable visual information about the ways in which police consistently violate the rights of those they surveil—profiling them based on their race, gender, or presumed identity as participants in the sex trades.

Photo shoot from Youth BreakOUT!'s
#KnowYourRights campaign, 2013.
Courtesy Youth BreakOUT!, New Orleans
Photos: Rush Jagoe

GRACE DUNHAM

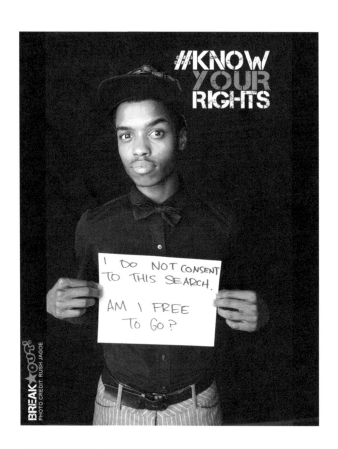

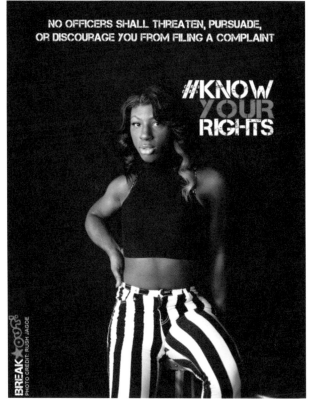

..

"Out of Obscurity: Trans Resistance, 1969–2016" is a dossier compiled and contextualized by writer and activist Grace Dunham in 2016 for this volume.

..

NOTES

——————

1. Arthur Bell, "Mayhem on the Gay Waterfront," *Village Voice* (January 1975): 5.

2. See, for example, Miss Major Griffin-Gracy, *Trans Oral History Project: Miss Major on Stonewall*, video, 3:08 min, June 27, 2015, https://www.youtube.com/watch?v =O8gKdAOQyyI.

3. Victor Silverman and Susan Stryker, dir., *Screaming Queens: The Riot at Compton's Cafeteria* (Frameline, 2005), 57 min.

4. Lillian Faderman and Stuart Timmons, *Gay L.A.: A History of Sexual Outlaws, Power Politics, and Lipstick Lesbians* (Berkeley: University of California Press, 2009), 1–3.

5. See, for example, Rickke Mananzala and Dean Spade, "The Nonprofit Industrial Complex and Trans Resistance," *Sexuality Research & Social Policy* 5, no. 1 (March 2008), http://srlp .org/files/NPICtransresistance.pdf.

6. For footage of Rivera's comments, see "Sylvia Rivera—'Y'all better quiet down' (1973)," YouTube, video, 4:08 min, accessed October 10, 2016, https://www.youtube.com /watch?v=9QiigzZCEtQ.

7. "Purpose," Black & Pink: Prison Abolition Now!, accessed September 28, 2016, http://www .blackandpink.org/.

8. See Jason Lydon, Kamaria Carrington, Hana Low, Reed Miller, and Mahsa Yazdy, "Coming Out of Concrete Closets: A Report on Black & Pink's National LGBTQ Prisoner Survey," Black & Pink, October 21, 2015, http://www.blackandpink.org/survey/.

9. "About," Southerners On New Ground, accessed September 28, 2016, http://southerners onnewground.org/about/.

10. Jordan T. Camp and Christina Heatherton, *Policing the Planet: Why the Policing Crisis Led to Black Lives Matter* (London: Verso, 2016), 41–61.

11. See, for example, Streetwise and Safe and the Global Action Project, *The Real T: This Is My Truth*, 2015, video, 12:54 min, accessed October 4, 2016, https://vimeo.com/134349934.

12. See Grace Dunham and Toshio Meronek, "How the United States' First LGBT National Memorial Gets It Wrong," *Truthout*, July 2, 2016, http://www.truth-out.org/news/item /36678-how-lgbt-national-memorial-gets-it-wrong.

13. Che Gossett, "Pulse, Beat, Rhythm, Cry: Orlando and the queer and trans necropolitics of loss and mourning," blog post, *Verso*, July 5, 2016, http://www.versobooks.com/blogs/2747 -pulse-beat-rhythm-cry-orlando-and-the-queer-and-trans-necropolitics-of-loss-and-mourning.

14. Transgender, Gender Variant, and Intersex Justice Project, "In Response to Increased Policing of Civic Center, Grand Marshals, Awardees Withdraw from Participation in Pride

Parade," *TGI Justice*, June 14, 2016, http://www.tgijp.org/solidarity/in-response-to-increased
-policing-of-civic-center-grand-marshals-awardees-withdraw-from-participation-in-pride-parade.

15. Lyle Matthew Kan and Ben Francisco Maulbeck, "2014 Tracking Report: Lesbian, Gay,
Bisexual, and Transgender Grantmaking by U.S. Foundations," *Funders for LGBTQ Issues*,
February 25, 2015, https://www.lgbtfunders.org/wp-content/uploads/2016/05/2014
_Tracking_Report.pdf.

16. For a recent example, see F2L, a group who describes itself on its Facebook page as "a New
York City based group of individuals doing support work for queer and trans people of color
facing time in the New York State prison system. We fight for queer and trans people of color
who have been charged with felonies and other higher level offenses, and individuals who are
appealing those convictions. We do this by resourcing individuals with commissary, housing,
care packages, books, cash money, and more. We also provide media support, courtroom
support, and general advocacy within state systems. F2L is a volunteer run project primarily
made up of other queer and trans people of color in New York City." "About," F2L Facebook
page, accessed October 4, 2016, https://www.facebook.com/F2L-149740108791084/about
/?entry_point=page_nav_about_item; see also "WeFight2Live," WeFight2Live, accessed
October 4, 2016, http://wefight2live.tumblr.com/.

INTRODUCING THE MUSEUM OF TRANSGENDER HIRSTORY AND ART

Chris E. Vargas

The Museum of Transgender Hirstory and Art (MOTHA) is dedicated to moving the hirstory and art of transgender people to the center of public life. The Museum insists on an expansive and unstable definition of transgender, one that is able to encompass all transgender and gender nonconformed art and artists. MOTHA is committed to developing a robust exhibition and programming schedule that will enrich the transgender mythos both by exhibiting works by living artists and by honoring the hiroes and transcestors who have come before. Despite its status of being forever under construction, MOTHA is already the preeminent institution of its kind.
—MOTHA Mission Statement

THE EMERGENCE OF MOTHA

For millennia, the patriarchy has had *his*tory; for a few years, in the 1970s, some white feminists had *her*story; but now, transgender people finally have a gender-neutral *hir*story all their own. The Museum of Transgender Hirstory and Art (MOTHA) has been a long time coming, and it is long overdue. Transgender people are a creative and hardy folk—we've endured invisibility and hyper-visibility; we've been demonized and pathologized, ridiculed and melodrama-tized. We have been the subjects of metaphor, suspicion, academic theorizing, medical and anthropological research, and, in the worst cases, violence and mur-der. But we've survived in creative and ingenious ways. We've thrived in this terrible transphobic world to such an extent that it's now time to preserve the legacy of our triumphs for future generations.

Since the emergence of the art museum, people have had various understandings of its purpose. Is it an elite institution or one for the people? Does it reflect who we are or who we strive to be as a culture? Who does the "we" refer to? All of us or a select few? Despite the flaws of the art museum—bureaucratic messiness, interdepartmental tensions, occasional insecurity about provincialism and a reluctance to program local artists, competing obligations to diverse local communities and a wealthy board of directors, and mega-monumental building designs that nearly eclipse the artwork inside—society has found no better alternative for preserving and displaying our history and art. So, rather than throw the baby out with the bathwater, we're going to stay with the trouble until we figure out something better.

We now live in a world where nearly every major city has an art museum; museums have become symbols of a city's cultural vitality, relevancy, and vibrancy. Among the tens of thousands of museums in the US, there exist only a handful dedicated to the art and history of marked or marginalized peoples: museums highlighting the experiences of African Americans and the African diaspora; museums of Asian American art; those dedicated to Jewish culture; a museum in Buffalo, New York, dedicated to disability history; a few museums dedicated to women and queer people; and a number of museums dedicated to other specific identities and cultural experiences. But there has been no museum dedicated to how all of these factors intersect specifically with the *hir*stories and art of genderqueer, gender nonconforming, gender nonbinary, and/or trans peoples. Until now.

MOTHA'S FIRST YEAR

MOTHA launched in 2013 with an artist-designed, black-and-white promotional broadside poster and has quickly grown into a widely respected, powerful cultural empire. The broadside, designed over the course of a year and distributed for free at MOTHA events and sold in our online gift shop, depicts more than 250 figures. In a social media–supported open call, members of the public were invited to recommend their personal transgressive gender hiroes, whether they be famous or infamous icons, artists, activists, or anybody with any sort of trans cultural significance. Suggestions included Christine Jorgensen, Chaz Bono, Carmen Carrera, Janet Mock, Peanuts' character Peppermint Patty, and a seahorse. Each figure was then collaged together into one yearbook-style class photo. The broadside's intended purpose was to plant a seed in the public's

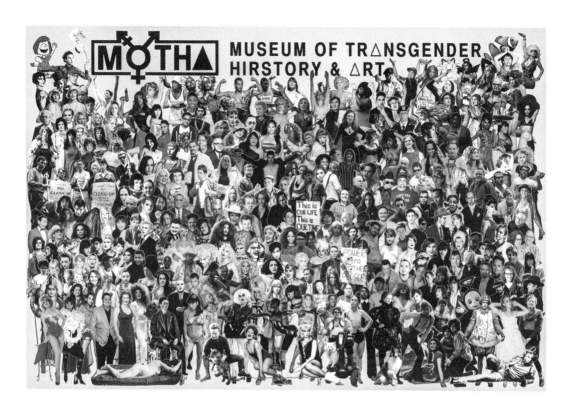

"Transgender Hiroes" promotional broadside,
MOTHA, 2013. Newsprint, 33 × 27 in
(83.8 × 68.6 cm). Courtesy Chris E. Vargas

imagination as to what the scope and function of a trans art and history museum should be. The reaction from the community was overwhelming, providing an impetus to move forward with the institution's development.

On June 21, 2013, a few days before the forty-fourth anniversary of the Stonewall rebellion, I, Chris E. Vargas, the museum's self-appointed Executive Director, hosted a ribbon-cutting ceremony and inaugural celebration for MOTHA in the Grand Lobby of San Francisco's Yerba Buena Center for the Arts. The celebration featured performances by drag queen Honey Mahogany of *RuPaul's Drag Race* season 5, along with San Francisco nightclub legend Gina La Divina and performance-art duo LOVEWARZ (Xara Thustra and Siobhan Aluvalot).

The ribbon-cutting was symbolic because, at that point (and to date), we have yet to finalize the museum's building design or even to secure a site on which to begin construction. This may seem like a case of putting the cart before the horse, but I assure you it is not. We here at MOTHA (and as with "they," this "we" may or may not refer to more than one person) are committed to making our presence felt as soon and as widely as possible, if only to inspire every trans and gender nonconforming artist and *hir*storian to continue making art and doing research, because one day soon there *will* be a facility dedicated to exhibiting their work.

Later in 2013, the first—and (so far) only—MOTHA Art Awards were held. Modeled after high-profile, industry- and identity-specific prizes such as the Lambda Literary Awards and the GLAAD Awards, which celebrate a select few achievements of the LGBT creative community and their mainstream media representations, the MOTHA Art Awards celebrated transgender contributions to our current cultural landscape, while simultaneously highlighting the limitations inherent in such systems of competition, exclusion, tokenism, and positive-image pandering.

The award nomination period from September to October and the month-long voting period in November took place online and were open to all who desired to participate. Voters were asked to make choices based on their own thoughtful and thorough research of all four hundred nominees in each of the sixteen award categories and to not be motivated by nepotism or coercion. There were nearly 2,700 total votes cast; multiple winners were selected in each category.

Some conventional categories included Artists, Performers, Films, Exhibitions, Musicians, Critical Writers, and Literary Writers of the Year. In recognition of the creative forms and lived experiences specific to our community, other categories included Transition Vlogs of the Year and two versions of Unrecognized Artists of the Year: "Hermit" and "Too Busy Surviving." One of the winners in the latter category was Chelsea Manning, who at the time was busy surviving a

Graphs showing the representation of transgender
artists in museums before and after the founding
of MOTHA, 2013. Courtesy Chris E. Vargas

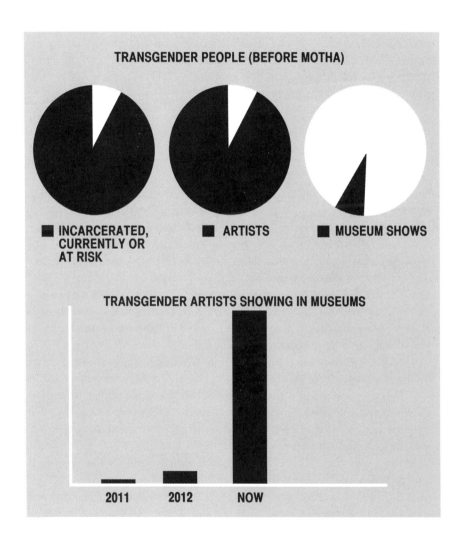

thirty-five-year sentence in Fort Leavenworth military prison—a sentence that was commuted four years later, in 2017, by outgoing President Obama. Each winner received nothing more than the title, and everyone else was encouraged to be "just happy to be nominated." A number of people were critical of the exclusionism inherent to the awards, even though this was a quality the project was designed to critique. The ensuing conversation online was at times thought-provoking but often devolved into the simple demands and character assassinations of call-out culture. This led to the museum's abandonment of its plan to host a second annual awards ceremony.

Since our momentous ribbon-cutting ceremony, MOTHA has existed in multiple iterations throughout the United States, in locations including Los Angeles, Chicago, New York, and even the small gay beach community of Cherry Grove, Fire Island. A special satellite project of MOTHA is slated for development at Cherry Grove, but more on that later.

MOTHA FACILITY

In planning MOTHA's building design, we naturally began with the bathrooms. For trans people, these hyper-gendered areas have long been a site of concern. Bathrooms represent both the least and the most of our problems, and the last ten years have been filled with activism and antagonism surrounding the issue. Initially, we considered designing the entire museum as one big gender-neutral bathroom, but we decided that might crowd out the art. Nevertheless, MOTHA will, of course, have gender-neutral bathrooms. Cisgender people will be obligated to use them, thereby neutralizing their own genders so they can't hurt us anymore. Informational placards will be posted outside these facilities to educate those who are unfamiliar with the bathroom issue.

MOTHA will also have special gendered bathrooms. Many of them, in fact. Only transgender people will be allowed to use these bathrooms during their visit. The bathrooms will be organized on a gender spectrum; trans museum visitors will be able to choose accordingly, based on how they understand their self-defined gender—that is, if they understand their gender on the spectrum at all. If not, we'll have a bathroom for that, too.

The museum café will be called Compton's Café in honor of the 1966 uprising in the cafeteria of the same name in San Francisco's Tenderloin neighborhood. This pre-Stonewall uprising was a reaction to persistent police surveillance and harassment of transgender people in public and commercial spaces. That fateful

night began when one trans woman, frustrated by yet another incident of harassment, threw her coffee in the face of a San Francisco police officer. This important moment of defiance and uprising is the focus of Susan Stryker and Victor Silverman's 2005 documentary *Screaming Queens*.

MOTHA's own Compton's Café will be a trans-friendly space in every respect. We will offer top-notch, affordable food. The majority of the menu will be made up of raw and vegan foods; selections that contain "phytohormonal" ingredients—naturally occurring hormones—will be highlighted in order to support and complement people's pharmacological and/or herbal transitions. In consideration of the number of trans people who are marginally employed, housed, and socially accepted, the menu will always have a "community item" for which customers may, unashamedly, "pay what you can." Additionally, customers may linger for as long as they want without fear of police harassment. Should a stray police officer wander into the building, the coffee will be served *hot*.

Beyond bathrooms and the café, we have left things up in the air in order to provide the community with an opportunity to have a say in the museum's design. In the coming years, we will be rolling out a call for architectural design ideas for MOTHA's building. The competition will adhere to the guidelines laid out by the American Institute of Architects (AIA) in their 1988 *Handbook of Architectural Design Competitions*. Designers will draft their plans for the museum and present them to the public, who will then have an opportunity to vote on the submissions.

MOTHA is committed to making its facilities available to the community. The museum will rent space for low or no cost for landmark events like birthdays, "tranniversaries," and surgery-fundraising parties in order to support the community.

MOTHA ON FIRE ISLAND

For four weeks in July and August 2013, I had the opportunity to represent MOTHA at Cherry Grove, Fire Island, the historic gay beach community on the barrier island off the southern shore of Long Island, New York. Cherry Grove has a deep historical connection to the homosexual Broadway theater scene of the early twentieth century. It is the older, less well-heeled, and more eccentric of two neighboring gay beach communities. The other, Fire Island Pines, known as "the Pines," is a modernist, "A-List" gay mecca. Both communities have abundant gay histories boasting many famous artist visitors, including painters, photographers, novelists, poets, playwrights, actors, musicians, performers, fashion designers, and architects.

While in Cherry Grove, I had the opportunity to talk to "house mothers" (who organize the vacation house shares), their friends, and renters, as well as the lesser day-trippers. I read literature and history and watched films about the community. I learned about an inspiring incident of rebellion that is commemorated every summer: In July 1976, Terry Warren, a popular local icon who'd been elected Cherry Grove Homecoming Queen, traveled in full drag from Cherry Grove to the Pines. There, she was refused service at the popular Botel disco by owner John Whyte. Soon after, Warren and a group of friends, also in full drag, returned to the Pines by water taxi. The queens made a clear statement to the well-manscaped inhabitants of the Pines that they would not stand for their snobbery and gender fascism.

The "Invasion of the Pines," as this event has come to be known, is memorialized each year during Fourth of July weekend. By the 1980s, the Invasion had grown so large that a double-decker ferry was required to transport the invaders. Today, the anniversary of the Invasion is a celebratory event, bridging the many class and generational divides that still exist between the inhabitants of Cherry Grove and the Pines. The Invasion also serves as a reminder of the countless queer, trans, and gender nonconforming people who aren't privileged enough to make the trip out to such a beautiful setting in order to encounter discrimination from cisgender gay men.

The region's gay history and connection to gender rebellion make Cherry Grove an ideal site for a satellite iteration of MOTHA, in the form of the museum's first theme restaurant, MOTHA Café. Unlike Compton's Café, this restaurant enterprise will serve beach fare: fried foods on sticks, piña coladas, and other blended drinks. Diners will be surrounded by *hir*storical artifacts and celebratory transgender memorabilia displayed and protected behind Plexiglas. Items on display will include the high heels Terry Warren wore during the first Invasion of the Pines and playbills from the stage productions performed at the historic Cherry Grove Community House and Theater. Transgender performers will dine for free at the restaurant and will be served higher quality food than other patrons.

MOTHA Café is the first of many MOTHA theme restaurants, hotels, and casinos that will be built across the country and, eventually, around the world. Each one will pay homage to the trans culture and *hir*story particular to its location. I look forward to embarking on this new chapter in MOTHA's development. Your table is waiting.

MOTHA is at work on a range of programs, including surveys of cutting-edge art by contemporary trans artists, *hir*storical exhibitions mining archives, and retrospectives of high-profile, internationally exhibiting artists.

MOTHA is currently preparing San Francisco–based ceramics artist Nicki Green's first solo museum exhibition, "It's Never Not a Mirror." The exhibition features Green's new work, which utilizes classical forms of ceramic art as a means of subverting normative ideas of history and inquiring into transgender archives and the messiness of gender identity. The show's title is inspired by Bay Area performer and playwright DavEnd's theatrical work, *Fabulous Artistic Guys Get Overtly Traumatized Sometimes: The Musical* (2012), and speaks to the reflective nature of making artwork, in that whatever is made is always a reflection of the maker, whether that was the initial intention or not. The title "It's Never Not a Mirror" might also refer to the way trans people are expected by the outside

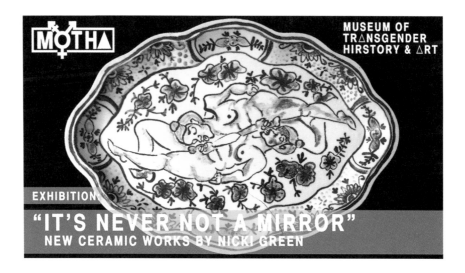

"It's Never Not a Mirror: New Ceramic Work by Nicki Green," digital exhibition poster, MOTHA, 2013. Courtesy Chris E. Vargas

world to always explain themselves and to regale us with their narratives of gender transition.

MOTHA is also developing film and video programming designed to recuperate Hollywood films featuring transgender and cross-gender performances, with series such as "I'd Fuck Me: Murderous Transsexuals in the Horror Genre" and "Necessary Disguise: The Temporary Transvestite Film." In counterpoint to these troubling mainstream Hollywood images, MOTHA has plans to present contemporary installation and moving-image work by artist, filmmaker, and 2012 Whitney Biennial alum Wu Tsang in an exhibition titled "The Fist Is Still Up: New Works by Wu Tsang." MOTHA's counterprogramming also includes work by Malic Amalya, a self-identified "queercore" artist who deploys 16 mm film, video installation, and photography. Amalya's work explores continual processes of deterioration and reformulation. He was awarded the 2013 MOTHA "Unrecognized Artists of the Year, Hermit" award. Clearly, he is no longer eligible in that category.

The museum is also devising new ways to make transgender *hir*story visible through exhibits mining the personal and public archive. For example, *hir*storian and filmmaker Reina Gossett is on board to curate "Pay It No Mind," an exhibition on the late transgender performer and activist Marsha P. "Pay It No Mind" Johnson. The cofounder of Street Transvestite Action Revolutionaries (STAR), Johnson helped to open STAR House, a place for queer and trans street youth who had no place else to go. STAR House operated for three years in the 1970s, housing, clothing, and feeding hundreds of trans people in need. Johnson was also present at the Stonewall riots in 1969, the mythological inception of gay liberation. Like many trans people, especially trans people of color, she met with a tragic, untimely death. Johnson's body was found at the Chelsea Piers in New York City's West Village, a historically important site for queer public sociality. The NYPD refused to investigate her death or to rule it a homicide for decades.

TRANS HIRSTORY IN 99 OBJECTS

MOTHA's staff is very busy. We are currently focused on a project inspired by BBC Radio 4 and the British Museum's joint radio series and book, *A History of the World in 100 Objects* (2010), and the Smithsonian's act of patriotic one-upmanship, MOTHA's *History of America in 101 Objects* (2013). Our own project is called *MOTHA's Trans Hirstory in 99 Objects* (... and a cis ain't one). It is a creative and critical exploration of LGBTQ archives. The title's numerical modesty

CHRIS E. VARGAS

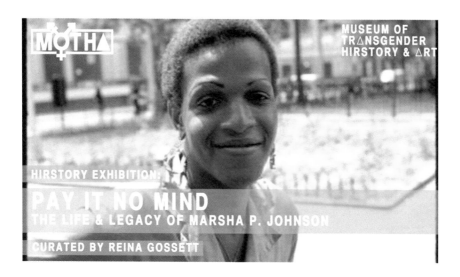

MUSEUM OF
TRΛNSGENDER
HIRSTORY & ΔRT

HIRSTORY EXHIBITION:

PAY IT NO MIND
THE LIFE & LEGACY OF MARSHA P. JOHNSON

CURATED BY REINA GOSSETT

"'Pay It No Mind: The Life & Legacy of Marsha
P. Johnson,' curated by Reina Gossett," digital
exhibition poster, MOTHA, 2013. Courtesy Chris
E. Vargas. Photo of Johnson: Diana Davies
photographs, Manuscripts and Archives Division,
The New York Public Library

suggests our recognition of the challenges, even the impossibility, of creating a cohesive *hir*story of our disgracefully under-historicized community. The project will include a book, gallery shows, a touring multimedia exhibition, and merchandising designed to cash in on today's flash-in-the-pan fascination with all things trans.

As Executive Director, I will travel with MOTHA's esteemed team of *hir*storians to LGBTQ archives throughout the US and Canada, as well as to public and private collections that have important transgender holdings, including the Transgender Archives at the University of Victoria in British Columbia, the imminent Living Transgender Archive in Los Angeles, the GLBT Historical Society in San Francisco, and the ONE National Gay and Lesbian Archives at the USC Libraries in Los Angeles.

Proposed objects include the shot glass thrown by Marsha P. Johnson in the early hours of June 28, 1969, at the Stonewall Inn in New York City; the first transgender pride flag, designed by Monica Helms; Dustin Hoffman's iconic red dress from the film *Tootsie* (1982); and the scissors that CeCe McDonald used to defend herself against street harassment in Minneapolis in 2011, which led to an international campaign for her release after she was convicted of manslaughter and incarcerated in a men's prison. Each object helps to create a narrative of trans history, inviting critical attention to the ways our history is continually being written and rewritten.

The book, gallery shows, and touring presentations will also give equal time to objects that are missing from the archives. After assessing the absences in each collection, I will commission transgender artists to create the missing archival

Mock-up of the forthcoming publication
MOTHA's Trans Hirstory in 99 Objects, 2015.
Courtesy Chris E. Vargas

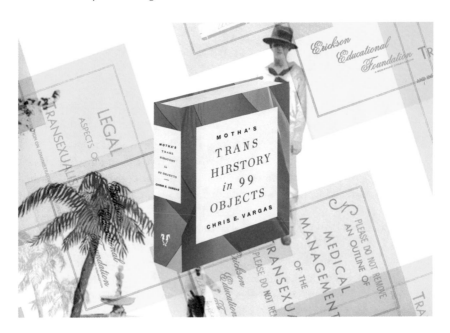

material. The project will be explicit about the fabricated nature of these objects, and the accompanying text will explore the cultural and political reasons for each omission. Full creative license will be given to the commissioned artists in rendering these missing *hir*storical artifacts.

An early iteration of this exhibition series, titled "Transgender Hirstory in 99 Objects: Legends & Mythologies," has already taken place. The show opened in the spring of 2015 in Los Angeles at ONE Archives and included work by eight contemporary artists—Craig Calderwood, Nicki Green, Onya Hogan-Finlay, Sam Lopes, Emmett Ramstad, Tuesday Smillie, and Wu Tsang and RJ Messineo— shown alongside artifacts and historical documents from the Archives' collections. The archival material in the exhibition pointed to a sampling of individuals who had an impact on the formation of transgender communities as we understand them today, including Angela Douglas, a legendary figure who connects early trans activism with a more evolved extraterrestrial life; Monica Helms, designer of the pride flag; Reed Erickson, ONE Archives' early, eccentric benefactor; and Sir Lady Java, a nightclub icon and outspoken opponent of Los Angeles' Rule No. 9, the anti-cross-dressing regulation that compromised many performers' livelihoods during the 1960s.[1]

IN COLLUSION

Much has changed during the short period of MOTHA's existence. In 2014, *Time* put Laverne Cox on its cover and heralded the "Transgender Tipping Point,"[2] which soon morphed into a Caitlyn-tinted Trans-Jenner Tipping Point. If anything is to be gleaned from this current trans-fascinated media moment, it is that we as a community are in need of much more than increased representation. As our communities continue to evolve and grow, as media spectacles run their course, and as language inevitably morphs into and out of existence, MOTHA will continue to investigate not only the power but also the traps of media exposure.

Several key questions remain: Is it the responsibility of an art and history institution, one that is dedicated to a historically marginalized community, to join the mainstream celebration of liberal inclusion? Or should that institution stay faithful to its history, rooted in disruption and transgression? If the latter, is it even possible for such an institution, by the very nature of its being an institution, to be antiestablishment? Can a canon-producing institution be all-inclusive? These questions and more are the fuel that keeps MOTHA's fire ablaze.

MOTHA is three years old at the time of this writing, and it shows no sign of slowing its meteoric rise to become the premier trans cultural institution. But we can't do it without you.

Dear reader, I now give you the opportunity to be among the early contributors to the Museum of Transgender Hirstory and Art, the first institution of its kind. Gifts of $10,000 and above will buy you a plaque on our donor wall, but any amount less than $10,000 can still help save a transgender life or—at the very least—a transgender art career.

"Introducing the Museum of Transgender Hirstory and Art" by artist Chris E. Vargas was written in 2016 for this volume.

NOTES

1. For more information on the exhibition, see "Transgender Hirstory in 99 Objects: Legends & Mythologies," ONE National Gay and Lesbian Archives at the USC Libraries, accessed August 15, 2016, http://one.usc.edu/motha/. For more on Sir Lady Java, see Treva Ellison, "The Labor of Werqing It: The Performance and Protest Strategies of Sir Lady Java," on page 1 of this volume.

2. Katy Steinmetz, "The Transgender Tipping Point: America's next civil rights frontier," *Time*, May 29, 2014, http://time.com/135480/transgender-tipping-point/.

ONE FROM THE VAULTS:
GOSSIP, ACCESS, AND TRANS HISTORY–TELLING

Morgan M. Page

I want to take you on a bit of a walk, through time and attitudes.
—Aiyyana Maracle, late Haudenosaunee trans artist and elder, speaking at
Writing Trans Genres, 2014

For 150 years, trans people have been hyper-visible within North American and European cultures—our lives driving cycles of sensational media coverage and repressive laws, from the anti-cross-dressing laws passed by thirty-four cities in twenty-one US states between 1848 and 1900[1] to North Carolina's controversial HB2 in 2016.[2] And yet, despite all this visibility, trans people remain largely historically isolated, adrift on the sea of history, with little access to knowledge of where we came from and who got us here. The media that make us visible simultaneously obscure our presence in history by continually framing trans people as new, as a modern, medicalized phenomenon only now coming to light in the topsy-turvy post–gay marriage world.

For me, finding trans history—a process that involved years of digging through the Internet Archive[3] to uncover half-deleted websites for now-forgotten events like Counting Past 2, the world's first transsexual and intersex multi-disciplinary arts festival—opened up a whole world of possibilities for dreaming myself into a future that was worth living. This opening up of possibilities through historical consciousness has shaped my work as both an artist and a social worker, particularly my work engaging trans youth.

For nearly five years, I facilitated Trans Youth Toronto, a community group in downtown Toronto for trans, genderqueer, and questioning people between the ages of thirteen and twenty-six. Many of the youth who came to the group, particularly in the pre–Laverne Cox world, were grappling with a problem I had experienced for years myself: a problem of images. Drowning in a sea of

Jerry Springer–style media representations, many of us felt unable to picture full lives for ourselves, lives in which we could aim our aspirations high. If you never see anyone like you achieve anything like your dreams, it's easy to begin to think your dreams aren't possible. I found that the only antidote to this problem was sharing the stories of our trans ancestors—individuals such as politician Georgina Beyer, filmmaker Christopher Lee, and Warhol superstar Candy Darling. These stories opened up whole worlds for many of the young people I worked with.

Seeing how powerful sharing this knowledge could be for trans people led me to create *One from the Vaults* (*OFTV*), a trans history podcast that focuses on making trans history accessible through short, well-researched, and humorous storytelling.[4] What follows is an exploration of the loose theoretical framework I use in thinking and talking about trans history in *OFTV*, as well as some thoughts about the ways in which visibility has affected trans peoples throughout the past 150 years in North America and in Europe.[5]

BREAKING OPEN THE ARCHIVE

Academic researchers and archivists have done some incredible work preserving trans history, including through the creation of recent trans-specific archives such as the Transgender Archives at the University of Victoria, in British Columbia, Canada. But the very nature of their work can, at times, create barriers to access for some of the trans people who are out on the streets creating that history. To better understand what I mean by "barriers," it's useful to think through the process of trying to access an institutional archive.

Entering an archive is intimidating. Let's take the ONE National Gay and Lesbian Archives at the USC Libraries in Los Angeles, for example. ONE Archives houses many important trans history documents, particularly those related to eccentric FTM multimillionaire Reed Erickson and his Erickson Educational Foundation, covered in episode five of *OFTV*.[6] According to ONE Archives' FAQ, when you arrive at ONE, you "must present a valid state identification card or passport to the desk attendant on duty. The attendant will have you create a research account in order to access materials or order reproductions from ONE Archives."[7] Additionally, the Archives' staff encourages visitors to contact them in advance of a visit, as much of their audiovisual material is "stored off-site or require[s] off-site equipment to view."[8]

Simply requiring identification documents cuts off many trans people, who may not feel comfortable sharing documents with a seemingly incongruent name

or gender, from entering the Archives. Add to this the additional steps of contacting the Archives in advance, arranging exact viewing times, paying admission fees, creating an account, and dealing with staff at an academic institution, and this material becomes even further out of reach for many low-income trans people whose lives may be too chaotic to accommodate this level of preplanning.

Once one manages to make it through the doors of an institutionalized archival space, the problems may not be over. Trans filmmaker and activist Reina Gossett, who has put years of work into making available online the history of Sylvia Rivera and Marsha P. Johnson—two trans women of color activists and Stonewall veterans now seen as the godmothers of today's trans political movement in North America—writes, "I unearthed this material thru hustling my way into spaces that are historically unaccessible [*sic*] to black trans women. Most recently when I went to the New York Public Library to try and find STAR's statement I was accosted coming out [of] the bathroom and scrutinized by security. This isn't something new, just part of living for me. But that's also part of the story of how the statement landed on the internet."[9] Racist transphobic harassment within the archive adds another layer of inaccessibility to trans history. Outside of the archives, trans history is often only recorded in dense, academic literature. As with most academic work, these articles are frequently available only through paywall journals or expensive textbooks. Again, while this work is important, academic structures make it difficult, if not impossible, for many trans people to access.

By releasing trans history through posts on Tumblr, Twitter, and Instagram, trans activists like Reina Gossett, Trace Lysette, and me are breaking out of the archive and bringing trans history directly to trans people. *One from the Vaults* is the latest in a series of efforts to subvert the archive and to engage people in trans history. It's free, accessible on multiple platforms online, and, because of its audio format, doesn't require strong literacy skills (though this strength is also a drawback in terms of accessibility for Deaf and hard-of-hearing people). Outside of the archive, trans history can come alive for trans people today.

HISTORY AS HOT GOSSIP

One of the big problems with writing and talking about history is that history has a reputation for being boring. When I was in school, history class entailed memorizing a dry list of dates and events that advanced a narrative of white settler "progress"—what I now know as colonization—and didn't have room for women, people of color, or sexual and gender variance. This failure of the

education system cuts us off from the fact that history is actually richly enter-taining—or, as I like to say, the best kind of gossip.

My guiding principle in thinking, writing, and talking about history is that it's full of gossip and, as a notorious gossiper, I'm all ears for it. Knowing that Roberta Cowell was the first trans woman in the United Kingdom to undergo a vagino-plasty isn't all that interesting—but when you learn that she gained access to that surgery by leading on and eventually breaking the heart of trans man Michael Dillon (subsequently ruining his entire life), it really comes alive![10]

More than just a gimmick to keep people's attention, choosing gossip as an entry point centers history on the interpersonal, a feminized topic often treated as trivial or irrelevant. Examining the interpersonal relationships and foibles of historical trans people not only makes the subjects more relatable, it also sheds light on why people made the choices they did. For instance, in order to under-stand why Dillon fled England and became a monk in India, a decision that ulti-mately led to his untimely death, we have to explore his relationship to Cowell. After using him to gain access to hormones and surgeries and then rejecting his marriage proposal in the early 1950s, she appears to have sold their stories to the press, destroying both his anonymity and his carefully constructed stealth life as a ship's doctor in one fell swoop.[11] *OFTV* aims to be the "Page Six" of trans history, the scandal rag of the trans archive, and, in this manner, to make trans history fresh and relevant to contemporary trans people, many of whom don't have the time, access, or interest to pore over archival documents.

Cover of *Picture Post* featuring Roberta Cowell,
March 13, 1954. Courtesy Getty Images. Photo:
Maurice Ambler

PICTURE
POST

4ᴰ
13 MARCH 1954

ROBERTA COWELL'S OWN STORY
—Exclusive

HULTON'S
NATIONAL
WEEKLY
VOL 62 · NO 11

In order to tell history, it is necessary to determine a starting point. Much of the scholarship and popular coverage of trans history has chosen to begin with the moment Christine Jorgensen stepped a well-turned heel onto the tarmac at what is now John F. Kennedy International Airport in New York City and ignited a worldwide sensation. "Ex-GI Becomes Blonde Beauty," reads the December 1, 1952, *New York Daily News* headline, marking the beginning of a flurry of media coverage around the world and launching Jorgensen, whether or not she wanted it, as the first international trans celebrity.[12]

The treatment of Jorgensen's story was undeniably the most historically significant media coverage of a trans person in the twentieth century—if not in human history—but locating her at the beginning of trans history has several, perhaps unintentional, effects. This reading of history promotes the idea that trans people are an invention of the postwar era, a thoroughly modern and Western creation of medical science. It reifies the idea that trans people exist only as products of pharmacological-surgical processes, rather than as people who may or may not choose to access such processes. And it places a white, American "blonde bombshell," who was living on stolen indigenous land, in the role of progenitor of the wildly diverse trans cultures that have existed throughout time.

This representational choice further obscures the underground histories of how most trans people actually lived then and continue to live now. It ignores or glosses over the importance of criminalized economies, such as sex work and drug dealing, that made and continue to make trans life possible for many of us. And it tells us that this history "belongs" solely to middle-class white people like Jorgensen.

"Ex-GI Becomes Blonde Beauty," *New York Daily News*, December 1, 1952, page 3. Courtesy Getty Images. Photo: © *New York Daily News*

Ex-GI Becomes Blonde Beauty

Bronx Youth Is a Happy Woman After Medication, 6 Operations

By BEN WHITE
(Copyright 1952 by News Syndicate Co Inc)

A Bronx youth, who served two years in the Army during the war and was honorably discharged, has been transformed by the wizardry of medical

George-Christine as a girl.

George-Christine as a boy.

science into a happy, beautiful young woman, The News learned yesterday.

Subject of the rare sex-conversion is the former George W. Jorgensen Jr., son of a Bronx carpenter, whose name and all past Army records have been officially changed to Christine Jorgensen. The new woman has made a successful career for herself as a cotor photographer in Denmark and hopes some day to go to Hollywood, either as a photographer or an actress.

It was through a rare and complicated treatment that George became Christine. The conversion—rare when a woman becomes a man, much rarer when a man changes into woman—involved five major operations, a minor operation and almost 2,000 injections which worked both physiological and glandular revolutions in George-Christine's body.

The story of George-Christine was told yesterday by the father, George, a Board of Education carpenter, and his wife, Florence, at their home 2847 Dudley Ave., Bronx.

Not till last June, after the protracted treatment had been successfully completed, did the Jorgensens know that their son had even contemplated the radical sex change.

Then, in a long letter which enclosed photographs of the new Christine, now a 26-year-old blonde, they learned what had been happening at the Riche, Hospital, Copenhagen, under the world-famed Prof. Hamburger.

"Several small unimportant-looking glands and yet our whole body is governed by them," the letter said.

And, again: "It is more a problem of social taboos and the de-

George-Christine models jacket and skirt she made for herself after her transformation into normal, pretty girl. At right is her notation on back of picture, modestly admitting her pride in her handiwork.

Letter Informing Parents
(Copyright 1952 by News Syndicate Co. Inc.)

Here is the text of the sensitive and affectionate letter in which George Jorgensen Jr. told his parents that his sex had been changed and that he was now their daughter Christine. Dated June 8, 1952.

It read:

My Dearest Mom, Dad:

I am now faced with the problem of writing a letter, one which for two years has been in my mind. The task is a great one and the two years of thought haven't made the task any easier.

To begin with, I want you to know that I am healthier and happier than ever. I want you to keep this in mind during the rest of this letter.

Seeking the Way When Something Goes Wrong

I suppose I should begin with a little philosophy about life and we, the complex people who live that life. Life is a strange affair and seems to be stranger as we experience more of it. It is often that we think of the individuality of each person, and yet we are all basically the same.

Nevertheless, we are different, looks, temperament and then nature often for some unknown reason steps in and adds her peculiarties. Complex about various things and physical deformities.

Those things are all a part of life—but we do not accept them and strive through science to answer the great question of "Why"— "Why did it happen," where did something go wrong and, last but not least, what can we do to prevent it and cure it if it has already happened.

At times it is obvious something has gone wrong but in many other cases it is not obvious and only shows up in small ways. This leads to investigation and, if necessary, medical aid.

Imbalance in Glandular System Cleared Up

We humans are perhaps the greatest chemical reaction in the world and therefore it is not strange that we are subject to so very many physical ailments. Among the greatest working parts of our bodies are the glands. Several small unimportant looking glands, yet our whole body is governed by them.

An imbalance in the glandular system puts the body under a strain in an effort to adjust that imbalance. This strain, although

(Continued on page 22, col. 1)

sign not to speak of the subject because it deals with the great hush hush, namely sex."

Feared Harm to Mind.

Then there was a line: "You see, I was afraid for a much more horrible illness of the mind." Farther on, still without quite breaking the news, the letter said, "Right from the beginning, I realized that I was working toward the release of myself from a life I knew would always be foreign to me."

And then the shock:

"Just how does a child tell its parents such a story as this . . . I am still the same old Brud (nickname), but, my dears, nature made a mistake which I have had corrected and now I am your daughter."

Father Informs Friends.

And, finally, the strange, wistful ending:

"I do so want you to like me very much and not to be hurt because I did not tell you sooner about why I came over here.

"Love,
"Chris
"Brud"

Thunderstruck, the Jorgensens held family council with their only other child, a daughter, who is

(Continued on page 22, col. 4)

21 Shopping days to Christmas

NEWS ON THE AIR

TELEVISION—WPIX—Channel 11

3.45 p. m.—News
6:30 p. m.—Telepix
7:00 p. m.—News at Seven
10:30 p. m.—Telepix
10:45 p. m.—Tomorrow's News
11:30 a. m.—Sandman News

RADIO—WPIX—Dial 1130
"Race Around the Clock"—at half past every hour.

In creating the content for *OFTV*, I have made a conscious attempt to reject this coalescing of ideas about what it means to be trans and where in history we belong. It felt important to foreground different voices and different ideas about what it has meant to be trans throughout history. Ultimately, I chose two approaches for constructing an alternative trans history: first, I chose to focus the initial episodes of *OFTV* on sex-working trans people of color; second, I included in each episode an acknowledgment of the Algonkian and Haudenosaunee peoples upon whose traditional territories the episodes are recorded. My take is that no history can be written without an acknowledgment of the lands upon which it occurred—and in North America, that land's story is one of genocide, colonization, and continuing occupation. The act of naming the traditional caretakers of the territories upon which the show is created is one small attempt to keep this history visible.

By beginning my trans history with, for example, indigenous trans sex workers fighting gentrification on the streets of 1970s Vancouver,[13] my aim was to create an understanding of trans history that has room for more than just the white, middle-class aspirations and successes with which trans studies has found itself most concerned. This new framing of history contextualizes our current lives through both the past and contemporary struggles of the most marginalized members of our communities.

CYCLES OF VISIBILITY, CYCLES OF VIOLENCE

It has become clear to me through my work researching and sharing trans histories in *OFTV* that our current cultural moment—the so-called transgender tipping point[14]—is not the panacea we're told it is. Drowning in a sea of media and legislative visibility, we've been sold the lie that visibility and "awareness" will save us.

It's an incredibly seductive lie, one that preys upon our culture's obsession with celebrity and its false narrative of linear progress toward equality. But this lie begins to unravel with only the slightest tug. The loose thread is the notion that the current media moment is somehow new. But the truth is that we've been here before. In fact, there are eerie parallels with previous periods of trans visibility: Who is Caitlyn Jenner, if not this generation's Renée Richards? Much like Jenner, Richards was a professional athlete who rose to prominence after her transition in 1975. A tennis player, she was initially banned from competing in the 1976 US Open but fought her case in court and won the

right to play tennis as a woman, making her the media's go-to trans advocate for several years, just as Jenner has become today.[15] Like I said, we've been here before.

As happened during previous periods of increased media visibility for trans people, we are currently experiencing a crackdown on the everyday lives of trans people by both the government and the general population. When newspapers fanned the flames of scandal over the "public indecency" of cross-dressing and sex-working people in 1860s San Francisco, the city council responded with the 1863 "good morals and decency" laws, which made cross-dressing a criminal offense.[16] Similarly, the glut of supposedly positive media exposure throughout 2014 and '15 seems to have led directly to the wave of proposed and enacted anti-trans laws—such as North Carolina's HB2—that criminalize trans people's movements through public space.[17] At the same time, in the United States, trans women of color, particularly sex workers, are facing increased violence and a rising murder rate that activists are linking to this cycle of heightened media visibility.[18] As trans activist Masen Davis said in an interview in *Time*, "Right now we're experiencing a Dickensian time, where it's the best of times and it's the worst of times at once,"[19] when a "marked increase in public awareness" is coupled with a murder rate that nearly doubled in 2015.[20] "[H]ypervisibility puts marginalized groups at risk," writes Harmony Rodriguez in the *Guardian*. "[H]ypervisibility is what turns trans women's lives into spectacle."[21]

Further research may be needed to confirm the link between periods of media visibility for trans people and increased levels of physical and legislative violence against them, but from what I have observed through my historical research, the two seem to follow hand in hand. In mid-1970s Vancouver, for example, police raids on bars frequented by sex workers led to a dramatic increase in street-based sex workers, including trans sex workers. Fueled by negative media coverage, residents of Vancouver's Davie Village—a neighborhood in the city's West End popularly referred to as a "gaybourhood"—organized to expel trans sex workers from the West End through protests and a successful battle to pass legislation banning street sex workers from the area.[22] These trans sex workers reported that the attempts to further criminalize them and corral them away from Davie Village directly resulted in a number of stabbings and missing persons cases involving their fellow workers.[23] Rather than a linear narrative of progress, what we really seem to be dealing with are cycles of visibility over the past one and a half centuries that have had and continue to have direct, often negative, impacts upon the lived realities of trans peoples. Visibility, this supposed cure-all, might actually be poison.

PARTING SHOTS

At least part of the poisonous nature of this problem may be due to the fact that, for the most part, these cycles of media visibility have been outside of the control of trans people. Whether in "gender novels," in which cisgender writers claim a stake in telling our narratives without us,[24] films, in which the few non-murderous or non-comedic trans characters are inevitably played by cis actors (as was the case in Tom Hooper's 2015 film *The Danish Girl*), or the entire genre of invasive trans documentaries made by cis filmmakers, we have been rendered powerless by media representations of our own narratives. While trans people have been creating alternative media for decades, it is only with recent examples such as Sydney Freeland's web series *Her Story*—an Emmy-nominated series written and directed by and starring trans women—that we've begun to gain control over our own popular representations. It remains to be seen whether such examples can solve some of the problems media visibility has caused for everyday trans people.

As we move through continual cycles of visibility and violence that seem to have no end in sight, perhaps it is through control and access to our own narratives that we can begin to build a way out. Uncovering and sharing our histories is a powerful tool for helping us dream our way into futures we want to live. In *OFTV*, I've tried to make an alternative perspective on trans history entertaining, relevant, and accessible outside the walls of the academic institution— acting as one small cog in the machine of trans cultural production currently experiencing a renaissance.

..

"One from the Vaults: Gossip, Access, and Trans History–Telling" by artist, writer, and activist Morgan M. Page was written in 2016 for this volume.

..

NOTES

1. Clare Sears, *Arresting Dress: Cross-Dressing, Law, and Fascination in Nineteenth-Century San Francisco* (Durham, NC: Duke University Press, 2014), 3.

2. Garrett Epps, "North Carolina's Bathroom Bill Is a Constitutional Monstrosity," *Atlantic*, May 10, 2016, http://www.theatlantic.com/politics/archive/2016/05/hb2-is-a-constitutional -monstrosity/482106/.

3. The Internet Archive's Wayback Machine is a searchable database that preserves online digital content. Since its creation in 1996, it has archived partial and sometimes full-page captures from 498 billion websites. To search its contents, go to https://archive.org/web/.

4. Morgan M. Page, *One from the Vaults*, accessed July 11, 2016, https://soundcloud.com /onefromthevaultspodcast.

5. I decided to limit the scope of *OFTV* to the past 150 years in North America and in Europe in order to avoid the many pitfalls associated with reading current Western gender and sexual identities into other cultures and other eras. Forcing other cultures and eras into Western boxes is, in my opinion, a form of cultural imperialism. That said, I would also argue that the Western concepts of "man," "woman," and "straight" are just as culturally and temporally constructed as "trans," "gay," "lesbian," "queer," etc. Essentially, it's a real can of worms.

6. Morgan M. Page, "OFTV 5: The Trans Howard Hughes," *One from the Vaults*, podcast audio, 38:30, accessed July 11, 2016, https://soundcloud.com/onefromthevaultspodcast /oftv-5-the-trans-howard-hughes.

7. "FAQ," ONE National Gay and Lesbian Archives at the USC Libraries, accessed July 11, 2016, http://one.usc.edu/about/frequently-asked-questions/.

8. Ibid.

9. Reina Gossett, "On Untorelli's 'new' book," *Reina Gossett*, blog entry, March 13, 2013, http://www.reinagossett.com/on-untorellis-new-book/.

10. Morgan M. Page, "OFTV 4: Valentine's Day Special!," *One from the Vaults*, podcast audio, 44:44, accessed July 11, 2016, https://soundcloud.com/onefromthevaultspodcast/oftv-4 -valentines-day-special.

11. Ibid.

12. For additional information on Jorgensen and her story, see Susan Stryker, *Transgender History*, Seal Studies (Berkeley, CA: Seal Press, 2008), 47–49; and Joanne Meyerowitz, *How Sex Changed: A History of Transsexuality in the United States* (Cambridge, MA: Harvard University Press, 2002), 51–97.

13. Morgan M. Page, "OFTV 2: The Golden Age of Hustlers," *One from the Vaults*, podcast audio, 31:14, accessed July 12, 2916, https://soundcloud.com/onefromthevaultspodcast /oftv-2-the-golden-age-of-hustlers.

14. See Katy Steinmetz, "The Transgender Tipping Point: America's next civil rights frontier," *Time*, May 29, 2014, http://time.com/135480/transgender-tipping-point/. The cover of the magazine features a photograph of Laverne Cox accompanied by the title of Steinmetz's article.

15. Meyerowitz, *How Sex Changed*, 252.

16. Sears, *Arresting Dress*, 44.

17. Epps, "North Carolina's Bathroom Bill Is a Constitutional Monstrosity."

18. Katy Steinmetz, "Why Transgender People Are Being Murdered at a Historic Rate," *Time*, August 17, 2015, http://time.com/3999348/transgender-murders-2015/.

19. Ibid.

20. Zach Stafford, "Transgender Murders in US Have Nearly Doubled Since Last Year, Activists Say," *Guardian*, November 6, 2015, https://www.theguardian.com/society/2015/nov/06/transgender-murders-double-2015-united-states.

21. Harmony Rodriguez, "We Can't Let Increased Transgender Visibility Lead to More Vulnerability," *Guardian*, August 21, 2015, https://www.theguardian.com/commentisfree/2015/aug/21/transgender-visibility-vulnerability.

22. Becki Ross and Rachael Sullivan, "Tracing Lines of Horizontal Hostility: How Sex Workers and Gay Activists Battled for Space, Voice, and Belonging in Vancouver, 1975–1985," *Sexualities* 15, no. 5–6 (September 2012): 604–21.

23. Becki Ross, "Outdoor Brothel Culture: The Un/Making of a Transsexual Stroll in Vancouver's West End, 1975–1984," *Journal of Historical Sociology* 25, no. 1 (March 2012): 126–50. On page 139, Ross discusses the aftereffects of media sensation and legal intervention against transsexual sex workers in Davie Village: "To Raigen, the Chief Justice's searing indictment in 1984 destroyed the very fabric of her community: 'CROWE and the Judge said that it was okay to violate prostitutes. ... And what happened right after that? More missing women, people dying, people getting stabbed like crazy. ... Today, we need to have a float in the Pride Parade with a whole bunch of coffins on the trailer.'"

24. Casey Plett, "Rise of the Gender Novel," *Walrus*, March 18, 2015, http://thewalrus.ca/rise-of-the-gender-novel/.

EVERYWHERE ARCHIVES: TRANSGENDERING, TRANS ASIANS, AND THE INTERNET[1]

Mel Y. Chen

INVISIBLE SPECTACLE

———

Scene 1: The Oprah Winfrey Show. *Thomas Beatie and his wife Nancy sit down before Oprah Winfrey for a television interview. The show has advertised the meeting: pictures flash by of a male of apparent Asian descent, "34, happily married …" (beat, pause), picture of shirtless Beatie holding his apparently pregnant belly, "… and pregnant." His first television interview. Oprah: "When did you first decide to get pregnant?" Voice-over: "The cameras capture it all." Layered structures of authority (Oprah's presentational voice-over, Oprah's voice in archived excerpts being replayed, hyperproduction, music, and swooping, god's-eye mobile cameras).*[2]

Scene 2: The YouTube video proceeds much like any other. A window animates at left, while suggested "related" videos appear on a scroll bar at right; at upper right, a small box presents the author and a blurb about the video. Like many self-produced "talking" videos, this one could be described as pragmatic. Zach—a pre-transition FTM-identified transsexual, who is of Asian appearance and in his early twenties, and has immigrated to or at least now resides in the United States—peers into the camera, introduces himself, and proposes a revisory approach to tags, language, and the YouTube archive. "Actually I was searching on the YouTube for videos, videos of all the FTM friends and people and it's kinda really hard. A lot of FTM tags actually are weird things like 'fear the mullet' and I have no idea what. So I have an idea, why not everybody who's putting a video on FTM guys or anything, anything FTM-related, um, why don't we use the special tag 'FTMtrans'—that's 'F-T-M-T-R-A-N-S'—so all the people who are really interested in female-to-male people will be able to find out our information without having to sort through a bunch of rubbish and weird stuff? So if you think this is a good idea, pass it on, tell it to everybody you know."[3]

Thomas Beatie's relatively spectacular membership in what we could call the "Asian FTM archive" is noteworthy perhaps for a reason that initially seemed to have nothing to do with his racial assignation: his transmale pregnancy. Beatie is a female-to-male transsexual who became pregnant post-transition. He is of Filipino and Anglo heritage. On the internet, viewers are presented with archives of photographs and video clips that both detail his transition and document his pregnant moment of entry onto the national stage. For instance, online audiences see Beatie's former female self, Tracy Langondino, as she competes in a teen beauty contest. Now, in a studio shot, Beatie willingly (although it is unclear by whose suggestion) displays his bare, pregnant torso. For such candor, he has received both celebration and grief, and a wealth of fascinated attention. The *Oprah* mini-documentary records observers' facial expressions of disgust and confusion, and replays hate messages left on Beatie's voicemail.

The display of Beatie's pregnant torso comments ironically on pervasive representations of women's bodies as fragmented, as well as, simultaneously, on the iconic sexual imagery of bare-chested men: the "horrifying" presence of his absent breasts, breasts that should otherwise be covered in this public representation of his (fe)male nudity. Furthermore, his presence is deemed perverse: while his female properties that are profiled are life-giving, he is questioned by Oprah as if he should have signed away whatever reproductive rights he had upon entering the seemingly toxic and irredeemable field of transsexual existence. The young Langondino who struts across the stage in the past competition becomes a *present analogy*: not only does she comparatively present a nostalgic ideal of a normatively and firmly gendered past, but she also suggests the threatening future possibility of the drag queen-ization of all things *thought* to be innocent.

The spectacularity of Beatie's persona on the internet is at once gendered, sexualized, and racialized. Perhaps not coincidentally, the pregnant Beatie-Langondino blended imaginary replicates, indeed *triplicates*, that paradoxical racial position in which Asian femininity is both modest and oversexualized, while Asian masculinity remains a queer, sinister impossibility, harking back to the days of the Yellow Peril and Second World War anti-Japanese sentiment in the United States (if not also a feminized, "pale" relation to white masculinity).[4] Furthermore, Beatie's position as a male heterosexual husband to a white woman deepens his reversal of expected positions for Asian males—that they be feminized, queered, desexualized, or otherwise submissive. These are positions which survive as part of the racial complex of the United States and which continue to be rehearsed non-problematically by the media, to the extent they are represented at all. Beatie's presence on the mainstream gender map thus constitutes

MEL Y. CHEN

a commentary on the media's racial organization by which Asian bodies can be both invisible and yet spectacular—never, arguably, simply ordinary.

While Beatie's representations constitute a spectacle for the public of an FTM body in a paucity of representation of FTMs, and a spectacle of an Asian FTM body in a paucity of representation of Asian FTMs, transsexual people *do* appear with regularity in the form of murdered MTFs in crime-procedural television dramas like *CSI*. Indeed, the cultural assignation of morbidity to queers conditions the possibility of violent deaths especially for transgender women and poor gay men, a possibility that intensifies for people of color.[5] The horror some viewers have evinced at Beatie's reproductive possibilities and at his reproductive intentions suggests this racialized morbidity is quietly at work, precisely because reproduction would presume the entailment of a life.

Zach's first video on YouTube is described above. Subsequent videos provided periodic updates on his transitioning life, trailing to an end in January 2008. The videos are informal, filmed in the style of a "day-in-the-life-of" documentary, offering updates on all aspects of Zach's life. At moments he refers explicitly to his transition, for instance noting changes in his voice; at other times he does not. The videos thus serve as organic narratives rather than guides or directives. Zach's only tags (the searchable YouTube keywords chosen by him) include "FTM," "trans," "transgender," and "'FTMtrans.'" Unlike the *Oprah* clip, which has, at the time of writing, been uploaded to YouTube and replayed 10,955 times, Zach's video has been viewed just 919 times (including about five of my own). Yet, arguably, it is Zach's video that may well have launched an archive of its own. Following Zach's recommendation, all the videos tagged "FTMtrans" by other YouTube authors appear chronologically after this one. This fact alone suggests the utility of moving beyond thinking merely in terms of spectacle or visibility, and thinking more intensively about the *kinds* of presence that may be carved out in a given medium.

While Zach does not discuss his ethnicity or racialization in the video, one of his respondents in the comment field expresses appreciation for finding "another Asian FTM on YT," presumably referring to a judgment based on his appearance and/or his style of spoken English. Zach's Asianness is thus named only incidentally. His racialization, quite like that of Beatie, would seem to reside primarily in the eyes of the viewer, via phenotypic judgment, and secondarily perhaps in his elaborated location in the organic structuration of the YouTube archive.[6]

Zach's video is one of many transition videos found online. Transition videos can be considered archives in a couple of senses: they serve as collections, centrally accessible, around specific themes of cultural life; and they serve as specific sites of knowledge production. Many FTM-identified YouTube authors in fact

announce that these episodic videos serve as archives for themselves, as well as resources for other FTMs. Such videos are procedural resources in the sense that they can constitute how-tos: FTMs who wish to pass or plan to transition find out how to bind, how to pack, and how to inject themselves with testosterone. They also learn what to expect in a transition, though what is common to the YouTube FTM transition-related videos is the frequent articulation of the author's awareness of the diversity of FTM experience, the sense that every transsexual life is unique. As procedural resources, resources concerned with the art and craft of gendered living, YouTube FTM archives therefore diverge from a reading of the archive as a static repository.

TIME, IMMIGRATION, AND THE ARCHIVE

By and large, the "You" in "YouTube" signals the public-, personal-, and community-based appeal of the online platform: videos are self-uploaded and as-sumed amateur; they are not filtered by production values alone, and the well-produced ones seem to be suspiciously out of place. Indeed, videos appearing on YouTube produced or funded by corporations (for purposes of advertising, as an example) have attended to this sensibility by mimicking home video–making.

The practical nature of the FTM transition videos on YouTube suggests that users' "personal" archives follow somewhat different rules from "state" archives. While traditional state archives could certainly also be described as pragmatic in design and in archiving technique, and while in their digitizing modern-day forms they are becoming just as random-access and rhizomatic as YouTube itself, the pragmatics involved are essentially different. State archives are bound up inextricably with interests of citizenship and could be described as biopolitical. Unlike personal archives, state archives have been historically conjured and implemented for the purposes of social and resource management and control; among their more condemnable uses have been the management of colonial resources, of which human labor was often considered integral. Only in retro-spect, as state archives take on new life as "historical archives," have their uses been imaginable by archivists, historians, activists, and others as possible for a different kind of public good in the community's interest. The US Freedom of Information Act, a statute existing since 1966, defines the right to appropriate limited products of state interests—archives of the US government—for poten-tially non-state purposes, such as a critical history of the state, or the building of a public case against the state. Amendments have been installed under various

administrations to respond to changing security interests and archival forms, including "electronic information."

To the degree that both personal and state archives rely on flagging specified identities, their knowledge productions cannot help but overlap. If one were to consider the internet's role with regard to transnational FTM concerns in the swirling, overlapping, cross-linked, hierarchical, transnational, semi-regulated geographies of the internet, then what exactly would count as a state archive? What distinguishes a state archive from a personal one? Would it be fair to say that the *Oprah* mini-documentary about Beatie has little to do with a state archive, while Zach's video has even less?

The politics of location become truly entangled when considering not only the virtual, unbordered space of the internet but also the transnationality of users of the internet, its access inequities included, and the necessary contingencies of such things as gender and sexual identities and positions.[7] The critique of location implicit in the internet (not that it is always critiqued) is potentially useful for thinking transnationally, particularly in terms of critical gender and race. If we were thus to "locate" Asian FTM archives not only in terms of material storage (dusty sheets and computer servers alike) but also in terms of embodiment itself, we might think not only in terms of "Asian male identification," but also in terms of limits to that identification and what is done in one's own collected archive, one's accreted gendered embodiment. Such an archive must consider the creative possibilities of racial melancholia, cross-gender identification, pan-ethnic identifications, and queer temporalities.

Against the force of some trans normative requirements to restore a life-long trans narrative—that is, a narrative equally invested in a proper early trace of transgendered consciousness as much as in a future gendered arrival—some subjects may, for entirely separate reasons, be less interested in the past than in the future. That is, an entity that has "archive effects"—for instance, a repository that has served present or future interests—need not render only historical archives as present resources; it may equally render present archives as present resources. Leaving aside the complex questions of digital historicity, this is precisely why the internet must be acknowledged as a potent archiving resource; even as it is understood to be transient, "non-credible," "unreputable," "unofficial," and "disordered," its unique architectures must be understood.[8]

The YouTube video by Zach at the outset of this article is much like other clips on the internet authored by Asian FTMs in that it seems to be invested in seeking (or creating, or recuperating) not an authorized past archive, but a present or future one. For all the digital transiency of an entity like YouTube, these trans narratives are told "in one's own voice" as compared with the degree of

their broad accessibility (formerly the province of mass media). Some might suggest that in the case of YouTube the suspension of minoritarian voices to transiency, periphery, and the region of the small is no different from other modes of archival accumulation. Yet the YouTube video intervenes in an immediate and effective way, showing up as a top result of a search for "FTMtrans." It makes its own gendered logic by skewering the white-tuned map of genders, relying on random access to alert us to a vision of FTM gender with Asian at its center, enabling archives to come from, and be (re)constructed live from, there. And in contradistinction to a vision in which a video with 916 views is "insignificant," the tag "FTMtrans" has become a point of access and, hence, of community-forming and reflection.

Critical archive studies has insistently opened up definitions of archives from traditionally imagined physical collections of blatant state provenance and management. Archives can therefore be personal repositories, transitory intentional collections, virtual spaces like the internet or virtual collections of resources like digital libraries, organic systems of identification and labeling, records of subcultures, and so on. A queer of color approach to the archive requires a genuine receptivity to the material effects of archival sources in skewed or odd relation to state archives. This includes new media, including internet forms. Those that have been relatively democratized offer us new architectures of access and of archive-building. On a factual basis—both in hierarchized mainstream media and the "hypersearch" Google-based presence like YouTube where searches for Asian FTMs suggest very few similar hits—Asian FTMs are well-nigh "invisible." The spectacle of Beatie's pregnancy arguably does not reduce this effect.

Anjali Arondekar, in "Without a Trace: Sexuality and the Colonial Archive," takes stock of sexuality studies' interest in archives and puts them under the weight of considerations of the colonial archive.[9] As a repository for information and transactions whose orders of knowledge have been, until now, primarily lexically and English-based, the internet is not a naïvely idealized "new" form of archive independent of state categories and interests. While it offers tendrils of democratization, departures from state categories never fall too far from the tree—that is, not in great numbers. The accumulation- and quantity-driven logics of search engines effectively guarantee this "smallification" of radically nonnormative investments. As suggested above, while "smallness" is an illusion borne by state interests, it is not borne by all. For instance, a queer of color perspective is at once minoritized in relation to the normative whiteness of queer theorizing, while constituting its own theoretical core. Smallness need

not necessarily be tied to the logic of capitalist accumulation; rather, it can stand as an alert to the majoritizing and minoritizing structures as they work.

There is at once, it seems, a paucity and a richness of archive in relation to Asian FTM bodies in the United States. The paucity of archive may be indicated by a number of factors, many of which I will explore here. I would like to challenge the apparent febrile "insignificance" of the Asian FTM archive. Not merely to "pad the numbers" as it were, I suggest that there are good reasons for the Asian FTM archive to be the subject of an epistemology that locates it everywhere that Asian bodies are found. This is largely because available genealogies of "feminine Asian" bodies and "masculine Asian" bodies become mappable only through wholly distorting, racialized histories of sexualized masculinities and femininities. Thus, the Asian FTM body in its multiple interpellations (female masculinity/femininity, male masculinity/femininity, transsexuality) calls for a rich set of archival paths.[10]

It is this multilinearity that requires that "Asian FTM" come to suspicions about its own identity, particularly with regard to the forces of state archivization and the archive fever that lie within its terms of production. To the extent that past archives become important, "everywhere archives" (or, alternatively, discursive or viral archives) suggest not a recuperative will to numbers, but a restoral of archival possibility and an easing of the colonial grip on the otherwise denuded Asian FTM archive. As will be examined below, "everywhere," here, intentionally overreaches in response to the formal impossibility of its archival subject. By everywhere archives, I indicate a critical reach beyond the poor gendering and the rarefied genres that emerge in association with the Asian FTM figure, while retaining the ontological potencies of the term. In such a way, healthy suspicions may collegially coexist with archival richness and may be at ease with the possible impossibility of the Asian FTMs among us living, rewriting, and materializing gender every day. If archives are not merely about the past, but also about becoming—much like the transition videos described here—then there are substantive and useful distinctions to be made between the traditional archive and the discursive or viral archive.

LANGUAGE, GAPS, MELANCHOLY

Many ironies inhere in an essay that purports to consider an amalgam of categories, particularly raced and gendered ones, whose internal consistency is illusory. As for "Asian": About whom or what are we speaking? When do Asian-continent

denizens self-refer as Asian, except in recognizing larger trans localities? When does "Asian" name culture vs. geography, and how is it temporalized? How do we read East, South, and Southeast Asian geographies against migration and diasporas? "FTM" is no simpler. How do we define "female" or "male," much less the diversity of trajectories traced between two endpoints? Is FTM a temporal narrative, or simply a matter of self-identification and positioning, no more, no less? The same questions, of course, are asked of "white," European, Anglo loci. Categories, to the extent they are officially recognized, entrain state archives and are more often than not hegemonically defined. Sometimes categories do not entrain subcultural archives in the slightest. Thus, this essay must also ask what role the pan-ethnic, pan-racial, pan-geographic, and pan-migratory categories "Asian" and "FTM" play. Because they must and do participate in dynamic fields of study centered around transgender, archives, and race, such categories persist in the sedimentation of epistemology.

Debates around transgender experience have been particularly inflamed around insinuations felt to be made by those averring the performative constructedness of transsexual (or, differently, transgender) identities on the one hand and the realness, the *lived nature*, of such identities on the other. This is not to mention the contestations between transgender and transsexual lives or, from another angle, the "trans-" prefix that signals the transnational analysis hiding behind terms of living, whether former or contemporary. I refer here to the argument made lucid by Jay Prosser that a preference in queer theory for the dynamism and fluidity of gender, and a concomitant repudiation of gendered stasis, lead "queer" to glorify the dynamism, the transition part, of trans identities, while effectively maligning (desires for) stable gendered identity.[11] Jack Halberstam has taken issue with Prosser's reading, claiming that such an argument incorrectly diagnoses queer theoretical investment.[12] Note, however, that my discussion does not in fact participate directly in this debate; rather, it focuses on the dynamism or stasis of the archive itself. In part, categories remain ghosts, hinting at certain contained pasts, presents, and futures, while being absolutely unfaithful to any of these historical imaginaries.

The vexed historiography of the construction of "Asianness" and a paradoxical history of (iconically East-) Asian gender formation in the United States—in which Asian masculinity was queered while being emptied of masculine valences and notions of Asian femininity emerged through hypersexualized stereotypes— have contributed to confusions around the Asian FTM archive.[13] Halberstam suggests: "it is the very elasticity of the gender binary in particular that allows the biological categories of male and female to hold sway, despite widespread proof that the binary has been engulfed by local and folk productions of wild

gender."[14] The idea of gender binaries might be deployed in such a way that allows consideration of racialized genders as having *zones of attraction*, zones designated in part by the sociological and cultural conditions in which they appear. How do such racialized, hyperbolic zones of attraction, whose imaginary hold remains, converse or fail to converse with Asian FTM self-productions?

Asian gender in the context of the United States could easily here be thought of as adding layers of complexity in comparison to the detailing of hegemonic white masculinities and femininities, which is no simple feat in itself. Either in psychoanalytic or cultural studies terms, however, it is well accepted that the very formation of whiteness has depended on the simultaneous formation of "other" racial groupings, characterizations, and so on. This suggests that the "complexity" or "mystery'" of Asian (trans)gender in Western contexts is a nominalization drawn from the perspective of gender-normative whiteness itself. Yet, a comparative race framework need not rely on this structured perspective; rather, the very terms "masculinity" and "femininity" themselves must be questioned and reexamined. Despite the fact that the well-trained scholars among us have learned to order our masculinities in the impartial and equitable nomination and detailed style of coffee drinks—"white middle-class rural masculinity" on one day, "Asian working-class urban masculinity" on another—the general temptation is still to take recourse to a certain shifted calculus with an original at its fundament: that is, it is typical to consider Asian masculinity as feminized (shifted) in relation to (original) white masculinity. But what does this really mean, and do the accounts that have been offered so far remain adherent to the inner logic of origins? What do such questions offer in the consideration of archives: their content, their raciality, their vocality, their revisability?

David Eng considers racial and sexual formations together, by analyzing "the various ways in which the Asian American male is both materially and psychically feminized within the context of a larger US cultural imaginary."[15] While Eng is clearly working with the Asian American male figure, what is the status of the gaps in Eng's archive: What of the Asian American "masculine women" or of the "female men"? What of Asian American female subjects who are interpellated as male? Departing somewhat from Eng's psychoanalytic framework, I suggest it is fruitful to explode this racial-sexual nexus to include gender. Eng's original object, the Asian American male, can be put forth for reconsideration. Rather than a sexed body which is analyzed in terms of its figuration, it is useful to study that set of figures which *informs* the formation of the sexed body: Asian masculinity itself. It is the construction of Asian masculinity which arguably informs the reception of the representation of both Zach and Beatie on the internet (and, in the case of Beatie, across multiple mediums). Again, Beatie presents as

a queer Asian masculine male whose acts of reproduction, coded externally (but not by Beatie) as "female," defy, indeed upset, the expectations of that dominant construction of Asian masculinity as effeminate and homosexual.

One other case on the internet, which predates Beatie's media spectacularity by six years, exemplifies the racialized and sexualized gendering of Asian maleness to which Eng refers, suggesting that the internet itself has been populated by threads of racialized Asian sexualities and genders, instead of snuffing them out. At the time of writing, among the top results of a Google search for "pregnant man" is the website established in 2002 entitled "The First Male Pregnancy—Mr. Lee Mingwei."[16] The main page shows the institutional banner for "RYT Hospital—Dwayne Medical Center." The star patient, prominently framed in the center of the page and facing the viewer, is a shirtless, Asian American male, arms held away from torso in a pose suggesting medical documentation and showing a significant central bulge that signifies not a beer belly, but his pregnancy. We can watch a clip of the documentary in progress and follow this pregnant man's life as he takes a taxi and undergoes a routine visit to the doctor. While the website is fabulously convincing, rendering its dramatic send-up of societal expectations in highly muted tones, the documentary representation is not seamless; on closer examination, the hospital facilities look suspiciously like a hotel room or an apartment. It turns out that the pregnant man is a Taiwanese American artist, Lee Mingwei, who has, in collaboration with digital artist Virgil Wong (who held a side job as a web center director for a major New York hospital), staged an elaborate and repeatable performance. Did Lee's Asianness make his fertility, as a kind of transgendering, more plausible, even as perhaps Beatie's Asian raciality made his pregnancy more horrifying to certain consumers of the image? In view of the above troubling of what is meant by Asian masculinity, what would it then mean to include Lee in the Asian FTM archive? What would it mean *not* to do so?[17]

Lee and Wong's website cannily anticipates the horrified response by citing the feedback of several viewers, including one who voices the opinion of the religious right: "This is against God. Mr. Lee is a sick man. Repent now before it's too late. You sick, sick people ..." In a section entitled "Media Coverage," the website provides a link to the *Advocate* with the title "Mr. Lee Mingwei congratulates fellow pregnant dad Thomas Beatie," proactively generating hyperlinks and thus continuing to infuse the Asian FTM archive with its own concocted rehistories. While Beatie's sincerity is evident and adds to his credibility, the style of the *Oprah* interview and mini-documentary approach of the Beatie video expropriate his self-narrativity and subsume it to the archive of the spectacular (Oprah's voice-over: "the cameras capture it all"), even as Oprah at moments

demonstrates and urges compassion. The gender normativity characteristic of *Oprah* is not exclusive to the talk show. Such gender-normative investments are inseparable from race discourses and ultimately cannot be divorced entirely from state interests.[18]

The internet allows both Zach and collaborators Lee and Wong to make their archives usable, not as moribund repositories, but as generative resources for identity. Zach, Lee, and Wong have exploited the architectural peculiarities of the internet in which their archives appear, keeping revisions to omnipresent state interests palpable and within reach. Both presume, in their own ways, that identities are not preset. They are live, constructed, presentist, futurist, real. In their dynamism, their virtuality, their interconnectedness, their evanescence, their craft, and their readiness, these archives might be thought of as viral: not alive, since digital; not dead, since mobile. They are not archived reliably, and so they must be concocted again and again; even if identity itself is forestalled and forestalled and forestalled, the archives make and make.

"Everywhere Archives: Transgendering, Trans Asians, and the Internet" by scholar Mel Y. Chen was first published in the journal *Australian Feminist Studies* in June 2010. It is reprinted here by the permission of Taylor & Francis Ltd. and appears with minor revisions.

NOTES

1. The author wishes to thank Julian Carter, Rebekah Edwards, and Don Romesburg for their transformative contributions to this essay. Any errors are the author's alone.

2. "First TV Interview: The Pregnant Man," *The Oprah Winfrey Show*, aired April 3, 2008 (Chicago: Harpo Productions, 2008).

3. Untitled, YouTube video by "Zach," accessed April 27, 2009, https://www.youtube.com/watch?v=RwOz2v-498c. As of 2016, this video is no longer available on YouTube.

4. David Eng, *Racial Castration: Managing Masculinity in Asian America* (Durham, NC: Duke University Press, 2000).

5. See, for instance, Lee Edelman's *No Future: Queer Theory and the Death Drive*, a psychoanalytic examination of the cultural assignation of queerness to negativity. Lee Edelman, *No Future: Queer Theory and the Death Drive* (Durham, NC: Duke University Press, 2004).

6. It might be useful to compare the ways in which race is and is not marked on YouTube with its marking on other internet sites of exchange. Juana Rodriguez's "'Welcome to the Global Stage': Confessions of a Latina Cyber-Slut" recounts a number of identitarian

misapprehensions on an online chat site. Notably, the chat site and the troubles to which she refers involve only textual exchanges; there are no photos or video. Thus, the internet itself encompasses a variety of economies of signification involving text, image, and video. Juana Rodriguez, "'Welcome to the Global Stage': Confessions of a Latina Cyber-Slut," in *Queer Latinidad* (New York: New York University Press, 2002), 114–52.

7. I refer here to Adrienne Rich's noted use of the term "politics of location," in which she refers to the transnational politics of racial location in the context of the United States and its implications for feminism—specifically, the societal (predominantly white, middle-class) location from which American feminisms were being dominantly shaped. See Adrienne Rich, "Notes Toward a Politics of Location," in *Blood, Bread, and Poetry: Selected Prose 1979–1985* (New York: W. W. Norton, 1986), 210–32.

8. Renée M. Sentilles considers the complexities of the internet as a possible resource for archival research and as a kind of "archive of archives." She ends her essay "Toiling in the Archives of Cyperspace" by settling the question of the internet with a return to her preference for and belief in the superior experience of physical repositories: "it is that human response to tangible artifacts that I have seen time and again in my students as well as myself that convinces me that virtual archives will never serve as more than a place to begin and end the research journey; never as a place to dwell." Renée M. Sentilles, "Toiling in the Archives of Cyberspace," in *Archive Stories: Facts, Fictions, and the Writing of History*, ed. Antoinette Burton (Durham, NC: Duke University Press, 2005), 155.

9. Anjali Arondekar, "Without a Trace: Sexuality and the Colonial Archive," *Journal of the History of Sexuality* 14, nos. 1–2 (2005): 10–27.

10. For a performative reading of Asian transgendering and for an examination of the combinatory possibilities that occur in multiple narrations of gendering, see Sel J. Wahng, "Double Cross: Transmasculinity and Asian American Gendering in *Trappings of Transhood*," in *Violence and the Body: Race, Gender, and the State*, ed. Arturo J. Aldama (Bloomington: Indiana University Press, 2003), 287–310.

11. Jay Prosser, *Second Skins: The Body Narratives of Transsexuality* (New York: Columbia University Press, 1998).

12. Judith Halberstam, "Transgender Butch: Butch/FTM Border Wars and the Masculine Continuum," *GLQ: A Journal of Lesbian and Gay Studies* 4, no. 2 (1998): 287–310.

13. It is notable that the US Asian archive has its own priorities, skewed toward East Asians. Its representative center is constituted by stereotypes about Chinese and Japanese gender systems in particular, while tending to bypass Filipino and South Asian genders. For a refreshing recent study of Filipino tomboy identity in relation to the coproduction of Filipino masculinities in global transit, see Kale Bantigue Fajardo, "Transportation: Translating Filipino and Filipino American Tomboy Masculinities through Global Migration and Seafaring," *GLQ: A Journal of Lesbian and Gay Studies* 14, nos. 2–3 (2008): 403–24.

14. Judith Halberstam, "Mackdaddy, Superfly, Rapper: Gender, Race and Masculinity in the Drag King Scene," *Social Text* 52/53 (1997): 104–31, 109.

15. Eng, *Racial Castration*, 2.

16. See The First Male Pregnancy, http://www.malepregnancy.com/, and its associated website, RYT Hospital—Dwayne Medical Center, http://www.rythospital.com/, both accessed April 27, 2009. As of 2016, the first website redirects to a related YouTube video, titled "The World's First Male Pregnancy," rather than an indexed main page, and the second website is defunct.

17. The question seems to remain, in an economy of gender appropriateness both within and without racialized identity categories, how far is too far; when do troubling categorical edges slide into appropriation, and then what ethics are called for? A recent controversy erupted in the Femme Conference of 2008 in San Francisco, California, around the film *Female to Femme*, which provocatively used the concept of "transitioning" in mock interviews to describe a woman's shift in aesthetic and gender sensibility from "dyke" or "lesbian" to "femme." Many people found the use of "transition" in this context offensive and transphobic. *Female to Femme*, directed by Kami Chisholm and Elizabeth Stark (San Francisco: Altcinema, 2006).

18. Paisley Currah connects responses to Beatie's story to the recent debates about the status of transgender people in the formation of the proposed US Employment Non-Discrimination Act (ENDA), which seeks to prohibit employment discrimination on the basis of sexual orientation or gender identity. After much controversy among activists and lawmakers about the inclusion of gender identity in a bill that was envisioned to address a core constituency of non-transgendered gays and lesbians, in 2009, for the first time in its years of attempted passage, ENDA included protections for gender identity as well as sexual orientation. However, despite bipartisan support at a September 2009 congressional hearing, the bill remains sidelined as of the time of writing of this article in 2010. The back and forth of the status of gender identity vis-à-vis sexual orientation suggests the uncertain political, epistemological, and affective position that "gender identity," and/or "transgender bodies," hold on the stage of national politics, mainstream LGBT organizations, and the US legal framework. Paisley Currah, "Expecting Bodies: The Pregnant Man and Transgender Exclusion from the Employment Non-Discrimination Act," *WSQ: Women's Studies Quarterly* 36, nos. 3–4 (2008): 330–36.

DARK SHIMMERS:
THE RHYTHM OF NECROPOLITICAL AFFECT
IN DIGITAL MEDIA

micha cárdenas

SUN, JUN 12, 9:20 AM
———

The first time I heard about the shooting at the Pulse nightclub in Orlando, Florida, was through a text message conversation. The message was from a dear friend who knew that I had taken the last five months off of Facebook and probably hadn't heard the news. Getting off of Facebook played a major part in my recovery from depression, which had emerged in part due to the repeated trauma of experiencing media depictions of violence against trans and black people in my newsfeed. Many of my most intimate, significant life events are filtered through algorithmic media, occurring on digital communication platforms, time-stamped and arranged on highly designed mobile interfaces. These range from text message break-ups to Skype conversations with lovers, from watching my nephew grow up on Facebook to learning about deaths in my communities. This brief text-message exchange was followed by waves of grief. I read articles; I watched video clips; and I went to the Black Power Epicenter, a healing space for queer and trans people of color. There, after many of the people present shared their feelings, cried, and sang, it was the DJ's rhythms that allowed us to shift our affect from slowly rocking grief to cathartic, connecting movement. These days, I am splintered—shattered by sadness, shock, and fear—from news of events that come in an irregular, but inexorable, rhythm. This poetic/performative essay is an effort to bring that rhythm to life and to reflect upon its significance by considering the relationship between visibility and affect and how the digital acts as a medium for flows between, through, and across both.

Our necropolitical moment is one in which horrific stories of the murders of people in our communities and families come to us daily through networked media. If the primary tool of biopolitics was the census, perhaps we can

Screenshots of text-message conversation,
June 12, 2016. Courtesy micha cárdenas

MICHA CÁRDENAS

consider the paradigmatic tool of necropolitics to be the algorithm. In his essay "Necropolitics," philosopher Achille Mbembe describes necropolitical war machines as "polymorphous and diffuse organizations," which include "sensors aboard unmanned air vehicles (UAVs) … an Earth-observation satellite, [and] techniques of 'hologrammization,'" and which perpetrate "invisible killing."[1] He describes a contemporary moment in which visibility is complex, shifting, and automated, and often occurs because individuals are being targeted for violence. Algorithms deliver death coolly, emotionlessly, through coded, logical decisions. The emotional and affective impacts of our lives unfold around the contours of these digital, time-stamped moments. Algorithms manage visibility on social media, but their reach extends much farther than that. As Mbembe mentions, the UAVs (also known as drones) that are used daily in the United States' racialized War on Terror also function by way of software. Algorithms, encoded in software and in the hardware of electronic circuits, manage the decisions of who lives and who dies under necropolitics. This reality continues to expand: numerous governments have begun to purchase robots to be armed with lethal weapons and used for policing, and the number of cities employing the algorithms of predictive policing, including New York, Los Angeles, Chicago, and Miami, continues to grow.[2] In July 2016, Micah Johnson, who allegedly shot and killed five police officers at a #BlackLivesMatter rally in Dallas, became the first civilian known to have been killed by a police robot.[3]

In the days that followed the Orlando attack, I learned that the shooting occurred during Latinx night at Pulse and that there were transgender women at the club. For the past year, in response to earlier shootings of black trans women, I had been working on a project called Unstoppable, which aims to create bulletproof clothing for trans women; in the aftermath of this attack, I wished that my work had been more effective. The dramatic increase in visibility for trans women of color in 2014 was followed by a significant increase in the number of murders of trans women in 2015. Unstoppable grew out of this reality, in the summer of 2015, as a collaboration with Patrisse Cullors, cofounder of #BlackLivesMatter, Chris Head, an artist with whom I had collaborated previously, and Edxie Betts, an artist-activist in Los Angeles. The project is an expression of solidarity between black people and trans women, stemming from a feeling of shared urgency. Inspired by Cullors's collaboration with artist-activists Damon Turner and Foremost on a clothing line called #Bulletproof, Cullors, Head, Betts, and I began to research methods and materials to create affordable bulletproof clothing. To date, our results have been inconclusive. Our testing has revealed that some used tires can stop 9mm bullets, but only when the tires are layered eight deep. We have also found that some airbags, salvaged from wrecked and

abandoned cars, are made out of Kevlar, a fabric that is said to be bulletproof when piled twelve layers deep. We have also learned that some cutting boards made of ultra-high molecular weight (UHMW) plastic may stop low-caliber bullets, but we have not yet determined which brands use this material. Our research continues and is available at weRunstoppable.com.

Unstoppable is a project that began by acknowledging that visibility is not enough to keep us safe. Mourning for the forty-nine people murdered at Pulse, I felt my own ineffectiveness and wished I had the resistant algorithm to share with people, the steps necessary to turn junk into lifesaving bulletproof armor. But we don't have it yet. As this train of thought continued, I knew that it was a way of avoiding the underlying grief I felt for the victims and survivors of the shooting, to whom I felt closer given what I imagined were our shared experiences as queer and trans Latinx people—an identification that is an assemblage of many widely differing experiences.

By studying the effects of digital media, I have explained elsewhere that algorithmic analysis extends the assemblage model.[4] Theorist Jasbir K. Puar has argued that Kimberlé Crenshaw's intersectional model of structural oppression can be usefully extended with Gilles Deleuze and Félix Guattari's concept of assemblage to incorporate relationships between many axes of oppression that change over time.[5] I have also argued that the assemblage model introduces ambiguity and that the mathematical basis of assemblages can be modeled through algorithms. Further, I claim that algorithms, understood most simply as a list of ingredients and a series of steps, are uniquely suited to the understanding of oppression today as it is managed by digital technologies. Here, I engage in affective and algorithmic analyses of a few moments of time in the months of June and July 2016, during which extreme violence against trans, black, and Latinx people occurred repeatedly, rhythmically. Theorizing violence against queer people of color as queer necropolitics, Puar states that it "entails the increasingly anatomic, sensorial, and tactile subjugation of bodies—whether those of the detained of Guantánamo Bay or the human waste of refugees, evacuees, the living dead, the dead living, the decaying living, those living slow deaths—it moves beyond identitarian and visibility frames of queerness to address questions of ontology and affect."[6] Her formulation is particularly important to considerations of trans of color politics in the wake of the increased violence that has coincided with increased visibility.

The time stamps on significant moments in our lives unfold multiple meanings through algorithmic considerations. Time stamps may conjure images from science fiction (such as the way *Star Trek* episodes were each introduced by a "Captain's log star-date"), pre-digital epistolary fiction, or the precision of

Edxie Betts modeling a Kevlar tube dress as part of the Unstoppable project, 2015. Digital image of a live performance. Courtesy micha cárdenas and Edxie Betts. Image: © micha cárdenas, 2015

scientific experiments. And yet, the presence of digital media time stamps goes beyond a desire to record personal experiences; it reveals the way our communications are stored in databases for future use by entities that are not us. These databases are often relational, based on Structured Query Language (SQL), itself a kind of algorithm. They house our memories, words, winks, and emojis, and are owned by corporations such as Verizon, Apple, Facebook, and Tumblr. Through a simple friend request on Facebook, one has access to information that maps another's affects through time, and often their geolocation stamps as well. In the browser-based Javascript programming language that is the basis for most interactivity on the web today, there is an Application Programming Interface (API) called Geolocation, which makes it easy to request and record time and location data together as one object—Position.timestamp—which includes GPS coordinates and a time stamp with precision to the millisecond.[7] An algorithmic analysis could be performed by writing software to map affects from one's Facebook page over time and place, or one could use Facebook's Graph API to map the speed at which an affect travels geographically, by tracking posts about a particular violent event and doing a sentiment analysis on the words in the posts.

To imagine what an algorithmic analysis might map, I only have to consider a brief sampling of my Facebook friends' responses to the video released online of the murder of Alton Sterling, a black man shot multiple times by Louisiana police while being held on the ground.[8] These responses included a range of affects such as grief, shock, anger, frustration, and numbness. In "Shame in the Cybernetic Fold," queer theorists Eve Kosofsky Sedgwick and Adam Frank discuss the complex layerings and crossings of digital and analog phenomena in the work of Silvan Tomkins, who developed early affect theory. They state that "the tacit homology machine: digital :: animal: analogical (and concomitant privileging of the machine/digital) is … a very powerful structuring presumption for current theory and emerges especially strongly as a reflexive antibiologism. But it represents bad engineering and bad biology, and it leads to bad theory … the distinction between digital and analog is anything but absolute."[9] According to Sedgwick and Frank, one way of understanding affect is to think of it as an analog phenomenon, because there is a one-to-many relationship between a stimulus and the resulting affect. An example of this kind of relationship is Tomkins's experiment documenting many different responses to the same stimulus of an electric shock.

Affect moves through space and time in gradations of intensity that increase and dissipate, and time stamps can mark that movement. Trans studies scholar Che Gossett, reflecting on the Orlando massacre in an article titled "Pulse, Beat,

Rhythm, Cry: Orlando and the queer and trans necropolitics of loss and mourning," calls attention to the centrality of the beat: "Anti queer/trans necropolitical violence is about stopping the pulse of queer and trans of color life/worlds and the club was a target because the club is a flashpoint for eroticopoliticized desire."[10] A pulse is a biological indicator of life; it can also be a pulse of light in a fiber-optic cable carrying digital communications, or the pulse of a strobe light on the dance floor, moving with a beat.

FRIDAY, JUNE 24TH, 2016, AT 12:13AM

I've begun to slowly reintroduce Facebook into my life in controlled ways, checking it once every few days or once a day at most. Opening Facebook in my web browser, I am presented with a newsfeed. One method of algorithmic analysis is the common hacking method of reverse engineering. The algorithm for my newsfeed may be composed of the following steps, and may contain other steps made invisible by the technology of server-side web content processing:

1. Find the list of my friends

2. Find posts from my friends in the last twenty-four hours

3. Sort by time stamp, number of likes, and number of comments

4. Adjust the sort according to any additional algorithms for relevance, such as inserting posts which have been paid for, or adjusting users' feeds to alter their emotions—thereby producing data for a study on how emotions are contagious, which Facebook denies was tied to the US government[11]

5. Display as many of the sorted posts as will fit on the screen; store the rest in order in case of scrolling

In my feed, I see an image of a gender nonconforming person with a bloodied face. The experience is quick, without a conscious choice on my part. The caption tells me that this person is trans and that they were attacked leaving a benefit for the "Orlando 49" in Seattle's Capitol Hill neighborhood—just minutes from where I live—an area of the city I frequent multiple times a week. This is too much. I didn't want to see this now. I often scroll past these posts when I am not in an emotional state in which I can handle them. I often feel numb when I see

them and, sometimes, will slightly dissociate. Perhaps this is a privilege that I exercise—to not think about these violent acts until I am ready to—or perhaps it is a survival mechanism and a form of emotional intelligence that I have built up in order to withstand the repeated murders of people close to me, in my community, and in communities like mine.

Facebook and other social media corporations profit off of every click and every scroll. Contemporary social movements' usage of these platforms to spread data benefits the information economy that sells users' demographic data to advertisers, who pay per thousands of impressions and per click. Each death that is posted about on social media keeps users scrolling and clicking, increasing revenue for these corporations; they very literally profit off of our deaths, our mourning, our communication, the spread of our affects. In his essay "Subject(ed) to Recognition," professor Herman Gray writes of the ways that neoliberalism has incorporated difference into a profit-making mechanism, stating:

> [W]ith the proliferation of representations made possible by new media technologies and distribution platforms, will the intensity, variety, and reach of representations of race or ethnicity, gender or sexuality that daily crisscross the Internet challenge and destabilize the structure and cultural dispositions of identity, self, community, belonging, and politics to which we have become so accustomed? I side with critiques of representation that doubt that merely seeing more members of heretofore aggrieved and excluded communities in the media will increase access to life chances.[12]

Gray articulates the way that the diversity of representations in digital media not only benefits global capitalism but is fundamental to it. He describes in detail the role of technology in managing velocity and difference in order to generate profit, saying, "[t]he capacity to detect and respond to the slightest variation or shift in global markets, finance, and trade, where the difference between growth and stagnation means global financial crisis, is built on *speed* and *differentiation*."[13] Algorithms, such as those responsible for high-frequency trading of stocks by the millisecond, facilitate the control of different elements at speeds that far exceed human cognition.[14]

Gray's intervention highlights the blurred lines between the hegemonic power of corporations that control digital media and the struggle of people working for social justice, pointing out that "the alliance of difference and power instigates a yearning for *representation as an end in itself* that perfectly expresses the logic of market choice, consumer sovereignty, self-reliance, and cultural

diversity. In short, the *incitement* to media visibility and the *proliferation* of media images that it generates is a technique of power."[15] Gray's critique echoes Sedgwick and Frank's turn to affect as a means to avoid simple binaries that result from misinterpretations of Michel Foucault's repressive hypothesis and always reduce their objects to "binarized, highly moralistic allegories of the subversive versus the hegemonic, resistance versus power."[16] The harm that people cause one another through the spread of affects such as shock, grief, and numbness on social media is an example of how the lines of subversion/resistance versus hegemony/power are not so clear. When allies of transgender people post violent images and videos of trans people's murders, they sometimes are harming the very communities they intend to aid by not considering who the audience is for their posts, or by not considering carefully how that media will be distributed. My claim here is not intended to continue the trend of disparaging allies, as I believe that solidarity is essential to advancing social justice; this critique also applies to trans people, people of color, and others engaging in the sharing of media when it is done carelessly. Rather, my intent is to urge that more care be taken to consider how affect is spread on social media, who is affected, and for whose benefit.

JUNE 25, 2016

One of the main vectors of affective contagion today is social media, a space created by algorithms. In many ways, the algorithm has replaced modernist notions such as journalistic objectivity or integrity. In place of these modernist ideals, algorithms are seen as the rational arbiter of content, imagined as the cold objectivity of steel and ions. Yet, as Microsoft principal researcher Kate Crawford points out in "Artificial Intelligence's White Guy Problem," published in the *New York Times* on June 25, 2016, algorithms are anything but objective.[17] The algorithms that decide what content one sees on Facebook, for example, are the product of many social and cultural assumptions. Furthermore, those algorithms remain hidden and, in some cases, have been shown to be designed to manipulate the feelings of Facebook's users.

While visibility is managed by the algorithms of social media and communications networks, affect is the excess that seeps through these attempts at management. The affects of outrage and melancholy travel through social networks today in stories about the murder of black people and trans people of color.

The increasing mainstream visibility of transgender people has been brought about by solidifying the line between who is an acceptable trans person and who is disposable. Now more than ever, it is evident that "visibility is a trap," as Michel Foucault claimed, and that the abolitionist, anticolonial, anti-normative tradition of transgender politics needs to be actively continued with actions that go beyond visibility.[18] On Thursday, June 30, 2016, CNN.com announced that the Pentagon "was ending the ban on transgender people being able to openly serve in the U.S. military."[19] One could watch the streaming video of Defense Secretary Ash Carter announcing this historic event. Many trans theorists and artists, including Che Gossett, responded critically to this event. They posted on Facebook: "In our time of trans visibility and incorporation into the military industrial complex (Pentagon ending its ban) I'm thinking about the legacy of Sylvia Rivera, Puerto Rican cofounder of Street Transvestite Action Revolutionaries, who at age 18 staged a direct action in resistance to the draft and US imperialism through a radical politics of trans and queer insurgency. Sylvia Rivera's anticolonial & revolutionary trans politics = insurgent theory and praxis."[20] The lifting of the ban and the happy incorporation of transgender people into the US military further cements a trend made clear by the visibility of Caitlyn Jenner's right-wing politics in the popular media: there is no longer a link that can be assumed between transgender experience and radical politics, if there ever was one.

What does "trans visibility" mean? For trans visibility to be a reality, there would have to be an essential trans identity to make visible, but there is not. How could one make visible an identity that begins with the claim: "I am not what I appear to be; I know this because of a feeling that I have; I am my vision of my future self." *Often, trans experience begins with an affective claim to futurity that rejects the truth of the visible.*

In this moment when trans people appear to be winning a struggle for visibility while also continuing to be murdered on a daily basis, it is important to look to black studies scholars who have thought through these apparent contradictions already, while at the same time being very cautious not to equate or conflate blackness and trans experience. In "Postmodern Blackness," author and activist bell hooks writes, "we should indeed be suspicious of postmodern critiques of the 'subject' when they surface at a historical moment when many subjugated people feel themselves coming to voice for the first time."[21] Similarly, critiques of struggles for visibility fought and won by transgender people must be made carefully, so as not to reproduce transphobic logics and discredit the important work being done by many trans people. As hooks goes on to say,

"Employing a critique of essentialism allows African-Americans to acknowledge the way in which class mobility has altered collective black experience so that racism does not necessarily have the same impact on our lives. Such a critique allows us to affirm multiple black identities, varied black experience. It also challenges colonial imperialist paradigms of black identity which represent blackness one-dimensionally in ways that reinforce and sustain white supremacy."[22]

Trans studies scholar Eva Hayward has articulated how materialist feminist Rosi Braidotti uses transsexuals as a symbol of panic and disintegration, yet I still find some of Braidotti's claims about visibility in digital environments to be useful for the present consideration.[23] Braidotti critiques the ways that postmodern rhetorics undermine claims to visibility for oppressed groups just as they come into visibility. She states:

> [I]n postmodernity ... it is the thinkers who are located at the *centre* of past or present empires who are actively deconstructing the power of the centre—thus contributing to the discursive proliferation and consumption of former "negative" others. Those same others, however— especially in post-colonial, but also in post-fascist and post-communist societies—are rather keen to reassert their identity, rather than deconstruct them. ... [T]hink for instance of the feminist philosophers saying: "how can we undo a subjectivity we have not even historically been entitled to *yet*?" or the black and post-colonial subjects who argue that it is now their historical turn to be self-assertive. ... The point remains that "difference" emerges as a central—albeit contested and paradoxical—notion.[24]

Like Braidotti, Donna Haraway also makes a critique of the binary essentialism of gender in order to shift toward an intensive concept of difference through an analysis of information technologies.[25] Haraway's analysis has a strong relevance for trans experience. In "A Cyborg Manifesto," she argues that "[t]here is nothing about being 'female' that naturally binds women. There is not even such a state as 'being' female, itself a highly complex category constructed in contested sexual scientific discourses and other social practices. Gender, race, or class consciousness is an achievement forced on us by the terrible historical experience of the contradictory social realities of patriarchy, colonialism, and capitalism."[26] We can extend this argument to contend that there is nothing about being trans that binds trans people together as a singular identity group. There is no such state as "being trans," which is a Western colonial medical term that encompasses so many varied experiences and politics. Artist and theorist Sandy Stone's 1987

essay "The *Empire* Strikes Back: A Posttranssexual Manifesto," which many have described as the founding document of transgender studies, expands this critique of essentialism through the lens of trans experience.[27] Following Stone's call that what is needed is for trans people to write the multiplicity of their experiences, it is important that trans activists and scholars learn from movements such as the black radical tradition and women of color feminism to fight for, articulate, and remember an abolitionist trans tradition that understands gender policing as part of a larger colonial project including police, prisons, universities, and surveillance technologies. In *Invisible Lives*, trans studies scholar Viviane Namaste describes the condition of trans people in the year 2000 as one of erasure and invisibility; that erasure continues even as the history of transgender resistance to colonialism, policing, and imprisonment is itself constantly erased, requiring continued efforts by those of us in the abolitionist trans tradition.[28]

Mainstream trans visibility today is put in the service of selling magazines, video streaming services, and web advertising impressions and clicks in order to erase the anticolonial struggles and histories of struggle of trans people of color. The ways that affects such as grief are concretized into media and placed within specific narratives shape what political mobilizations occur in response to the murders of transgender people. A clear example of this is seen in the ways that the deaths of the Orlando 49, with which I opened this essay, were used against Muslim people; and the responses of activists underscore the ways that histories of solidarity are erased in mainstream media. For instance, the Audre Lorde Project (ALP) published a statement about the Orlando murders titled "Don't Militarize Our Mourning" that states, "there is an epidemic of murder of Black and Latinx Trans Women and Gender Non Conforming people and this tragedy is part of this ongoing colonial project."[29] Their statement seeks to challenge the mainstream media accounts of the Orlando massacre, which framed it as an act of terrorism by a Muslim man in order to support a vision of the United States as exceptional in its tolerance of queer and transgender people. In response, ALP points to the long history of the United States' violence against black and Latinx people and how that history is central to the colonial nature of the founding of the nation. In doing so, ALP remembers and rearticulates an abolitionist trans tradition that sees gender variance as part of precolonial histories and people of color communities, in contrast to a homonationalist or transnationalist narrative that works to support the white supremacist War on Terror narrative that argues the United States is an enlightened bastion of freedom for transgender people under siege from less civilized people of color.[30]

An abolitionist trans politics requires that visibility for trans people of color not be promoted in the absence of anti-prison, antipolice, and anticolonial critiques, because it is precisely this absence which allows neoliberalism to manage the determination of which trans people are acceptable (namely, those who work toward the shared ideologies of neoliberalism) and which trans people are disposable (those who reject the neoliberal ideologies of assimilation and conformity to market demands that rely for their continuation on the deaths of disposable populations). In the place of external demands for visibility, trans people can work toward more material safety and a shift in the affects that permeate our lives. I want more than representation; I want to live in a world where I don't have to fear for my life every day, where I can have the satisfaction of achieving my goals and the joy of being close to others.

Many queer of color theorists have pointed to the need to move beyond visibility politics. For instance, Puar points instead to the importance of theorizing affect.[31] The repetition of affects of grief and shock over the hyper-visible murders of black and trans people on a daily basis underscores the need to think through affect and its importance for politics. Moreover, in "An Inventory of Shimmers," Melissa Gregg and Gregory Seigworth argue: "Affect, at its most anthropomorphic, is the name we give to those forces—visceral forces beneath, alongside, or generally *other than* conscious knowing, vital forces insisting beyond emotion ... that can even leave us overwhelmed by the world's apparent intractability."[32] This overwhelming feeling has been the continued condition of the summer of 2016, with news of the Orlando shooting, the murders of Alton Sterling and Philando Castile, and the Dallas police shooting. News of these events was delivered through algorithmic digital media, running in loops that provide constantly varied information in a repeated format.

TUESDAY, JULY 5, 2016, AT 9:20 PM

————

A Facebook post by Patrisse Cullors is the first place I learn of Alton Sterling's death. Her words are all I need to read to know that another black person has been murdered by police. Scrolling through my Facebook feed, I see posts from dear friends expressing extreme grief and tagged #AltonSterling, accompanied by a link to the video of officers shooting him. I am overwhelmed, and I know by now that I cannot watch the video. I see my friends who are black and trans ask, "When will I become a hashtag?" speculating on a transcendence into the digital only occasioned by death.

Patrisse Khan-Cullors
July 5 at 9:20pm · Twitter · 👥

You can't keep doing this to us. #AltonSterling #BlackLivesMatter

👍 Like 💬 Comment ↪ Share

👍💀😢 Esperanza Fonseca, Yesenia Valdez and 93 others

Screenshot of Patrisse Cullors's Facebook page,
July 5, 2016. Courtesy micha cárdenas and
Patrisse Cullors

UPDATED 4:57 AM ET, FRI JULY 8, 2016

A few days later, an unprecedented intensity of necropolitical media occurs when Diamond Reynolds livestreams the murder of Philando Castile by Jeronimo Yanez, a police officer in Falcon Heights, Minnesota.[33] I refuse to watch the video for my own mental health. How is it that consuming media depicting murder has become commonplace today? In the following week, thousands of people in #BlackLivesMatter protests mobilize in streets around the world, including a protest that blocked Interstate 880 in Oakland, California.[34]

WED JUL 13 23:25:05 PDT 2016

In *The Undercommons: Fugitive Planning and Black Study*, Fred Moten and Stefano Harney write: "Our task is the self-defense of the surround in the face of repeated, targeted dispossessions through the settler's armed incursion. ... Politics

is an ongoing attack on the common—the general and generative antagonism—from within the surround."[35] Their reference to the repetition of violent, armed incursions is one of the few theoretical statements that begins to grasp the present series of violent moments, with a rhythm so fast as to be shocking, repeated to the point of inducing numbness. Yet my reading of their statement falters, as I understand myself to be a settler here, living on the Duwamish land known as Seattle, Washington, or at best, an "arrivant," to use African Caribbean poet Kamau Brathwaite's term for settlers of color who have been forced by empire to live on native lands.[36] Nonetheless, the sense of repeated violence as a condition of contemporary existence resonates. Moten and Harney's reference to self-defense brings me to my current project, #stronger, which follows the strategy I propose above, of focusing on affect and safety instead of visibility. #stronger is being developed in the lab I founded at University of Washington Bothell, the Poetic Operations Collaborative, with research assistants Lundy By, Frances Lee, Kate Sohng, and Annie Zeng. By focusing on helping individuals build strength and health, #stronger intends to shift my own and my community's affective condition, while also creating more material security for us.

#stronger engages with the algorithms of social media visibility to share my affective experience of gaining strength through CrossFit, a high-intensity interval training program. The project uses algorithms in two ways: one is by sharing media on existing social networks, and the other is by creating an IOS app that will help trans and gender nonconforming people to create their own networks of friends interested in fitness. In a sense, the project relies on the same algorithms that often cause harm to trans people, but it attempts to subvert them to build a sense of safety and an increase in strength and health for trans communities.

The official CrossFit organization has stated that trans women must compete in the men's category, in contrast to the International Olympic Committee's decision that trans women can compete with their gender after receiving sexual reassignment surgery.[37] So, in some ways my participation in CrossFit at the local level is an act of infiltration and subversion. #stronger asks, "Can I become #HarderToKill [a popular CrossFit hashtag] by improving my physical and mental health?" The risk here is to place responsibility for violence or safety on individual trans people instead of on the people and institutions, including police officers, prisons, and Immigrations and Customs Enforcement officials, who are committing the most violence against trans people daily. Yet, instead of focusing only on individual experience, #stronger uses the algorithms of social media to distribute images of strength and health for trans people, in the hope of encouraging more trans people to prioritize practices that increase their own fitness and wellness.

#stronger is changing my affective state. Knowing that I can lift 209 pounds allows me to walk in the world more calmly and with less fear. Knowing that I can set difficult strength and fitness goals and achieve them also gives me more confidence, dignity, and self-respect. In addition, having more strength and more self-defense skills makes me safer, and I intend to share that.

#stronger also includes interviews with transgender people and medical health professionals. To help spread these practices among my communities, I am working with the Poetic Operations Collaborative to design speculative fitness apps for queer and trans people and all people who feel alienated by gendered

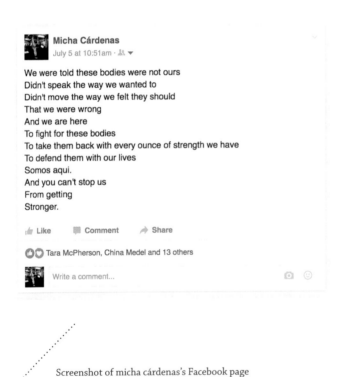

Screenshot of micha cárdenas's Facebook page featuring #stronger post, July 5, 2016. Courtesy micha cárdenas

Screenshot of "Friend Nearby" screen from
#stronger app prototype, 2016. Courtesy
micha cárdenas. Photo: Andrew Bueno,
Foundation Crossfit

fitness apps. These app designs imagine a feature that allows users to connect to others nearby using the #stronger app to find trans and queer workout partners.[38] In addition to the app, #stronger will include public workshops where I will share what I have learned with others and bring the public into the design process. At the time of writing, I have worked on the project for only four months; I am still in the very earliest stages of developing it, but my aim goes beyond visibility to shift affective conditions and to create more safety. #stronger continues a practice I have used in projects in the past, attempting to subvert existing technologies and to repurpose them for ends for which they were not designed. In this case, I am attempting to use the algorithms that often reproduce necropolitical surveillance and violence on social media and smart phones[39] to bring about more safety for myself and my communities.

THE SHIMMERING NOW

In their essay "An Inventory of Shimmers," Gregg and Seigworth call on "social theorists … to examine not just institutions but moments," which they describe as "the shimmering relays between the everyday and affect."[40] I use this method to continue the practice of women of color feminism's attention to the everyday lives of queer women of color as the basis for theory, giving attention to the daily moments in which a trans woman of color is surrounded by flows, rhythms, and movements of violence, grief, and resistance experienced through digital media. Social media has succeeded in turning our lives into commodities. No matter how moving or intimate or mobilizing your post is, it's still selling more advertisements and generating more data for corporations like Facebook and Twitter. Imagine if every activist flyer you saw, every family photo you have, and every love note you ever sent were covered in corporate logos and ads. That's life on social media; the more powerful the media one posts on social networks, the more money corporations make. As such, a consideration of the politics of affect in social media is urgent, as is the development of new networks.

What might a dark shimmer look like? If more visibility for transgender people has resulted in more violence, then perhaps what is needed are new modes of visibility or methods that do not prioritize visibility. The projects I have described here consider the shifting and automated systems of visibility that Mbembe describes as part of the conditions of necropolitics. In response to these conditions, and following the urging of queer people of color scholarship, I propose that trans people can focus on changing their affective conditions and

their material conditions of safety. Unstoppable and #stronger are examples of digital media projects that are based on these aims. They are part of a larger project of combining theory and practice to go beyond the digitized sounds and images of death that are repeated on social media today and to open up possibilities of life for transgender people of color.

..

"Dark Shimmers: The Rhythm of Necropolitical Affect in Digital Media" by artist and theorist micha cárdenas was written in 2016 for this volume.

..

NOTES

———

1. Achille Mbembe, "Necropolitics," trans. Libby Meintjes, *Public Culture* 15, no. 1 (2003): 29–30.

2. See "About Us," Campaign to Stop Killer Robots, accessed July 14, 2016, https://www .stopkillerrobots.org/about-us/; and Kate Crawford, "Artificial Intelligence's White Guy Problem," *New York Times*, June 25, 2016, http://www.nytimes.com/2016/06/26/opinion /sunday/artificial-intelligences-white-guy-problem.html.

3. Matt McFarland, "Robot's Role in Killing Dallas Shooter Is a First," *CNN Money*, July 11, 2016, http://money.cnn.com/2016/07/08/technology/dallas-robot-death/.

4. micha cárdenas, "Trans of Color Poetics: Stitching Bodies, Concepts, and Algorithms," *S&F Online*, no. 13.3–14.1 (2016), http://sfonline.barnard.edu/traversing-technologies /micha-cardenas-trans-of-color-poetics-stitching-bodies-concepts-and-algorithms/.

5. Jasbir K. Puar, "'I Would Rather Be a Cyborg than a Goddess': Becoming-Intersectional in Assemblage Theory," *philoSOPHIA* 2, no. 1 (2012): 49–66.

6. Jasbir K. Puar, *Terrorist Assemblages: Homonationalism in Queer Times* (Durham, NC: Duke University Press, 2007), 35.

7. "The Graph API," Facebook for Developers, accessed July 14, 2016, https://developers .facebook.com/docs/graph-api; and "Position.timestamp," Mozilla Developer Network, accessed July 14, 2016, https://developer.mozilla.org/en-US/docs/Web/API/Position /timestamp.

8. Catherine E. Shoichet, Joshua Berlinger, and Steve Almasy, "Alton Sterling Shooting: Second Video of Deadly Encounter Emerges," *CNN*, July 6, 2016, http://www.cnn.com/2016 /07/06/us/baton-rouge-shooting-alton-sterling/index.html.

9. Eve Kosofsky Sedgwick and Adam Frank, "Shame in the Cybernetic Fold: Reading Silvan Tomkins," in Sedgwick, *Touching Feeling: Affect, Pedagogy, Performativity* (Durham, NC: Duke University Press, 2003), 101.

10. Che Gossett, "Pulse, Beat, Rhythm, Cry: Orlando and the queer and trans necropolitics of loss and mourning," blog post, *Verso*, July 5, 2016, http://www.versobooks.com/blogs/2747 -pulse-beat-rhythm-cry-orlando-and-the-queer-and-trans-necropolitics-of-loss-and-mourning.

11. See Vindu Goel, "Facebook Tinkers With Users' Emotions in News Feed Experiment, Stirring Outcry," *New York Times*, June 29, 2014, http://www.nytimes.com/2014/06/30 /technology/facebook-tinkers-with-users-emotions-in-news-feed-experiment-stirring-outcry. html; and Samuel Gibbs, "Facebook Denies Emotion Contagion Study Had Government and Military Ties," *Guardian*, July 4, 2014, https://www.theguardian.com/technology/2014 /jul/04/facebook-denies-emotion-contagion-study-government-military-ties.

12. Herman Gray, "Subject(ed) to Recognition," *American Quarterly* 65, no. 4 (December 2013): 773, doi:10.1353/aq.2013.0058.

13. Ibid., 779 (emphasis added).

14. Anora Mahmudova, "This Man Wants to Upend the World of High-Frequency Trading," *MarketWatch*, February 17, 2016, http://www.marketwatch.com/story/this-man-wants-to -upend-the-world-of-high-frequency-trading-2016-02-02.

15. Gray, "Subject(ed) to Recognition," 784 (emphasis his).

16. Sedgwick and Frank, "Shame in the Cybernetic Fold," 110.

17. Crawford, "Artificial Intelligence's White Guy Problem."

18. Michel Foucault, *Discipline and Punish: The Birth of the Prison* (New York: Vintage Books, 1977), 200.

19. Jennifer Rizzo and Zachary Cohen, "Pentagon Ends Transgender Ban," *CNN Politics*, June 30, 2016, http://www.cnn.com/2016/06/30/politics/transgender-ban-lifted-us-military/.

20. Che Gossett, Facebook page entry, June 30, 2016.

21. bell hooks, "Postmodern Blackness," *Postmodern Culture* 1, no. 1 (September 1990), http:// www.africa.upenn.edu/Articles_Gen/Postmodern_Blackness_18270.html.

22. Ibid.

23. Eva Hayward, "Spider City Sex," *Women & Performance: a journal of feminist theory* 20, no. 3 (November 1, 2010): 227, doi:10.1080/0740770X.2010.529244.

24. Rosi Braidotti, *Metamorphoses: Toward a Materialist Theory of Becoming* (Cambridge, MA: Polity Press, 2002), 15.

25. "Intensive" is used here in a Deleuzian sense to refer to degrees of intensity, to gradation, as opposed to a digital on/off binary state. For more on this usage, see Manuel Delanda, *Intensive Science and Virtual Philosophy* (London: Bloomsbury Publishing, 2013).

26. Donna J. Haraway, "A Cyborg Manifesto: Science, Technology, and Socialist-Feminism in the Late Twentieth Century," in *Simians, Cyborgs, and Women: The Reinvention of Nature* (New York: Routledge, 1991), 155.

27. Sandy Stone, "The *Empire* Strikes Back: A Posttranssexual Manifesto" (1987), in *The Transgender Studies Reader*, ed. Susan Stryker and Stephen Whittle (New York: Routledge, 2006), 221–35.

28. Viviane Namaste, *Invisible Lives: The Erasure of Transsexual and Transgendered People* (Chicago: University of Chicago Press, 2000), 4.

29. "Statement: Do Not Militarize Our Mourning; Orlando and the Ongoing Tragedy Against LGBTSTGNC POC," Audre Lorde Project, June 15, 2016, http://alp.org /do-not-militarize-our-mourning-orlando-and-ongoing-tragedy-against-lgbtstgnc-poc.

30. Roderick A. Ferguson points to the ways that neoliberalism manages the visibility of difference in order to fend off claims for material redistribution. See Roderick A. Ferguson, *The Reorder of Things: The University and Its Pedagogies of Minority Difference* (Minneapolis: University of Minnesota Press, 2012).

31. Puar, *Terrorist Assemblages*, 35.

32. Melissa Gregg and Gregory J. Seigworth, "An Inventory of Shimmers," introduction to *The Affect Theory Reader*, ed. Gregg and Seigworth (Durham, NC: Duke University Press, 2010), 1.

33. Eliott C. McLaughlin, "Woman Streams Aftermath of Fatal Officer-Involved Shooting," *CNN*, July 8, 2016, http://www.cnn.com/2016/07/07/us/falcon-heights-shooting-minnesota /index.html.

34. See "All Lanes of I-880 in Oakland Reopen after Protest Blocks Highway," *ABC7 News*, July 8, 2016, http://abc7news.com/news/protesters-shut-down-lanes-of-i-880-in-oakland -/1418202/; and Jennifer Hassan and Jason Aldag, "Protesters March Around the World in Solidarity with Black Lives Matter," *Washington Post*, accessed August 28, 2016, https:// www.washingtonpost.com/video/world/protesters-march-around-the-world-in-solidarity -with-black-lives-matter/2016/07/11/e4340908-477e-11e6-8dac-0c6e4accc5b1_video.html.

35. Stefano Harney and Fred Moten, *The Undercommons: Fugitive Planning and Black Study* (Brooklyn, NY: Autonomedia, 2013), 149.

36. Cited in Jodi A. Byrd, *The Transit of Empire: Indigenous Critiques of Colonialism* (Minneapolis: University of Minnesota Press, 2011), Kindle edition, 187.

37. Madison Park, "Transgender Athlete Sues CrossFit for Banning Her from Competing as Female," *CNN*, March 7, 2014, http://www.cnn.com/2014/03/07/us/transgender-lawsuit -crossfit/index.html.

38. These apps have been exhibited at neue Gesellschaft für bildende Kunst, Berlin, as part of "contesting/contexting SPORT" (July 9–August 28, 2016), and at the 2016 Seattle Design Festival. More information on the project can be found at https://www.instagram.com /michacard.

39. As "The Drone Papers" points out, smart phones are often used to target individuals for drone strikes. See Josh Begley, "A Visual Glossary," in "The Drone Papers," *The Intercept*, October 15, 2015, https://theintercept.com/drone-papers/.

40. Gregg and Seigworth, "An Inventory of Shimmers," 20–21.

BLACKNESS AND THE TROUBLE OF TRANS VISIBILITY

Che Gossett

Blackness troubles trans/gender; blackness is trans/gender trouble. This essay is a reflection on how blackness destabilizes trans/gender, the human, and the category of the animal—logocentrism and anthropocentrism. I reflect on how blackness—in its troubling of human/animal binaries and trans/gender—also troubles the politics of trans visibility.

Black trans lives matter, and for Black trans women in particular, the struggle for life in all its capaciousness is a struggle against ongoing premature death. With the 2015 killing of Kiesha Jenkins in Philadelphia,[1] we are again reminded of the vicious violence against Black trans lives and the urgency of Black trans lives mattering as a matter for all Black lives.

As the Combahee River Collective states, "We Cannot Live Without Our Lives."[2] What is critical in our contemporary moment of neoliberal trans visibility and respectability politics is not only an understanding of the struggle against hyper-incarceration, HIV criminalization, and the prison—as both a necropolitical institution and a racialized and gendered apparatus[3]—but also a commitment to disability justice and healing justice, following the legacy of Sylvia Rivera, Marsha P. Johnson, and the liberatory and revolutionary trans political horizon they envisioned when they formed Street Transvestite Action Revolutionaries (STAR). One of the traps of trans visibility is that it is premised on invisibility: to bring a select few into view, others must disappear into the background, and this is always a political project that reinforces oppression. Trans visibility upholds what Audre Lorde calls a "mythical norm,"[4] while its discourse and politics reinforce what Herbert Marcuse calls "repressive tolerance."[5] The violence of colonialism and racial slavery, through which Black, queer, and/or trans identities have been forged, cannot be addressed through the politics of trans visibility. Trans (neo)liberalism and its attendant visibility

and respectability politics not only obfuscate liberatory trans politics—such as those emergent in the Stonewall uprising—but ultimately offer little recourse to those of us most targeted by the prison regime and white supremacy under the guise of feminism.

As non-sovereign and metapolitical, blackness makes for trans/gender trouble and invisibility. All too often, the ongoing black freedom struggle is seen as past and, therefore, becomes the absent presence that ghosts and haunts political imagination and social movements. The Black Lives Matter movement disrupts the institutional invisibility of blackness and the epistemic violence of anti-Black racism that enables it. Blackness is metapolitical; it transforms the world as we know it. Blackness escapes conceptual captivity under regimes of knowing, so that typical categories of political economy like "citizen" fall flat in the face of the murders of Eric Garner and countless others under the watch of the carceral state. Malcolm X knew this; he knew that we are "so-called" citizens,[6] as did James Baldwin, who said, "Blacks have never been, and are not now, really to be considered citizens here."[7] The colonial violence of the Middle Passage, which Fred Moten calls "the interpellative event of modernity,"[8] forms what might be considered the event horizon of racial capitalism.

Who gets to assume a body? Who gets to assume the integrity and security of that body? In this time of Black Lives [still] Matter, the answers to these questions are thrown into historical relief, as they were for Frantz Fanon and for so many others writing about the psychic life of racism in the afterlife of slavery. The contemporary wave of anti-trans bathroom legislation—part of anti-trans lawfare—across the United States cannot be disimbricated from the legacy of racial slavery and the criminalization of trans survival. The bathroom, with its gender-binary regime of sexual difference, is one of the signatures—along with hyper-incarceration, mass deportation, and racial capitalism—of the afterlife of slavery. The bathroom signs of the Jim Crow era referred to "men," "women," and "colored," dramatizing how the Lacanian "sexed body"[9] is always already a racialized body and a colonized body, and how Black and/or indigenous peoples have always figured as sexual and gender outlaws to be disciplined and punished. Trans of color prison abolitionists, from Miss Major to CeCe McDonald,[10] are part of an ongoing political struggle against the prison as a gendering racial and colonial apparatus, and extend the radical vision of abolition as a planetary relation.

In her canonical essay "Mama's Baby, Papa's Maybe,"[11] Hortense Spillers draws a distinction between the body, meaning selfhood and subjectivity, and the flesh, which is pre-discursive material and a zone of non-personhood, a state of abjection—a word derived from Latin meaning "to be cast down." Spillers moves us from the somapolitics of the body of the racial-colonial category of the

human to the flesh of the commodity—flesh as a mark that cojoins blackness and animality as property. In Spillers's theorization, there is a transfer of scale through the anatamo-political violence of colonialism and racial slavery, which renders the body flesh via racial capitalist logics of commodification:

> But I would make a distinction in this case between "body" and "flesh" and impose that distinction as the central one between captive and liberated subject positions. In that sense, before the "body" there is "flesh," that zero degree of social conceptualization that does not escape concealment under the brush of discourse, or the reflexes of iconography. Even though the European hegemonies stole bodies—some of them female—out of West African communities in concert with the African "middleman," we regard this human and social irreparability as high crimes against the flesh, as the person of African females and African males registered the wounding. If we think of the "flesh" as a primary narrative, then we mean its seared, divided, ripped-apartness, riveted to the ship's hole, fallen or "escaped" overboard.[12]

Spillers emphasizes the violence of the Middle Passage, during which commodity personhood is torn asunder and relinquished and the person is reduced to the flesh. Spillers's hermeneutics names this a process of de-subjectification. Under capitalism—which is always already racial—the Black body and the animal body are fused symbolically, and both are rendered as disposable. As Spillers makes clear, this flesh is also "ungendered":

> The [New World] order, with its sequence written in blood, represents for its African and indigenous peoples a scene of actual mutilation, dismemberment, and exile. First of all, their New World, diasporic flight marked a theft of the body—a willful and violent (and unimaginable from this distance) severing of the captive body from its motive will, its active desire. Under these conditions, we lose at least gender difference in the outcome, and the female body and the male body become a territory of cultural and political maneuver, not at all gender-related, gender-specific.[13]

Blackness ruptures trans representability, respectability, and visibility. The grammar of "cisgender" lacks the explanatory power to account for the colonial and anti-Black foundational violence of slavery and settler colonialism through which the gender and sex binary were forcibly rendered. From the Combahee

River Collective's critique of biological essentialism as a "dangerous and reactionary basis upon which to build a politic"[14] to trans genealogies of black feminism—or, black feminism as always already trans—black feminism has always issued challenges to the categories of binary gender and of medically assigned binary sex, while continuing to call for liberatory forms of abolition. Perhaps the various black radical feminist devices that insurgently undermine white supremacist settler colonial heteropatriarchy might be linked up and networked, or perhaps they are already linked up and networked—a structure of black feminism as always already encompassing trans radical feeling.

The colonial racialization of blackness is imprinted on modernity through the animalization and bestialization of blackness. In *On the Postcolony*, Achille Mbembe shows how the African is depicted via "the metatext of the animal—to be exact about the beast."[15] It is through what he calls this "grammar of animality" that the African is placed in the double bind of the beast.[16] On the one hand, Mbembe argues that the African, like the animal, figures as monstrous, wild, etc., and on the other hand, that the African, just like the animal, is capable of eventual domestication and even so-called civilization.[17] And yet, blackness remains the unthought of both critical animal studies and animal liberation discourse. For animal studies activists and philosophers, slavery and abolition are often narrativized as teleological—as though Black freedom has been secured and now the animal must be freed.[18] Melding Frederick Douglass with Raymond Williams, we might say that an anti-Black structure of feeling saturates critical animal studies as a thought style.[19] Ironically, even in its anti-anthropocentric claims, critical animal studies repeats a familiar pattern of liberal humanist thought when it hollows out the political grammar of "slavery" and "abolition" in an act of erasure and extraction from racial slavery and anti-Black racism. Blackness still figures as a surrogate body—in this case, a body of scholarly knowledge—for white appropriation.

The human/animal binary corresponds with an animate/inanimate binary. As Mel Y. Chen shows in *Animacies: Biopolitics, Racial Mattering, and Queer Affect*, the "animacy hierarchy" in linguistics reinforces the ordering of life along a scale of sentience premised on a Cartesian dualism of body and mind.[20] Against this, they theorize animacy as a continuum, a horizontal field, and unlike many new materialists and object-oriented ontologists, they maintain a critical stance toward racialization, colonialism, and capitalism. Chen argues for a vitality immanent to all material and shows how, for enslaved Africans, racialization is animalization. Their work on the animacy hierarchy in linguistics connects to the theorizations of postcolonial studies scholars, such as Lisa Lowe, Sylvia Wynter, and Denise Ferreira da Silva, who deconstruct not only liberal humanism and the human as sites and

technologies of racial-colonial scientism, but also Enlightenment/Reason (with its roots in the Islamic Enlightenment obscured) as sovereign knowledge/power.

In contraposition to this long historical framing, Black radical thinkers from Frederick Douglass to Frantz Fanon to Angela Davis have posed a radical revision of the terms of the human/animal binary, using their unique ontological position to consider the ways blackness has been rendered as outside of the human and in proximity to the animal—namely, as beast. As Fanon and other Black intellectuals have (re)marked, blackness has been rendered sub- and suprahuman through onto-epistemologies of colonial racialization as animalization and racialization as mythologization (blackness framed as radical evil).[21] The black radical tradition forces a rethinking of "the problem of the human" (as subject) and the "problem of the animal" (as object) from the position of always affectively knowing—in a haptic sense (to touch an object)—how it feels to be a problem.[22]

In her brilliant essay "Slavery as Contract: *Betty's Case* and the Question of Freedom," Sora Han discusses blackness as nonperformance, conceptualizing blackness as "a performative against all performances of freedom and unfreedom dependent on the historical dilemma of a lack of meaningful distinction between freedom and slavery."[23] This provides a means to think about the gender trouble caused by blackness as well: blackness as gender nonperformance. Visibility politics, or the kind of queer and trans politics we might call neoliberal, cannot account for the ways that blackness ghosts and haunts the normative, the way it exceeds representational fixity. Black studies and Native studies as trans studies open out toward insurgent trans worlding. This opening outward might be analogized to what poet Nathaniel Mackey terms "centrifugal writing": "Centrifugal work begins with good-bye, wants to bid all givens goodbye. ... In the face of a widespread fetishization of collectivity, it dislocates collectivity, flies from collectivity, wants to make flight a condition of collectivity."[24]

Making flight a condition of collectivity harkens back to the figure of the maroon. Through this figure, blackness troubles both the human and the undomesticated animal as property. The maroon is escaped property, property on the run. The maroon is dis-possession. The maroon throws into relief how the regime of racial capitalism orchestrates both animal and human captivity under colonial lawfare. Blackness—as metapolitical, para-human, and para-animal—troubles both logocentrism and its attendant anthropocentrism. Mackey's call for "flight as a condition of collectivity" also echoes George Jackson's influence on Gilles Deleuze and Félix Guattari's rhizomatic thought style, specifically the concept of lines of flight.[25] The maroon also marks a fugitive move away from both what Sylvia Wynter calls the "genre of 'Man'"[26] and what we might call, following her

thought style, "the genre of the animal." Blackness as a refusal of the genre of the hu-Man is also a refusal of the violent strictures of binary gender and sexualization imprinted on black sociality via racial slavery and colonization.

...

"Blackness and the Trouble of Trans Visibility" by scholar, activist, and archivist Che Gossett was written in 2016 for this volume. It expands on some of the ideas presented in their essay "Žižek's Trans/gender Trouble," published in the *Los Angeles Review of Books* on September 13, 2016.

...

NOTES

1. Cleis Abeni, "Philly Trans Woman Becomes 20th Murdered in U.S. in 2015," *Advocate*, October 6, 2015, http://www.advocate.com/transgender/2015/10/06/kiesha-jenkins -becomes-20th-us-trans-woman-murdered-year.

2. Maria Elena Gonzalez, Margo Okazawa-Rey, Barbara Smith, and Demita Frazier, all members of the Combahee River Collective, carried a banner emblazoned with these words during a 1979 march in Boston protesting the murder of Black women. For more on the collective, see Winifred Breines, "Alone: Black Socialist Feminism and the Combahee River Collective," and "Apart and Together: Boston, Race, and Feminism in the 1970s and Early 1980s," in *The Trouble Between Us: An Uneasy History of White and Black Women in the Feminist Movement* (Oxford: Oxford University Press, 2006), 117–50 and 151–92, respectively.

3. For more on the prison industrial complex and its relationship to trans, see Eric A. Stanley and Nat Smith, eds., *Captive Genders: Trans Embodiment and the Prison Industrial Complex* (Oakland, CA, and Edinburgh: AK Press, 2011 and 2015).

4. Audre Lorde, "Age, Race, Class, and Sex: Women Redefining Difference," in *Sister Outsider: Essays and Speeches* (Freedom, CA: Crossing Press, 1984), 116.

5. Herbert Marcuse, "Repressive Tolerance," in Robert Paul Wolff, Barrington Moore Jr., and Herbert Marcuse, *A Critique of Pure Tolerance* (Boston: Beacon Press, 1965), 81–117.

6. In a debate with Bayard Rustin, Malcolm X said: "You preach one thing and practice another thing. You say that this is the land of equality, and twenty million black citizens, so-called citizens, don't have equality. You say this is the land of freedom, and twenty million black people here don't have freedom. You say that this is the land of justice, and twenty million black people here don't have justice. And the government, from the Supreme Court, the Senate, and the Congress, and the President, on up or down combined is not able to bring about any change in the attitude of white America toward black America." Malcolm X, "Separation or Integration: A Debate Between Malcolm X and Bayard Rustin," January 23, 1962, video, https://www.youtube.com/watch?v=cYiTcWsgNqQ.

7. James Baldwin, *The Evidence of Things Not Seen* (1985; repr., New York: Henry Holt, 1995), 31.

8. See Fred Moten, "Notes on Passage (The New International of Sovereign Feelings)," *Palimpsest: A Journal on Women, Gender, and the Black International* 3, no. 1 (2014): 65.

9. Kirsten Campbell, *Jacques Lacan and Feminist Epistemology* (New York: Routledge, 2004), 64.

10. For more on Miss Major and CeCe McDonald, see Miss Major Griffin-Gracy and CeCe McDonald in Conversation with Toshio Meronek, "Cautious Living: Black Trans Women and the Politics of Documentation" on page 23 of this volume.

11. Hortense J. Spillers, "Mama's Baby, Papa's Maybe: An American Grammar Book," in *Black, White, and In Color: Essays on American Literature and Culture* (Chicago: University of Chicago Press, 2003), 203–29.

12. Ibid., 206.

13. Ibid.

14. Combahee River Collective, "The Combahee River Collective Statement," *Circuitous*, accessed September 22, 2016, http://circuitous.org/scraps/combahee.html.

15. Achille Mbembe, *On the Postcolony* (Berkeley: University of California Press, 2001), 1.

16. Ibid.

17. This argument naturally extends to racial slavery, what Moten (via Louis Althusser) calls "the interpellative event of modernity," and Dionne Brand calls "a tear in the world." See Fred Moten, "Notes on Passage (The New International Sovereign Feelings)," 65; and Dionne Brand, *A Map to the Door of No Return: Notes to Belonging* (Toronto: Vintage Canada, 2012), respectively.

18. See, for example, Sarah Grey and Joe Cleffie, "Peter Singer's Race Problem," *Jacobin*, August 6, 2015, https://www.jacobinmag.com/2015/08/animal-rights-cecil-the-lion-peter-singer-speciesism/.

19. Here, I mean to bring together Frederick Douglass's thoughts on "anti-black feeling," as expressed in his 1845 speech, "American Prejudice Against Color," and Raymond Williams's discussion of a "structure of feeling." See Frederick Douglass, "American Prejudice Against Color," in *The Frederick Douglass Papers: Series One—Speeches, Debates, and Interviews*, vol. 1, ed. John Blassingame et al. (New Haven, CT: Yale University Press, 1979), 59; and Raymond Williams, *The Long Revolution* (Petersborough, ON: Broadview Press, 2001).

20. Mel Y. Chen, *Animacies: Biopolitics, Racial Mattering, and Queer Affect* (Durham, NC: Duke University Press, 2012).

21. See Frantz Fanon, *Black Skin, White Masks* (1952; repr., New York: Grove Press, 2008).

22. As W. E. B. Du Bois wrote: "Between me and the other world there is ever an unasked question: unasked by some through feelings of delicacy; by others through the difficulty of rightly framing it. All, nevertheless, flutter round it. They approach me in a half-hesitant sort of way, eye me curiously or compassionately, and then, instead of saying directly, How does it feel to be a problem? they say, I know an excellent colored man in my town; or, I fought at Mechanicsville; or, Do not these Southern outrages make your blood boil? At these I smile, or am interested, or reduce the boiling to a simmer, as the occasion may require. To the real question, How does it feel to be a problem? I answer seldom a word." W. E. B. Du Bois, "Of Our Spiritual Strivings," in *The Souls of Black Folk* (1903; repr., Mineola, NY: Dover, 1994), 1.

23. Sora Han, "Slavery as Contract: *Betty's Case* and the Question of Freedom," *Law & Literature* 27, no. 3 (2015): 407.

24. Nathaniel Mackey, "Destination Out," in *Paracritical Hinge: Essays, Talks, Notes, Interviews* (Madison: University of Wisconsin Press, 2005), 241.

25. See Michelle Koerner, "Line of Escape: Gilles Deleuze's Encounter with George Jackson," *Genre* 44, no. 2 (2011): 157–80; and Jeremy M. Glick, "Aphoristic Lines of Flight in *The Coming Insurrection*: Ironies of Forgetting yet Forging the Past—An Anamnesis for George Jackson," *Situations: Project of the Radical Imagination* 4, no. 2 (2012): 81–109.

26. "I am trying to insist that 'race' is really a code-word for 'genre.' Our issue is not the issue of 'race.' Our issue is the issue of the genre of 'Man.' It is this issue of the 'genre' of 'Man' that causes all the '-*isms*.'" Sylvia Wynter, quoted in Greg Thomas, "PROUD FLESH Inter/Views: Sylvia Wynter," *PROUDFLESH: A New Afrikan Journal of Culture, Politics & Consciousness* (2006), https://serendip.brynmawr.edu/oneworld/system/files/WynterProudflesh.doc.

REPRESENTATION AND ITS LIMITS

Roundtable Participants: Lexi Adsit, Sydney Freeland, Robert Hamblin, and Geo Wyeth
Moderator: Tavia Nyong'o

In the summer of 2016, the editorial team for *Trap Door: Trans Cultural Production and the Politics of Visibility* invited cultural critic, historian, and performance studies scholar Tavia Nyong'o to moderate an online roundtable discussion on the topic "Representation and Its Limits" with writer and producer Lexi Adsit, director and filmmaker Sydney Freeland, artist and activist Robert Hamblin, and artist and musician Geo Wyeth. The discussion evolved from an initial prompt developed by the volume's coeditors (and reproduced below), upon which Nyong'o expanded with a series of questions to engage the participants in dialogue.

.........

While the past few years have seen more attention to (some) transgender people and issues in the mainstream media, what are the pitfalls of this increased visibility? When trans life or "trans art" can be co-opted to advertise the progress and benevolence of art world institutions and the state, what new obstacles arise? How do trans artists in particular find a way through institutions that invite some in, know their preferred names and pronouns, and occasionally offer all-gender bathrooms, yet could not exist without capitalism, ableism, transphobia, and white supremacy? What are the limits of representation, and what strategies are we using now—in the visual realm and in general—to make a way out of no way?

ROBERT HAMBLIN: My mentor says art is entertainment. When previously hidden people rise into the public eye, it functions as entertainment; it is part of the violence of life. During my transition from female to male, I functioned as entertainment for South Africa's most privileged—white Afrikaans media

covered my story extensively. I felt the peering gaze of my own class: I was a trans* poster boy for them. During this time I was also cofounding a transgender rights organization, Gender DynamiX. But there I realized that my narrow and privileged view of transgender emergencies was redundant. The work for activists and organizations lay elsewhere: black transgender people were acutely visible and in danger in society, and their rights were nowhere in reach. I left Gender DynamiX and started volunteering at the organization SWEAT, which works for sex workers' rights. There I helped cofound the Sistaaz Hood, a support group for trans* women who are homeless and who sell sex in Cape Town. My privileged life and their very untamed experiences of the city we shared were polar opposites. The tension of this intersection between our lives as gender transgressors seemed like the space I needed to explore.

By the time I exited organizational work professionally and returned to art, I felt angry about being stared at. The members of the Sistaaz Hood were keen to make art with me, but I needed to somehow sabotage the way people were looking at us. I wanted privacy for my and their pain, but also I wanted to use our lives to deflect a patriarchal gaze. I wanted to use the visual tensions between what my body and their bodies represented to point out a fault line in society through my art, rather than symbolize a pocket of cloistered nonconformists.

GEO WYETH: There are holes in every surface, and maybe we could live inside them.

I am a performer, and a pervert. I kind of enjoy the push and pull of an audience's eyes—it gives me a clown zone to play in as I distort and disrupt my own image. This interplay allows me to shift the conditions of the moment, but perhaps those conditions never become entirely clear. Then where are we? Who are we? When "who I am" is not just about what I look like, how can we meet one another?

I think a lot about what it means to be visible, to whom and to what ends, and like you, Robert, I take issue with being "looked at," even as a white-looking, passing trans man. I generally don't participate anymore in mainstream commercial opportunities to be a poster boy, because I feel like my image tells a particular story of "passing = beauty" to the mainstream media that I am not interested in and that I don't think helps anything. Here I am participating in this discussion, though. Whom am I targeting with my representation? Do I have a responsibility to use a certain rhetoric or style of image-making as a transgender person?

The self, to me, seems to be a roving ghost of desire, necessity, circumstance, and reception, which may or may not always be explicit, depending on where one is. I am how I am seen or viewed by others. But if I am black or I am trans,

and if people can't see that, then what am I? Sometimes it's hard to distinguish the difference between the self we hold inside of us and the self that is named by others.

We become "visible" on our own terms, perhaps in order to eliminate the control that someone else's gaze has. The problem is that once I become visible through naming myself, I become an image. I have recently been making a lot of work with words and names, and thinking about the idea of going inside the word, or behind a name, to find an interior space—some kind of windstorm or fish tank or inner chamber. Also, I have been thinking about names and words as shields.

Emily Roysdon asks, "Does naming time generate time?"[1] I say that naming ourselves, out loud, on TV, to people who know little about the realities of our lives does generate new understanding, new ways of being, and hopefully, empathy, *but* it can't stop there. In fact, this kind of self-entrapment/self-determination needs to be levied by ways of being that are not reliant on the image as the sole definer of the self. Do I have to name myself to be visible?

SYDNEY FREELAND: I transitioned over ten years ago, and most of my experiences early on revolved around how "exotic" I was. I remember, growing up, the only Trans representation I really saw was on talk shows like *The Jerry Springer Show* and *The Maury Show*. I think this can be harmful when people stop looking at you as a person. I've found that those who are attracted to that "exotic" nature tend to have very specific motivations. On the flip side, those who are "against" who I am tend to have a very simplistic and biased view of the Trans community. Again, there is a tendency to not see you as a person. Some of the violent acts I've seen committed against my community come from a place of seeing us as "less than," which can then be used to justify the violence.

This brings us to our current time. The Trans experience has now become mainstream, and I would go so far as to say it's even popular to be Trans. I think this is a great opportunity to educate people. In 2016, I was hired to direct a web series called *Her Story*. What attracted me to the project was that it was a story about Trans Women, but it wasn't about transitioning. I thought that was really interesting, but when we went into production, I wanted to push things further. My goal while shooting and editing the project was not to focus on how different or exotic the characters were, but to get people from outside the community to be able to relate to these characters on a personal level. I think this is one of the good things about Trans representation in the media. The more we see of the community, the more we have the chance to be viewed as people.

TAVIA NYONG'O: Art and self-fashioning have long been central to the world-making projects of minoritarian subjects. In what ways do you see your work as contributing to transgender communities, counterpublics, worlds, or movements?

LEXI ADSIT: My entry point into art was in 2014 with an organization called Peacock Rebellion, a San Francisco Bay Area–based Queer and Trans People of Color crew of artist-activist-healers who make sassy, sexy art to help build a culture of social justice, with an emphasis on healing justice. I received training as a stand-up comedienne, and the special aspect of Peacock Rebellion's training program is that we turn the jokes against systems of oppression. We make fun of medical gatekeepers instead of Trans people. We make fun of border patrol instead of people seeking to survive and thrive, who have to cross an imaginary border. This collaboration culminated in the first edition of an annual show called Brouhaha in 2014, with a mixed lineup of ten Queer and Trans People of Color who had been trained by Micia Mosely and Nia King. Our show was produced by Peacock Rebellion's Artistic Director, Devi K, and Artistic Core member Jezebel Delilah X. Peacock Rebellion's work had opened the door for Queer and Trans People of Color to turn the tables of comedy against people who would usually make us the butt of a joke.

In 2015, at Devi's invitation, I became a producer of Brouhaha and was given creative control over its content. We brought on a lineup of only Trans Women of Color to be trained by Luna Merbruja in comedy-based storytelling. Something more unique about the 2015 show was that our intentions shifted midway through our training program, from putting on the best show we could to giving Trans Women of Color a space to share their stories. It became a historic and widely recognized event, receiving coverage in *Bitch* magazine, on *Autostraddle*, and in the *East Bay Express*.

Recently, in 2016, we created a comedy mega-show, bringing back a mix of artists from the previous two shows and including special guests CeCe McDonald and Miss Major. I produced our 2016 show with Nava Mau, and there was no training program. Our shift to focus heavily on Trans Women of Color in 2015 and 2016 was in response to the egregious amounts of violence our community had faced. As a Transgender Latina woman myself, I wanted to make sure that Trans Women of Color had an opportunity to laugh and heal from the daily violence and trauma that we experience. Bringing first-time comediennes and artists into our programs and training them are extremely important for reflecting the diversity and depth of our local community in the Bay Area. Eventually we hope to shift our comedy and shows to more closely reflect campaigns by our partner organizations from previous shows, such as the Transgender, Gender Variant,

and Intersex Justice Project; El/La Para TransLatinas; Communities United Against Violence; and others.

HAMBLIN: My first body of work as a trans* person, *The Sistaaz Hood* (2012), was made with the Sistaaz Hood support group. How would I fulfill my ambition to only present our bodies conceptually and resist the documentary impulse of photography and all the oppressive dictations inherent in it? It was a difficult task because I wanted to collaborate with people who spoke an entirely different lingo than I did. I was steeped in international advocacy language and art concepts. Even as an "outsider artist" without academic training, I was still departing from a space where I was heavily influenced by my relationships with artists in the mainstream of contemporary art. The months I spent with the members of the Sistaaz Hood were at their pace, and naturally there was an exchange of knowledge. Some of them became interested in international trans* advocacy language and activism, information about medical transition, and applicable identity laws. I can't claim this as an intentional effect; it was just an outcome.

I suppose some would say I did "workshops" with the group members, but in all honesty, the group was so informal and chaotic that the process with them was more like noisy, scary, haphazard conversations. They wanted to make it clear that sex work was their occupation and that the male/female conundrum did not diminish their desirability. They wanted to be beautiful in the images and for me to treat them in the same manner as I treated my privileged cis female subjects—obscuring undesirability and optimizing their femininity, as done in magazines. We agreed on nudity with some makeup and minimal feminine accessories, and movement to illustrate how they work. In South Africa we have an identity document with a personalized number. The middle digits of this number are coded to indicate the gender/sex of the person that is assigned at birth. A male person's number falls above five thousand, and a female person's number falls below. To bring this element into the work, I dot-pierced the final images with four-digit numbers above five thousand. Most often, I used the subject's actual identity number, which would naturally be a number above five thousand because they were assigned the gender/sex of male at birth; this number is in contrast to their feminine expression. The trans* women in the portraits are unable to change their documents and the male number assigned to them because of [their] poverty and lack of access to medical care related to transgender health. It is impossible to live a functional life without the correct documents; you need them to open bank accounts, apply for employment, and access medical care and grants, to name just a few applications. Juxtaposing their bureaucratic identity with their expressed identity was an advocacy effort

to point to the injustice a system imposes on trans* people's lived identities. I also split some of the images with the framing mount to indicate the break a gendered bureaucratic system causes in their lives.

After working with the Sistaaz Hood, I felt a little frustrated. I might have diverted the popular way to look at "us," but I was feeling nervous about my whiteness, as a problematic presence in the group. I started a new project, *Threshold* (2013–16), in which I photographed cis men with whom I identify, keeping the aesthetic I had developed in the previous project and incorporating movement, blur, and performance. I was now looking back at those who were looking at us. I was looking at men now and at their bodies. In interviews before the shoots I would confront them with my identity, the workings of my body; we would compare notes. Excerpts from their interviews were translated into binary code and penciled onto the images. I chose quotes where they express fears of how their masculinity is valued in society and frustration at how the measuring of their masculinity felt like the devaluing of their humanity. I identified with the notion of one's humanness being valued according to one's ability to perform gender.

WYETH: Sometimes I am skeptical about community, or what it means, and who is included. I will always feel queer, I am queer, and the queer performance community made me. But I am also a sneak and a cruiser; I like to be kind of roaming and mostly on my own, like that person wearing sunglasses in the movie theater. I feel like Batman a lot. Because I pass in many ways, many of them circumstantial but not arbitrary, I am not sure what communities I am beholden to. I often feel isolated, but perhaps this is just part of the position I hold. I think about my friends often when making work, but many of them live far away and come from a vast group of people that is international and culturally diverse. In my personal experience coming up as a performer in New York, community has mostly happened through parties, and so I started one here in Amsterdam at a local bar, which I perform at every month. This has been a great way to interface with a local community, and to find ways of connecting cross-culturally. Different artists perform, do readings, and hold screenings. We generate revenue for a local business on a weeknight. This feels like community to me; we are beholden to one another.

I out myself constantly in many ways; I enjoy confusing people, and each place I perform in calls for its own terms of engagement. Recently, I have been performing a lot in art institutions, and there've definitely been weird moments. I am currently at Rijksakademie, an international artist residency in Amsterdam, where I'm the only transperson. How am I beholden to this institution, as a

member of its community? I just try to communicate to whoever is there, to meet them where they are (or at least try to), and to challenge them when I feel it is necessary. I do spend an enormous amount of energy talking about gender and identity with straight people, and I feel this means something in terms of world-making—trying to mangle the "truth" of gender and identity without giving people too many easy answers. This is a position that I have mixed feelings about, but ultimately embrace and try to use.

NYONG'O: Is the art institution in any way redeemable at an ideal level? Or is our relationship to it a necessarily criminal one, as Fred Moten and Stefano Harney have remarked of the university institution (another site where ideals radically diverge from reality)?[2]

ADSIT: No. It's not redeemable. Not in a world where paychecks are prioritized over people. I can't talk about all the violence I've witnessed at the hands of art institutions, but I can say that they have been replicating and reifying our larger systems of oppression. I do believe they are "necessarily criminal," and Peacock Rebellion is constantly finding ways to resist that, while at the same time trying to survive.

We were born out of the brilliance of other performance arts groups such as Mangos With Chili, Sins Invalid, and the Queer Women of Color Media Arts Project. The work by so many Queer Women of Color has allowed Peacock Rebellion, primarily led by Trans femmes and Trans Women of Color, to exist and thrive in this modern space. However, we still have to navigate a lot of traumatizing events and institutions that try to make us jump through hoops that we don't have the ability to jump through.

Also, art institutions will at times protect artists in our community who replicate transmisogyny, racism, ableism, or other oppressions under the guise of art. Art, to me, doesn't mean you can just throw anything on a stage. We as Trans people and producers have a responsibility to our audiences, artists, and communities to not make the gallery or theater a less safe space. I also find that this means these producers and organizations become complicit with the larger art institution, even when they've intended to resist it. Having to navigate any institutional world, especially the arts, is toxic for any marginalized person. When you experience intersectional oppression, it can be that much worse. You are, in any institutional space, held to higher standards and given less reward for your hard work. Your brilliance is often co-opted and [your] labor often erased. Your identity gets commodified.

WYETH: I think the art institution is like the Blob: it can devour you, and then you become a part of it. But then what do you do? How are you beholden to it? It is also a conduit; it is a donut; it is a hoop spinning—they want you to jump through it, in roller skates. I relate to Lexi's statement about how navigating institutions is toxic. The amount people have to prove in terms of their worthiness of institutional support is sickening. And then the support is not that great, and could result in your work being flattened, misrepresented, etc. I think the best thing to do is to just focus on what the work needs and allow institutions to help you if you need help, and if you don't, move out of the way so other people can get the help. And just murder the institution while it is sleeping, pet it to death, and hold it accountable. Help your friends, and invite everyone you love to reap the benefits if there are any.

NYONG'O: Is the idea of an artistic avant-garde (a small group united in posing a militant challenge to the existing order) in any way appealing to you? How do you find questions of identity and difference handled within an art world context, in possible contrast to other communities or worlds that you belong to or are in-volved with?

HAMBLIN: I think the notion of queer artists or trans* activists being a united group is a romantic one. I have never had such an experience, perhaps others have. Rather, my experience has been much like the well-known story that com-pares oppressed people to crabs thrown into a basket. Crabs have the habit of perpetually pulling one another down, which causes an interesting maelstrom wherein none of them manage to escape, even when the basket has no lid. In the story, one crab manages to climb to the top of the basket, poised to escape from captivity. However, the fisherman who had caught them simply drops the escapee back into the basket ... Both my life and my art-making only fall within a so-called group when seen from an outside perspective. Curators, galleries, and writers would make attempts to frame me or resist framing me in these catego-ries, whichever seemed more worthwhile to their commodification of my work. For me, the categories of "queer" and "trans*" are, by design, in reference to an imaginary norm.

ADSIT: Of course the idea of an avant-garde appeals to me! Very much so, in the way that becoming a superhero also appeals to me. And, of course, it also has its limitations and unrealistic expectations. Just one of the issues we've faced as an organization at Peacock Rebellion is trying to maintain our Artistic Core, which is meant to be a group of people that lead our events and programs.

However, with very human realities of gentrification, employment, and relationships, people have had to move on or out of the San Francisco Bay Area, whether it was their choice or not. One of the big differences I've noticed between art groups and the other worlds I navigate is the scarcity and lack of money moving towards groups of Queer and Trans People of Color and the lack of resources for Transgender Women of Color specifically. I see many Transgender Women of Color artists not getting the same recognition or space to succeed within art spaces, which is why Peacock Rebellion is so important to me.

Finally, our group's approach to supporting our artists differs significantly from those of other groups working with Queer and Trans People of Color. For example, I've seen artists and organizations perpetuate transmisogyny and racism either in art performances or internal practices and not take responsibility for these issues. However, what I've seen at Peacock Rebellion internally is [that] we do two, three, or four times as much work and get about half as much credit as we should. And that's also something I've experienced in my professional life. As a producer, I have achieved a high level of success and exposure, often being told I am "low-key famous." However, while my labor was key to the success of the 2015 and 2016 *Brouhaha* shows, I did not feel like it was my artistic labor that was being celebrated or nurtured within these spaces.

NYONG'O: I'm glad the "superhero" fantasy of the avant-garde resonated with Lexi. Are fictions and speculations inspirational for how you resolve these dilemmas of art versus activism, the individual versus the community, and visibility versus fugitivity?

ADSIT: I could name a number of fictional characters that have given me inspiration, but I most want to recognize my mentors and friends who have made this world a much better place. The Artistic Director of Peacock Rebellion, Devi K, and fierce Trans rights advocate Miss Major. Ancestor Sylvia Rivera. Ancestor Marsha P. Johnson. Executive Director of the Transgender, Gender Variant, and Intersex Justice Project, Janetta Johnson. Executive Director of El/La Para TransLatinas, Susana Cáceres. Having had most of my formative experiences within the nonprofit world, I have been blessed to find people within that community that nurture, guide, and teach me about what it means to be a leader, an organizer, and an artist.

WYETH: Yes, definitely. To process some harsh truths, I find speculation and fantasy helpful, and more often illuminating, because fantasy and speculation take me inward, rather than outward. I spent a lot of time alone as a kid, and I

always relied on my mind to take me to other places. I can process things through my imagination, constructing worlds or rewriting histories to include expanded versions of truth. For example, in a recent song I wrote, "Juice Inferno," a lost tourist stands outside a nightclub and makes a jingling sound with his eyes, sending a signal across a street to an imaginary entity named Juice. Juice is a sort of wormhole in time, represented by a vortex created by a rolling suitcase and a red hoodie. The two objects are spinning in the air in front of a shop on the corner. I think the character is feeling a sensation of disassociation in the face of a complex and potentially violent scene. Like, they are seeing a portal to another dimension and calling out to it as though it were a person. Fugitivity could be another mode of telling—like when someone runs away from visibility, makes themselves scarce, what does it say? What truths does it hold up? Refusal can be a sort of protest of all of these conditions of being.

..

This roundtable discussion was convened online in the summer of 2016 for this volume.

..

NOTES

1. Emily Roysdon, "Uncounted," accessed October 12, 2016, http://emilyroysdon.com/index .php?/texts/uncounted/.

2. Stefano Harney and Fred Moten, *The Undercommons: Fugitive Planning and Black Study* (Brooklyn, NY: Autonomedia, 2013), 26–30.

Heather Love

Alison Bechdel published the first drawing from her long-running comic strip *Dykes to Watch Out For* in the radical feminist newspaper *WomaNews* in 1983. Over thirty years later, in the spring of 2015, a musical based on her best-selling graphic memoir *Fun Home: A Family Tragicomic* (2006) opened at the Circle in the Square Theatre on Broadway. The musical, adapted by Lisa Kron and Jeanine Tesori, broke box office records and won five Tony Awards, including Best Musical, Best Book of a Musical, and Best Original Score. Bechdel's memoirs, *Fun Home* and *Are You My Mother?* (2012) won her widespread recognition, critical acclaim, and a place on many college syllabi.[1] The appearance of *Fun Home* on Broadway made her a star, albeit a reluctant one. Bechdel's story can be told as an artistic genius's long road to recognition. This story is true—but it is not complete. During the same decades that Bechdel deepened her art and took on an autobiographical project of Proustian ambition, new audiences emerged for queer, lesbian, and transgender work. Her early drawings of "whacked-out" lesbians exemplify minor or niche representation,[2] but *Fun Home*—despite the fact that it is about a lesbian who is pretty whacked-out—is widely hailed as a story of universal significance.

In a 2015 profile in the *New Yorker*, Bechdel expressed ambivalence about the "universal" framing of her work: "It's funny. … When the memoir came out, I bristled at critics who qualified the struggle it describes as 'universal.' It felt like they were trying to co-opt my identity. But it doesn't strike me that way anymore. I've come to the conclusion that we're all queer—there is no normal."[3] Bechdel's vision of a queer takeover of the mainstream is very appealing, and it accounts, to some extent, for the cultural phenomenon of *Fun Home*. As the *New York Times* notes, the musical overcame "enormous skepticism about its Broadway viability":[4] the story of a middle-aged, butch lesbian cartoonist grappling with

Alison Bechdel, *Marianne, dissatisfied with the breakfast brew*, plate no. 27, *Dykes to Watch Out For*, 1982. Ink on paper, 8 ½ × 11 in (21.6 × 27.9 cm). Courtesy the artist. Image: © Alison Bechdel, 1983

the probable suicide of her closeted gay father does not scream "box office." The same *New York Times* article notes that the play was "unable to build the audience for a multiyear run on Broadway."[5] By whatever measure, though, the success of *Fun Home* is remarkable. While we may understand that success in the terms Bechdel proposes (everyone is queer now), another, bleaker, explanation also presents itself: no one is.

That a story of a genderqueer childhood set in a funeral home in rural Pennsylvania would capture the imagination of mainstream theatergoers may not be that surprising given what Hilton Als describes as Broadway's taste for otherness. Pointing to the centrality of outsiders in even the most traditional plots (his main example is *Oklahoma!*), Als asks, "If American composers and lyricists were to jettison the idea of difference from their plotlines, would they still be writing American musicals?"[6] Als argues that American musicals integrate the threat posed by an outsider into the social order. But *Fun Home* works differently: it describes a thwarted longing for normalcy by Alison's closeted gay father Bruce and, at the same time, narrates Alison's escape from normalcy into a different kind of life. Through her "honesty and strength," Als writes, Alison is able to "articulate her choices and follow them openly."[7] But if the brave choices that Alison makes go on to be applauded by sold-out audiences on Broadway, does the resolution of *Fun Home*—awkward, anxious child becomes assured, adult lesbian artist—count as a break with normalcy or merely an adjustment of the norm to make it more inclusive? Is everyone queer, or no one?

Like many queers, I sat in the audience of *Fun Home* with mixed feelings. A long-time fan of Bechdel's work, I was happy but disoriented to see what, despite all evidence to the contrary, I still understood as a subcultural aesthetic greeted by such widespread and enthusiastic acclaim. I considered myself hardened to such ups and downs, having witnessed so many waves of LGBT visibility come and go without leaving a trace on politics or everyday life. *Fun Home*'s success might be just another flash in the pan. But this felt different because it formed part of what Susan Stryker, in a response to Jill Soloway's *Transparent* (Amazon Prime, 2014–ongoing), called an "utterly transformed" media landscape.[8] This transformation included the rise of transgender icons from Laverne Cox to Chelsea Manning to Caitlyn Jenner, the runaway success of award-winning shows like *Transparent* and *Orange Is the New Black* (2013–ongoing), and the popularity of books such as Janet Mock's *Redefining Realness* (2014) and Maggie Nelson's *The Argonauts* (2015). While some of these representations trafficked in familiar ploys—the centering of Piper Chapman's point of view in *Orange Is the New Black*, for example—they also introduced unprecedented diversity in cast and crew, and brought recognizably queer and trans perspectives to a general

audience. *Fun Home* won recognition as the first Broadway musical to feature a lesbian protagonist, but it was hardly a "homonormative" representation: dealing with themes including intergenerational sex and suicide, it also focused significantly on genderqueerness and, through its representation of Alison at different ages, put several varieties of butch gender on stage.[9] Taken together, these shows suggested that gender normativity was no longer a strict condition of mainstream success, as it long had been in queer media, even if the racial and class norms governing that success remained mostly unchanged.

Legal and social changes over the past decade have made visibility feel less detached from the infrastructure of queer and transgender life. At the same time, ongoing violence against the most marginalized and vulnerable can make visibility itself seem not only irrelevant but toxic. Still, understanding the limits of visibility does not necessarily protect one against its power. As a white, middle-aged butch lesbian, my identification with Bechdel's memoir runs deep. Though I resist the universalizing reading that *Fun Home* has received in mainstream reviews, I am also deeply moved by its success. This essay is an attempt to make sense of this new media landscape, focusing on recent cultural production that addresses both queerness and genderqueerness. I attempt to grapple with the mixed feelings these productions inspire by thinking through the dilemmas of legibility and acceptance that they raise.

DELETED SCENES

In the summer of 2015, New York City performance artist Erin Markey worked through her own mixed feelings about *Fun Home* in a solo show called *Deleted Scenes from* Fun Home, which she performed at the Duplex Cabaret Theater in the West Village. The audience was made up mostly of queer and genderqueer people in their twenties and thirties, many of them downtown habitués and longstanding fans of Markey. In her opening monologue, she narrated her experience of going to see *Fun Home* on Broadway, emphasizing both the emotional impact of the play and her feelings of alienation while watching it.

In an interview in *Weird Sister*, Markey describes being "activated in a strange way" by the musical for "unnameable or unknowable reasons":

> When I listened to *Fun Home* (over and over) and then saw *Fun Home*, there was no way for me to process the show on a level of just liking it or not liking it. I could not afford myself that kind of calm or democracy. I

Erin Markey, *Deleted Scenes from* Fun Home, 2015.
Image of a live performance. Courtesy the artist
and Bobby Miller. Photo: © Bobby Miller, 2016

could really only watch myself because I was being kind of intense. I felt mirrored by the three versions of Alison and Bruce (her dad) and angry that this basic acknowledgement of a kind of person (Alison) never happened before on Broadway and fascinated that there was this flashlight exposing the contents in a hole inside of my brain and annoyed at/empowered by the PR and the emphasis on "universality" and generally just hang-jaw.[10]

Comparing the experience of seeing *Fun Home* live to having a flashlight "expose the contents in a hole inside of my brain," Markey emphasizes both her deep identification with the content and artistry of the show and the pain she felt in the public exposure and universalization of Bechdel's subcultural material.

At the Duplex, Markey described her obsession with *Fun Home* at length and recalled her efforts to get the money together for a Broadway ticket. The set-up is comic, but the monologue turns somber when Markey describes how affected she was by seeing female masculinity represented on stage. She slows the pace of her monologue, emphasizing the emotional impact of this rare moment. In *Fun Home*, the cartoonist's stand-in is represented at three ages: the "three Alisons" embody different versions of gender non-normativity. One of the most memorable songs in the musical celebrates the "swagger" and "bearing" of an "old school butch" who never appears on stage.[11] The song, "Ring of Keys," dramatizes a moment in Bechdel's memoir when "a truck-driving bulldyke" comes into a diner where Alison is eating with her father. Bechdel writes this moment as a scene of recognition: "I didn't know there were women who wore men's clothes and had men's haircuts. But like a traveler in a foreign country who runs into someone from home—someone they've never spoken to, but know by sight—I recognized her with a surge of joy."[12] In the memoir, Alison's childhood joy in seeing this woman is doubled by Bechdel's loving and detailed drawing of her. But Alison's joy is shadowed by her father's disapproval. He asks sternly, "Is *that* what you want to look like?"[13] In an article in *Variety*, Kron talks through the doubts she had about dramatizing this moment: "I was concerned with how to write about butchness for what would presumably be an audience that is not completely made up of lesbians. ... I didn't know how Alison could talk about that delivery woman without the audience laughing at her. This is a stock target of ridicule. I didn't believe we could do it."[14] The hyper-visibility and devaluation of the butch lesbian make representing her a tricky business: with Tesori's encouragement, they went ahead, building the song around the detail of the ring of keys on the woman's belt and dropping the term "bulldyke" in favor of the less marked language of "just-right clothes."[15]

Sydney Lucas (left), Beth Malone (center), and
Emily Skeggs (right) playing the "three Alisons"
in *Fun Home*, 2015. Broadway production still.
Courtesy Joan Marcus. Photo: © Joan Marcus

Kron's account of her anxiety about "Ring of Keys" and Markey's description of sitting in the audience at *Fun Home* resonate with the moment in Bechdel's memoir when identification threatens to turn into shame. While Kron and Tesori manage this difficulty by softening and abstracting the image of the old-school butch, Markey exacerbates it by making *Deleted Scenes from* Fun Home. That is to say, Markey embraces the difficulty of the original text by going deeper into the shame and stigma of gender and sexual difference. Markey recounts episodes from her life that wouldn't cut it on Broadway: surreal childhood sexual fantasies of hitchhiking as a pregnant prostitute and her stint working as a stripper after college. In her opening monologue, Markey introduces these "deleted" scenes by narrating the experience of going to see the musical with her friend, transgender writer and director Silas Howard. After the show, they stop into a Starbucks in Times Square to use the restroom, and Markey describes her altercation with the woman behind them in line:

> We get to the front of the line and it's Silas's turn to pee. And he is sort of chatting his way into the area of the bathroom and then shuts the door behind him. And then all of a sudden I hear from behind me, "Faggots taking their time to get into the bathroom ... Having a conversation when there's people waiting for the toilets ... Faggots taking their time—"[16]

Markey, who is from Michigan, has a vocal repertoire that includes a variety of Midwestern accents; after a thorough reading of the woman's outfit, she mimes her speech using a harsh, flat intonation, hitting the *F* in "faggots" very hard. Recalling her reaction, Markey performs disdain with a trace of shock, and, after a pause, she drawls: "And my heart started beating, like, really hard. And I was like, I am going to tell on her."[17] As absurd as the moment is, Markey *does* tell on her, to the delight of the audience at the Duplex. But she suggests here that the meaning of *Fun Home* the musical is defined in part by its appearance in mainstream spaces of leisure and consumption.

Deleted Scenes is not an attack on *Fun Home* or an indictment of its arrival on Broadway. Markey's admiration for Bechdel's memoir and for the musical is palpable. Instead of critiquing the musical, she juxtaposes it with the kind of subcultural productions (comics in alternative newspapers, downtown cabaret) that nurtured it, and reminds the audience of the violent social world that it was meant to protest. The increasing acceptance of some forms of LGBT existence has diminished the urgency of this project of representation: new civil inclusions in the US, as well as an expanded media landscape, have made it possible to represent gender and sexual outsiders at an unprecedented scale, and

118

often on their own terms. There is, of course, a trade-off. Bechdel has addressed the compromises of mainstream recognition repeatedly and eloquently. In a *New York Times* piece, the interviewer asks, "Do you think something is being lost now that queer culture is becoming more mainstream? Are gay people like everybody else now?" Bechdel responds:

> We are. And there is a sadness in that. I wanted to think we were special, more highly evolved somehow. I really believed that in my youth. Obviously that's ridiculous—we're the same as everyone else, and it's amazing that that is being acknowledged. But I feel wistful for the sense of being special. When gay people were rejected, there was this camaraderie and this sense of community that I don't feel anymore. I miss that. But I wouldn't want to go back politically.[18]

According to Bechdel, the loss of community that comes with rights and recognition is to be lamented. But she balances the desire for a sense of specialness with an awareness of the ultimate goals—political representation and freedom from violence. Yet, as Markey reminds us, social recognition is tenuous and profoundly uneven: violence continues to proliferate alongside new forms of inclusion, and many scenes are still deleted.

BECOMING ORDINARY

In her 2015 book *The Argonauts*, a genre-bending memoir of her life with the transgender artist Harry Dodge, Maggie Nelson reflects on the contradictions of contemporary queer life. She writes, "There's something truly strange about living in a historical moment in which the conservative anxiety and despair about queers bringing down civilization and its institutions (marriage, most notably) is met by the anxiety and despair so many queers feel about the failure or incapacity of queerness to bring down civilization and its institutions, and their frustration with the assimilationist, unthinkingly neoliberal bent of the mainstream GLBTQ+ movement."[19] Like *Fun Home*, *The Argonauts* presents traditionally marginalized experience in ways that many readers have understood to be universal, and it garnered Nelson major critical and popular acclaim.[20] Combining memoir with critical reflection on queer theory and politics, the book describes some traditional aspects of family life (childbirth, family illness) alongside new forms of kinship and embodiment, such as artificial insemination,

stepparenting, and gender transition. The mixture is important: the book describes what it is like to negotiate ordinary domestic cares in circumstances seen by many as extraordinary. *The Argonauts* responds to the situation of queer and trans people at a moment when new opportunities for recognition and acceptance exist alongside ongoing exclusion and violence. Nelson thinks through these contradictions, using her own experience as evidence. Throughout the book, she chafes at the inadequacy of the terms "normative" and "transgressive" to describe either this historical situation or people's ways of living in it. While it is no longer true that to be queer or trans automatically makes you a social outcast, neither is it the case that gender and sexual minorities are seamlessly integrated into the social world. *The Argonauts* is an attempt to account for the new access to the ordinary experienced by some queers and trans people while continuing the project of critique.

Nelson contemplates the possibility that queerness will be universalized out of existence, citing a banner that appeared at San Francisco Pride in 2012: "CAPITALISM is fucking the QUEER out of US." She notes the difficulty of articulating goals that go beyond "claw[ing] our way into repressive structures."[21] And yet, her point is not only, or not exactly, to criticize LGBT assimilation into the army, the mainstream media, corporate life, or marriage. Instead, she insists on the inadequacy of the opposition between queer radicalism and assimilation, suggesting—controversially—that "perhaps it is the word *radical* that needs rethinking."[22] Nelson's key example for the inadequacy of the opposition between radical and normative is the family. Through an extended engagement with the queer critique of marriage and family, she argues that women and children are regularly turned into scapegoats for a despised normativity. She also locates queerness at the heart of the family, suggesting the perversity and surprise covered over by the narrative of dull normativity.

In addition to treating her experience with Dodge, Nelson engages with other examples of queer kinship and family. She reflects at length on Catherine Opie's photographs of queer domesticity and perverse motherhood. Early in *The Argonauts*, Nelson mentions Opie's 1993 photograph *Self-Portrait/Cutting* in relation to Proposition 8, the 2008 California Ordinance that reversed the state supreme court's decision to legalize gay marriage. In a scene from the first year she is with Dodge, Nelson casts herself as a bad reader of Opie's work, trying to make the photograph mean only one thing; Dodge responds with a defense (albeit a low-key one) of the complexity of individual lives and works of art:

> Throughout that fall, yellow YES ON PROP 8 signs were sprouting up everywhere. ... The sign depicted four stick figures raising their

"CAPITALISM is fucking the QUEER out of US"
and "ASSIMILATION = DEATH" banners at
San Francisco Pride, 2012. Digital photograph.
Image first appeared on the website of San
Francisco Bay Area Independent Media Center
(Indybay). Photo: Bad Bitches

hands to the sky, in a paroxysm of joy—the joy, I suppose, of hetero-normativity, here indicated by the fact that one of the stick figures sported a triangle skirt. ... PROTECT CALIFORNIA CHILDREN! the stick figures cheered.

Each time I passed the sign stuck into the blameless mountain, I thought about Catherine Opie's *Self-Portrait/Cutting* from 1993, in which Opie photographed her back with a drawing of a house and two stick-figure women holding hands (two triangle skirts!) carved into it, along with a sun, a cloud, and two birds. She took the photo while the drawing was still dripping with blood. "Opie, who had recently broken up with her partner, was longing at the time to start a family, and the image radiates all the painful contradictions inherent in that wish," *Art in America* explains.

I don't get it, I said to Harry. Who wants a version of the Prop 8 poster, but with two triangle skirts?

Maybe Cathy does, Harry shrugged.[23]

Who could want this? Nelson asks. Her comment shows a lack of attention to medium, suggesting that any image of family, whether printed on a homophobic campaign poster or carved into a queer woman's back, means the same thing—that its meaning can be boiled down to one word, "heteronormativity," and that it is a given that one would want to purge one's life of all traces of it. Dodge's comment, though terse, points to the possibility that other forms of satisfaction lurk within an image that Nelson finds both obvious and obviously distasteful.

Nelson explores the vexed terrain of other people's pleasures through a sustained engagement with Opie's work. She returns to *Self-Portrait/Cutting* later in *The Argonauts*, after she and Dodge have taken advantage of the brief legality of same-sex marriage in California, marrying in a tacky West Hollywood chapel. She writes:

Like much of Catherine Opie's work, *Self-Portrait/Cutting* (1993), which features the bloody stick figures cut into her back, gains meaning in series, in context. Its crude drawing is in conversation with the ornate script of the word *Pervert*, which Opie had carved into the front of her chest and photographed a year later. And both are in conversation with the heterogeneous lesbian households of Opie's *Domestic* series (1995–98)—in which Harry appears, baby-faced—as well as with Opie's *Self-Portrait/Nursing* (2004), taken a decade after *Self-Portrait/Pervert*. In Opie's

nursing self-portrait, she holds and beholds her son Oliver while he nurses, her *Pervert* scar still visible, albeit ghosted, across her chest.[24]

If in her first reading of Opie's photograph, Nelson compares it to the iconic image of the family appropriated by the Prop 8 campaign, in her second reading she frames it in the context of Opie's other work—in particular, in relation to a series of other images that represent Opie's body. In contrast to the static, storybook image of the family that *Self-Portrait/Cutting* responds to, Nelson reads the photograph as a historical image, layered over the fading image of *Pervert* and anticipating the image of queer motherhood to come. The turn to narrative is crucial in Nelson's refusal to collapse domesticity, motherhood, and care into a monolithic heteronormativity.

Nelson revisits Opie's work one last time in *The Argonauts*, citing an interview with the artist in *Vice*. The interviewer comments: "I think you going from the SM scene to being a mom, and all your new photos are these blissful domestic scenes—that's shocking in a way, because people want to keep those kind of separate." Opie responds: "They do want to keep it separate. So basically, becoming homogenized and part of mainstream domesticity is transgressive for somebody like me. Ha. That's a very funny idea."[25] Nelson responds by rearticulating queer suspicion about domesticity. "Funny to her, maybe," she writes, "but to those who are freaked out about the rise of homonormativity and its threat to queerness, not so much."[26] Nelson acknowledges the real anxiety about the depopulation of spaces of public sex and the destruction of alternative kinship relations as perverts migrate into the nuclear family and the domestic sphere. But she also critiques the position that would narrate Opie's story as one of assimilation or selling out. After acknowledging that what Opie finds funny or ironic about the transgression of her becoming a mom might freak out some other queers, Nelson writes, "But as Opie implies here, it's the binary of normative/transgressive that's unsustainable, along with the demand that anyone live a life that's all one thing."[27]

Nelson's reading of Opie calls out the reductive impulse that turns different ways of life into stick-figure images of transgressive or normative ideologies. Instead, as in her reading of the palimpsest of Opie's body, she captures the historical layers and contradictions that make up a life. The radical specificity of this account is a tribute to the work of Nelson's mentor Eve Kosofsky Sedgwick.[28] "The great mantra, the great invitation" of Sedgwick's work, according to Nelson, is "to pluralize and specify."[29] As she argues, "This is an activity that demands an attentiveness—a restlessness, even—whose very rigor tips it into ardor."[30] Nelson's Sedgwickian approach to queer motherhood and family frustrates

Catherine Opie, *Self Portrait/Cutting*, 1993. C-print,
40 × 30 in (101.6 × 76.2 cm). Courtesy Regen
Projects, Los Angeles. Image: © Catherine Opie

dichotomies between normativity and anti-normativity. In the rapidly changing and uneven situation in which queer and trans people find themselves today, such narrative and descriptive accounts are more useful than either the sweeping indictment or the welcoming embrace of assimilation.

.........

In the "Man on the Land" episode in season 2 of *Transparent*, several campers sit around a fire at the Michigan Womyn's Music Festival discussing its transgender-exclusion policy with Leslie (Cherry Jones), Ali Pfefferman (Gaby Hoffman), and Maura Pfefferman (Jeffrey Tambor). Maura has just recently discovered the existence of the policy and wants to leave the "Land" as soon as possible. At first, the women greet her and get into a genial conversation about the popularity of SM at the festival; soon however, the conversation turns to sexual violence and male privilege, and open conflict erupts. Hurt and angry, Maura heads back to get her stuff and leave. Ali reluctantly follows, gets lost alone in the woods, and sees a vision of Nazis burning the contents of Magnus Hirschfeld's Institute for Sexual Research library and dragging away her transgender ancestor Gittel (Hari Nef). The analogy between the Nazi murder of transgender and queer people and the festival's womyn-born-womyn-only policy is, in the words of *New Yorker* TV critic Emily Nussbaum, a "gambit" that "risks glibness" by "conflating moral horrors."[31] But Nussbaum, like many other critics, ultimately praises the episode for its risk-taking and political insight, calling out the campfire scene in particular for its nuanced dramatization of the conflict around the radical lesbian feminist exclusion of transgender women.

As they sit around the glowing campfire chatting amicably, one woman offers a toast: "Here's to the last remaining extremists."[32] The wistful quality of this moment underlines a fact that is not represented in the episode but which informs both its aesthetics and reception—the closing of the Womyn's Festival in August 2015, after forty years in existence. The panoramic, inclusive style of the episode, with its affectionate tribute to the pastoral, blissed-out pleasures of the festival, has an ethnographic quality: we sense we are looking at this world—with its strange rituals and intense fellowship of clothed and naked women of all ages, races, and body sizes—for the last time, and there is a need to document it. The final oneiric sequence suggests a comparison between the destruction of the Hirschfeld Institute's library and the trans-exclusionary policy of the Womyn's Festival; at the same time, it evokes the closing of the festival, which in its final years faced, among other difficulties, boycotts staged in response to this policy. This analogy, through its instability, suggests a potential alliance between radical

"Man on the Land," *Transparent*, season 2, episode
9, December 11, 2015 (still). HD video, sound,
color; 30 min. Courtesy Amazon Prime Video

feminists and trans activists, who continue to fight bitterly but who nonetheless share a position on the margins of the mainstream. The campfire scene is in this sense a family portrait: here's to the last extremists. The irony this scene points to (and exacerbates) is that formerly obscure conversations between marginalized social groups are now being staged for the benefit of a much larger audience. These are the conditions of the new media landscape, and the meaning of each of these productions is shaped by an overhearing public whose contours are still emerging. A book burning is not, perhaps, the most apt symbol of this moment. Now, more than ever, people are *buying* books, while violence against women, queers, and trans people continues.

..

"The Last Extremists?" by scholar Heather Love was written in 2016 for this volume.

..

NOTES

1. *Fun Home* made several best books lists for the year and was nominated for the National Book Critics Circle Award in the memoir/autobiography category. It was listed as one of the best books of 2006 by the *New York Times*, *New York* magazine, the *Times* of London, and *Publisher's Weekly*. Bechdel went on to win a MacArthur "Genius Grant" in 2014.

2. Alison Bechdel used this term to describe her first-ever *Dykes to Watch Out For* drawing (*Marianne, dissatisfied with the breakfast brew*, plate no. 27). Alison Bechdel, interview with Anne Rubenstein, *The Comics Journal* 179 (August 1995): 116. Bechdel elaborated on the origins of the strip in a 2007 interview, emphasizing the extremely small audience of this early work: "*Dykes to Watch Out For* was my desire as a young lesbian just out of college to see reflections of myself in the culture. I was very hungry to see visual images of people who looked like me and I didn't see them anywhere. So I started drawing them, just for my own amusement. Actually, for a friend. I had a friend who I was corresponding with, and I started this little series of crazy-looking lesbians in these letters to her." Alison Bechdel, interview with Lynn Emmert, "The Alison Bechdel Interview," *Comics Journal* 282 (April 2007): 41.

3. Judith Thurman, "Finish Line," *New Yorker*, May 11, 2015, http://www.newyorker.com /magazine/2015/05/11/finish-line-backstage-at-fun-home.

4. Michael Paulson, "'Fun Home' to Close in September," *New York Times*, June 21, 2016, http://www.nytimes.com/2016/06/22/theater/fun-home-to-close-in-september.html. *Fun Home* closed on Broadway on September 10, 2016, approximately a year and a half after its opening. The national tour began in October 2016.

5. Ibid.

6. Hilton Als, "The Wanderers: Musical Outsiders," *New Yorker*, May 4, 2015, http://www
.newyorker.com/magazine/2015/05/04/the-wanderers-theatre-hilton-als.

7. Ibid.

8. Susan Stryker, "The New Trans Landscape," *Public Books*, August 1, 2015, http://www
.publicbooks.org/artmedia/virtual-roundtable-on-transparent.

9. In addition to featuring the first lesbian protagonist, *Fun Home* was also the first Broadway
musical for which an all-female writing team won a Tony. See Carey Purcell, "*Fun Home* Duo
Make History as First All-Female Writing Team to Win the Tony," *Playbill*, June 7, 2015,
http://www.playbill.com/article/fun-home-duo-make-history-as-first-all-female-writing
-team-to-win-the-tony-com-350678.

10. Erin Markey, interviewed by Cathy De La Cruz, "You Could Be There: Erin Markey's
Deleted Scenes from *Fun Home*," *Weird Sister*, June 18, 2015, http://weird-sister
.com/2015/06/18/you-could-be-there-erin-markeys-deleted-scenes-from-fun-home/.

11. "Ring of Keys," music by Jeanine Tesori, lyrics and book by Lisa Kron, 2015. Based on
the 2006 graphic novel *Fun Home: A Family Tragicomic* by Alison Bechdel (Boston: Houghton
Mifflin, 2006).

12. Bechdel, *Fun Home: A Family Tragicomic*, 118.

13. Ibid.

14. Lisa Kron, quoted in Gordon Cox, "Road to the Tonys: How the 'Fun Home' Creators
Unlocked 'Ring of Keys,'" *Variety*, June 2, 2015, http://variety.com/2015/legit/news
/fun-home-tony-awards-nominations-2015-1201510353/.

15. Ibid.

16. Erin Markey, *Deleted Scenes from* Fun Home, performance, the Duplex Cabaret Theater,
New York, 2015.

17. Ibid.

18. Alison Bechdel, interviewed in Lydia Polgreen, "Alison Bechdel Misses Feeling Special,"
New York Times Magazine, May 13, 2015, http://www.nytimes.com/2015/05/17/magazine
/alison-bechdel-misses-feeling-special.html.

19. Maggie Nelson, *The Argonauts* (Minneapolis, MN: Graywolf Press, 2015), 26.

20. Published by Graywolf, an independent press based in Minnesota, Nelson's book won the
National Critics Book Circle Award for criticism and was named as one of the year's best books
by NPR, the *Guardian*, the *New York Times*, and *Publisher's Weekly*. In 2016, just two years after
Bechdel received the honor, Nelson was also awarded the MacArthur "Genius Grant."

21. Nelson, *The Argonauts*, 26.

22. Ibid., 27.

23. Ibid., 10–11.

24. Ibid., 64.

25. Amy Kellner and Catherine Opie, "Catherine Opie," *Vice*, July 2, 2009, http://www.vice .com/read/catherine-opie-934-v16n7, quoted in Nelson, *The Argonauts*, 74.

26. Nelson, *The Argonauts*, 74.

27. Ibid.

28. Nelson received her PhD in English from City University of New York, where she studied with Sedgwick.

29. Nelson, *The Argonauts*, 62.

30. Ibid.

31. Emily Nussbaum, "Inside Out: The Emotional Acrobatics of 'Transparent,'" *New Yorker*, January 4, 2016.

32. "Man on the Land," *Transparent*, season 2, episode 9, aired December 11, 2015.

AN AFFINITY OF HAMMERS

Sara Ahmed

We learn about worlds when they do not accommodate us. Not being accommodated can be pedagogy. We generate ideas through the struggles we have to be in the world; we come to question worlds when we are in question. When a question becomes a place you reside in, everything can be thrown into question: explanations you might have handy that allow you to make sense or navigate your way through unfamiliar as well as familiar landscapes no longer work. To be thrown by a question is to be thrown into a world that can be hostile as well as startling. Another way of saying this: when we are not at home, when we are asked where we are from or who we are, or even what we are, we experience a chip, chip, chip, a hammering away at our being. To experience that hammering is to be given a hammer, a tool through which we, too, can chip away at the surfaces of what is, or who is, including the very categories through which personhood is made meaningful—categories of sex and gender, for instance, that have chipped away at us.

This reciprocal hammering can be thought of as an affinity. I want to explore my relationship to transfeminism as an affinity of hammers. Why use the term "affinity" here? Let's assume that transfeminisms are built from or out of trans experiences in all their complexity and diversity. I write then of affinity as a way of recognizing that I write from a position of cis privilege. I am writing of how I came into contact with a hammering I did not directly experience because of that privilege. The question of how we can account for that privilege is one that I will keep live throughout this piece.

A starting point is the point from which we proceed, from where a world unfolds.[1] We have many starting points. I write this contribution as a cis lesbian who has experienced gender norms as alienating insofar as gender norms are so often heteronorms: rules of conduct that direct girls toward boys and that render

heterosexuality the right or best or happiest destination. I write this contribution as a woman of color who finds that gender norms so often remain predicated on an unremarkable whiteness: the evocation of a fragile female body who needs to be defended from various racialized as well as sexualized others. This is intersectionality. It is about ups and downs, stopping and starting—about how we pass through at one moment while being stopped at another, depending on who is receiving us and what is being received through us. An affinity of hammers does not assume we will automatically be attuned to others who are stopped by what allows us to pass through, even when we ourselves have the experience of being stopped. We have to acquire that affinity. It is what we work toward.

THE LETTER

I want to account for the problem of trans-exclusionary radical feminism, the problem of how it is, within some feminist spaces, that this hammering is happening. I will start with a letter, even though the letter in question is not the starting point of a certain kind of feminism that has long been chipping away at trans lives. On Sunday, February 1, 2015, a letter denouncing the tactics used by trans and sex-worker activists to contest speech they perceived as violent toward them was published in the *Guardian* under the headline, "We Cannot Allow Censorship and the Silencing of Individuals," followed by a subheading, "Universities Have a Particular Responsibility to Resist This Kind of Bullying."[2] It was signed by 130 prominent feminists, academics, and activists and became a flash point in a long-running conflict regarding the relationship of transgender issues to feminism. Four examples are mentioned as evidence of this worrying trend: the cancellation of Kate Smurthwaite's comedy show at Goldsmiths, University of London; the calls for the Cambridge Union to withdraw its speaking invitation to feminist writer Germaine Greer; the pressure on the Green Party to "repudiate" academic and politician Rupert Read after he "questioned the arguments put forward by some trans-activists"; and the "no platforming" of the "feminist activist and writer" Julie Bindel by the National Union of Students.

I will not rehearse some of the wider problems with this letter that I have discussed elsewhere.[3] I want to focus instead on how trans comes up. The word "trans" is mentioned both as a description of activists and as a style of accusation: the letter refers to "a worrying pattern of intimidation and silencing of individuals whose views are deemed 'transphobic' or 'whorephobic.'"[4] The statement then says, "Today [no platforming] is being used to prevent the expression

of feminist arguments critical of the sex industry and of some demands made by trans activists."[5] Put the sentences together and you have the picture: feminists who are critical of some of the demands of trans activists (Which demands? one wonders)[6] are accused of transphobia, which is how they are silenced. A summary: the accusation of transphobia is a means by which critical feminist voices have been silenced.

The sentences in the letter work to create a figure of the trans activist as one who is making unreasonable demands and arguments, and who is using the accusation of transphobia as a means to silence feminists. Indeed, if words like "silencing," "bullying," and "intimidation" cluster around the figure of the trans activist, then words like "critical," "questioning," and "democratic" cluster around the figure of the cis feminist.[7] The letter does not have to make an argument explicit: it works to create an impression that is sticky; trans activists are bullying the feminists, and universities are allowing this bullying to happen. The letter does not have to say explicitly that critical feminists and trans activists are distinct camps, one of whom is silenced and intimated by the other, to carry the point.

The letter uses the language of free speech; in a way, it both insists on free speech while also announcing that free speech is under threat. In the United Kingdom, all speech is understood as free speech, with the exception of speech that is an "incitement to violence." Free speech is increasingly mobilized as an ideological weapon by the creation of a clear distinction between offensive statements and "incitements to violence." Let me offer an example. On March 15, 2015, a leading Black public figure, Trevor Phillips, the former head of the Commission for Racial Equality, released a documentary, *Things We Won't Say About Race That Are True*, which ends up defending racism as a form of free speech.[8] The claims made are familiar, though they are more usually articulated in the right-wing press. Antiracism or political correctness is inflated as if it is a hegemonic discourse that has prevented "us" from being able to speak truths (things we cannot say). The story goes something like this: we cannot ask legitimate questions about immigration because we will be branded "racist." The very accusation of racism is understood as what stops us from asking legitimate questions. Paradoxically, then, racism is now incited by being understood as prohibited or minority speech. In such an account, the very act of being offensive or causing offense (often through articulating stereotypes about others) speaks to how we assert our national character (as being tolerant of different views) as well as our freedom.[9] In such a schema, dominant views become rearticulated as if they are minority views that we have to struggle to express. Racism is enacted by the claim that we are not free to be racist.

Let's return to our letter. I do not think it justifies the freedom to be "critical of … some demands made by trans activists" as the freedom to be offensive; rather, what is being implied is that trans activists, by labeling critical feminist speech as offensive (through the liberal use of the illiberal word "transphobia"), intend to impose a restriction on feminist speech. In other words, being offended is registered as an imposition on the freedom of others. The real offense is caused by those who are offended. This is how the very use of the word "transphobia" is heard as an attempt at censorship. We might note that the claim to be censored can be generative of speech. The example of Germaine Greer mentioned in the letter is a case in point: she was not stopped from speaking at all. She did speak, as did transfeminist activists at another event organized by the LGBTI Society and the Women's Society (speakers included writer, critic, and poet Roz Kaveney and activist and blogger Sarah Brown).[10] If anything, the evidence here points to the opposite of what the letter claims: protests about who is speaking have led to the proliferation rather than prevention of discourse.

When the letter says that critical feminists are being silenced, it is implying that "being critical" of the "demands of trans activists" is a legitimate form of feminist speech. In other words, the letter relies on the assumption that we can distinguish "critical feminist speech" from an "incitement to violence," and that there is censorship because others have failed to make that distinction. Behind the letter, I can hear these sentences uttered in unison: "It is not racist to ask critical questions about immigration; it is not transphobic to ask critical questions about the demands of trans activists." But this distinction between critical speech and incitements to violence breaks down, which is how an incitement to violence is justified as freedom of speech.

Let me give an example of how this distinction breaks down. At a Reclaim the Night march that took place in London in November 2014, a pamphlet entitled *Not Our Sisters* was distributed by trans-exclusionary radical feminists.[11] On one side of the pamphlet is written text. It begins by describing Reclaim the Night as "protesting male violence against women." It then describes trans women as "male transgenders" and suggests that "male transgenders" commit violence against women "at exactly the same rate as non-transgender males." This violent misgendering enables trans women to be positioned as imposters within a feminist march, as perpetrators rather than victims of male violence. On the other side of the pamphlet are four photographs of trans women who are given a story that is not theirs: they have committed violence against women; they have tried to hide that violence by describing themselves as trans or not men. The photographs are used to retell a story, to abbreviate and condense the associations made by the written text: trans women are "male transgenders,"

trans women are men; as men, they use "trans" as a mask to commit and conceal violence; trans women as men injure, rape, and murder women.

To abbreviate and condense this association in the form of an equation:

$$Trans = violence \ and \ death$$

I was on Facebook when someone's status update caught my attention. The person spoke of how, sadly, a peaceful feminist march was interrupted by "trans activists." Outrage about violence becomes the cause of a disturbance and not the violence itself. In the next section, I will return to the issue of how disruption is located and narrated. When I wrote in response to that update of my own outrage about the pamphlet, one of the people named in the letter referred to above responded, "So are you saying it is as bad as the Holocaust?" By "it," I think she was referring to both the pamphlet that I had described as hate speech and the more general domain of anti-trans feminist speech. It would take us a long time to unpack what is wrong with this statement. But just note the implication that violence against trans people is "relatively" minor, a footnote in a much more horrifying history of human hatred. And it is this very implication that was carried by the letter: "'No platforming' used to be a tactic used against self-proclaimed fascists and Holocaust-deniers. But today it is being used to prevent the expression of feminist arguments critical of the sex industry and of some demands made by trans activists." So this comparison ("it" is not like the Holocaust) is already in use not only to present feminists critical of "some demands made by trans activists" as unjustly censored but also to recast that critical speech as not as violent or offensive as other kinds of speech. I make this point just to make clear that even if those who signed the letter might argue that critical feminist speech can or should be separated from the kind of speech represented by the pamphlet, the terms of the letter point to such speech: it is exactly this kind of speech that becomes justifiable as a relatively minor form of offense, or even as no offense at all.

Some forms of violence are so often understood as trivial, or not as violence at all. Violence is so often reproduced by not being understood as violence. So much violence directed against groups (that is, directed against those perceived as members of a group) works by locating that violence as coming from within those groups. Thus minorities are often deemed as being violent, or as causing violence, or even as causing the violence directed against them. To give an account of trans people as causing violence (by virtue of being trans) is to cause violence against trans people. We are most certainly talking about lives and deaths here; and we are most certainly talking about an incitement to violence.

The letter tells a tale: that to take offense at "critical feminist speech" is a wrong (the offense taken is heard as antifeminism) that leads to more wrongs. To take offense at the letter would thus be judged as enacting the very problem described by the letter. Those who protested against the letter were indeed understood not as expressing their freedom of speech but as displaying their desire to restrict freedom of speech in the very act of "being offended" by it. There is an economy of speech at work here. Some protests are judged as stifling free speech while other protests (such as the letter itself) become expressions of free speech. We learn that free speech has become a political technology that is used to redefine freedom around the right of some to occupy time and space. Whenever people keep being given a platform to say they have no platform, or whenever people speak endlessly about being silenced, you not only have a performative contradiction, you are witnessing a mechanism of power.

A REBUTTAL SYSTEM

When I first read the letter, I remember thinking that one of the worst consequences of it would be the new legitimacy it would give to anti-trans and transexclusionary feminism. I thought at first I was indeed witnessing an increase of such speech. But once I began to work through the networks that supported that letter, mostly on social media, I began to realize that what I first heard as a turning up of the volume was just more of the same thing that had been going on all along for many trans people: that volume switch was already stuck on full blast. My cis privilege was, until then, not having had to notice that harassment or not having had to hear the sound of that blast.

In order to explain how this letter was taken up, we need an account of how privilege is affective as well as effective. When I think of affectivity, I think of skin: a border that feels. Privilege could be thought of as rather like contact dermatitis; we are inflamed by something when or because we come into contact with it. Privilege is also thus: being able to avoid contact with the cause of an inflammation. We could contrast contact dermatitis with eczema, which is often called a "basket category," used to describe skin conditions in which the cause of the inflammation is not known. With eczema, it can feel as if you are the cause of your own inflammation, whether or not you are the cause, because there is no safe externality—nothing that can be eliminated to heal the skin or the situation.

Like all analogies, this one is imperfect, but I want to use it to dramatize how causality becomes a contact zone in everyday social experience. Let's think of an inflammation as a conversation. Let's say when you enter the room, things become inflamed. If this keeps happening, then you can feel like the cause of that inflammation, whether or not you are. You learn that you cannot stop an inflammation even if you begin to try to "tone things down." So much racism feels like this: the volume turns up when race is mentioned, or the volume turns up when you turn up as a person of color. Racism is precisely how a body of color becomes the cause of tension. I am always reminded of bell hooks's description of how "the atmosphere will noticeably change when a woman of color enters the room."[12] A joyful atmosphere, an atmosphere of warm solidarity, is lost. It becomes tense. Given that wherever you go, your body goes with you, it can end up feeling like you cause the loss of a good atmosphere. You become tense.

Privilege can be what does not come up when we turn up. This letter was signed by many academics and activists who I do not think would endorse the kind of pamphlet I described in the previous section. So why did they sign such a letter? How could they sign it? I suspect they did not hear the "point" of the letter. Many of those who supported that letter have not been in contact with the relentless nature of the harassment against trans people. They do not have to come into contact with harassment; this is what makes privilege a privilege. Privilege is what can allow a world to recede. When someone brings something up, it can then seem they are bringing something into existence that would otherwise not have been there.

Something I have learned from my work on my blog *Feministkilljoys* is how people witness a reaction as the beginning of something because they do not notice what people are reacting to. Think of a twig that snaps under pressure. A snap sounds loud, and it seems like a sudden movement. But the snap would only seem the start of something, or as the beginning of violence, if you did not notice the pressure on the twig. Pressure is hard to notice unless you are under pressure. A system can put some bodies under pressure without that pressure being experienced, let alone witnessed, by others who are not under that pressure.

A snap is not the starting point even if a snap is a start of something. Violence does not originate with the one who snaps. But so often the exposure of violence is perceived by the privileged as the origin of violence. Yet, when the exposure of violence is perceived as the origin of violence, the origin of the violence that is exposed is often not revealed. The figure of the bullying trans activist circulates because of what is not being revealed—that everyday relentless hammering at the house of trans being. Following T. L. Cowan, we could think of this figure of the bullying trans activist as the transfeminist killjoy.[13]

The killjoy is without doubt a violent figure: to point out harassment is to be viewed as the harasser; to point out oppression is to be viewed as oppressive. Part of the work of the killjoy is to keep pointing out violence. In making these points, killjoys are treated as people who originate violence. This is the hard work of killjoys. They are up against it!

Transfeminist killjoys expose hammering as a system of violence directed against trans people, including from some of those who identify as radical feminists. Some of the hammering might seem on the surface quite mild because it appears as an instance: a joke here, a joke there. And jokiness allows a constant trivializing, as if by joking, someone is suspending judgment on what is being said. "She didn't mean anything by it; lighten up." A killjoy knows from experience: when people keep making light of something, something heavy is going on.

Something heavy *is* going on. Many of these instances might be justified as banter or humorous (the kind of violent humor that feminists should be familiar with because feminists are often at the receiving end). So much of this material makes trans women in particular the butt of a joke. Following Julia Serano, I would describe much of this material as trans misogyny: what is evoked is the figure of the hyper-feminine trans woman as a monstrous parody of an already monstrous femininity.[14] In January 2013, for example, British feminist journalist Suzanne Moore published a piece on women's anger that makes casual reference to the figure of the "Brazilian transsexual" as the "ideal body shape" that most women are angry about because they do not have it.[15] This statement could be understood as a form of casual racism as well as trans misogyny: the other over there is a means by which a subject here is given contour and definition, a "we" takes shape from what we are not. Another journalist, Julie Burchill, then writes a piece defending Moore against trans activists (quickly described as the "trans lobby"—another inflationary mechanism) whose protests against Moore's statement are called "bullying," a piece that deploys as weapons such violent phrases as a "bunch of dicks in chick's clothing."[16] These two pieces, one much more extreme than the other, are not simply related through a citational chain; they are both part of what I would call a "rebuttal system."

A rebuttal is a form of evidence that is presented to contradict or nullify other evidence that has been presented by an adverse party. A rebuttal is a form of evidence that is directed against evidence that has already been presented. What if you are required to provide evidence of your own existence? When an existence is understood as needing evidence, then a rebuttal is directed not only against evidence but against an existence. An existence can be nullified by the requirement that an existence be evidenced. The very requirement to testify to your existence can end up being the very point of your existence.

To be treated as a being who needs to provide evidence of being is also to be treated as an adverse party. The word "adverse" implies "opposing," but it is often used to create a stronger impression, to convey a sense of hostility or harmfulness. To present evidence that nullifies that presented by an adverse party might be how a party is treated as adverse in the first place: you direct evidence to the one who is deemed to be opposing something in the very manner of their existence. Words can be teachers. The word "rebuttal" derives from "butt" and is often used in the sense of a target or aim, as in the butt of a joke. Trans women are made into the butts of jokes. When materials such as those described above make trans women into butts, they are functioning as a rebuttal system, which is to say, they are working together to target an existence. Jokey comments and exchanges have become a significant part of this system. And other, more qualified forms of speech make use of other kinds of "buts" to create a softer impression: I am not saying trans women are not women, *but*. What follows this "but" can contradict what precedes this "but." To qualify an argument can be how an argument is made. We learn to hear the "but," how it is pointed at someone because it has been repeated, over and over again.

Words do not always do what they say. The expression "gender critical" is now used by trans-exclusionary radical feminists to describe their own commitments. ("Trans-exclusionary radical feminism" [TERF] is regarded by this group as an antifeminist and even misogynist slur.) Of course, the implication of this expression is that trans activism (or trans existence) requires being gender *un*critical, thus nullifying the long and varied critiques of the category of gender (including as a diagnostic category) made within trans communities.[17] Putting the problem of this expression to one side, I think we need to treat these arguments about gender as techniques of rebuttal, different ways of rebutting an existence, different ways of saying, for instance, that trans women are not women, that trans women are imposters in women's spaces and in the feminist movement.

There are different ways of saying something, which is how something can keep being said. This is why the criteria being used to exclude trans women from "women" keep changing. When content (a woman is x) is being used as an end (you are not x), ideas have already become weapons. At the present moment, "biology" has become weaponized in feminism. This is quite odd and actually rather striking: there are some who hold onto rigid ideas of biological sex, but I do not expect feminists to be among them. When I hear people refer in code to "biology 101," meaning the scientific basis of female and male sex difference, to claim that trans women are not "biologically women," I want to offer in rebuke, "Biology 101? Patriarchy wrote that textbook!" and pass them a copy of Andrea

Dworkin's *Woman Hating*, a radical feminist text that supports transsexuals' having access to surgery and hormones and challenges what she calls "the traditional biology of sexual difference" based on "two discrete biological sexes."[18] To be so-called gender critical while leaving traditional biology intact tightens rather than loosens the hold of a gender system on our bodies. But if we start engaging with arguments on these terms, the target will move. Trans women will become not women because they were socialized as boys and men, or for some other reason that has yet to be invented.

When people use such criteria to decide who counts, that criterion has already become a technique for exclusion because it is not a criterion that will be shared by others. Criteria have become points: they are pointed at someone; they are aiming to do something; they are sharpening an edge. The criteria will change if the rebuttal is rebutted because the criteria have become the basis of exclusion. The target is thus a moving target: the policing of the boundaries of "woman" will take place on whatever basis can be found. In our collective feminist histories, the policing of who are "women" has been about how a specific group of women has secured its right to determine who belongs within feminism (whiteness being a key mechanism for policing feminism). The policing of the boundaries of "women" has never *not* been disastrous for feminism.

It is in this context that we need to think about invitations addressed to trans activists to have a dialogue with trans-exclusionary feminists. Invitations can function as part of a rebuttal system. A dialogue is not possible when some people exercise arguments as weapons by treating others as evidence to be rebutted. When you are asked to provide evidence for your existence, or when you are treated as evidence, your existence is negated. Transphobia and anti-trans statements should not be treated as just another viewpoint that we should be free to express at the happy table of diversity. There cannot be a dialogue when some at the table are in effect (or intent on) arguing for the elimination of others at the table. When you have "dialogue or debate" with those who wish to eliminate you from the conversation (because they do not recognize what is necessary for your survival, or because they don't even think your existence is possible), then "dialogue and debate" become a technique of elimination. A refusal to have some dialogues and some debates is thus a key tactic for survival.

The very expectation that a conversation with trans-exclusionary radical feminists is possible is evidence of what people have not yet come into contact with. It is an expectation that derives from privilege, from not having been worn down by the relentless questioning of your being. Even that hopeful liberal question, "Can't we just have a conversation?" can become another kind of hammering. It makes those who refuse to participate in a conversation into the

problem, the cause of a division: so those "trans activists" who are making demands, who are not listening, not engaging, who are using "transphobia" to block feminist critique become those who are getting in the way of the liberal promise of reconciliation, the promise that we can move forward by getting along.

CONCLUSION: HAMMERING AWAY AT THE SYSTEM

Survival becomes a project when your existence is the object of a rebuttal. You have to survive a system that is constantly chipping away at your being. A feminism that participates in that chipping away is not worthy of the name.

Chipping away is something we too can do. Transfeminism is a form of diversity work. In *On Being Included: Racism and Diversity in Institutional Life*, I discuss diversity work in two senses: the work we do when we aim to transform an institution (often by opening it up to those who have been historically excluded), and the work we do when we do not quite inhabit the norms of an institution.[19] These two senses often meet in a body: those who do not quite inhabit the norms of an institution are often those who are given the task of transforming those norms. We can think of gender, too, as an institution. We can think of gender norms as places in which we dwell: some are more at home than others; some are unhoused by how others are at home. When we talk about the policing of gender, we are talking about walls, those ways in which some individuals are blocked from entry, from passing through. We might say that all women, including cis women, have to pass through the category of "woman": no one is born "woman"; one must be assigned to her. An assignment is what is received by others, how we exist in relation to others. But we don't all experience ourselves as passing. If you do not constantly have your legitimacy thrown into question, if you are not asked whether you are a woman, constantly, repeatedly, if you do not have the door shut in your face when you try and enter the room, then you do not have to pass through "woman" in the same way.

We notice norms as palpable things when they block rather than enable an entry. If you do not conform to an idea of "woman"—of who she is, how she comes to be, how she appears—then you become a diversity worker in both senses. For to exist as a woman would require chipping away at the walls that demarcate who resides there, who belongs there. And this is what diversity workers come up against: walls. An institutional wall is not something that we can point to: "There it is, look!" An institutional wall is not an actual wall that exists in front of everyone. It is a wall that comes up because of who you are or what

you are trying to do. Walls that are experienced as hard and tangible by some do not even exist for others. And this is how hammering, however exhausting, can become a tool. Remember, it is through hammering that these walls become tangible. We can direct our attention toward those institutions that chip away at us. We chip away at those walls, those physical or social barriers that stop us from residing somewhere, from being somewhere. We chip away at those walls by trying to exist or trying to transform an existence.

We learn from political labor because of the resistance we encounter: walls come up because of what we are trying to bring about. The effort to transform a world is hopeful, not only or always because of what we do bring about (we might fail; we do fail) but also because of what (and who) we come into contact with. Contact gives us a chance. We don't have to take that chance. We can retreat. We can turn away and build fortresses around our own bodies. Feminism too can be turned into a fortress, which is another way of saying that feminism, too, is where hammering is happening. This is why when I use the word "affinity," I am pushing against another wall. That word is often used to indicate a natural attraction, a natural tendency. An affinity of hammers is an affinity that is acquired; we become attracted to those who chip away at the worlds that accommodate our bodies. I think of the potential as atomic: an attraction or force between particles that causes them to combine. We have to take a chance to combine our forces. There is nothing necessary about a combination. In chipping away, we come into contact with those who are stopped by what allowed us to pass through. We happen upon each other. We witness the work each other is doing, and we recognize each other through that work. And we take up arms when we combine our forces. We speak up; we rise up.

Chip, chip, chip: an affinity of hammers is what we are working toward.

..

"An Affinity of Hammers" by scholar, writer, and activist Sara Ahmed was first published in the journal *Transgender Studies Quarterly* in May 2016. It is republished here with the permission of Duke University Press, with all rights reserved. It appears with minor revisions.

..

SARA AHMED

NOTES

1. See Sara Ahmed, *Queer Phenomenology: Orientations, Objects, and Others* (Durham, NC: Duke University Press, 2006).

2. Beatrix Campbell et al., "We Cannot Allow Censorship and Silencing of Individuals," *Guardian*, February 14, 2015, https://www.theguardian.com/theobserver/2015/feb/14 /letters-censorship.

3. See Sara Ahmed, "You Are Oppressing Us," blog post, *Feministkilljoys*, February 15, 2015, https://www.feministkilljoys.com/2015/02/15/you-are-oppressing-us/.

4. Campbell et al., "We Cannot Allow Censorship."

5. Ibid.

6. The example of Rupert Read might allow us to specify the demands: his comments related to trans women's use of public toilets.

7. The use of "critical" is of special interest to me: I think "critical of" also evokes "gender critical," which, as an expression, is used to mask anti-trans sentiment as feminist argument. See the following section on how arguments become part of a rebuttal system.

8. Vicki Cooper, dir., *Things We Won't Say About Race That Are True*, presented by Trevor Phillips, Outline Productions and Pepper Productions, aired on Channel Four Television Corporation, March 25, 2015. See http://www.channel4.com/info/press/programme -information/things-we-wont-say-about-race-that-are-true.

9. The documentary is premised on a misunderstanding of the nature and function of stereotyping. The point is that some generalizations "stick" because they naturalize an association between groups and qualities (often, but not only, negative qualities). Racism works by rendering some problems into problems of culture. So when Pakistani men are found guilty of child abuse, that comes to express a quality of Pakistani or Islamic culture (or even immigrant culture), while when white men commit child abuse, that violence is understood as individual and idiosyncratic.

10. See Brown's own discussion of the problems in Sarah Brown, "Whatever This Nonsense Letter Is Complaining About, It Is Not Censorship," blog post, *Sarah Brown's Blog*, February 14, 2015, http://www.sarahlizzy.com/blog/?m=201502.

11. You can see the pamphlet itself, as well as a discussion of what happened at the march, on *GenderTrender*, a UK-based, trans-exclusionary radical feminist website. For the pamphlet, see "*Breaking News* Reclaim the Night London 2014," *GenderTrender*, November 22, 2014, http://gendertrender.wordpress.com/2014/11/22/breaking-news-reclaim-the-night -london-2014/. For the discussion, see "Reclaim the March! Statement from Radical Feminists on What Occurred at London Reclaim the Night 2014," *GenderTrender*, November 24, 2014, http://gendertrender.wordpress.com/2014/11/24/reclaim-the-march-statement-from -radical-feminists-on-what-occurred-at-london-reclaim-the-night-2014/.

12. bell hooks, *Feminist Theory: From Margin to Centre* (London: Pluto, 2000), 56.

13. T. L. Cowan, "Transfeminist Kill/Joys: Rage, Love, and Reparative Performance," in "Trans Cultural Production," special issue, *Transgender Studies Quarterly* 1, no. 4 (November 2014): 501–16.

14. See Julia Serano, *Whipping Girl: A Transsexual Woman on Sexism and the Scapegoating of Femininity* (Emeryville, CA: Seal, 2007).

15. Suzanne Moore, "Seeing Red: The Power of Female Anger," *New Statesman*, January 8, 2013, http://www.newstatesman.com/politics/2013/01/seeing-red-power-female-anger.

16. This piece was originally published by the *Observer* but was removed.

17. See Tim R. Johnston's patient review of Sheila Jeffreys's equation of "transgenderism" with being uncritical of gender. He writes, "To the contrary, there have been many transgender people and allies who have used the resources of social constructionism to question both the medicalization of transgender identity and the social forces that constructed the diagnostic criteria for gender identity disorder (GID) and gender dysphoria." Tim R. Johnston, review of "Sheila Jeffreys, *Gender Hurts: A Feminist Analysis of the Politics of Transgenderism*," *Hypatia Reviews Online*, 2014, accessed September 10, 2016, http://www.hypatiaphilosophy.org /HRO/reviews/content/214.

18. Andrea Dworkin, *Woman Hating* (New York: E. P. Dutton, 1972), 181, 186.

19. See Sara Ahmed, *On Being Included: Racism and Diversity in Institutional Life* (Durham, NC: Duke University Press, 2012), 175.

THE GUILD OF THE BRAVE POOR THINGS[1]

Park McArthur and Constantina Zavitsanos

[A black-and-white photograph documenting two small, empty rooms that share a single wall. The rooms mirror one another. Each has a small window high on the back wall. It looks as if these windows have bars over them.]

Sid Barker, *Untitled (Ground floor view of the cells in Friern Hospital, London)*, 1997. Silver gelatin DOP print, 5 × 4 in (12.7 × 10.2 cm). Courtesy Historic England. Image: © Crown Copyright

What about a door is a trap when it's known, or known to be unknown? What a bout is the trap of civility. There's something about a threshold that has to do with what forms may arise on the other side, on the other way phone, telephonic to what has been called to exit in place of its entrance. By this we mean to question what happens behind closed but public doors or chambers—what is posited as solitary and yet has everything to do with sociality, what is promised in what has been quarantined elsewhere in the segregation of bathrooms and fountains (de facto, de jure, and du jour), under the juridical invocation of bathroom bills or the estranged case of Anna Stubblefield[2]—in which the state seeks to disentangle the social bonds of lovers in common while supplanting them with the too-proximate harm, deemed care, of sovereignty.

COURTSHIP

For centuries, disabled people have been held and exhibited as objects in courts: put in state courts "for their own protection" and collected as "natural fools" in royal courts for the amusement and protection of the king under "jester's privilege"—a prefiguration of both institutional critique and the critique of the institution of sovereignty itself.[3] The material of that critique is performance and its method is humor, however sardonic it may appear from a distance. In the painting *The Family of Henry VIII* (ca. 1545), court jesters William and Jane appear in doorways framing royal family members in the center of the image. William and Jane stand at the thresholds—as thresholds—to openings beyond critique, openings reached through the specific capacities of their foolery. Critique is surrounded on the page by performance.

We are a dime a dozen, which is to say we are a surplus in many senses of that word. We are extra and extremely common, left over and in excess. And we are everywhere.

A roll of the dice will always, from a distance, appear a hand job. But a hand job doesn't appear, or take form. It takes place in the inner surface of touch, and what appears is the back of the hand that conceals it in motion. Labor resists the image in favor of, and in substance as, feel. I want to get too close to see, so close you gotta feel through someone elsewhere or somewhere elseone as never one. We arrive together in continuous dislocation. These arrivals constitute a field—a field of consent—where we consent not to be unreasonably withheld, and consent not to be a single being through our completely unreasonable entanglement of need and enjoyment, our joy of missing out, of planning without splaining.[4]

[A painting of King Henry VIII and his family in the center of a large, ornate hall. At each end of the hall, archways that lead outdoors frame the court fools. The family looks forward, posing for their portrait. The king's fools, William and Jane, frown and look away. A monkey is on William's shoulder. All figures appear to present as white and are dressed in the binary gendered clothing specific to their role in the court.]

British School, sixteenth century, *The Family of Henry VIII*, ca. 1545. Oil on canvas, 55 ½ × 139 ¾ in (141 × 355 cm). Royal Collection Trust

We have to experiment with how to get around, because we are so inclined. We don't walk, we fall. In this constant experimentation on inclined plains, we render as falling no-bodies in speeds unknown, so fast light don't know, so slow every plane remains unsettled.

We, very unreasonably, will be held. We are one another's means without ends.

We, very unreasonably, have been held. Because care and abuse so often share a space so close and yet are so different, we can't say there's a distinct line between them. Before and before the event of care is the blur, not a line but a definite, indefinite shift in *flavor* cut specifically by weakness, or the weak (nuclear) force.[5] Care as an event presupposed "interdependent bodies," but the blur of care describes entangled flesh. These acts are performed in tight spaces, up close, whether or not things are personal. The tight space of need is the question we seek to open. It is not the entrance to the singular or the singularity of entrance to subjecthood or the subject of rights that we must entertain. Rather, we must enter the terrain of the need and the love below to celebrate and elaborate the ground we have before figure. This is about going back and getting stuck, remembering to double down, to go down in repetition and let it ride.

I am here to mess you up, drag you under, and, when or if ever I rise above, I'll remain in drag to bring you down so that we can even get down. If this sounds like a low blow, it is. We must lay humble, stay empathetic, play low, because killing me softly is also to say I really want to put you on. This kind of hitting below the belt is an act that recodes fighting as haptic, love in favor of a love for and through direct contact however distributed our intimacy must be, lest we lose our touch.

You make me know the space beyond twenty-nine inches' reach, what it is to go further—that need just past desire—the space between lids and lids, thighs and rolls, rolls and eyes, shade and voices thrown over stalls, four hundred pounds' weight uplifted, pants down, hands clasped, the praise of hands raised bars. Your grasped, weighed down, raised bottom garden bends time every time, folds mines and whatever it is to dig up or dig out under commons to holds the we of us let go.

Ankles on thighs, with bent knees crossing an open field, we look through a triangular loop at one another, through a frame that undoes the camera. What happens where cameras can't go? What peers through capture? What appears in capture is otherwise and that invisible to capture is elsewhere. What in aperture makes us mobile, keeps us on the run? What love is made reclined! What is lateral to bottom that perpendiculars spill as our loves come down; what acts of leisure lay our recreative rites bare by necessity?

Give us a little sign. (What does it mean for us to say we are in love?) "Some say Atlanta. Some say New York. Some say Paris, France, but who knows where this flower grows?"[6]

PARK MCARTHUR AND CONSTANTINA ZAVITSANOS

What is promised from necessity is promised forever. Bad debt is only badder in batches. Is it even possible to arrive alone?

We ask this from our conditions, however multiple, because with us, the seclusion of a non-surveilled public place (i.e., bathrooms) is never entered alone; our private parties are explicit. They unfold in tight spaces. For us it is not so much that the personal is political but that the party is public. Are there not other political animals? We are party animals. The transition from *zoe* to *bios* is never binary for us; we are scattered *and* social. And, in moving from "the ends of man" to "the crossing of borders," we promise to keep things common.[8]

The question of visibility for the nonconforming body is at stakes a double blind. We all know what's at stake in the question of "visibility"—how representation can make us targets in offering, or imposing, recognition. For many of us this is a life *and* death situation—a bond entered as a double bind, and all bound up with one another. For many of us, it is a life *or* death situation—a gamble we ante with a blind. And so we ask, how can we live? And we think one response to this call (among so many) is the love below—the stakes of which are double blind.

When Etta James sings that she'd "rather go blind" than see her lover walk away from her, we can't help but think she's already sensing a crip opacity beyond sight, appositional to the visibility of freedom. *I just don't want to be free.* It's her reflection in her glass that reveals her tears to her—as she was just, she was just, she was just sitting here thinking of your kiss and your warm embrace.[9] Here the *jamais vu* is also a *déjà vu*, which is to say the transparent misrecognition of her freedom in a place, in a glass, is also the very recognition of her already entangled love, the opacity of which offers more clarity, more charity, more love than its resolution or dissolve.

When justice is just a temporal lag in the rupture of time (*I was just, I was just, I was just*—a temporal drag in the rapture of rhythm), the ethics of freedom are a bet doubled blind. This is the love below. We are tempted to say it's one part of the love below—in recognition of the fact that the love below is common and readily available in its cast out, Outcast, even overcast, multiplicity—but we know that James's metonymy is the whole beyond partition.

▶ ‖ Enter Camera One
▶ ‖ Exit Camera Two

The double blind is this place where you're in whether you like it or not. It's the space that precedes but doesn't necessarily cede the "all in." But what is it to be all in? Because nobody does this when they are up, and I mean it. *Nobody* does this when they are up—but lots of people do it when they're down.[10] I want

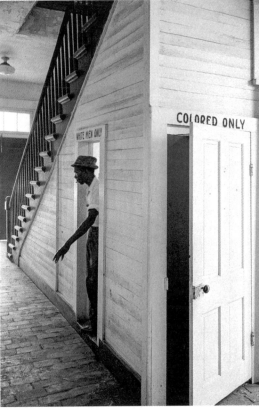

[Two images, in a row from left to right: On the left, a black-and-white photograph of an art piece by Marcel Duchamp. Two doorframes, joined at a right angle, share a single swinging door between them. The door can cover either doorframe, but not both at the same time.

On the right, a US civil rights–era black-and-white photograph of segregated bathrooms, adjoined at a right angle. The doors are separately labeled: "COLORED ONLY" and "WHITE MEN ONLY." A person who appears to present as a black man walks out of the door labeled "WHITE MEN ONLY."]

to think about what it means to be all in and why nobody is so good at going all in even when they're up. Let those that can feel, feel me here. In dissolving the rationality of commensurate exchange and expenditures, gambling shares something with what we've been calling care and need.

I'm trying to get at this idea that it is easy (and I like easy) to see how (living) labor produces value. This is what we know even when everybody (but never nobody) is telling us otherwise.

But I want to ask another question: not where value comes from—it comes from us—but rather, what produces *invalue*, what is already *in* value, what is invaluable?

I think it's the capacity of need, specifically an incapacity that has everything in having nothing. Is it need that produces invalue? Is it need that offers us debt, as debt elaborates our need?

Posse, Pogie, Pogey. The many make this power house pour, make this poor house power.

▶ ‖ Dear Camera One,
I made it this far while speaking love around you. For years I want you, and this is what I want: I want our own aubade, made among the myriad ways sex exists, the least of which imagines crotches. I want to hold the material we help our bodies make, operations in place with nowhere to go, we have no goal, our personal impact section repeats after us.[11]

We aren't going nowhere. It is not that we cannot move. It is that we move with and through others and that our movement—so often deemed immobile— is in fact, and in every case, a movement that makes a people rather than a people that participates in motion. The "nonconforming body" has as its ground the irreducible sociality of deformation—and policy can do nothing to form itself in opposition to this material resist. (And try as they might to make our beds owned, they know it was also made for them.)

Let's make a deal. What's both behind and before door number one is the productive capacity of labor and debility by the dozens, a critique and performance of multiplicity barred none (bar no-bodies; bar aubadies; nobody, babies). What is laid bare in the ungendering of gender that Hortense Spillers describes is the specifically speculative fiction and fraction of co-sent—an open field sequestered, a color field abstracted. To never arrive alone, to render incomplete, to go home, to never go home, to go back while moving forward in time, is to stick and move, to strand without landing, in recess doubled down in struggle and held by all those stranded.[12]

[A black-and-white photograph documenting the filming of *Let's Make a Deal*. Host Monty Hall gestures toward a group of contestants in the audience who are wearing costumes and holding signs, all of whom appear to have light skin. Behind Hall, a camera crew stands in front of a stage set that includes a large door labeled with the number "1."]

Production shot of Monty Hall with contestants and camera crew on the set of *Let's Make a Deal*, October 1, 1969. Courtesy ABC Photo Archives. Photo: © ABC/Getty Images

PARK MCARTHUR AND CONSTANTINA ZAVITSANOS

Find yourself.
Lose yourself.

SCORE FOR ADDED DOOR

Start with a narrow rectangular bathroom
In an apartment you don't own
Entering and exiting by only going forwards and backwards
Is adding another door possible?
Adding the ability to turn
Cut through drywall and miss the electrical wiring
Make an opening thirty inches or wider,
Connecting two rooms, the bedroom and the bathroom
For when the bedroom becomes a bathroom.

I THINK WE'RE ALONE NOW

There's a figure on a threshold, a glyph about us without us, a representation never of us that confronts us outside.[13] But inside, disfiguration challenges the expectation of privacy. We cross the threshold one after another, choosing who goes first and finding a stall together. In this public space of single installed privacy, we don't come alone; our privacy is public.

On the way in and out, our needs go monitored and surveilled in an attempt to interpellate, identify, and individuate us. We might be contagious; we might be touched. We might become somebody's close encounter of a third kind. The segmentation of the bathroom screens us in and out, bracketing the incontiguous touch that precedes and follows us, the touch that others have touched. They fear our accommodation, our commode, our relief, catching on.

And so we move together and keep our voices low. We scan the cracks between the wall and the stall to see who else is here. Do they hear us? Does it matter if they see us? No doubt they can feel us! And we surely feel them. We feel our disruption that comes after and comes after the right to privacy lawfully expected to be found inside these stalls. Leave us alone; don't leave us alone.

Privacy is such a funny way to think this intimacy, extimacy. Is a private act ever something done alone? How do we even get alone when everybody's doing it in private, sharing it in public, and liking it? The ways that self-sufficiency gets

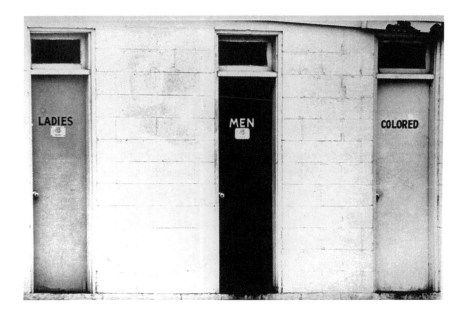

[A US civil rights–era black-and-white photograph of segregated bathrooms shows a wall with three narrow doors. The doors are labeled separately, from left to right: "LADIES," "MEN," and "COLORED." All three doors are slightly elevated with a continuous step below them and a single window above each of them.]

View of segregated public restrooms labeled,
"LADIES," "MEN," and "COLORED," ca. 1960.
Courtesy Hulton Archive / Getty Images

coupled with privacy—sometimes even the way private couples get self-suffi-cient—help things go awry: when you need a hand, when the call is not yet re-turned, when the text is just dot-dot-dot done-gone. This ellipsis can be all the *falling short* we need—where falling eclipses falling—to ground, or disfigure us public again. Somehow when the text is all ellipses and no words, we don't lose touch, we keep it. In this occlusion we find what we need, and we want it.

We're after that disfiguration that's not so readily separated and enclosed. And it's our deformity that informs us of this. It's our deformity that enforms us in this. Some of us will only ever hear this; some of us are *wayyy* too glamor-ous for the upgraded etymological swerve of grammar. Some of us will never need an exegetical reference because our reverence for empathy is word made flesh. And for those of us that slip away while held, or seize up in flow when touched out of sequence, we offer sequins to bedazzle every figuration back together and back to the future.

While the disfigured may (in some cases) come late and come solo—or play solo—we know disfiguration arrives always entangled and on time at every crucible-cubicle, the ground of which is doors unlimited, and the limit of which is so often a removed door, a poetics beyond relation and a rupture to the divi-siveness of every inclusion. Our ecstasy is a necessity and our resistance comes first. We don't make sense; we just feel it.

SCORE FOR REMOVED DOOR[14]

Cut from space an open.
-1/+1
Rue Larrey floored

ANTE, MONTE, MANY

Let's bluff. Behind door number four, a game of tag, where the one playing "it" plays blind and is desirous of improvisational contact on the run. Where "it" is contagious and the temporarily able pass around the play-feel of reshaped senses, trying to get closer.

A game of blind man's bluff, where "bluff" is a slur from "buff," or what it is to shine through repetitive touch. This game of blindfolded tag based in both the desire for and the avoidance of contagion has its variant in Marco Polo, a similar game of tag named after the fourteenth-century merchant traveler of the same

name—the one whose documented travels would later inspire Christopher Columbus. Played in and across water, it uses call and response to set in motion its play. Both games are all about hiding in plain sight and getting close without getting captured, being sensitive, being led on. Both games know in depth that love is blind, that blackness is love. And so they put "it" on, to be moved by love in the dark—to be enformed in this deformed, immature, overaged social life in rage and apposition to the premature death of capture. To be stranded as children is to play wrong and have it be so right.

The thing about "the blind leading the blind" is not just the idea that the blind must always be led, or even that in such cases it would be best to have the blind led by the sighted—when it is, in fact, the blind who are most equipped to lead the blind—but rather the assumption that leadership is necessary for navigation at all, that there must be both a telos and a pedagogical direction for such travel.

To seduce once meant to draw away, lead astray. What if the seduction of the wayward by the blind, of the sighted by the lost, were instead imagined as a chance to run away together? To get alone together? To tumble to the ground in fugitive entanglement? What if the sociality of blindness were to be taken as privileged haptic navigational egress back toward one another, set aside from the linear movement of progress this adage advises?

The mark's winning bet will never be accepted by the dealer. But the non-conforming mark drains the con of form; its material necessity overflows every khoratic occasion and immaterial use. All value here is surplus.[15]

A LOVE SEAT

The construction of a lap brought through haptic doubling, our weak nuclear force in close quarters across time, enacts a sexual cut that reproduces the recline in perpendicular repetition. This passive resistance absorbs any proprietary claim to our children, or rather to the children who have come to us as hours, the way time comes to a clock.

There are children here. We are children. There are no children here. We are the oldest children. What's laid to rest in this fictive kinship formation is the secretion of a value theory of labor, a living labor that haunts procreation (as guest and host), that seizes the liens of reproduction for re-creative means beyond measure in the elongated and crossed elaboration of our mutual funds, our surplus chromosomal stain, our incalculable inherited bad debt against inheritance.

SCORE FOR TRAP DOOR

Given:
1. hinges
2. trust
It will open when you need.

SCORE FOR CROSSING AN OPEN FIELD[16]

Notice your partner's lap has been the same shape for
some time and ask if she'd like it tight or open.
Wait for her response.
Bend over and pick up her leg from the mid-calf.
Place her ankle over her opposite thigh.
Adjust as directed.

To lean on our peers—an act within the production of art so often deemed an influence, which is in fact influenza—we catch and make contagious a transmission across time, in which sharing is our greatest weapon. We fold these leans on the piers back to the future to locate again—without the relocation that has proved their removal—what we might site as a productive degenerate space where "people met to invent new forms of congregation" and to offer new opacity through difference without separation because this is what crossing and undressing can open in their specifically closed maneuvers.[17]

Here we cite a kind of recreation against procreation, means to end linear reproduction, a rupture to the genius and genus of lineage, a crooked leg bent over backward, cripped to turn out a sociality that exceeds itself, its affective capacity to care, to, like, give a fuck, or to like what it is to take a fuck as gift.

I want to let our looking from above alone, climb down scaffolding, and leave the camera on, Camera One. I want to lie next to you as a two-by-four stretches across a brick, as a poem rests inside another poem. I want to strap a camera on something else for once and use a dolly for play. Strap a camera on something else for once, strap it to you and me: film a foursome, destroy the film, and play the oldest hand for free.

A bed. This foursome—

Fuck with me, the oldest hand for free.

What might the construction of a lap produce and bear in apposition to the bare removal of social life and its infrastructural supports? What doors does Hujar leave ajar for us? The basin becomes the back. And the back, by turns, a lap. A love seat, glancing off an interior and exterior into an ulterior. This beyond,

not presently in lieu, may remain distant and remote while coming into view, a fountain. What doors does Hujar keep closed?

WELT, WEALTH

From inside the *vulnus*, or the wound, life's critical conditions disrupt the continuity of what is thought of as "someone's life," and open into the generative feeling of flesh. What about a wound is vulnerable? What about an injury is a wronging of the law? The *vulnus* of vulnerability, like the *in juris* of injury is instantiated as the right and the wrong of laws—both in the laws of grammar and in the rule of laws. A fish was once a fish until fish were fished. I wanna ask before the net—to ask after a fish's eye that sees the net, the line, the pole, and swims the other way. But what is figured as the penalty of pain, also opens the welt and wealth of joy, occupying the same space. The fish-eye lens of the peephole bends the room's edge.

To hang low, to be suspended in time and space, is to depend. To be pending, waiting, wading, held up, stuck, is to depend. From this comes our erotic capacity to droop heavy and seize up, to be let down or let go. From it also comes the other sense of dependency as causality and derivation. We rely, we rally, we gather, to just hang on and to just hang out.

I never considered knowing you. Not because you don't exist (I see you everywhere). Not because I am not proud being near you alive in the world (my hands are this pride), but the issue of protection never came up: the pa and the law that fucks us all up turned into a top-and-risk, a control tower beeping through distance. And try as we might to make our own bed, we know it was also made for us.[18]

Dependency (de)generates in entanglement. If we think of labor in terms of value, we think of need in terms of the invaluable. If all you have to contribute is your need, throw that in the pot. It's more than enough. *In my condition, I don't want to be alone.*[19]

In our conditions we aren't alone: both in the ways that our conditions form solidarities around what might be called shared experience, and also in the ways that our conditions necessitate being together. These needs constitute the we— the depending, deep-ending parabolic droop, bottomed in the catenary, merged in the swerve, and singing:

[A black-and-white photograph of a person reclining on the Christopher Street Piers in New York. The person wears work boots and short shorts with legs propped up and crossed ankle over thigh. In the background is a large ship on open water. The person appears as gender nonconforming with light skin.]

Peter Hujar, *Christopher Street Pier #2 (Crossed Legs)*, 1976. Vintage gelatin silver print, 20 × 16 in (50.8 × 40.6 cm). Courtesy Pace/MacGill Gallery, New York, and Fraenkel Gallery, San Francisco. Image: © 1987, The Peter Hujar Archive LLC

If there's a cure for this
I don't want it
(Don't want it)
If there's a remedy
I'll run from it
(From it)[20]

SCORE FOR POCKET DOOR

Split jamb.
That's my jam.

SCORE FOR CROSSING AN OPEN YIELD

Ask your partner if she knows what is in one leg to know that the other is next
and that both are on fire.
Ask if she knows what it is to have the power in degrees of freedom from the
body but not in it.
Wait for her to answer.
Keep waiting.

..

"The Guild of the Brave Poor Things" was coauthored by artists Park McArthur and Constantina
Zavitsanos in 2016 for this volume.

..

NOTES

1. Started in 1894, the Guild of the Brave Poor Things was an English group for disabled
children. In nature and mission, it was primarily social, though also pedagogical. The
organization's 1907 annual report contains an account of a young girl exclaiming: "'O! I am
so glad to be a cripple!' When asked ... why she would be glad, the girl responded, 'It is so
beautiful to belong to the Guild, and I couldn't unless I had lost my leg.'" As quoted in Michael
Mantin, "'A Great Army of Suffering Ones': The Guild of the Brave Poor Things and Disability
in the Late Nineteenth and Early Twentieth Centuries" (undergraduate thesis), University of
Bristol Department of Historical Studies, accessed July 13, 2016, http://www.bristol.ac.uk
/history/media/docs/ug-dissertations/2009mantin.pdf.

2. In 2015, Stubblefield, a Rutgers ethics professor working in disability studies, was found
guilty of first-degree aggravated sexual assault of her friend and collaborator, a disabled man
named in court documents as "D. J." First with Stubblefield, and then with others, D. J. had

employed a method of assisted or "facilitated" communication (FC) using a keyboard. Before the trial, the judge ruled that FC "failed New Jersey's test for scientific evidence," citing studies that found that FC users' speech was not their own, but was an ideomotor effect originating with facilitators, like the movement of a Ouija pointer.

When D. J. was in his twenties, New Jersey's Bureau of Guardianship Services determined that he "lack[ed] the cognitive capacity to understand and participate in decisions." Extending this assessment, the jury in the Stubblefield case judged him incapable of sexual consent, of rendering sex as decision. Speaking for oneself, posited as the illusory precondition for the (sexual) entanglement and dependency that are its very ground, is what D. J. put under threat. D. J. did not testify, but entered the courtroom as a "demonstrative exhibit." Without mobility aids such as a wheelchair, or communication aids, he was supported by his mother, who said, "This is my son." It is the lack of a certain kind of speech that is criminalized here and not the question of consensual sex. While the case is posited as against Stubblefield, it is also (and perhaps primarily) against D. J. If disabled people are deemed incapable of giving consent because they lack certain forms of speech, then any of their sexual encounters may later be deemed sexual assault.

For coverage of the trial, see Julie Equality, "Some of My Thoughts on the Anna Stubblefield Case," blog post, *Julie's Writings*, accessed June 21, 2016, http://julieswritings.blog.com/2015/09/13/some-of-my-thoughts-on-the-anna-stubblefield-case/; Astra Taylor, "Anna Stubblefield Was Convicted of Raping Her Disabled Student. But Was the Trial Fair?," *fusion*, November 12, 2015, http://fusion.net/story/231772/anna-stubblefield-was-convicted-of-raping-her-disabled-student-woman-with-cerebral-palsy-weighs-in/; and Daniel Engber, "The Strange Case of Anna Stubblefield," *New York Times Magazine*, October 20, 2015, http://www.nytimes.com/2015/10/25/magazine/the-strange-case-of-anna-stubblefield.html. For D. J. and Stubblefield's writing on facilitated communication, see DMan Johnson, "The Role of Communication in Thought," *Disability Studies Quarterly* 31, no. 4 (2011), http://dsq-sds.org/article/view/1717/1765.

3. Historian Suzannah Lipscomb writes: "In 1616 Nicholas Breton defined a natural fool as one 'Abortive of wit, where Nature had more power than Reason'. The legal term *idiota* was interchangeable with 'natural fools', who were characterized as incapable or insensible of their actions: a visitation of a nunnery in 1535 reports the presence of one Julian Heron, 13 years old and 'an idiot fool'; Bishop Cuthbert Tunstall writing to Thomas Cromwell in 1538 identifies 'an innocent natural fool' whom 'by no means we could make to grant' that he had spoken words of malice against the king; a statute of 1540 establishes the royal prerogative over 'idiots and fools natural'; while even Shakespeare's *All's Well that Ends Well* mentions 'a dumb innocent', pregnant because she 'could not say him nay'." Suzannah Lipscomb, "All the King's Fools," *History Today* 61, no. 8 (August 2011), http://www.historytoday.com/suzannah-lipscomb/all-king's-fools.

4. The phrase "consent not to be a single being" is Édouard Glissant's, by way of Fred Moten. In answering the question, "What is departure?" posed to him by Manthia Diawara, Glissant answers, "It's the moment when one consents not to be a single being and attempts to be many beings at the same time. In other words, for me every diaspora is the passage from unity to multiplicity" (Glissant, quoted in Manthia Diawara, "One World in Relation: Édouard Glissant in Conversation with Manthia Diawara," trans. Christopher Winks, *Nka: Journal of Contemporary African Art* 28 [2011]: 4–19). Moten takes up this phrase not only as part of a critique of individuation, but also as a critique of the proper through the dispossessive force of blackness. See Fred Moten, "to consent not to be a single being," blog post, *Harriet*, accessed August 6, 2016, https://www.poetryfoundation.org/harriet/2010/02/to-consent-not-to-be-a-single-being; and Fred Moten, "Blackness and Nonperformance," talk delivered

as part of "Afterlives: The Persistence of Performance," Museum of Modern Art, New York, September 25, 2015, https://www.youtube.com/watch?v=G2leiFByIIg. On related questions of consent and contract, see Sora Han, "Slavery as Contract: *Betty's Case* and the Question of Freedom," *Law and Literature* 27, no. 3 (2015): 395–416.

5. Weak nuclear force is one of the four fundamental forces that govern all matter in the universe. The other three are gravity, electromagnetism, and the strong force. The weak force changes the flavor of subatomic particles, particularly particles known as quarks. The weak force allows these quarks to swap flavors. The flavors, which give the composite quark particles their properties, include up, down, strange, charm, top, and bottom.

6. OutKast, "The Love Below (Intro)," on *Speakerboxxx/The Love Below*, LaFace Records, 2003.

7. For more on the Dozens, see Leroy F. Moore Jr., "The Dozens, Slavery, Disability & Hip Hop: Making the Connection," blog post, *KRIP-HOP NATION*, February 13, 2017, http://kriphopnation.com/the-dozens-slavery-disability-hip-hop-making-the-connection/.

8. See Jacques Derrida, "The Animal That Therefore I Am (More to Follow)," trans. David Wills, *Critical Inquiry* 28, no. 2 (2002): 369–418: "If I am to follow this suite [*si je suis cette suite*], and everything in what I am about to say will lead back to the question of what 'to follow' or 'to pursue' means, as well as 'to be after,' back to the question of what I do when 'I am' or 'I follow,' when I say '*Je suis*,' if I am to follow this suite then, I move from 'the ends of man,' that is the confines of man, to 'the crossing of borders' between man and animal" (371–72).

9. Etta James, "I'd Rather Go Blind," written by Ellington Jordan, on *Tell Mama*, Cadet Records, 1968. Jordan drafted the song in prison, and James heard and developed it when she visited him there. See Etta James and David Ritz, *Rage to Survive: The Etta James Story* (Cambridge, MA: Da Capo Press, 1995), 172.

10. In referring to "nobody," we follow Denise Ferreira da Silva: "Do we want to be somebody under the state, or no-body against the state?" Ferreira da Silva's question locates the "nobody" we want to be (with)in subaltern resistance to subjection and subjecthood under racial capitalism. But Ferreira da Silva's use of the term "no-body" also requires us to think specifically about the (some)*body* as a putatively discrete anatomical form, and its relationship to individual subjecthood under the state. To be no-body against the state— to elude or be denied the anatomical referent of the subject—is to take up, as Ferreira da Silva does, Hortense Spillers's distinction between "body" and "flesh."

Spillers describes chattel slavery as a "theft of the body," not only in terms of physical abduction, but also in that the "captive community" was rendered flesh—in other words, rendered available for terrible corporeal and social reorganization, dismemberment, scientific study, and use, not as discrete bodies, but as "captive flesh": "I would make a distinction in this case between 'body' and 'flesh' and impose that distinction as the central one between captive and liberated subject-positions. In that sense, before the 'body' there is the 'flesh,' that zero degree of social conceptualization that does not escape concealment under the brush of discourse, or the reflexes of iconography." Hortense Spillers, "Mama's Baby, Papa's Maybe: An American Grammar Book," *Diacritics* 17, no. 2 (Summer 1987): 66.

Spillers's concept of de-individuated flesh gestures especially at questions of disability and disfigurement, and the relationship between medico-scientific and sociological epistemology and subjection; "the entire captive community," Spillers writes, "becomes a living laboratory" (68). The rendering of captive flesh radically deterritorializes and "ungenders" the captive. It breaks down or precludes the anatomical articulation of parts from

PARK MCARTHUR AND CONSTANTINA ZAVITSANOS

wholes and selves from others. Flesh undercuts the link between anatomy and the human. But flesh, because it is shared, describes a sociality that resists individuation. Spillers has said that flesh is another name for "empathy"; see her remarks in *Dreams Are Colder Than Death*, directed by Arthur Jafa (Very Special Projects: 2014). Flesh as empathy might also be described as the wealth of no-bodies, what Ferreira da Silva calls "difference without separation." Denise Ferreira da Silva, remarks delivered at "Episode 6: Make a Way Out of No Way," Arika, Tramway, Glasgow, September 26–28, 2014. For more on the "no-body," see also Denise Ferreira da Silva, "No-Bodies: Law, Raciality, and Violence," *Griffith Law Review* 18, no. 2 (August 2009): 212–36.

11. Park McArthur, "Desire Behind the Form" (unpublished manuscript for a play, 2013).

12. "Every act of recess is an immediate act of struggle where we're stranded and held by those stranded with us." Stefano Harney, remarks at "Constantina Zavitsanos: Speculative Planning Session with Fred Moten and Stefano Harney," New Museum, New York, April 25, 2015, *Livestream*, https://livestream.com/accounts/3605883/events/3991702.

13. "Nothing about us without us" became a common slogan in disability political work in the 1990s.

14. Made so that a single door would serve three rooms connected by two doorframes, *Porte: 11 Rue Larrey* is, for us, an example of how states of revelation and obscurity can manifest as conditions of the same plane, rather than as opposites. In an interview, Duchamp emphasized that in the work, necessity produced, rather than precluded, aesthetic play: "In Paris I was living in a very tiny apartment. To take full advantage of the meager space, I thought to make use of a single door which would close alternatively on two jamb-linings placed at right angles. I showed it to some friends and commented that the proverb 'a door must be either opened or closed' was thus caught *in flagrante delicto* for inexactitude. But people have forgotten the practical reason that dictated the necessity of this measure and they only think of it as a Dada provocation." Marcel Duchamp, quoted in Arturo Schwarz, *The Complete Works of Marcel Duchamp* (New York: Harry N. Abrams, 1970), 497.

Given the interplay of necessity and traffic in these doorways, we really like that the short Paris street of Rue Larrey—where Duchamp completed *Porte: 11 Rue Larrey* in 1927— had been home to a public "water bath" and a store selling "mechanical beds and armchairs for the ill and wounded" approximately sixty years prior. For further reading on the buildings of Rue Larrey, see Alexandra Schwartz, "Paris Reborn and Destroyed," *New Yorker*, March 19, 2014, http://www.newyorker.com/culture/culture-desk/paris-reborn-and-destroyed.

15. "Khora" is a transliteration of the Greek χώρα, which means "place" and refers in philosophy to the slippery concept of a quasi-maternal receptacle, space, or interval that precedes, and perhaps gestates, form. The term has been taken up in the writings of Plato, Jacques Derrida, Martin Heidegger, Julia Kristeva, and many others. See, for example, Jacques Derrida, "*Khora*," in *On the Name*, ed. Thomas Dutoit, trans. David Wood (Stanford, CA: Stanford University Press, 1995), 89–130.

The phrase "khoratic occasion" is meant to refer to Nathaniel Mackey's phrase "natal occasion": "You got me all wrong on what I meant by 'a sexual cut' in my last letter. I'm not, as you insinuate, advancing severance as a value, much less pushing, as you put it, 'a thinly veiled romance of distantiation.' … What I was trying to get at was simply the feeling I've gotten from the characteristic, almost clucking beat one hears in reggae, where the syncopation comes down like a blade, a 'broken' claim to connection. Here I put the word 'broken' in quotes to get across the point that the pathos one can't help hearing in that claim

mingles with a retreating sense of peril, as though danger itself were beaten back by the boldness, however 'broken,' of its call to connection. The image I get is one of a rickety bridge (sometimes a rickety boat) arching finer than a hair to touch down on the sands at, say, Abidjan. Listening to Burning Spear the other night, for example, I drifted off to where it seemed I was being towed into an abandoned harbor. I wasn't exactly a boat but I felt my anchorlessness as a lack, as an inured, eventually visible pit up from which I floated, looking down on what debris looking into it left. By that time, though, I turned out to be a snake hissing, 'You did it, you did it,' rattling and weeping waterless tears. Some such flight (an insistent *previousness* evading each and every natal occasion) comes close to what I mean by 'cut.'" Nathaniel Mackey, *From a Broken Bottle Traces of Perfume Still Emanate* (New York: New Directions, 2010), 34–35.

For an account of khora as the "errant feminine" in Plato, see Emanuela Bianchi, "Receptacle/*Chora*: Figuring the Errant Feminine in Plato's *Timaeus*," *Hypatia* 21, no. 4 (Fall 2006): 124–46.

16. Park McArthur and Constantina Zavitsanos, "Other forms of conviviality: The best and least of which is our daily care and the host of which is our collaborative work," *Women and Performance: A journal of feminist theory* 23, no. 1 (2013): 126–32.

17. "In *Day's End*, a piece which he [Gordon Matta-Clark] constructed on an abandoned pier on the West Side waterfront of New York, he injects light into the very shadows that the S/M community has claimed as the very field of the material for their encounters. What was once a shadowy space where people met and invented new forms of congregation—he floods with light." Laura Harris, "The Volatility of Ferment: Investigations into Living Labor by Karl Marx and Gordon Matta-Clark," paper delivered at "Living Labor: Abstraction & Excess," New York University, April 12, 2014, *vimeo*, https://vimeo.com/102570180.

18. McArthur, "Desire Behind the Form." "Top and risk" is meant to address the specifically sexual violence of the NYPD protocol. On the pat-down and the body search as sexual and gender-based state violence, see Reina Gossett, "Foreword," in *Queering Sexual Violence: Radical Voices from within the Anti-Violence Movement*, ed. Jennifer Patterson (New York: Magnus Imprint, 2016), 1–3.

19. SWV, "Weak," written by Brian Alexander Morgan, on *It's About Time*, RCA, 1992.

20. Diana Ross, performance of "Love Hangover," written by Marilyn McLeod and Pam Sawyer, on *Diana Ross*, Motown, 1976.

SPIDERWOMEN

Eva Hayward

TO TRANSPOSE
———

To write this text, I took the word "transposition" for a series of walks through a number of readings alongside experiences and down city streets (which are all the activity of transposition itself): a mapping of senses through which one's body (as a set of specific, sociohistorical constraints—as in, "a white trans-woman") and embodiment (the sense of being bodily, "my body hurts") emerge. That is to say, transposition is both cause and effect—the everyday act of becoming otherwise, as well as its foreclosures, refusals, and limits. As for a definition, "to transpose" is to change something into another form, or to transfer to a different place or context: transmutations but also translations and alterations in modes of life and death. Transposition can be a deviation that discomposes order—transpositions are equally as destructive as they are generative. Working with these traipses and etymologies of transposition, I want to suggest that sexual transitions (for my purposes, particularly transwomen's) are fused with, and perhaps constituted by, forces and excitations of location, of neighborhood. I mean that, for me, transpositions refer both to the sensation (a composite of affects and percepts) of bodily change and to the corporeal states constituted through transsexual[1] transitions, which are all shaped by spatial and environmental orientations.[2]

 To do so, I use myself (or parts of myself) as a starting point: I am transitioning. My account of male-to-female transsexual transitioning in an urban setting might appear unavoidably self-indulgent, drifts in personal recollection—as in "my story"—but it is meant to suggest, however speculatively, and without aiming toward universalizing, the sensuous (in this word, hear "violence" as much as "pleasure") and materialist transactions between body, desire, and environment.

First, it is impossible anymore, if even it ever was, to categorically define the ways that transsexuals become trans-sexed. Attempts to name, chart, and absolutely frame all matrices of transitioning are among the injustices committed against transsexuals.[3] So, why? Why this personal approach? The personal is not the same as the individual, but an opportunity to see how lived experience can be the basis for investigation.[4] To some degree, the effort to "tell my story" is to tell the reader lies. Not intentionally, but obscuration is the unavoidable effect of reporting on the self; "my story" is shaped by repression, a wish to be seen as I want to be seen. But—and this is an advisory "but" for all of us who write about trans/gender/sex—"my story" is a necessary component of trans care. If you are able, and not all trans people are, to receive care, an account of a trans self is obligatory. Even beyond health care, a narrative for "why you want to transition" is solicited by lovers, friends, family, and many others. To transition, to change or alter sex/gender demands a story. Personally, the demand helps with the unexpected, with the inevitable feeling of bodily betrayal. Socially, the account assuages anxiety that sex/gender might change for anyone. Stories, then, are acts of violence and deception, even as they are made necessary.

By redeploying the medicalized legacy of transsexuals' self-narrativizing—constructing a diachronic narrative from a synchronous field of wrong body-ness so that an account can be given—I use my own felt-body knowledge of transsexuality to push back at larger political, historical, and cultural currents. Rather than reading such reflexivity as a failure of critical distance, I want to say that transsexuality is not about authenticity or originality, but reveals how bodily feeling and desire are constituted socially and spatially. I may want to wish away the narrative demands imposed on transsexuals—after all, they are transphobic, internally and socially—but this imperative reveals the discursive nature of bodies and embodiment, of how political, affective, and social registers work to produce "my body." Consequently, I offer transpositions not through absolute definition—not to reinforce an "accurate" accounting of the self as definitive—but through description, an effort to describe transitional sensations as they are shaped by a specific location. What is described, what is formalistically detailed, is also transpositional: an effect of forms and forces that causes yet other effects. In other words, transpositional for this essay is a formal account, an attending to the material and sensual constraints of transitioning (as opposed to a purely identitarian refrain).

..........

*Tenderloin, tender meat—taken from under the short ribs in the hindquarters—is the loin, animal flesh, or soft underbelly. In common vernacular, a "Tenderloin" is a district of a city where crime and vice are prominent. Perhaps no surprise that hard-boiled detective fiction (Dashiell Hammett lived at 891 Post Street) and film noir (*The Maltese Falcon, *John Huston, 1941) would emerge from the wet, chiaroscuro streets of San Francisco's Tenderloin. My home: 1028 Post Street, San Francisco, part of that Hollywood-inspired noir-hood. It is a small studio. A claw-footed bathtub. One view of the neighboring brick building. A fire escape. I am here to "tend my loins," to trans sex. My sex is turned to meat, to post-animal (the afterward of the animal is meat), to my tenderloin. I am not sure why this neighborhood, but it seems like a return. An effect of après-coup, of retroaction? Coming home to a place already made by the labors, deaths, and loves of other transwomen, already made by my memories?*

NEARNESS OF NEIGHBORHOOD

Neighborhood: The *Oxford English Dictionary* tells us that neighborhoods are "a community; a number of people who live close together; a vicinity or surrounding area." They are "the quality, condition, or fact of being situated near to someone or something; nearness, proximity." An urban neighborhood in the US: people moving along streets on foot or by car or bicycle; cell phones vibrating and ensuing conversations; pigeons sitting on the eaves of buildings; federal and state policies subtending urban plans; gentrification and racialization determining who is, and is not, here; a hot day fills alleyways with the stink of urine, rotting food, vomit, and unknowable things; traffic lights directing movements; city sounds building out scale and volume; eateries and shops indulging the walker with window scenes. A plenum of gregariousness, a pulse, a conglomerate that constantly respires and excretes, the neighborhood holds ground just as it lurches for new resources. It is a bumptious, brutally lively, *coherence* of bodies (human and nonhuman), ecosystems, communities, and buildings. These are not utopic zones of love, though love can be found; neighborhoods are stresses even in apparent moderation, vehemently intractable. Neighborhoods exclude, are designed to make some vulnerable while others safe; neighborhoods can be percussed by bullets as much as by traffic. To be neighborly is as much a threat as an invitation.

Out of the midst of this San Francisco verve, gestated by my own transposing, I again wonder: How do transsexuals living in neighborhoods experience

the reaching and refusing nature of these populated zones in relationship to their own sexual transitioning? First, not all transsexuals transition, certainly many do not, and what counts as transitioning varies greatly, but I am specifically interested in those bodies, particularly transwomen, who alter themselves through surgeries and hormones to feel themselves differently in the world. By "transitioning," I do not mean a monolithic movement between states, rather I mean simply an emergence of a material, psychical, sensual, and social self through corporeal, spatial, and temporal processes that transfigure the lived body. Rather than accounting for transsexuality as a psychological condition, or a purely sociological production, or as some biological imperative, I offer a supplemental reading that is about the expressiveness of trans. I am not proposing that these other registers of interpretation are without merit; however, I wonder what else can be asked about transitioning. Specifically, how might a transitioning body experience the sensually teeming place of a neighborhood? And, conversely, how do urban forces accompany transsexual transitions—radical alterations to bodily sensoriums—that shape and reshape a neighborly self? What is the somatic sociality of transitioning?

.

I live directly across from Diva's. Standing outside the bar, at all hours, are dazzling women. Their heels cantillate, sounding out the streets. They gather at the entry of the bar, which recedes from the sidewalk just enough to offer shelter and vantage. Their aesthetic exuberance is framed by concrete and steel. They are hyper-visual and their shimmer, sparkle, dazzle also confuse vision, an excess that clouds the question of visibility; the gilded surface deflects a desire for depth even in its allure. Differences in race, ethnicity, and class are not lost—going into Diva's, you are confronted with how race territorializes—but necessity makes the entry a temporally shared space between these glittering women. A glistering threshold—charged with desire and fear— the doorway is the only common ground. Even still, every entry is also a foreclosure. An open door is a closed door, too.

.

There are many peoples and histories at play in San Francisco's Tenderloin district.[5] Significant legacies of racial politics, struggles for sex-worker justice, immigration rights, and homelessness activism define the pavement, street corners, community centers, and churches—and these are but some of the accounts that structure this neighborhood. Susan Stryker and Victor Silverman's documentary *Screaming Queens: The Riot at Compton's Cafeteria* (2005) depicts

transgender political work in the Tenderloin and the unlikely alliances with various social justice movements. They offer an intersectional arrangement of historical struggles and the rekindled activist energies still at work in challenging transphobia, xenophobia, racism, and poverty.

My project is a narrowing, perhaps even a preterition, of these critical efforts by situating the current Diva's bar, 1081 Post Street, San Francisco, as a hub for the activities of transwomen in this neighborhood. This is arguably an arbitrary center—though how center are any centers?—but, still, Diva's is a place where many transwomen experience kinds of communion. Some of these women are sex workers, some are not; some women go to the bar seeking community, others pleasure. Some women are simply surviving, while others find that these streets are full of deadly consequence. Some women find the visiting men a nuisance; others find the men the reason to come to Diva's at all. Transwomen of color, black transwomen, poor transwomen, feminine transgenders, immigrants and migrants seeking refuge, *fa'afafine, kathoey, māhū*, and others also find something they need among the streets of Post, Geary, Polk, Turk, O'Farrell, and more. For me, Diva's creates its own gravitational drive, an excited charge in the greater pull of the city, a place of coming together (sometimes forced) even if never visited, with transwomen living, working, and dying in the surrounding area.

.........

Tergiversation, a politically suspect form of evasion: Some days I try to distance myself from other women working the streets by reading and walking, code switching to shield myself from approaching men. The performance feels tenuous and necessary, but also ruthless. I fold myself inward and lower my vision into my feet; my feet "look out" for me. My toes begin to apprehend the crosswalks differently. Toes register as eyes—"toed-eyed"—giving me a planar view that senses beyond the peripheral through reverberation. Often my guise works, but occasionally men slow their cars anyway and signal me for a paid tryst. "Do you want an ice cream cone?" Depending on my needs, I pretend not to understand.

ANIMATED CITY, ANIMALIZED SPACE

The neighborhood around Diva's is an animated zone, a multispecies site. In addition to transwomen, buildings, and streets, pigeons, spiders, crows, rats, insects, pets, molds, viruses, and numerous other beings share the architectural forms with human selves and their intentions; they, too, are neighbors.[6] Perhaps it

seems an unlikely linking of transsexual transitioning and urban space with animality, or risky in that transpeople may appear animalized or that it reduces the lived struggles of animals to make anthropocentric claims.[7] But to refuse the linkage is to refuse how race is at work here. Black transwomen and transwomen of color are already marked by dehumanization, by the racialized limits of "the Human." Race anticipates the human/animal divide, and as such the problem of "the Human" is everywhere.[8] For transwomen who undergo hormonal and surgical alterations, the animal has always been present. Which is to say, while the human/animal divide is a false one—false because it assumes a shared access to the promise of liberal Humanism and its inalienable rights—animals still exist, even if they are also foreclosed from Humanism. Just as racial thinking and violence—for example, the Tuskegee Syphilis experiments, J. Marion Sims's gynecological experiments, and the cloning of cells from Henrietta Lack's cervix—inform the sexually and surgically changing body, so does the instrumentalization of animal life.

Premarin® is a standard hormonal treatment for transwomen, consisting primarily of conjugated estrogens isolated from mares' urine.[9] The story of Premarin® is full of political contestation, horses kept in cycles of gestation and impregnation so as to collect their urine. The effects of this animal, non-bioidentical hormone are to immerse the body's organs in a chemical bath such that one's proprioceptive senses are as radically changed as one's external presentation: vision is distorted, one is disoriented by racking focus; haptic senses are reworked, making handled things feel like never before; taste is refracted through hormonally changed buds; smells redefine space. The organization of thoughts is sometimes nervous and, at other times, shot through with bliss.[10] The expressive potential of the body, its capacity to respond to the world, is substantively disfigured, transforming the sensuous exchange of self and environment. Changing sex, then, is also always about changing senses and species.[11]

In Myra J. Hird's 2006 essay "Animal Transex," she invites us to think about transsexuality in relation to sex changing in other species. Working from a "new materialism" that finds "agency and contingency within the living and non-living world," Hird argues that an attention to bio-materiality and bio-mimicry might redefine debates about transsexuality.[12] Eschewing a nature/culture distinction, she offers that "trans exists in non-human species."[13] Though differently refracted through speciated milieus, sex changing can be accounted for by the organism's reading of changes in the environment. Taking over from David Policansky's findings on sex changing in plants and animals, Hird enumerates a vast array of organisms such as fishes, marine snails, worms, and insects that change their sex in relation to environmental pressures, reproductive

potential, or even the vagaries of taste.[14] I do not cite this to propose that human transsexuals change for the same reasons—obviously the modes of change, of transitioning, are at radically different scales and refrains—but that the enactment of sex change is in some way a bodily engagement *with* and *of* the planetary forces (anthropic or not). It is the constitution of a relational milieu, an in-between site through which conductivities and energies form bodiliness through limits of expressiveness or responsiveness. The excitation of transfers is what is at stake in speciation and, for that matter, in sex and sexual orders. Sexual *differences* (not sexual difference) remain unfinished; sexual ontologies stay active, ongoing, differentiating. If sexual differences and sexuality are exuberances,[15] contingencies, then sex is profusive, which is to say it is a continually de-ontologizing event.

.........

My body is still "my body," but also not—hormones initiate radical relays of transformed bodiliness that exceed intentionality, control, authorship. I start to wonder if my "conjugated equine estrogens" are reshaping my species along with my sex. Could mare chemistry be interlacing my own, giving me more of an insight into horse perception than sex perception? I am sure there are no horses in the Tenderloin (although certainly pony/horse play is taking place somewhere in the neighborhood), but as elements of mare urine course through me, I am sensitized to the fact that animals and other nonhumans are everywhere in the city. It is not that I am becoming horse—I am not—but the disfigurement of my sensorium through Premarin® alerts me to forces and presences that had been concealed by my sensory habits.

How many transwomen on Post, Larkin, Geary, Jones, O'Farrell, Sutter, Turk, and Taylor are mixing species in their own bodies? How many of us are engaged in some kind of trans-speciation? This is not utopic; on the contrary, it is layers of violence—medicalization, economic/racial inequality in access to trans health care, and domination of species—that subtend my transformed sensorium. And yet, I still desire to feel my body otherwise, to be accounted for in ways that I experience myself. However we may wish transitioning to be self-affirming (and it can feel as such), it is also an act of exclusion and power. Perhaps transpositioning—as subtending the transitional— better attends to (1) trans hatred that imagines transwomen as porous—the threat of psychosis subtending the transsexual "diagnosis"—literally a sex in pieces; (2) the ways our neighborhoods, the spheres that our bodies inhabit—the spheres of the imagination, but also of injustice and unequal access—are necessarily part of our transitions; and (3) how our positions are predicated as much on impossibility as possibility, on what is foreclosed to us as opposed to what is available.[16]

Louise Bourgeois's *Crouching Spider*: on the Embarcadero at Mission Street—
Entry Plaza at Pier 14. Bourgeois's spider is located outside the Tenderloin, but
its touch percusses, vibrates, plucks at the streets from the Financial District
as far as the Tenderloin, perhaps just as transwomen's heels (for those wearing
them) click and clack, resonating far beyond the Tenderloin. The spider is an
effect of gentrification in San Francisco, even as it reaches beyond this. It is a
sculpture, but also a provocation. How might this spider, and its fleshy referent,
elaborate on the relationship between bodies and spaces? After all, a spider's
proximity to its web, made of its own secretions, proposes that home and terri-
tory are *of* and *with* the body. A spider makes a web to reach out into the upsurge
of energies, to eat, to become more than itself.

Bourgeois's sculpture invites me to think about transwomen as spider-
women, spinsters, over-reaching subjects. Transwomen are abjected—disfigured
gender cues cause shock, fright, even disgust—just as spiders are scenes of
arachnophobia and revulsion, but I want to hold open another line of inquiry.
Might web-building best articulate (from concatenation to skeletalization) the
act of extending bodily substance through sexual transition; that is to ask, does
webbing, and the capacity to weave, describe how transsexuality is also an ex-
pression of the body (from sociopolitical to psychical to corporeal) as an address
and as a habitat? Expressivity of transsexuality is not a trivialization of a dif-
ficult process; on the contrary, transition (or transposition) is an arrangement
between the sensorial milieu of the self and the profusion of the world. The
improvisation is particular, deadly serious, but also always relational.

Crouching Spider: It evokes an extreme response; an enormous bronze spider
edging water and land. Neither he nor she, it signifies "it." Uncanny; the size is
dwarfing. The legs are spindly, poised on sharp tips; even in their stillness they
are lively.[17] Its legs are stretched, as if on the move; motion caught in repose.
Is it in its territory? Hunting ground? Is it a trope for fear as an emanation of
Freud's "phallic mother"?[18] Like its fleshy counterpart with a cuticle of chitin, this
spider's exoskeleton protects it. The networks of nervous and respiratory systems,
the hydraulic forces that make other spiders dynamic, are not visible, but this
arthropod's segments, its cephalothorax and abdomen, are enmeshed and knotted
with now-cooled metal joins.

Crouching Spider: The shadow of itself is impossible to ignore, even in fog-
heavy San Francisco. Balanced on its own silhouette, a spider in a noir-lit web; it
is its web. Equally difficult to overlook is the setting. Yes, the city, the Tenderloin
neighborhood. Yes, the boundary between ocean and earth. From one angle, it is

EVA HAYWARD

Louise Bourgeois, *Crouching Spider*, 2003.
Installation view: Embarcadero, San Francisco,
2007. © The Easton Foundation/Licensed by
VAGA, NY. Photo: Eva Hayward

at the center of a city in pieces: rising rates of homelessness; housing prices that make unlivable neighborhoods (generating yet more homelessness); unfulfilled promises of utopic inclusion (sexual, national, racial); ever-rising HIV rates among transwomen, especially among black transwomen and transwomen of color; and ever-spreading gentrification that bleaches, whitens, communities. And also, from this angle, the Bay Bridge extends this giant, metal spider, giving it a capacious outstretch that recalls the racial and economic divides (divisions are always also dependencies) between Oakland and San Francisco. Though its spinnerets are encased in inorganic hardness, it seems to have spun out a filament web made of steel and concrete. The spider metonymizes, generating zones of correlation and correspondence between object and space. It is not an endless reach; all things are not counted equally, though one could go far on these threads. This spider is an urban designer just as it is sculptural, a weaver of cityscapes, concatenating parts of the city into its grasp.

The unfolding scene of Bourgeois's spider stringing out the city from itself recalls Jean-François Lyotard's flaying of the body into what reads like a street map:

> Open the so-called body and spread out all its surfaces: not only the skin with each of its folds, wrinkles, scars, with its great velvety planes, and contiguous to the scalp and its mane of hair, the tender pubic fur, nipples, nails, hard transparent skin under the heel, the light frills of the eyelids, set with lashes ... dilate the diaphragm of the anal sphincter, longitudinally cut and flatten out the black conduit of the rectum, then the colon, then the caecum ... armed with scalpels and tweezers, dismantle and lay out the bundles and bodies of the encephalon; and then the whole network of veins and arteries, intact, on an immense mattress, and then the lymphatic network, and the fine bony pieces of the wrist and ankles ...[19]

Lyotard continues: "We must not begin with transgression, we must immediately go to the end of cruelty, construct the anatomy of polymorphous perversion, unfold the immense membrane of the libidinal 'body,' which is quite the inverse of a system of parts."[20] Lyotard's contiguous membrane is indiscriminate, postmodern, joining diverse elements into irreverent intimacies. He suggests that the libidinal body seeks to conserve substances and extend them into ever-growing physical and social configurations, while becoming splayed, rendered, and eviscerated. Sexuality is too often imagined as political promise (for instance, the radical force of nonnormative sexualities), but sexuality is, as Freud teaches us, regressive. To manage the regression, we presume that objects (the attachment sites of our sexual drive) will resolve the trouble with sexuality. That "I am trans" is

EVA HAYWARD

not radically transgressive; on the contrary, it reveals a compliance with the regulatory regime of the social even if in oppositional form. The sexuality of trans, transsexuality, is the energetic and fantastic space between objects, leaving actual objects (social identity) as necessary compromises. Similarly, the webbing from Bourgeois's spider joins, aggregates others with others, but the responsive sensuality of the web is at work in the prepositions.[21]

Silken spiderlines reference the skeletalization of surface; the web is an extension of the surface affects of the spider—*it feels with its web*. This is not a shallow surface, but a dynamic threshold of sensuality. Likewise, the body is stretched topographically to affectively and perceptually (sensually) react through a spatial and temporal generativity. Bodies are not ruptured or burst open such that they are boundless. Instead, bodies, like cities and web-builders, are inter- and intra-threadings of many sensuous vectors that relay like the spider in its web.

WEAVERS

Thresholds in architectural forms: the sills of doorways, stoops, gates, portals, façades, and kinds of embellishments. But also, interesting nuance: in verb form, thresholding—an intensity that must be exceeded for a reaction to occur. Here in my home, I am freshly aware that my body is a threshold, an entry between rooms, the way the doorframe delimits zones where spiders build tangles across them. It is not as simple as to say that I am crossing from "man" to "woman." I am not sure I know what such a claim would mean for me, let alone anyone else. But, on a scalpel of desire along a hormonal riptide, I am crossing the matter of my body on a bridge of sensation, moved along by desire. What does it mean to desire cutting? To cut the world, a world that insists on gender? As my body becomes legibly "woman," a white woman, I am aware that the limits of my body are also energized zones. Transpositional: I stay at the threshold, while actively crossing that very threshold; I am caught and yet mobile in a state of articulation as I make myself intelligible enough to myself and to my neighborhood.

.........

In her 2008 essay "Dungeon Intimacies: The Poetics of Transsexual Sadomasochism," Susan Stryker stitches together bodies, places, and histories through the erotic and social force of sadomasochism; she is, I think, the widow building her web. "I envision my body as a meeting point, a node, where external lines

of force and social determination thicken into meat and circulate as movement back into the world."[22] For Stryker, carnal improvisations, pulses, resonances, rhythms "thicken into meat" and bruised tributaries, only to flow back out of this subjective reservoir and into political projects and critical interventions. Web slinging can take the form of a crop, a flogger, and a paddle; the energetic surge, the movement between, is where sexuality is at work.

From Stryker's vantage point, the cityscape is meshed with *pastpresents* (an always present past in the present) such that engaging the space around her is dimensionally extended by "observations into the patterns longer than ... lived experience."[23] History is entanglement, knotting, a game of cat's cradle that maps impressions and embodiments through libidinal tracings, erotogenic intensities, and psychical cartographies. The central trope for Stryker's telling is "porosity" as poïesis: "Transsexual sadomasochism in dungeon space enacts a *poesis* (an act of artistic creation) that collapses the boundary between the embodied self, its world, and others, allowing one to interpenetrate the others and thereby constitute a specific place."[24] Divides between subjects and objects, selves and others, are ruptured and distorted, generating new subjective configurations, but only through the constraints of an impassioned embodiment. Stryker risks physical integrities—skins welt, shoulders empurple, wrists chafe—to explore the inherent openness or pliability of the body:

> I invent new choreographies of space and time as I dance my whip across the creature's ass. It is not that I somehow internalize as my own the structure or content of the scene in which I participate, receiving its impression the way clay would receive a sculptor's mark. It is rather a proprioceptive awareness, as I flog, of the role of my body as medium in the circuit of transmissions, and of the material efficacy I possess in my subjective ability to choose one thing rather than another or to poetically imagine the shape of a new pattern.[25]

In Stryker's striking vision of San Francisco, her "autoethnography" of dungeon scenes, she gives an account of making matter ("the way clay would receive a sculptor's mark") through the breaking of bodily boundaries; the scene of the city cuts through Stryker's body and her "creatures" through acts of "reciprocal vulnerability."[26] In contrast, transposition is not interpenetration, not about broken boundaries; it is, instead, an expressive excitation that acts between others because they are others, are unavoidably different, not as engulfing of the other. As such, transposition is a provocation of difference that cannot be resolved by penetration or collapsed selves. Transposition is the energetic force prior to

finding an object, prior to dominating, or submitting to, an object. It may be that identities (selves and others) are compromise formations, but they remain necessary if also precarious and unavoidably temporary.

.........

The sole witness, I spend hours before the refracting reflection of my transmutating body, tending the sensations, newnesses, and curves that I am manifesting and experiencing. I give my life over to these changes. They exceed beyond what I might have desired. They are unpredictable; they are their own agents.[27] *Carefully and deliberately, I emerge as a transsexual self: my transitioning body and I find, tenderly, a new kind of accommodation, negotiating each other. My body is my most intimate other; so close is this other to me that I enact bad boundaries, sometimes lovingly, but also brutally. We create an in-between-ness, a state of psychical process, invention, and sensuous (re)construction. I am of her, and she is with me—this is not remarkable, this is the remarkably banal state of bodily being. It is transitioning that exposes what is disavowed, what is concealed by the everyday; it is transpositioning that exposes the process of bodily being within overpopulated milieus.*

.........

The transitional self (an effect of transpositioning) can never risk disembodiment or autogenesis; it is a sensuous self, made such only through the refrain of sensation (again, composite of affects and percepts). Senses and their subtending registers are reactive to the sensual abundance of the world but limited by affected perceptual milieus (i.e., eyes see only so much; ears hear only a fraction of the sounded-out information in an environment; the unbearability of the world is edited, repressed, managed for livability). The movement of affect with perception creates *texture*, which propagates embodiment, leaving marks and traces.[28] In other words, sensation creates remainders (what we might call "the feel" of things and others) that result in both new iterations of expressiveness as well as corporeality. Texture, then, is the residue of unmetabolized and metabolized sensations of animate forces. The emergence of bodiliness (as well as embodiedness) is manifested in the sensuous connectivity through which the limits between self and environment are activated.[29] The transitional body, in this way, is a textural body, generating contractions of the sensorium through the bio-pharmaco-socio-refractions of hormones, surgery, etc. As Walter Benjamin and Asja Lacis describe Naples:

At the base of the cliff itself, where it touches the shore, caves have been hewn. ... As porous as this stone is the architecture. Building and action interpenetrate in the courtyards, arcades, and stairways. In everything they preserve the scope to become a theatre of new, unforeseen, con-stellation. The stamp of the definitive is avoided. No situation appears intended forever, no figure asserts it "thus and not otherwise." This is how architecture, the most binding part of the communal rhythm, comes into being here.[30]

.........

Lacis and Benjamin describe an almost erotic interchange between place and flesh; distinctions between body and architecture appear conjugal, loving, enflamed, not un-like Lyotard's libidinal body. Bridges, crosswalks, alleys, bus routes, streets are pleats in the city through which bodies pulse. On the SF MUNI, I am hurled through concrete veins and steel arteries, along funiculars and elevators. I hold my body in positions that signify my desire, despite my critical resistance, to "pass." But less obviously, hid-den in my interior, estrogens have begun to refigure my olfactory nerves. I am smelling layers of place, registering different saturations of funk and perfume.[31] The interior of the train thickens like a miasmic genealogy, and my altering senses work to make sense of it.

Moving under the city, the train vectors its way toward my endocrinologist and esthetician so that I may undergo something like a second puberty; puberty is always disfigurement, always a body exceeding intentionality even as the social maps onto puberty, seemingly insisting on the biologization of sex. In this second act of puberty, I tend to myself through the fantasy that this disfigurement will make me more myself. This, of course, is a necessary lie, because disfigurement will exceed my efforts, even as the social accommodates (violently or not) these changes.

My body is morphed by a daily dose of 8.5 mg of Premarin®, 300 mg of Spironolactone, and regular treatments of laser hair removal. (There are days I am grateful for the men who slow their cars.) Under the play of bodily forces, my face, breasts, hips, arms, legs, stomach, and shoulders become zones of grumblings, feel-ings, heavings, pleasures, and leakings, all along a tide of desire aimed toward being sexually otherwise. I try scrubbing out burnt hair follicles on my face—so swollen and raw from the procedure—and elsewhere from laser hair removal before they grow in-flamed, become solfataras, and leave darkened scars. Fat deposits uproot and travel to new sites of colonization: hips widen, breasts grow (and secrete fluid, lactate), face changes from oval to heart-shaped, and musculature softens and dissolves. Like too

many transwomen, I do this under the specter of AIDS.[32] *All my cuts, all my changes, all my desire is refracted through the anguish that is AIDS. What other word describes the multiple deaths at work? Yet and still, I transition even as AIDS reworks the positional. It is not that transwomen, even transwomen who survive through sex work, are at "greater risk of HIV" because of sexual practices—this reasoning is an effect of homophobia and racism—rather, transwomen are at risk because of racism and transphobia and the violent sociopolitical regimes that make transphobia and racism a necessary feature of what constitutes modernity.*[33]

.........

Transpositioning considers how a transsexual emerges through her body's own viscosity, through the energization of corporeal limits. The transpositional is a matrix through which sensations may be drawn back through the body, to make the body feel "familiar," even as familiarity remains ultimately unattainable. That which prompts a transwoman to transition is more than her appearance (what is familiar), and her appearance can only ever be understood as metonymic. Her appearance does not make her a woman, for she is always already un-male/not-man, but it allows her to emerge situationally as a woman, a gendered neighbor, a historical subject.[34] And more so, the affair between the felt-body and the lived-body is also enacted through habitation, the ecosystem of which the self is part. The transpositional, as Lyotard describes the libidinal body, is threaded through itself, just as it's webbed with its neighborhood.[35] A transitioning woman is enfleshing elements of her environment within herself and expressing parts of herself back into the social (social-political-ecological) environment as part of her transition. The environment, populated with inorganic and organic beings, political and psychical forces, holds her while she contributes, at the same time, to building it. This process serves as the conditions of transpositioning, the constitutive activities of sensing and living, and as a generative and disfiguring energy in iterative or "moreover" manifestations. As such, the transitioning woman is a spider in her web, or, more precisely, she is becoming her web, her trap.

TRAPS AND WEBS

A spider, in the corner of my studio, by the window, sits and sits. She is an "American house spider," Achaearanea tepidariorum. Her legs are white, and her cephalothorax is brown, dusted with black. For now, she is alone in her web. She will only live for a little more than a year. If she produces eggs, the spiderlings will float away on their own glossy lines (ballooning). She stays for what seems like days at the center of her web, her touch-world, while the web seems to trap only dust. And then, as if called from across the room, she moves quickly, even uncannily: there/then not, still/in motion, unsettling/reassuring. This little air-breathing arthropod with two body segments, a set of fangs, four pairs of eyes, eight legs, and pairs of movable spinnerets leaves behind a cobweb. Even now, after the silvery threads have come to look like unspooled, wooly yarn, the web remains a join between angles and planes, but, without her as the perceiving center, it feels ghostly. In contrast, the lived-in web is an optic skin, a resounding connective tissue, building a "home" that senses in order that the spider might feed, entrap, and make more of herself.

.

David Quammen counsels that we cannot easily identify with spiders; at best we are curious and at worse we are disturbed.[36] Spiders refuse face-to-face ethics; refuse "to face" with their too many eyes and fangs. The aesthetics of disgust and fright overwhelm ethics, perhaps exposing how aesthetics are always foregrounded in ethics. Quammen is right to expose the limits of identification. Identification aims to resolve the divide of difference: "I am like you," or "I know you." Between the spider and me: I cannot "become" *it*, I cannot be "like" *it*. It-ness—the indeterminate pronoun—is a refusal not only to regimes of gender ("him," "her," and other gender pronouns), but also to inclusion in Adam's nameable Eden of belonging. Being "it" is both a violent exclusion and an index of the limits of inclusion. In another register, "it" is often the moniker of sex/gender ambiguity: "What is it?" The "it," here, is not nonhuman or even subhuman; it works at the register of the un-human. It lacks humanness; it is constructed through an absence.

Returning to the spider, it is this it-ness—the limits of inclusion/exclusion—that Nina Katchadourian engages in her "Mended Spiderweb" series. With red thread, Katchadourian repairs torn webbing, mixing mediums to create cross-species rejoinders. The spiders never accept her interventions, cutting out and discarding her efforts with new silks. The desire to mend, to tend,

Nina Katchadourian, *Mended Spiderweb #8*, 1998.
Cibachrome print, 20 × 20 in (50.8 × 50.8 cm).
Courtesy the artist and Catharine Clark Gallery,
San Francisco

perhaps even to "love" the spider's web is always a scene of rejection, refusal. The limits of identification—to make a web like a spider's—is the scene that Katchadourian's work expresses. Both webs are remarkable, but what is profound about the work is not that the spider might accept the human web, but that it will not. And still, Katchadourian labors with this hopelessness; this too is "love." But there is something about the artfulness, or inventiveness, of the mended webs that speaks to my sense of co-presence, to shared forms of movement, animation, and percussion. The failure of collaboration, here, doesn't negate the energetic interactions of these species. Error is still expression, an intensity that is engaged by human and spider. Error exposes limits, even the limits of species, which are also near-ness. Spiders build out their worlds, and Katchadourian tunes her art practice to approximate the frequency of their effort. Her red-threaded webs do not look like the spiders'—they are always other to the other—but the capacity to create, to syncopate, to improvise, seems a co-reactivity between spiders and peoples. As Alphonso Lingis reminds us, humans are composites of zoo-intensities, animated movements, bio-differentials, making our experience of agency, sexuality, subjectivity less about individuated forms and more about distribution, collection, variation. He asks, "Is not the force of our emotions that of other animals?"[37] Rather than becoming, identifying, or interpenetrating (as Stryker might call it), difference is maintained even as sensation excites and disfigures limits of self and other. Excitement and disfigurement are discursive, but the effects are not to the same degree. The abyss between the spider and me in this apartment is unbearable (radical alterity is a confrontation with that absolute other, death), and yet we resonate in relation to our different movements and processes.

.

After my ordeal with the laser—the post-procedural feel of stung-singed-numbness always reminds me of Blake's "Tyger, tyger, burning bright"—I stop by Olive (a bar, 743 Larkin Street). In the windowless lounge, I feel like Alice descending into the rabbit hole, passing from the brightness of "not-passing" (so many staring eyes) to the dim shadows of (im)possibility, of inexpressible hope. As the curvature of my eye lenses changes through estrogen sensitivity, my vision brackets and shuttles between planes of focused activity, so that the variations of shadow in this bar are like scrims, opening up scenes as my eyes shift in their sockets.[38] I know these perceptual alterations will be assimilated into a bodily norm soon—the body aims for habituation— but in this newness of sensation, I delight in how my body feels this familiar place

EVA HAYWARD

afresh, restored of receivable sensory richness. I delight despite how my heightened sensitivity also makes me anxious, uncertain, paranoid—"Is everyone staring at the morphing 'it' that is me?" Remember, perception is always compounded by affect into sensation—my perceptions are refracted through psychic forces, regimes of repression.

.........

To push further the trope of transposition, I want to foreground the figure of the "trap" for transsexuals and spiders. First, for transsexuals, rather than emphasizing the feeling of "wrong-bodiness," as in the now familiar trope "trapped in the wrong body," what if we highlight other genealogies of the word "trap"? Trap is also a mouth, a mode of utterance, the "O" curve of lips and throat that sounds out and names the apprehension of being embodied.[39] A trap is the wet threshold between tongue and thought. Slang, but, like most lustful language, it longs, cries, erupts. In music, a trap is an ensemble of percussion instruments, drumming out collective arrangements and creative responses. Similarly, in weaving, a trap is a break in the threads of a warp, an unraveling, loosening, unwinding that undoes a tapestry. So, the language of being "trapped in a wrong body" must also, transpositionally, account for these alternate etymologies of articulation, of speaking oneself into culture and history, but also creating a site, a gap, making room in cultural and political fabrications, and finding a tempo, a beat. In this way, entrapment is always also about positionality. To be trapped in the body, then, is about building-out, unraveling, and unknotting so as to rework the territory of embodied self, to speak and receive ranges of sensuous input from one's environment.[40] To some degree, being trapped in a body is an existential crisis for all of us, trans or not. This is not another mind/body split; rather, our bodies are not endlessly available to intentionality. Bodies exceed intention, even as our intentions are always predicated on embodiment. We may belong to our bodies, but our bodies do not necessarily belong to us.

Similarly, the spider's web is a trap, a silk net, a sticky mesh. Created from proteinaceous fibers that are surprisingly light and yet have remarkable tensile strength, this trap is made from the spider; it is an expression of its bodily capacity. The web is a musical improvisation between the spider and its prey, but also between itself and its environment, an expressive extension, a rhythmic prosthesis that defines the limits of spidery sensoriums. As such, webs are predacious selves, augmented parts of the spider and its territory—so entrapment, but also resource and reach.

.........

Exit Theater (156 Eddy Street): Veronica Klaus performs her one-woman show Family Jewels. *In her performance she ponders, "People ask me if I feel like a woman. ... Do I feel like a woman? The truth is, I have no idea whether I feel like any other woman. I have no idea whether I ever felt like any other man. All I know is that I feel like me, Veronica. This person whose existence is partly innate, partly instinct, partly art, the art of creating. ... But I do find as I go through life I become more comfortable asking myself questions like 'Who am I?'"*[41]

.........

Might transsexuality be artfulness? If Gilles Deleuze and Félix Guattari suggest that art is not necessarily about aesthetics but about sensation, about the expressive potential of "cosmological forces," then could it also be about the transitioning of flesh, organs, and muscle into alternate modes of being?[42] Art in verb form (as in "to art," but also Old English "art"/"are") is an urge, an incitement, and an induction. By this, I mean something quite serious, not some frivolity of creativity, but art as intensifying bodily substance, to resonate otherwise. Transsexual embodiment, in part, is a provocation to live-out, to feel different corpo(realities) through zones of transition and intervention. As such, these provocations are responses to our capacities to resonate (to various degrees and not in terms of maximization) with environments, habitats, and spaces.

Transpositioning, then, is vibratory; a transitioning woman is, first and importantly, vibratory. She is a partly an "artful" response between emotion and environment, politics and ideological power, and for those who start transitioning with Premarin®, this responsiveness begins with animals (even, unfortunately, their brutal instrumentalization) and the violences that make possible medicalization, recognition, and subjectification. Unavoidably, nonhuman substances are unleashed into her body, transforming and altering it. Through the sexually differentiating forces of horses, the transwoman's body is made emphatically more and otherwise. And through the provocation of the senses, bodies become threaded through themselves in the act of changing their forms, architectures, ecosystems; an act manifested from drives materialized into exterior potentialities. Again, transitions are never utopic, because transitions function transpositionally; that is to say, we transition through matrices of sensation, power, institutionality, and situationality.

In terms of sensation, we transposition with our environment through the sleeve of our senses. Transpositionally, interiority can be understood, then, as

a sensuous exteriority drawn within the membrane of the "self." As Lefebvre writes, that space is "first of all my body, and then it is my body counterpart or 'other,' its mirror-image or shadow: it is the shifting intersection between that which touches, penetrates, threatens or benefits my body on the one hand, and all other bodies on the other."[43] Spiders, webs, traps, and some transsexuals are being iteratively reconfigured through sensuous involvements—threads held together, more or less conditionally, until they are eaten by the spider who spun them, or get swept away in a cleaning frenzy, or are reworked after having caught a meal, or are simply abandoned for another site.

...

"Spiderwomen" by scholar Eva Hayward was first published as "Spider City Sex" in the journal *Women & Performance: a journal of feminist theory* in 2010. It was later significantly revised for publication in *Transgender Migrations: The Bodies, Borders, and Politics of Transition*, ed. Trystan T. Cotten (New York: Routledge, 2012), where it appeared as "Spiderwomen: Notes on Transpositions." The latter version of the text was revised and expanded in 2016 for publication in this volume, where it is reproduced by the permission of Taylor and Francis Group, LLC, a division of Informa, PLC.

...

NOTES

1. "Transsexual" is an abandoned term, perhaps even an abandoned identity. I do not use "transsexual" to rescue this violently institutionalized, medicalized, and politically troubled category. And yet, I still find the "-sexual" of trans-*sexual* a provocation that holds sexuality in relation to trans. That is to say, sexuality cannot be disaggregated from trans-. What it is to be transsexual is, in part, about desire, fantasy, wish fulfillment, and other registers of Eros. The more voguish "transgender," or simply "trans," foregrounds the workings of identity and gender, which has resulted in both a whitening of transgender politics (race, ethnicity, and nationality are dislodged, even in intersectional projects, as tertiary to gender) and an investment in nameable identities over and against the precarity of subjectivities. I prefer to stay with all the trouble of transsexuality as a way to insist on not only sexuality, but all the unresolved politics associated with contemporary transgender movements and field formations.

2. See Sara Ahmed, *Queer Phenomenology: Orientations, Objects, Others* (Durham, NC: Duke University Press, 2006).

3. See Michael J. Bailey, *The Man Who Would Be Queen: The Science of Gender-Bending and Transsexualism* (Washington, DC: Joseph Henry Press, 2003); Bernice Hausman, *Changing Sex: Transsexualism, Technology, and the Idea of Gender* (Durham, NC: Duke University Press, 1995); Sheila Jeffreys, *Unpacking Queer Politics: A Lesbian Feminist Perspective* (Cambridge, MA: Polity Press, 2002); Catherine Millot, *Horsexe: An Essay on Transsexuality*, trans. Kenneth

Hylton (Brooklyn, NY: Autonomedia, 1990); and Janice Raymond, *The Transsexual Empire: The Making of the She-Male* (New York: Teacher's College Press, 1994).

4. See Vivian Sobchack, "Simple Grounds: At Home in Experience," in *Postphenomenology: A Critical Companion to Ihde*, ed. Evan Selinger (New York: SUNY Press, 2006), 13–20.

5. Pat Califia, "San Francisco: Revisiting 'The City of Desire,'" in *Queers in Space: Communities, Public Spaces, Sites of Resistance*, ed. Gordon Brent Ingram, Anne-Marie Bouthillette, and Yolanda Retter (Seattle, WA: Bay Press, 1997), 177–96.

6. See Mary Pavelka, "Sexual Nature: What Can We Learn From a Cross-Species Perspective?" in *Sexual Nature, Sexual Culture*, ed. Paul Abramson and Steven Pinkerton (Chicago: University of Chicago Press, 1995), 17–36; Myra J. Hird, "Naturally Queer," *Feminist Theory* 5, no. 1 (2004): 85–89; Catherine Ingraham, *Architecture, Animal, Human: The Asymmetrical Condition* (New York: Routledge, 2006); and Frances Bartkowski, *Kissing Cousins: A New Kinship Bestiary* (New York: Columbia University Press, 2008).

7. Lorraine Daston and Gregg Mitman, introduction to *Thinking with Animals: New Perspectives on Anthropomorphism*, ed. Lorraine Daston and Gregg Mitman (New York: Columbia University Press, 2005), 1–14.

8. What constitutes sex/gender—a consolidation of gender *as* sex—is predicated on the category of "the Human," which is an effect of antiblack violence (Hortense Spillers, "Mama's Baby, Papa's Maybe: An American Grammar Book," in *Black, White, and in Color: Essays on American Literature and Culture* [Chicago: University of Chicago Press, 2003], 203–29). So, while the desire for sex change is just that, it is a desire made possible through the construction of sex/gender by the legacy of "gratuitous" antiblack violence (Frank Wilderson, *Red, White & Black: Cinema and the Structure of US Antagonisms* [Durham, NC: Duke University Press, 2010], 60). My effort to frame the cut as "possibility" (after all, at some level, desire is regressive) also must reconcile "possibility" as a condition predicated on a history of black suffering, making a progressivist ("it gets better") grammar of transsexual life into a project of white uplift. Cut sex, then, is possible *because* sex is always sex (a construction made possible by racial violence), specifically antiblack racism.

Rewritten as "cut sex," the construction of sex as a racial project is foregrounded ("sex"), and the capacity to further alter sex ("cut") is recursive, is retroactive (the prefix "re-" is more often at work in trans- than not). We can say that transsexuals cut the technology of sex—an order, a regime, a categorization—but this cut is not only given meaning through racial capitalism. The institutionalization of "trans/gender/sexual" reifies the sex/gender order over the racial violence that made sex/gender coherent in order to be trans(gressed). Transsexuality, then, becomes the logic of sex healing itself through wounding—but, and this is the point I tried to make in my "Starfish" essay, sex (sexual difference) as the (white) logic of "the Human" is what must be thought otherwise. Cut sex, then, can also be an effort to recognize how sex—the wound in the world, as Dionne Brand describes the ongoing effects of the Middle Passage, a wound that made possible the "Human" sex/gender order (Dionne Brand, *A Map to the Door of No Return: Notes to Belonging* [Toronto: Vintage Canada, 2002])—is a (white) humanizing project. The starfish—starfish-ed body—locates the "oceanic" (Spillers, "Mama's Baby, Papa's Maybe," 214; where she redeploys Sigmund Freud's "oceanic") as the domain of racial slavery and colonization that continues to work for sex. The "lessons" (how is cross-species epistemology also an extracting—making fungible—of capacity?) from non-mammalian, invertebrate starfish are about the problem of sex (more precisely, the broader problem of racialized modernity). Transsexuality is not liberation—transsexuality

is not a solution to sex, nor for that matter is queer—but cut sex, or more exactly *cut sex*, is a refusal of anthropo—which, Wilderson excellently diagnoses as "the Human/the Black" (Wilderson, *Red, White & Black*, 64). To cut sex "otherwise" is to see how the industry of sex is built on colonial racism—intersectionality has become a misused tool for reinforcing the administration of sex (often in the form of white diversity), what was never Kimberlé Crenshaw's project, even as it has been read as such—a legacy that has installed Modernity and "The Human" (see Kimberlé Crenshaw, "Demarginalizing the Intersection of Race and Sex: A Black Feminist Critique of Antidiscrimination Doctrine, Feminist Theory and Anti-racist Politics," *University of Chicago Legal Forum* 140 [1989]: 139–67). This is what a regenerating starfish (again, regeneration is a negation of transcendentalism, and an insistence on the regressive nature of desire—regeneration is never utopic, quite the opposite) living in Middle Passage teaches us about sex.

9. To be clear, I do not advocate the use of Premarin®. The living conditions of horses used in urine collection raise serious ethical questions. Horses are impregnated, kept in small enclosures where they are unable to turn around, and rubber sacks are attached to hold their urine. Horses are given small amounts of water to get higher concentrations of estrogen. It has become more common for endocrinologists to put transwomen on plant-based hormonal replacement therapy. See Eva Hayward, "Transxenoestrogenesis," in "Postposttranssexual: Key Concepts for a Twenty-First Century Transgender Studies," special issue, *Transgender Studies Quarterly* 1, no. 1–2 (2014): 255–58.

10. See Sheila Kirk, *Feminizing Hormonal Therapy for the Transgendered* (Pittsburgh, PA: Together Lifeworks, 1999); K. L. Krenzer and M. R. Dana, "Effect of Androgen Deficiency on the Human Meibomian Gland and Ocular Surface," *Journal of Clinical Endocrinology and Metabolism* 85 (2000): 4874–82; E. Moore, A. Wisniewski, and A. Dobs, "Endocrine Treatment of Transsexual People: A Review of Treatment Regimens, Outcomes, and Adverse Effects," *Journal of Clinical Endocrinology and Metabolism* 88 (2003): 3467–73; and Hilleke E. Hulshoff Pol, Peggy T. Cohen-Kettenis, et al., "Changing Your Sex Changes Your Brain: Influences of Testosterone and Estrogen on Adult Human Brain Structure," *European Journal of Endocrinology* 155, no. 1 (2006): 107–14.

11. Eva Hayward, "More Lessons from a Starfish: Prefixial Flesh and Transspeciated Selves," *Women's Studies Quarterly* 36, no. 3–4 (2008): 64–85.

12. Myra J. Hird, "Animal Transex," *Australian Feminist Studies* 21, no. 49 (2006): 37.

13. Ibid.

14. David Policansky, "Sex Change in Plants and Animals," *Annual Review of Ecology and Systematics* 13 (1982): 471–95.

15. See Pavelka, "Sexual Nature"; Bruce Bagemihl, *Biological Exuberance: Animal Homosexuality and Natural Diversity* (New York: St. Martin's Press, 1999); Hird, "Naturally Queer"; and Joan Roughgarden, *Evolution's Rainbow: Diversity, Gender, and Sexuality in Nature and People* (Berkeley: University of California Press, 2004).

16. See Eric A. Stanley, "Near Life, Queer Death: Overkill and Ontological Capture," *Social Text* 29, no. 2 (2011): 1–19.

17. Mieke Bal, *Louise Bourgeois' Spider: The Architecture of Art-Writing* (Chicago: University of Chicago Press, 2001); Griselda Pollock, "Maman! Invoking the m/Other in the Web of the

Spider," in *Louise Bourgeois Maman*, ed. Marika Wachtmeister (Stockholm: Atlantis, 2005), 65–97.

18. Like Medusa, the "widows" of film noir are phallic women, threats emanating from a fetish. For Freud, the fetish is a disavowal of castration, a psychic compromise that invests an object, ambivalently, with the promise of an intact mother (phallus and all) and the threat of loss. The relationship between heterosexual men and pre/non-operative transwomen— often problematically called "tranny fetish" or "chicks with dicks"—reveals how fetishism maneuvers around homophobia (same sex, two penises) and endows heterosexuality (a man and a woman). Her genitals are what he desires as much as her femininity. She, literally, embodies castration; she is what he most fears. Her femininity—indeed, his desire for her to "pass"—is what shields him from her threat. For her part, his "straightness"—and, as difficult as it is to admit, possibly his homophobia—enables him to see her as she sees herself, as a woman. See Héctor Babenco's film *Kiss of the Spider Woman* (1985).

19. Jean-François Lyotard, *Libidinal Economy*, trans. Ian Hamilton Grant (Bloomington: Indiana University Press, 1993), 1.

20. Ibid., 2.

21. Alex Potts, "Louise Bourgeois: Sculptural Confrontations," *Oxford Art Journal* 22 (1999): 39–53.

22. Susan Stryker, "Dungeon Intimacies: The Poetics of Transsexual Sadomasochism," *Parallax* 14 (2008): 42.

23. Ibid., 37.

24. Ibid., 39.

25. Ibid., 42.

26. Ibid., 38, 43.

27. Kirk, *Feminizing Hormonal Therapy for the Transgendered*.

28. Eva Hayward, "Fingeryeyes: Impressions of Cup Corals," *Cultural Anthropology* 7 (2010): 576–98.

29. Elizabeth Grosz, *Architecture from the Outside: Essays on Virtual and Real Space* (Cambridge, MA: MIT Press, 2001); Alphonso Lingis, *Dangerous Emotions* (Berkeley: University of California Press, 2000); Juhani Pallasmaa, *The Eyes of the Skin: Architecture and the Senses* (West Sussex, UK: John Wiley & Sons, 2005).

30. Walter Benjamin and Asja Lacis, "Naples," in *Reflections* (New York: Harcourt, 1978), 165–66.

31. Moore, Wisniewski, and Dobs, "Endocrine Treatment of Transsexual People."

32. I have written: "*The cut is possibility*. For some transsexual women, the cut is not so much an opening of the body, but a generative effort to *pull the body back through itself* in order to feel mending, to feel the growth of new margins. The cut is not just an action; the cut is part of the ongoing materialization by which a transsexual tentatively and mutably becomes" (Hayward, "More Lessons from a Starfish," 72). Although this cut was meant to de-ontologize sex and "the Human"—an effort to make transsexual becoming speciated, a refusal of anthropos as about only sex, which is necessarily a refusal of anthropos more broadly—my cut was read as whole (over partial) or about able-ism (an inability to recognize

limits) (see, for example, Jasbir K. Puar, "Bodies With New Organs: Becoming Trans, Becoming Disabled" *Social Text* 33, no. 3 124 [2015]: 45–73; and Mel Y. Chen, *Animacies: Biopolitics, Racial Mattering, and Queer Affect* [Durham, NC: Duke University Press, 2012]). While I agree with these excellent critiques, I do think both (differently) misunderstand trans subjectivity, especially how trans women are always a sign of death, always a sign of *dis-*. For instance, one in three trans women are HIV+, which is to say that any "cut" is always an infected cut (certainly mine was). Che Gossett precisely describes the inextricable "vectoring" of criminalization, transphobia (especially transmisogyny), antiblack racism, and AIDS phobia—they write, "We are living in a time of 'chains and corpses,' death, loss and mourning, of outrage and activism in response to mass incarceration, mass detention and deportation, HIV criminalization, AIDS phobia and the ongoing AIDS epidemic, anti-queer and anti-trans police violence" (Che Gossett, "We Will Not Rest in Peace: AIDS Activism, Black Radicalism, Queer and/or Trans Resistance" in *Queer Necropolitics*, ed Jin Haritaworn, Adi Kuntsman, and Silvia Posocco [New York: Routledge, 2014], 31–50). HIV+ transwomen are regularly refused hormones or surgical interventions—Why would an already dead and dying body want to injure the body, make the body more vulnerable? Circumventing such restrictions—for instance, the vast majority of trans women, especially working-poor and of color, do not have insurance to cover bodily intervention—is always an act of resistance that cannot be reduced to queer understandings of normative/nonnormative gender/sex. To talk, to write, to theorize about transwomen, the force of HIV must always be attended to. To not attend to how HIV works as politically sanctioned death for transwomen is to make transwomen killable. Moreover, not attending to HIV rates among transwomen is also to not attend to race, particularly the role of antiblack racism that continues to define the AIDS epidemic (see Adam Geary, *Antiblack Racism and the AIDS Epidemic: State Intimacies* [New York: Palgrave Macmillan, 2014]).

33. See Geary, *Antiblack Racism and the AIDS Epidemic*.

34. Jay Prosser, *Second Skins: The Body Narratives of Transsexuality* (New York: Columbia University Press, 1998).

35. Lyotard, *Libidinal Economy*, 2.

36. David Quammen, "The Face of a Spider," in *The Flight of the Iguana: A Sidelong View of Science and Nature* (New York: Touchstone, 1998), accessed February 17, 2017, http://web .stanford.edu/~jonahw/AOE-SM06/FaceSpider.html.

37. Lingis, *Dangerous Emotions*, 36.

38. Krenzer and Dana, "Effect of Androgen Deficiency on the Human Meibomian Gland and Ocular Surface."

39. Ruth Salvaggio, *The Sounds of Feminist Theory* (New York: SUNY Press, 1999).

40. Hayward, "More Lessons from a Starfish"; Prosser, *Second Skins*.

41. Veronica Klaus, *Veronica Klaus*, accessed January 15, 2009, http://www.veronicaklaus.com/.

42. Gilles Deleuze and Félix Guattari, *What Is Philosophy?* (London: Verso, 1994).

43. Henri Lefebvre, *The Production of Space* (Cambridge, UK: Basil Blackwell, 1991), 184.

Roy Pérez

Every single time I step outside my body is a public object.
—Mark Aguhar (a.k.a. Call Out Queen), *Blogging for Brown Gurls*, June 4, 2011

1. PLATFORMS

In much of her art practice, Mark Aguhar used physical proximity as an artistic medium. Staging her body close to yours, Aguhar incited political and personal reckoning with gender, race, and desire. In one early performance installation, visitors sat with her in a fort made of bed sheets under a sign reading "BOIZ CLUB." Among her paintings and drawings is a watercolor series that features her naked body in a grid of her naked friends. In another series, two bottoms appear linked via a double-headed dildo. In one of her late performances, she sat among audience members telling a story about a denim jacket, and, in another, she simply posed to allow you to stare at her adorned self. During a studio visit, she might walk you around her space just telling you about her things—hauls of new make-up, exquisite leather gear, or a piece she was working on. Her work harnessed close proximity and its interpersonal transmissions as the art itself. Writing as the Call Out Queen on her website, *Blogging for Brown Gurls*, Aguhar theorized how space was charged with politics and how aesthetics could sneak interceptions into everyday encounters. She would turn interactions with classmates, fat/femme/brown shaming at Boystown queer bars, and exchanges with fans and critics on Tumblr into flashpoints for an art practice intent on exposing what her body ignited when it moved through spaces rife with misogyny and white supremacy. Finding glamour in the inevitable, thorny, and sometimes vicious transactions of such a world was Aguhar's platform.

In 2012, Aguhar was completing her MFA at the University of Illinois at Chicago (UIC). She performed *Casting a Glamour: Peony Piece* for an audience composed largely of classmates and friends as one of her final art school critiques. No video and only a few photos exist of the performance, so we have to construct the piece through the memories of audience members: Entering the room, one encountered a soft spotlight illuminating a pool of silk peony petals. Once the audience was positioned, Aguhar walked in wearing a strapless lavender A-line dress in long and pleated chiffon, her hair lying wavy and relaxed down past her shoulders, her face made up with carefully arched brows, long lashes, and feline eyes. At the perimeter of the small space, at the edge of the spotlight, Aguhar removed a pair of platform boots, stepped her bare feet lightly into the center of the pool of petals, and slowly lowered herself to the floor, her dress whirling and clearing away the petals around her. Sitting, one leg extended and the other tucked beneath her, Aguhar proceeded to gaze at the audience, her expression alternatingly demure, beseeching, and hostile. After some length of time, Aguhar rose, leaving petals whirling again in her wake, put the boots back on, and exited the room.

It's fitting that the piece exists only as ephemera. Among the mediums here are not just clothing and lighting, but the audience's affective transformations as the space changed. The performance brought classmates, professors, acquaintances, and friends from Chicago into the space of Aguhar's gender drift for prolonged reckoning, in contrast to the chance and fleeting encounters of everyday life. Her gaze invited the audience to take inventory of its own feelings about her transition and her body. By making each person in the room the object of her returned gaze, Aguhar revealed all the vectors of interaction along which we construct the social world together. The piece suspended normal, scripted avenues of communication and reclaimed this bandwidth for each person to experiment with and to reimagine queer relation. Her platform boots sat on the periphery, sparing the peony petals from getting squashed and giving Aguhar's feet a rest while she reclined for her viewers' gaze. The boots marked a threshold between the normative flow of everyday existence beyond the room's walls and the spotlit magic circle, what she sometimes liked to call her "goddess actuality."[2] The performance dared you to imagine yourself in a femme-empowered, brown-centering elsewhere.

The words "LOL Reverse Racism," painted in multicolored letters against a gold background on a sheet of five-by-eight-inch sketchbook paper, hung for a while on the outside of Aguhar's studio door at UIC. Eventually Aguhar posted a scan of the image on Tumblr with the hashtags "#WHITEGIRLPROBLEMS (#NOTATHING)," where it gained thousands of likes and reblogs, frequently appearing uncredited across the internet.

LOL Reverse Racism works like a page from a zine in its urgent and improvised construction. We can read it alongside an art tradition of political sign-making, like the work of Barbara Kruger, Bruce Nauman, Jenny Holzer, Martin Wong, or Glenn Ligon. But its original public display on Aguhar's studio door, in the quotidian space of UIC's linoleum-lined institutional hallways, where her neighbors could see, also suggests to me the wayfinding technologies of Jim Crow. Elizabeth Guffey and other historians of the visual culture of Jim Crow use the organizational design term "wayfinding" to describe how Jim Crow signs not only directed bodies through space but sought to direct public sentiment.[3] Whether these were official-looking signs composed in the banal language of colonial administration, or handwritten signs threatening violence against Black, Asian, and Latinx folks who dared to cross white thresholds, the sign systems of Jim Crow culture transmitted and amplified the affects of racism—the fear of proximity in light of inevitable proximity.

I am struck, for example, by the formal similarities between Aguhar's sign and a letter from the 1930s stored at the Bancroft Library at Berkeley, written with black marker on notebook paper, that reads "GET RID OF ALL FILIPINOS OR WE'LL BURN THIS TOWN DOWN." What happens when we understand *LOL Reverse Racism* in this historical continuum? How does this link alter the space of art school, queer community, or contemporary Chicago? Aguhar's sign takes up the person of color's inevitable proximity to whiteness and reveals the labor—and even the laughter, as a kind of critically flippant work—that goes into living that history of institutional racism and of the so-called postracial present simultaneously.[4] Appearing as a non sequitur on unlikely walls and Tumblr feeds, *LOL Reverse Racism* intervenes in white culture's acrobatic strategies for managing its proximity to everyone else.

While Aguhar's work laughs at the feats of paranoia that struggle to keep whiteness safe from racial proximities, it also basks sincerely in the problem of desiring whiteness. White desirability recurs in her art and writing. As part of a practice of radical disclosure that shapes her antiracist thinking and theorizing, her online writing narrates her attraction to white masculinity (in particular), and harnesses proximities for a complex eroto-aesthetic field. *IF U R GAY*

"GET RID OF ALL FILIPINOS OR WE'LL
BURN THIS TOWN DOWN." Copy of a
threatening letter from 1930. Courtesy the
James Earl Wood Collection of photographs
relating to Filipinos in California, BANC PIC
1945.010:64. The Bancroft Library, University
of California, Berkeley

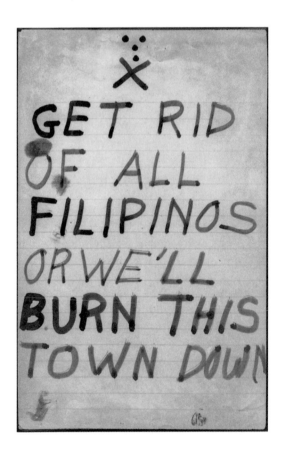

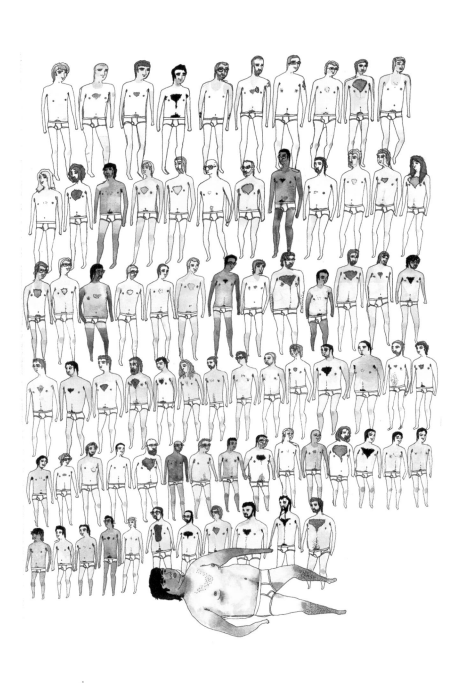

Mark Aguhar, *EVEN IF UR STR8 I STILL WANT TO FUCK YOU*, 2010. Watercolor on paper, 38 × 20 in (96.5 × 50.8 cm). Courtesy the Estate of Mark Aguhar

I WANT TO FUCK YOU (2010), for example, is an ink-and-watercolor painting in which Aguhar appears in lotus position above a field of (mostly white) men in white briefs arranged in rows that bring to mind the opposite-facing and interlocking lines of houndstooth print, one of her favorite textile patterns. Here, her figure seems to draw power from the vulnerability of the undressed bodies that stand or lie prone beneath her, some in corpse pose, others with wandering hands, but all in a stance of susceptible spread.

A second, sister image, *EVEN IF UR STR8 I STILL WANT TO FUCK YOU* (2010), complicates the first. Here, Aguhar's body, again larger than the others, lies prone at the bottom of the frame. The men are more carefully organized in a tighter pattern, each row facing alternate directions. The image of Aguhar's body serving as a rostrum for the seventy-five putatively heterosexual men standing above her is abject. But this abjection is complicated by the way in which the men's shared state of undress, and their entrapment in Aguhar's vision, distributes the vulnerability across all the figures. Viewed together, these two pieces produce a soft S&M dialectic in which the conventional division of abject labor is exploded into a field of shared, but relaxed, subjection.

The titles, *IF U R GAY I WANT TO FUCK YOU* and *EVEN IF UR STR8 I STILL WANT TO FUCK YOU*, make Aguhar's desire for the masculine objects seem inevitable. But the paintings seize this inevitability and lay it bare. By diagramming this erotic field, Aguhar draws a queer heuristic for owning, learning, and unlearning desire. The objects themselves, in their number and assembly, retain some individuality (there are lists of names that accompany these paintings), but altogether they are reduced to a series of coordinates in the deconstruction of desire and, particularly, white masculine desirability. This interrogation of desire, its fusing of the personal and the political, is one of the Call Out Queen's frequent occupations across her written and visual work.

3. THRESHOLDS

The intersectional nature of Aguhar's work—thinking and creating along race, gender, fatness, desire, depression, and other social vectors—invites encounters at multiple intellectual and embodied sites. But artist Edie Fake figures Aguhar's legacy as a sealed threshold. Fake's *Memory Palaces* series (2012) comprises fifteen geometric, pattern-rich renderings of doorways, archways, and storefronts in pen and paint dedicated to lost queer figures and spaces in Chicago, "spaces once associated with LGBTI newspapers, feminist clinics, dance clubs,

social spaces, punk venues, theaters, and other imagined spaces."[5] Five of these, named "gateways," are dedicated to departed artists, including Nick Djandji, Dylan Williams, and Mark Aguhar. *Gateway (for Mark Aguhar) (Palace Door: call-outqueen)* (2012) is a mosaic of tiles, wheels, and blocks, bright and solid like the imperial beaux-arts touches of old apartment buildings in Chicago, magnified and somewhat resembling the door to a boss's dungeon in a classic, pixelated video game. The drawing revels in the two artists' shared love of interlocking patterns, but, rather than paying tribute, Fake's palace door enacts a kind of archiving and reaching. It doesn't try to render Aguhar herself, or to remix Aguhar's aesthetic in a straightforward way. Instead, it deposits the viewer at the bejeweled threshold of her legacy, an altar that is not the endpoint but a passageway to somewhere else.

In this queer/trans transfiguration of the Call Out Queen from persona to passageway, Fake, a white artist, relieves Aguhar, a brown artist, from the burden of representation and instead engages her in space through a surrogate image. Fake's choice to render façades and thresholds and not faces themselves eulogizes the subjects of his drawings through proximity rather than appropriation. Figuring artists as gateways honors them as ways of viewing rather than as figures to be viewed. Assembled together through the brick and mortar of architectural façades, the artists Fake memorializes are also part of a larger fabric of queer remembering. The closed doors simultaneously obstruct and hold promise: they shut the door on the queer past, while keeping the universes they signified in proximity to ours as sources of creative energy.

To imagine Aguhar's legacy as a space—not instead of a body but as supplementary to it—encourages proximity without appropriation. A space allows Aguhar's inheritors to speak not for Aguhar but alongside her. Aguhar's mode of political and intellectual proximity gives us an alternative to notions of identity and embodiment. Rather than a quest for authenticity and final actualization, social identity—the way Aguhar practiced it (including racial, sexual, and gender identification)—can be viewed as a space within which we work. Identity does not walk into a room fully made, but takes shape in the refraction and refashioning of social relations as they shoot through bodies in a space. To imagine Aguhar's legacy as a space is also about being attuned to the way Aguhar herself used her proximity to others as an aesthetic instrument, not just in her physical performance work but also in her paintings and writing— including not only ecstatic and voluntary attachments, but also involuntary, inevitable, and inescapable sharing of space. She turned the inevitable into an opening toward elsewhere.

Edie Fake, *Gateway (for Mark Aguhar) (Palace Door: calloutqueen)*, 2012. Gouache and ballpoint pen on paper, 14 × 17 in (35.6 × 43.2 cm). Courtesy the artist. Image: © Edie Fake

ROY PÉREZ

4. INEVITABILITIES

But how to move now from Aguhar's aesthetics of inevitability and proximity to that which her final post invokes, which is the event of her death? The concept of inevitability is one way in which I've tried to grapple with and theorize Aguhar's death, and specifically, the inevitability with which Aguhar writes about suicide on her blog after her own sister Christine's suicide in 2011. *Call Out Queen* contains over nine thousand posts and reblogs that Aguhar published over the course of two years, from May 2010 until her death in 2012. She posted multiple times a day, and the content included selfies, porn, inside jokes, photos of art she was working on, a lot of Mariah Carey, responses to readers' comments, and her own theoretical writing on sex, race, desire, art, and grief. "Grief," she wrote shortly after her sister's death, "is violent, selfish, painful, and necessary."[6] The way Aguhar flagged her own suicide slowly became as inevitable as this grief. I am trying to think through Aguhar's own sophisticated thinking around suicide's inevitability and to understand her choice not as a question of morality or pathology, but as part of a political and aesthetic grappling with the inevitable abjection a queer body like hers endures when it moves through normative space.

I do not want to aestheticize Aguhar's death—it was not a performance or performative, nor can it be codified as an aesthetic act. Moreover, she did not invite us to do this. She did tell us that suicide, for her, exists on a continuum of brown and queer material life and that it can be felt and thought about as a rich source of agency, despite the negation to which it seems to surrender. Are suicide and its attendant grief other ways of sharing out brown affective labor? How can we theorize inevitability in Aguhar's art practice without letting her suicide overdetermine or negate the complex social relations her art explores? How can we acknowledge the inevitability with which Aguhar framed her suicide without aestheticizing it naïvely? How can we understand Aguhar's suicide as part of the constant war on transgender bodies, while still heeding the politics through which she conceived of suicide and the ways her art clues us into the social dynamics that beleaguer some queer bodies unto action and exhaustion? Here, I want to end this approximation of a theory of suicide, through which I'm still working, and leave you with Aguhar's own program for delaying and deferring:

HOW TO STAVE OFF SUICIDE FOR ANOTHER COUPLE HOURS

1. eat cheese or fried things or both or fried cheese

2. buy beautiful plants that remind you of yourself and that need careful attention

3 watch complicated movies about coming of age as a person of color in the 90s with a strong female lead

4. lay down the groundwork toward making hair extensions a reality

5. buy fashion that makes you feel like you are self-actualizing

6. consider the reality of hormones

7. shower or bathe as often as makes you happy

8. have serious heart-to-heart conversations with the people that you love

9. "WHAT THE FUCK DOES BEING A LADY HAVE TO DO WITH BEING A DOCTOR?"

10. find a therapist you get along with and that you can afford and be honest with them

11. cuddle with your friends as often and for as long as they are willing to stand you

12. remember that you are worthy

13. remember that the reason you don't want to commit suicide is because YOU don't WANT to[7]

..

"Proximity: On the Work of Mark Aguhar" by scholar Roy Pérez was first published in 2015 in the catalog *Platforms: Ten Years of Chances Dances*, edited by Aay Preston-Myint, on the occasion of an exhibition celebrating the tenth anniversary of Chances Dances, a Chicago-based collective of artists, activists, DJs, and educators. It was revised in 2016 for this volume.

..

1. I would like to extend my special thanks to Juana Paola Peralta, Aay Preston-Myint, and Michael Aguhar for their support, ephemera, and permissions.

2. Mark Aguhar, "Realizing the Goddess Actuality That I Always Have Been," *Blogging for Brown Gurls*, November 10, 2011, http://calloutqueen-blog.tumblr.com/post/12605852522 /realizing-the-goddess-actuality-that-i-always-have.

3. Elizabeth Guffey, "Knowing Their Space: The Design of Jim Crow Signs in the Segregated South," *Design Issues* 28, no. 2 (2012): 41–60. See also Elizabeth Abel, *Signs of the Times* (Berkeley: University of California Press, 2010).

4. See Roy Pérez, "Mark Aguhar's Critical Flippancy," *Bully Bloggers*, August 4, 2012, https:// bullybloggers.wordpress.com/2012/08/04/mark-aguhars-critical-flippancy/; and Young Joon Kwak, "Mark Aguhar," *Brooklyn Rail*, July 11, 2016, http://www.brooklynrail.org/2016/07 /criticspage/mark-aguhar.

5. "Eddie Fake," Exhibitions, Thomas Robertello Gallery, accessed 15 September 2016, http:// www.thomasrobertello.com/exhibitions/1346.html.

6. Mark Aguhar, *Blogging for Brown Gurls*, July 14, 2011, http://calloutqueen-blog.tumblr.com /post/7630338721/grief-is-violent-selfish-painful-and-necessary.

7. Mark Aguhar, "How to Stave Off Suicide for Another Couple Hours," *Blogging for Brown Gurls*, October 30, 2011, http://calloutqueen-blog.tumblr.com/post/12149066795/how-to -stave-off-suicide-for-another-couple-hours.

DYNAMIC STATIC

Nicole Archer

Once you can accept the universe as being something expanding into an infinite nothing which is something, wearing stripes with plaid is easy.
—Albert Einstein, quoted in *Patternalia: An Unconventional History of Polka Dots, Stripes, Plaid, Camouflage, & Other Graphic Patterns*

It is easy to be overwhelmed by Craig Calderwood's drawings (page 294): suspended in the silent blankness of the page and caked with the messy, material-semiotic accretions of desire, her noisy and heavily encrusted figures forcefully demand one's attention. It is an inimitable and distinctly queer pleasure to be caught in their dense but finely rendered patterns—ensnared somewhere in between signal and noise; stopped in one's tracks, yet ceaselessly following the phallic loops and yonic openings that obscure any semblance of a singular (true) body beneath a mélange of honeycombed sleeves, pansy-printed trousers, fruity masks, and apotropaic stockings.

One is reminded of critic Craig Owens's powerful analyses of feminist artist Barbara Kruger's bold imagery. Stylistically speaking, the art of Calderwood and of Kruger could not be more dissimilar; what unites them is a searing critique of gender identity and the ways that gendered stereotypes capture the body within a tight weave of politics and ideology. This critique is advanced by a shared aesthetic strategy—what Owens refers to as the "Medusa Effect."[1]

Not to be confused with or reduced to that climactic moment when Medusa's gaze freezes her own self-image in the form of an immobile, fetishistic totem, the Medusa Effect is a critical gesture better located when the swipe (or slash) of Perseus's sword just reaches the Gorgon's perfectly posed neck—a gesture

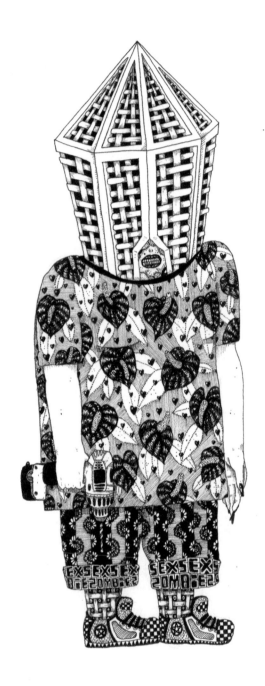

still pregnant with the possibility of infinite outcomes. Neither before nor after "the image," the Medusa Effect is located somewhere in between what Owens describes as, "in narrative terms, an initial moment of seeing" and "a terminal moment of arrest."[2] It is a transitory but potent act of resistance that lies between identity and difference in an intermediary space-time where the power of the imaginary can prevail over the restraints of reality.[3]

According to Owens, Kruger primarily deploys the Medusa Effect via her strategic use of personal pronouns, which serve to effectively disrupt the place of the viewer in regard to her signature-style artworks:

> Personal pronouns are also known as "shifters," but not, as is widely believed, because they allow speaker and addressee to shift positions; on the contrary, shifters establish a strict rule of noncommutability— "you" must never be "I." Rather, they allow speakers to shift from code to message—from the abstract to the concrete, the collective to the individual or, again, the impersonal to the personal. Hence their frequent appearance in messages of the mass media, which tends, as [Roland] Barthes observed, "to personalize all information, to make every utterance a direct challenge, not directed at the entire mass of readers, but at each reader in particular."[4]

As Owens states, in works like *Untitled (your moments of joy have the precision of military strategy)* (1980) (page 296), "Kruger parodies this tendency in her work, exposing the contradictory construction of the viewing subject by the stereotype."[5] It is uncomfortable to assume the position of *Untitled*'s particular addressee, so "you" disregard your disagreeable duty to receive its message, perhaps forcing yourself into the role of the other (the speaker). This leaves a hole in

Craig Calderwood, *Dissonance*, 2015. Ink on cotton paper, 8 ½ × 11 in (21.6 × 27.9 cm). Courtesy the artist

Barbara Kruger, *Untitled (your moments of joy
have the precision of military strategy)*, 1980.
Photograph, 37 × 50 in (94 × 127 cm). Courtesy
Mary Boone Gallery, New York. Image:
© Barbara Kruger

NICOLE ARCHER

the image's grammar—a hole that you cannot help stumbling back into, a hole with depths that you can only imagine.

Kruger refigures the personal pronoun's normal, operative function and, subsequently, offers viewers an opportunity to dislodge themselves from the law of the letter. This exposes the language of gendered oppression's limits. It reminds us, as the feminist and queer theorist Teresa de Lauretis details in her landmark essay "The Technology of Gender," that gender is a semiotic apparatus, albeit one with very real social and political functions. She explains, "The term *gender* is, actually, the representation of a relation, that of belonging to a class, a group, a category. ... [G]ender assigns to one entity, say an individual, a position within a class, and therefore also a position vis-à-vis other preconstituted classes."[6] Apropos of recent discussions regarding trans* visibility and the fight for gender self-determination,[7] Kruger's feminist-inflected pronoun play seems particularly consequential. The power of the personal pronoun, and the desire to find a way of articulating one's self beyond its strict logics, are certainly well acknowledged in trans* politics and poignantly felt in trans* experience, yet many artists, like Calderwood, whose work is certainly informed by the dynamics of these discourses, are choosing to take a different tack—focusing less on the linguistics of gender politics and more on its material, or sensual, dimensions.

In *Dissonance* (2015), for example, Calderwood optically jams the story of her figure by flooding the visual field with a miscellany of eye-catching patterns that refuse to add up, refuse to lend themselves to the task of figuring things out: Who is this? How did they arrive here? Where are they going with that electric drill, all dressed to the nines with perfectly lacquered fingernails? The inscribed textile attached to the hem of the figure's pants presents viewers with a displaced and scrambled text in medias res. Like a book that appears within a dream, we are unable to fully read the hem's lines, but we nonetheless sense, or feel, that the text's implications are far greater than the sum of its individual words.

In Calderwood's drawings, the act of looking is predicated on the contingency—as opposed to the certainty—of seeing (what lies beneath the garment, the code, the work of art). Her figures make no promises to resolve their identities. Like Kruger, she suspends the act of perceiving oneself from a particular, fixed place in order to open up onto a sense of imagination; unlike Kruger, Calderwood does not do this by offering her viewers an alternative subject position. Instead, she strategically manipulates the intensity of certain optical patterns in order to scramble—or dazzle—those fields of vision that the "apparatus of the pattern" is traditionally tasked with managing.[8] Along the way, she methodically obliterates any bodily features that qualify as cardinal coordinates or anchor points onto which preconceived gender identities could attach themselves. This

is because Calderwood's is a discourse of desire, and, as theorist Jean-François Lyotard writes, "Desire does not speak; it does violence to the order of the utterance."[9] Calderwood's figures do not have secret essences, or supplementary identities; they function to generate fantasy, to unfetter the language of the body from certain gendered orders, by offering an opportunity to actively imagine the body as otherwise and adrift. Down the rabbit hole we fall.

Trans* subjectivity is currently gaining remarkably increased attention within American popular culture, and a set of unmistakably clear patterns is being formally developed to mediate the terms through which trans* experiences, aesthetics, desires, bodies, and politics might pass into "proper view."[10] The dissonant and queer strategy of "pattern-jamming" presents both a serious mode of political resistance and a strategic plan for everyday survival during this key historical moment. It aims to ensure that nonbinary gender variance is not simply reduced to the proliferation of tick-boxes on tomorrow's identity papers.

PATTERN RECOGNITION

———

Patterns can take many forms: repeated surface decorations; standardized shapes; or duplicated arrangements of sounds, images, or movements. Whether they are understood primarily as modes of ornamentation or as systems of organization, all patterns naturalize the appearances of certain recurrences in life along with the meanings that we ascribe to such repetitions. Patterns stabilize our notions of ourselves and our notions of others. They work in both the present and the past tense, while simultaneously serving as an essential forecasting tool. It is through their rhythms that we come to place bets on our futures—as it did yesterday and today, the sun also rises tomorrow.

Patterns *make* sense in important multidimensional and multisensory ways, and, once recognized, they are stubbornly hard to ignore or to break.[11] The capacity to establish or to identify a pattern comes with great authority—it is a right granted to our artists, to our geniuses, and to our bureaucrats.[12] Patterns make for suspiciously strange bedfellows.

In his classic 1927 essay "The Mass Ornament," Frankfurt School scholar Siegfried Kracauer observes that "an analysis of the simple surface manifestations of an epoch can contribute more to determining its place in the historical process than judgments of the epoch about itself."[13] Between their dots, lines, and dashes, their foregrounds and their backgrounds, patterns make latent and manifest admissions about those who claim to perceive them. The most enduring

patterns are, at their hearts, maps of those terrains where belief most directly meets desire, where aesthetics meets significance. To behold a pattern is to lay claim to these terrains and to their particular histories—consciously or not.

Take stripes. At their most basic level, they are equally spaced sets of contrasting colored bars. Whether draped across the shoulders of athletes or sailors, forced onto the backs of prisoners, or ceremoniously hung from flag poles, present-day stripes absolutely vary in style and significance, but, as the medieval historian Michel Pastoureau explains in his 2001 book *The Devil's Cloth: A History of the Stripe*, what all of these disparate types of stripes have in common is the capacity to serve as "a tool for setting things in order."[14] To modern eyes, trained to root out binary patterns, stripes appear as an ideologically neutral or simple means of codifying certain cultural arrangements; they are as plain as those "uncontested" oppositions situated at the heart of everyday life: good versus evil; black versus white; girl versus boy. Yet between the lines, a tangle of uncanny specters lurks.

As Pastoureau details in his masterful survey, the present-day stripe's "unremarkableness" is afforded by a litany of more aberrant associations. During the Middle Ages, for instance, the stripe literally served as a "cause of disorder and transgression" within Western culture.[15] In many regions across medieval Europe, striped cloth was reserved for the garments of "those who practice[d] such trades not to be confused with honest citizens," namely prostitutes, jugglers, clowns, and hangmen.[16] Other societal outcasts and condemned individuals, including lepers, heretics, and non-Christians, were similarly marked by striped clothing. And by contrast, religious officials—such as Carmelite monks—were formally banned from wearing striped habits.[17]

According to Pastoureau, the establishment of these dress codes and sumptuary laws was owed to the stripe's ability not simply to signify but to formalize (or figure) the abnormal within medieval visual and material cultures:

> People in the Middle Ages seemed to feel an aversion for all surface structures which, because they did not clearly distinguish the figure from the background, troubled the spectator's view. … An image was created by superimposing successive levels, and, to read it well, it was necessary—contrary to our modern habits—to begin with the bottom level and, passing through all the intermediary layers, end with the top one. … [W]ith stripes, such a reading is no longer possible. There is not a level below and a level above, a background color and a figure color. One and only one bichrome level exists, divided into an even number of stripes of alternating colors. With the stripe … the structure *is* the figure.[18]

In a culture accustomed to transmitting visual messages along very different frequencies than those used today, stripes made a great deal of noise. They were used as a way to break the visual field open and to force certain bodies into genuine non-places, or fields of actual nonsense.[19] That the modern stripe's clarity is bound both to its capacity to scramble certain forms of visual logic and to discipline certain bodies makes a clear case for just how ideologically saturated, or unnatural, the act of looking is. It also suggests an exciting critical possibility for those whose subjectivities are actively legislated against or criminalized under the signs of abnormality and deviation from the normal patterns of behavior and identification. The genealogy of the stripe makes patent how historical processes work to transform yesterday's noise into today's signal—the degree to which modernity is organized around logics not of sameness and continuity but of difference—or, as Michel Foucault suggests in *The Archaeology of Knowledge*, of "discontinuity, rupture, threshold, limit, series and transformation."[20] This is precisely what makes the work of pattern manipulation so strategically necessary: power is formally established and formally critiqued through the adaption or the obliteration of patterns.

This is not to suggest that modern stripes—or patterns more generally—are simply suffering from a kind of identity crisis that needs to be rectified, or that the aim ought to be the permanent suspension of any and all sense of visual coherence. Rather, this is a call to take advantage of those aesthetic practices that can direct attention away from a pattern's typical symbolic functions (or responsibilities to secure meaning and certain attending forms of power). It is a call to aestheticize the pattern's capacity to function performatively as a kind of critical figure that is always already inserted within the discourse of everyday life for the sake of marking how and "where the negative knowledge about the reliability of linguistic utterance is made available."[21] This, as the theorist Paul de Man explains in his essay "The Resistance to Theory," is because the figural dimension of a text "gives the language considerable freedom from referential restraint, but it [also] makes it epistemologically highly suspect and volatile, since its use can no longer be said to be determined by considerations of truth and falsehood, good and evil, beauty and ugliness, or pleasure and pain."[22]

Manipulating the figure of the pattern provides a way to critically and actively resist ideology, or to critically gesture toward and theorize the possibility of "another way" (another world). For subjects whose minority status is legitimized by the ways in which their very being threatens the order of things, artworks that mobilize this trope can serve as an important call to resist both oppression and assimilation.

This trope is clearly operative in the work of Nicki Green, another Bay Area–based artist and close interlocutor of Craig Calderwood. Green's sculptures borrow shapes and patterns long associated with blue-and-white ceramics in order to support narrative scenes of trans* life and ritual in ways that connect these themes with complex political and cultural histories.[23] Scrambling the typical shape of delftware tulip vases in works such as *It's Almost as if We've Existed (Tres in Una)* (2015) (page 302), Green boldly aestheticizes the genital panic that seems forever lodged within the heart of discourses on sexual or gendered difference. The fragility of the work's phallic attachments formalizes castration anxiety and makes a mockery of the overdetermined and ideologically saturated morphologies and biologies that so many transphobic lawmakers use to ground their political fights against trans* rights. The unglazed edges of Green's pottery resist the usual "shine"—the bounded and limited forms that capital places on the material world, on the body, and on the earth itself. These raw edges remind viewers of unformed clay, rife with potential. Beyond the imagistic depictions of trans* mythologies, this formal decision works to materially activate what art historian David Getsy refers to as sculpture's "transgender capacity," its potential "for making visible, bringing into experience, or knowing genders as mutable, successive, and multiple."[24]

Green's work deftly manages to insert issues of trans* representation into both the long and short histories of global artistic practice, while many of her formal choices align her work with other contemporary artists who have similarly opted to examine the varied ways that pattern is used to put one in one's place. Yayoi Kusama's lifelong exploration of dot patterns, for example, complicates and exposes the limits of phallic power and ancillary notions of "the self"; and Adriana Varejão's sculptural paintings of azulejo tiles viscerally expose the ways in which the indigenous peoples and cultures of South America were rendered into a sort of flesh, or meat, that empire has feasted upon for centuries. Moreover, the way Green uses simple decorative patterns to tell complex and messy stories cannot but evoke Yinka Shonibare's commanding use of distinctly patterned Dutch wax-printed fabric in his sculptural and photographic tableaux vivants, which serve as searing critiques of the ways that imperial Europe has built its wealth through the exploitation and oppression of colonial African subjects.[25]

Nicki Green, *It's Almost as if We've Existed (Tres in Una)*, 2015. Glazed earthenware, 15 ½ × 12 × 3 ½ in (39.4 × 30.5 × 8.9 cm). Courtesy the artist

PATTERN DISRUPTION

Approaching the pattern from a somewhat different angle, Jonas N. T. Becker's multimodal 2014 work *The Pile* (page 304) shifts attention away from patterns of surface decoration and toward the spaces that lie between the patterned behaviors governing so many of our lives and gender identities. Curious about what people "wanted," Becker hosted a series of public forums where he asked over two thousand participants the question, "What one thing would make your life better?" While people responded in ways that were certainly personal, most answers proved to be far less variable than one might expect. Patterns quickly emerged, and Becker set out to give these repetitions a kind of form. He created *The Pile* by translating each response into a two-dimensional image that served as a pattern for a stuffed, red-felted, hand-sewn soft sculpture.[26] Where answers clearly overlapped, the patterns were literally repeated. When displayed—as the title suggests—in a pile, the legibility of each of the individually patterned shapes is overwhelmed by the noise produced through the accrual of their similarities. Heaped upon one another, these wishes appear like a stockpile or a mass casualty of a political economy based, in part, upon a logic of endless accumulation. The result is a clear, albeit melancholic, call for the rearticulation of our desires outside capitalist logics of (re)production: a call to resist the fetishistic reification of desire by drawing viewers' awareness to the odd, unpredictable spaces that open up between the smoothly patterned objects—the spaces where desire's variability is unbounded.

Opaque (2014), produced by the collaborative partnership of Pauline Boudry and Renate Lorenz—who appear similarly interested in using the trope of the pattern to deconstruct the politics of desire—is a multimedia installation that includes a ten-minute filmed performance featuring Ginger Brooks Takahashi and Werner Hirsch (page 306). Claiming to be representatives of an underground organization, Takahashi and Hirsch appear to viewers in the middle of an abandoned public pool. Initially, they are hard to discern—the contours of Takahashi's silhouette meld with a glorious accumulation of the queerest pink, tiger-striped pattern imaginable, while Hirsch is enveloped in a color-coordinated plume of pink smoke. All that is solid melts into air! The performance is punctuated by the dramatic pulling back and fondling of a series of curtains, each of which represents a distinct visual logic: first opaqueness, followed by camouflage, then dazzling brilliance, and, finally, a display of loose transparency. As the action unfolds, the duo recites a desirous ode for a "proper faultless enemy" that is inspired by the writings of French novelist Jean Genet. The extravagantly queer patterning of the space of appearance functions like the

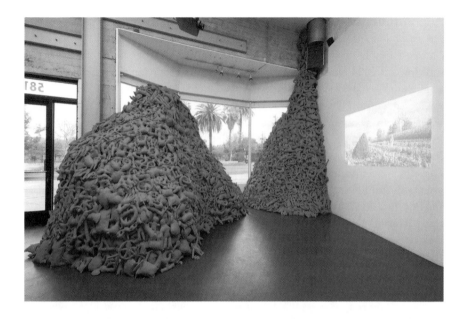

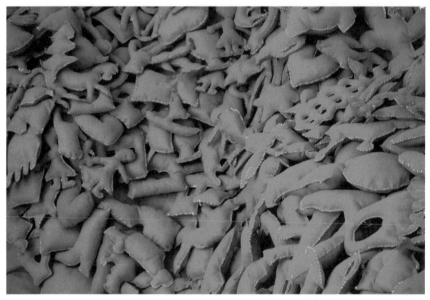

NICOLE ARCHER

stripes of medieval Europe, theatrically blurring "the dividing lines between same and other, between accomplices and enemies."[27] *Opaque* thus forces viewers to acknowledge that "conflict" is, itself, something that is desired—enemies need to be wanted. The work demands that we ask whether queer desires might make something different of conflict, considering that normative patterns of desire have thus far led only to war—endless, all-consuming, preemptive war, which aims to defeat or obliterate difference.

Opaque challenges one to consider the unique forms of pleasure yet to be mined from the depths of the hostilities that seem to mark every level of modern human interaction, but the aesthetics of pattern disruption can also be used to concentrate attention on the disproportionate risk that some bodies are subjected to within existing cultures of violence. In *Black Patois* (2016) (page 308), Zawadi Ungadi, a black Kenyan trans* man, presents viewers with a constellation of images that are emblematic of the violent patterns of behavior that are all too often directed toward his body. The images present Ungadi literally and figuratively painted into a series of corners: as a fictionalized runner, a mythical "purse snatcher," the object of intense sexual desire, and, with his hands up, as a victim of endless suspicion and murderous rage. The brutality of living within such overwhelming patterns of racism is made abundantly clear. A sense of the different amounts of noise that one is subjected to, depending on one's particular identity coordinates, is made manifest. The work isolates a series of bodily gestures that are patterned and arranged to support a culture of antiblackness.

Pauline Boudry / Renate Lorenz, *Opaque*, 2014
(still). Single-channel super-16mm HD video,
sound, color; 10 min. Courtesy Ellen de Bruijne
Projects, Amsterdam, and Marcelle Alix, Paris.
Image: © Boudry / Lorenz

Ungadi challenges people, and particularly white people (given the presence of a second, white figure in many of the images), to imagine modes of relation to his black masculinity that are not pictured and that might emerge out of the unifying blackness that frames his images, a border ripe with creative potentiality.

The work of the artist Kiam Marcelo Junio refigures the pattern along similar lines, in order to stage the opportunity for queer and trans* aesthetics to interrogate the depths of current and historical forms of racialized and gendered state violence. In a series of works collectively titled *Camouflage as a Metaphor for Passing* (2012) (page 309), Junio, a naval veteran, mobilizes the highly charged rhetoric of passing vis-à-vis a variety of visual and aural patterns in order to investigate militarized zones of contact—zones that exist between individual and collective bodies, nation-states, or even one's own competing senses of self.

In works like *Crypsis I* and *Crypsis II* (2012), Junio engages the pattern across multiple registers, producing replicas of their US Navy camouflage jacket that mirror the government-issued garment's shape, only to forestall the authority typically vested in such standard uniforms by fashioning the jackets from atypical fabrics. In *Crypsis I*, Junio silkscreens the jackets with the silhouettes of foliage found in their home city of Chicago. This camouflage made for "here" versus "over there" questions where the frontline really is, where the fight festers and is fueled versus where the violence of desire is meted out and cathected. In *Crypsis II*, Junio's use of red Chinese brocade in the reconstruction of their jacket, and its pairing with the historically charged cheongsam—a type of Chinese dress—that is printed with an allover pattern of all-seeing eyes, provokes many conversations, including one regarding the highly gendered and racialized dynamics of the gaze: Why is the uniform, and its implied right to camouflage or concealment, offered to some bodies, while others are offered only the conditions of hyper-visibility?

In *Dazzle I and II (Nangyayari Na Suite)* (2015), a two-channel soundscape produced in collaboration with Najee-Zaid Searcy and sometimes installed with *Camouflage as a Metaphor for Passing*, Junio floods the sonic dimensions of the exhibition space with a layered cacophony of sound that includes traces of radio transmissions about casualties of war, historical accounts of the United States' colonial occupation of the Philippines, and the distinct sounds of sobbing. As Junio states on their website, "Filipino/Tagalog for 'It is already happening,' NANGYAYARI NA is a mantra, a chant, a call to arms."[28] It is an aesthetic refusal to accept that war is something that ever has a true beginning (or cause) or that it ever promises a true end. With each cut-off transmission, an ellipsis manifests itself and a fissure appears in the fabric of the stories that we tell ourselves in

Zawadi Ungadi, *Black Patois*, 2016. Eight
digital inkjet prints mounted on PhotoTex,
72 × 72 in (182.9 × 182.9 cm) overall.
Image: © Zawadi Ungadi

Kiam Marcelo Junio, *Crypsis II*, from the series
Camouflage as a Metaphor for Passing, 2012
(details). Silk brocade; replica of military jacket,
ISO Standard XS. Images: © Kiam Marcelo
Junio, 2013

order to justify the continued legacies of violent oppression that large-scale military forces are built to sustain.

All students of art history are familiar with the juxtaposition of static and dynamic imagery. It is a juxtaposition that lies at the very heart of art history's accounting of Western culture—the contrast forged between the "dynamic" figures of Ancient Greece and the "static" images found in early Dynastic Egypt or the Ancient "Near East." The fissures opened up in Junio's work, through their rendering of dynamic static, force us back into the disturbing circumstances of this foundational comparison. They create a critical rupture within the story of "Art" itself, by laying open a space in which we must consider how the coherence we ascribe to the notion of Art maps onto the coherence we ascribe to gender, to race, to nation, and to civilization.

It is within this fissured space that the Black Salt Collective, a Bay Area–based group consisting of Sarah Biscarra Dilley, Grace Rosario Perkins, Anna Luisa Petrisko, and Adee Roberson, challenged itself to curate "Visions Into Infinite Archives," an exhibition on view from January 14 to February 10, 2016, at SOMArts Cultural Center in San Francisco (page 311). Like Junio's work, "Visions Into Infinite Archives" leveraged the figure of the jammed pattern, or dynamic static, to formally decolonize the space of the gallery. Dedicated to "contemporary non-linear identity in which experience results in atmosphere,"[29] the group installed the work of over two dozen intergenerational artists of color and included a host of supplementary performances and critical dialogues that were intended to support the exhibition's primary goal of activating the non-linearity of ethnic, sexual, gendered, and intergenerational cultures. The tactical use of exuberantly mismatched surface patterns appeared as a key trope across the works of artists who were positioned within a broad scope of gendered identity formations, but who all directly or indirectly worked to activate the pattern's "transgender capacity."

Chief among these artists was one of the Black Salt Collective's members, Adee Roberson. Roberson's multipaneled painting *Say Her Name into the Ocean* (2015), a "memoriam to Black women and girls who have lost their lives in result of systematic oppression, and the violence that is the white supremacist patriarchy,"[30] explores how bold patterns of line and color might complement, or serve as politically potent counterweights to, the hyper-visibility of certain stereotyped images of black gendered subjectivity. The work demands that viewers acknowledge the violent erasure, or dismissal, of images of black gendered life, pain, pleasure, and mourning that break from the patterns of representation that are prioritized by the mass media and other disciplinary regimes of vision.[31]

Black Salt Collective, in collaboration with Diyan
Bukobomba, Kenneth Brown Jr., Jade Ariana
Fair, José Luis Íñiguez, Inés Ixierda, Titania
Kumeh, Amy Martinez, Jeffrey Martinez, Olen
Perkins, and Iraya Robles, *Infinite Archive*, 2016.
Installation view: "Visions Into Infinite Archives,"
SOMArts Cultural Center, San Francisco.
Courtesy Black Salt Collective. © SOMArts
Cultural Center. Photo: Dan Fenstermacher

Critically queer pattern-jamming also served as a kind of curatorial paradigm for "Visions Into Infinite Archives." Throughout the exhibition space, Black Salt caused viewers to encounter artworks outside normal patterns of reception by arranging them in ways that frustrated normal viewing habits: Works were presented at heights and distances that belied typical display practices. The binary of the wall versus the floor was sacrificed throughout the exhibition in order to produce a clamorous network of colors, textures, and histories that engaged all the works included in the exhibition and the bodies of those visitors who navigated the show's queer coordinates. This had the effect of powerfully muddling another "immutable" binary within art discourse—namely, that of art object versus art viewer—transforming an art exhibition into the kind of space "where there are alternative futures and alternative pasts, where oracles become realities, where histories are honored and transmuted, where deep healing can take place."[32] Rather than simply allowing themselves to uncritically rely upon the pattern's tendency to regulate the body and regimes of sight into predicable, uniform arrangements, in "Visions Into Infinite Archives," the members of Black Salt Collective drew upon the pattern's prodigious capacity to figure the abnormal.

STATIC CLINGING

Pattern-jamming necessarily obfuscates the neat ways that gender and other modes of identification are rendered into discrete bands within the patterns of everyday living. It revels in the genealogical and aesthetic attachments that connect the fight for gender self-determination with other liberatory practices and histories, particularly those pitted against colonialism and antiblackness. As the queer theorist, activist, and filmmaker Eric A. Stanley explains in their keyword entry on "Gender Self-Determination" for the inaugural issue of *Transgender Studies Quarterly*:

> [G]ender self-determination is affectively connected to the practices and theories of self-determination embodied by various and ongoing anticolonial, Black Power, and antiprison movements. For Frantz Fanon and many others, the violence of colonialism and antiblackness are so totalizing that ontology itself collapses; thus the claiming of a self fractures the everydayness of colonial domination. ... To center radical black, anticolonial, and prison abolitionist traditions is to already be inside trans politics. ... Gender self-determination opens up space

for multiple embodiments and their expressions by collectivizing the struggle against both interpersonal and state violence.[33]

In the second chapter of philosopher, psychoanalyst, and revolutionary Frantz Fanon's 1959 text *A Dying Colonialism*, Fanon tells a story about the slow adoption of the radio by the Algerian people and how this "instrument of colonial society and its values"[34] was transformed during the Algerian War of Independence into a key revolutionary technology. As Fanon explains, Algerians were very hesitant to adopt the radio into their homes, for Radio-Alger was recognized as simply "a re-edition or an echo of the French National Broadcasting System operating from Paris."[35] Its transmissions were part of the occupier's culture.

As the fight for independence gained momentum and an increasing number of people outside the densely populated metropolitan centers started to concern themselves with the revolution, it became essential to quickly spread news regarding the movement's progress to remote parts of the country. French officials were quick to label the reading of certain publications as punishable acts of Algerian nationalism, and the public purchase of certain newspapers became a considerably dangerous proposition. Enter the Voice of Fighting Algeria.

The Voice was a pirate radio station built to broadcast news of the ongoing fights in Arabic, Kabyle, and French from the perspective of the Algerian combatants. Colonial authorities quickly came to recognize the threat that the Voice posed, and as Fanon explains, "The highly trained French services, rich with experience acquired in modern wars, past masters in the practice of 'sound-wave warfare,' were quick to detect the wave lengths [*sic*] of the broadcasting stations. The programs were then systematically jammed, and the *Voice of Fighting Algeria* soon became inaudible."[36] This signal-jamming proved to be crucial—but not for the French government. Rather than help to quash the uprising, this tactical maneuver activated the bodies and the imaginations of those who depended on the Voice for news. It threw listeners into a constant state of alert. Beyond white noise, beyond the anticipation of information, the static became a point of intense concentration. This transformed the radio into a fulcrum for the revolution by producing a radically contingent "pattern of listening habits."[37] Groups of people huddled around a community's radio operator, searching the airwaves for a signal amid the noise. At best, only snippets of news could be heard, but in the midst of the static and jammed signals, a space opened where people were forced to collectively imagine what was going on … out there … beyond what they already knew.

By clinging to static, one can argue, the power of fantasy is activated; people's desires are aroused, their unconscious, unpatterned energies are pricked, and

they become libidinally invested in the fight. Fantastic conditions and alternative arrangements of being start to take uninhibited shape. If the fight is, indeed, for gender self-determination and to decolonize the spaces of trans* visibility, then radical trans* aesthetics must work to flood the transmission of heteronormative gender-binary patterns. The fantastic production of visual noise (exuberant, hyperextended, mismatched, and deconstructed patterns of dress, drawing, painting, living, and loving) is a key strategy within the struggle for trans* liberation. Liberatory politics demand imagination.

"Dynamic Static" by scholar Nicole Archer was written in 2016 for this volume.

NOTES

1. Craig Owens, "The Medusa Effect, or The Specular Ruse," in *Beyond Recognition: Representation, Power, and Culture*, ed. Scott Bryson, Barbara Kruger, Lynne Tillman, and Jane Weinstock (Berkeley: University of California Press, 1992), 191–200.

2. Ibid., 197.

3. "The Medusa Effect" is highly inflected by Lacanian psychoanalysis. As Owens states, it requires an appreciation of "the duality, the specularity, the symmetry and immediacy that characterize Lacan's Imaginary Order" (197); it is also, as Owens directly acknowledges, a kind of "critical renaming" of Lacan's concept of "the suture"—a renaming that demands a more feminist account of the "'pseudo-identification' of an initial moment of seeing and a terminal moment of arrest" (198). Owens chooses the name of the Medusa in order to summon the thinking of feminists such as Hélène Cixous, whose influential 1975 essay "The Laugh of the Medusa" sought to reclaim this classical femme fatale (or fetishistic figure of sexual difference) vis-à-vis the sexist treatments that she'd received, not only throughout the long history of Western art but also within the modern psychoanalytic archive. See Hélène Cixous, "The Laugh of the Medusa," trans. Keith Cohen and Paula Cohen, *Signs* 1, no. 4 (Summer 1976): 875–93.

4. Owens, "The Medusa Effect," 193.

5. Ibid.

6. Teresa de Lauretis, "The Technology of Gender," in *Technologies of Gender: Essays on Theory, Film, and Fiction* (Bloomington: Indiana University Press, 1987), 4.

7. For more on this topic, see Eric A. Stanley, "Gender Self-Determination," in "Postposttranssexual: Key Concepts for a Twenty-First-Century Transgender Studies," special issue, *Transgender Studies Quarterly* 1, no. 1–2 (May 2014): 89–91.

8. This is not to suggest that no other artists have previously addressed pattern as a way of critiquing gender relations. For instance, within the generation of feminist artists that claims Kruger, one might recall the Pattern and Decoration movement, a group of artists that included Valerie Jaudon, Joyce Kozloff, and Miriam Schapiro, among others, who collectively claimed that their politically conscious explorations of surface ornamentation were grounded in an effort to dispel "the prejudice against the decorative," which had "a long history and [was] based on hierarchies [that they also hoped to dismantle, namely]: fine art above decorative art, Western art above non-Western art, men's art above women's art" (Valerie Jaudon and Joyce Kozloff, "Art Hysterical Notions of Progress and Culture," in *Theories and Documents of Contemporary Art: A Sourcebook of Artists' Writings*, ed. Kristine Stiles and Peter Selz [Berkeley: University of California Press, 1996], 154).

9. Jean-François Lyotard, "The Dream-Work Does Not Think," in *The Lyotard Reader*, ed. Andrew Benjamin (London: Basil Blackwell, 1989), 19.

10. At the time of writing this essay, numerous examples of such disciplinary tactics abound. They take a variety of cultural and legislative forms, but all tend to rest on an insistence on the gender binary—or a cultural and political will to "resolve" trans* issues by demanding that all trans* subjects "stabilize" their gender identity and "resolve their gender dysphoria" by transitioning to "the other, pre-patterned" gender identity. This is, perhaps most acutely demonstrated in the US Pentagon's June 2016 policy changes regarding the service of transgender military troops and the formation of a Department of Defense working group to "study the policy and readiness implications of welcoming transgender persons to serve openly in the military" ("Working Group to Study Implications of Transgender Service," *U.S. Department of Defense*, July 13, 2015, http://www.defense.gov/News-Article-View/Article/612640).

 According to the Pentagon, the new policy is primarily intended to allow transgender service members to serve openly and to ensure that "Any discrimination against a Service member based on their gender identity is sex discrimination and may be addressed through the Department's equal opportunity channels" ("Transgender Service Member Policy Implementation Fact Sheet," *U.S. Department of Defense*, accessed July 26, 2016, http://www.defense.gov/Portals/1/features/2016/0616_policy/Transgender-Implementation-Fact-Sheet.pdf).

 Military-funded medical services are also set to be made available to transgender service members who seek "in-service transitions." For those individuals who transitioned prior to seeking military employment, the "initial accession policy will require an individual to have completed any medical treatment that their doctor has determined is necessary in connection with their gender transition, and to have been stable in their preferred gender for 18 months, as certified by their doctor, before they can enter the military" (ibid.).

 Presented as a boon for the trans* community, and as a fix for what former Secretary of Defense Ash Carter openly referred to as an "outdated" approach, the new policy actually offers little that is new (see Marina Koren, "The U.S. Military's Welcome for Transgender Troops," *Atlantic*, June 30, 2016, http://www.theatlantic.com/news/archive/2016/06/transgender-military/489584/). From the outset, the question of whether someone transitions prior to or during military service has appeared as a central concern within military memos. Within military news outlets and discussion groups, "transitioning" similarly serves as an issue of primary importance (see, for example, Andrew Tilghman, "Here Are the New Rules for Transgender Troops," *Military Times*, June 30, 2016, http://www.navso.org/news/here-are-new-rules-transgender-troops). This, no doubt, is owed to many factors. First, the previous policy was to deem any individual who had transitioned or who desired to transition as

being "medically unfit to serve." Second, all military branches require personnel to adhere to very strict codes of comportment and physical health that are delineated in starkly gendered terms (e.g., women and men literally have different uniform-wear rules and physical fitness standards as a part of their service requirements).

The focus on transitioning implies that one does not need to be cisgender to serve in the US military, but one does need to stabilize one's identity along the gender binary to serve (and in a way that meets certain military-mandated requirements). Ergo, this new policy does not seem likely to allow for gender self-determination in the widest sense of the term. Instead, it is likely that the final policy will simply serve to establish a clear pattern for "how" to be a transgender subject under the deeply gendered terms of the US military, a pattern that will only further stabilize the preestablished gender binary. This, of course, is only if the schematics of the 2016 policy remain uncontested by the notoriously conservative Donald J. Trump administration.

Given the Trump White House's populist platform, there is real fear that the lifting of the ban on transgender service members might be in peril. In support of this opinion, many cite Trump's response to a question asked by Army Col. Don Bartholomew on the campaign trail regarding the status of transgender service members—a response that affirmed Bartholomew's own assessment of the new policy as being "politically correct," and neither "combat-effective or readiness-driven" (see Jenna Johnson, "Here's how Trump responded to a question about women and transgender individuals in the military," *Washington Post*, October 3, 2016, https://www.washingtonpost.com/news/post-politics/wp/2016/10/03 /heres-how-trump-responded-to-a-question-about-women-and-transgender-individuals -in-the-military/?utm_term=.a412af6cc474).

11. Here, in recognition of the pattern's disciplinary and performative functions, i.e., a pattern's capacity not just to signify a sense of order but to enact an order of things, it is worth recognizing queer theorist Judith Butler's watershed text *Gender Trouble* and her critical investigations of how a certain, gendered "construction of coherence" is erected via performative, corporealized patterns of behavior that work to conceal (non)binary gender variance and to regulate the body's cultural significances and capacities. See Judith Butler, *Gender Trouble* (New York: Routledge, 1999), esp. 172.

12. To this end, I have always found it fascinating that popular films often choose to signify genius, or the quality of being exceptionally (or, dare one say, singularly or abnormally) intelligent, through a character's capacity to see patterns, or sameness, where others see nothing but disparity. In film after film, audiences are invited to peer through a protagonist's eyes as duplicate numbers or forms are magically illuminated, and streamlined constellations of meaning dramatically emerge from clouds of chaos. All the excessive information or noise dims, the code is forever broken, and the soundtrack inevitably swells to a crescendo.

While I have little interest—or belief—in genius, I am nonetheless drawn to this cinematic trope and what it reveals about the ways certain contemporary cultures understand and evaluate the relationship between "the one and the multitude," "the singular and the plural," or "the queer and the norm." How else might the cinema, a quintessentially modern art form, handle the challenge of representing the aberrant than by making it the servant of normality via the pattern?

13. Siegfried Kracauer, "The Mass Ornament," in *Critical Theory and Society: A Reader*, ed. Stephen Eric Bronner and Douglas MacKay Kellner (New York: Routledge, 1989), 145.

NICOLE ARCHER

14. Michel Pastoureau, *The Devil's Cloth: A History of Stripes*, trans. Jody Gladding (New York: Washington Square Press, 2001), 4.

15. Ibid.

16. Ibid., 13–14.

17. Ibid., 7–16.

18. Ibid., 3.

19. This is not to suggest that this tendency has been completely disavowed within all modern, institutional applications of the stripe. One obvious example is the striped prison uniform, which makes clear claims on both the stripe's symbolic security and its optical volatility. Another example is the British and US development of "dazzle patterns," which served as a form of camouflage intended to protect Allied naval vessels from German submarine attacks during World War I. Unlike "ground camouflage," which works to dissipate a form's visibility via a logic of maximum mimesis, dazzle painting requires camoufleurs to cover whole naval vessels in bold, zigzag stripes that break apart the formal integrity of the ship by jamming the logic of the visual field itself. As art historian and camouflage expert Roy R. Behrens explains, "In ground camouflage, the object to be camouflaged is often stationary, and one is more or less assured of a fixed and predictable background. In naval camouflage, however, the object to be camouflaged is nearly always moving, and its background is frequently shifting as well. … Since invisibility was impossible in naval camouflage, it would be more effective to paint erratic patterns on the ship's surface, making it even more visible, and thereby confuse or 'dazzle' the submarine gunner so that he could not be sure about the target's course, size, speed or distance" (Roy R. Behrens, *False Colors: Art, Design and Modern Camouflage* [Dysart, IA: Bobolink Books, 2002], 86).

Anyone interested in dazzle patterns, both historically and critically speaking, is encouraged to explore not only the work of Behrens, but also that of the artist Stephanie Syjuco, in particular her *Neutral Calibration Studies* from her ongoing *Ornament + Crime* project ("Ornament and Crime from Stephanie Syjuco," *Stephanie Syjuco*, accessed July 31, 2016, http://www.stephaniesyjuco.com/p_ornamentandcrime.html). The work of Hito Steyerl, in particular *How Not to be Seen: A Fucking Didactic Educational .MOV File* (2013), is similarly engaging (Hito Steyerl, "How Not to be Seen: A Fucking Didactic Educational .MOV File, 2013," *Artforum* Videos, accessed July 31, 2016, https://www.artforum.com/video/id=51651&mode=large&page_id=2). Steyerl has also written on patterns, misrecognition, and big data; see, for example, Hito Steyerl, "A Sea of Data: Apophenia and Pattern (Mis-)Recognition," *e-flux journal* 72 (April 2016), http://www.e-flux.com/journal/a-sea-of-data-apophenia-and-pattern-mis-recognition/.

20. Michel Foucault, *The Archaeology of Knowledge & The Discourse on Language*, trans. A. M. Sheridan Smith (New York: Pantheon Books, 1972), 21. As the art historian and cultural critic Kobena Mercer is always quick to remind his readers, such a mention of Foucault should not be made without then invoking the work of cultural theorist Stuart Hall, for fear that we will "lose track of the politics of identity in favor of the ecstasy of endless mutability" (Kobena Mercer, *Travel & See: Black Diaspora Art Practices Since the 1980s* [Durham, NC: Duke University Press, 2016], 46). Here I offer a passage from Hall's keynote address "Museums of Modern Art and the End of History," delivered at a conference at Tate Modern, in which he reminds us that "modernity was precisely a fundamental rupture with 'the past' in that sense [the sense that the past is what determines the present or future]. It was a break into contingency and, by contingency, I do not mean complete absence of pattern, but a break from the established continuities and connections which made artistic practice intelligible

in a historical review. It focused as much on the blankness of the spaces between things as on the things itself [*sic*] and on the excessive refusal of continuities. It was always caught between the attempt, on the one hand, to turn the sign back to a kind of direct engagement with material reality and, on the other, to set the sign free of history in a proliferating utopia of pure forms" (Stuart Hall, "Museums of Modern Art and the End of History," in *Annotations 6: Stuart Hall and Sarat Maharaj: Modernity and Difference*, ed. Sarah Campbell and Gilane Tawadros [London: Institute of International Visual Arts, 2001], 12).

21. Paul de Man, *The Resistance to Theory* (Minneapolis: University of Minnesota Press, 1986), 10.

22. Ibid. The quotation continues: "Whenever this autonomous potential of language can be revealed by analysis, we are dealing with literariness and, in fact, with literature as the place where this negative knowledge about the reliability of linguistic utterance is made available."

23. In thinking of other artists who similarly manipulate the figure of patterns and have been covered elsewhere, one might recall the Op art–inspired work of Linda Besemer, whose flexible, sculptural paintings of stripes were featured in J. Jack Halberstam's book *In a Queer Time and Place: Transgender Bodies, Subcultural Lives* (New York: New York University Press, 2005); or the uncanny, striped sculptures of artist Math Bass. David Getsy—the author of *Abstract Bodies: Sixties Sculpture in the Expanded Field of Gender* (New Haven, CT: Yale University Press, 2015)—has analyzed Bass's work on numerous occasions, most notably, perhaps, in his critical conversation with fellow art historian and critic Jennifer Doyle (Jennifer Doyle and David Getsy, "Queer Formalisms: Jennifer Doyle and David Getsy in Conversation," *Art Journal* 72, no. 4 [2013]: 58–71).

24. David Getsy, "Capacity," in "Postposttranssexual: Key Concepts for a Twenty-First-Century Transgender Studies," special issue, *Transgender Studies Quarterly* 1, no. 1–2 (May 2014): 47. For more on this topic, see Getsy, *Abstract Bodies: Sixties Sculpture in the Expanded Field of Gender*, a key text located within the overlapping fields of art history and transgender theory.

25. It is worth noting here that the aesthetic strategy of pattern-jamming has also emerged as a key trope across the practices of a wide range of prominent black diasporic artists. Directly or indirectly speaking, it can be argued that Sanford Biggers, Nick Cave, Renée Green, Hew Locke, Xaviera Simmons, Mickalene Thomas, and Kehinde Wiley (just to name a few) have all developed bodies of work that investigate the politics and aesthetics of the pattern in the name of liberation. As I will detail in the conclusion to this essay, this speaks volumes to the genealogical links that co-constitute trans* and diasporic black aesthetics and politics.

26. The artist Eli Burke is similarly interested in patterns as kinds of duplicable and standardized (or industrialized) shapes. Burke's video *Dress Pattern* (2014) commences with an image of the artist's head hooded under the thin paper of a commercial dress pattern. Over the course of 3:19 min, Burke draws the pattern into his mouth using only the force of his tongue and lips, slowly masticating the pattern into a crumbled wad of paper that he then spits out at the performance's conclusion. Between the droning sounds of the crinkling paper and Burke's determined yet almost affectless chewing, a clear and clever sense of boredom and dissatisfaction with the standardization of the body is made evident.

27. Pauline Boudry and Renate Lorenz, "Opaque," *Pauline Boudry/Renate Lorenz*, accessed May 27, 2016, https://www.boudry-lorenz.de/opaque/.

28. Kiam Marcelo Junio, "Nangyayari Na: A Multidimensional Mixtape," *Kiam Marcel Junio: visual and performance artist*, accessed May 28, 2016, http://www.kiam-marcelo-junio.com /nangyayari-na/.

29. Sarah Biscarra Dilley, Grace Rosario Perkins, Anna Luisa Petrisko, and Adee Roberson, "Black Salt Collective," *Black Salt Collective*, accessed May 27, 2016, blacksaltcollective.tumblr.com.

30. Sarah Biscarra Dilley, Grace Rosario Perkins, Anna Luisa Petrisko, and Adee Roberson, "Curatorial Statement," in *Visions Into Infinite Archives Information Packet* (San Francisco: SOMArts Cultural Center, 2016), 17.

31. Another artist featured in "Visions Into Infinite Archives" whose work clearly engages the liberatory and transgender capacities of the pattern is Indira Allegra. And while not shown in this exhibit, Allegra's large-scale video text/ile installation *Blackout* (2015) is also worth mentioning, as it provides further avenues of investigation into the political valence of pattern-jamming. For more information, see "Work > Documentia," *Indira Allegra*, accessed July 31, 2016, http://indiraallegra.com/artwork/3830490-Blackout.html.

32. Biscarra et al., "Curatorial Statement," 2.

33. Stanley, "Gender Self-Determination," 90.

34. Frantz Fanon, *A Dying Colonialism*, trans. Haakon Chevalier (New York: Grove Press, 1965), 69.

35. Ibid.

36. Ibid., 85.

37. Ibid., 96.

MODELS OF FUTURITY

Roundtable Participants: Kai Lumumba Barrow, Yve Laris Cohen,
and Kalaniopua Young
Moderator: Dean Spade

In the summer of 2016, the editorial team for *Trap Door: Trans Cultural Production and the Politics of Visibility* invited lawyer, scholar, and activist Dean Spade to moderate an online roundtable discussion on the topic "Models of Futurity" with artist and activist Kai Lumumba Barrow, artist and dancer Yve Laris Cohen, and scholar and activist Kalaniopua Young. The discussion evolved from an initial prompt developed by the volume's coeditors (and reproduced below), upon which Spade expanded with a series of questions to engage the participants in dialogue.

.........

Beyond strategies of intervention, reparation, and reform to combat anti-trans discrimination and violence, how can we imagine a radical break? What constitutes a prefigurative politics of trans liberation? Can we translate the spirit of abolitionism broadly, looking forward to not only the dismantling of the prison industrial complex, with its many racist, transphobic, and homophobic vectors, but also toward a more expansive alternative for trans life without the constant threat of death? How can we respond to the often specious applications of the prefix "post-" with regard to social justice ("post-racial," "post-feminist," "post-critical"), keeping in mind legacies of trans struggle while not giving up on the idea of radical futurity? What role does aesthetics play in speculating about transformation?

DEAN SPADE: I would like to acknowledge that we are initiating this conversation about abolition, survival, and transformative futures at a very intense moment: The past few weeks have included the tragic massacre at the Pulse nightclub in Orlando, Florida, the bombings at the Istanbul airport and in Baghdad, the

police killings of Alton Sterling and Philando Castile, the Brexit vote, the lifting of the ban on trans military service, important actions against police participation in Pride celebrations, and Micah Johnson's shooting of five Dallas police officers during a protest against police brutality. It is a complex and difficult moment, and a deep one for thinking about white supremacy, queer and trans life, state violence, and nationalism. Given the conditions under which we are initiating this conversation, I would like to begin by asking how recent events and/ or movement mobilizations in response to them are impacting your thinking about transformative futures, abolition, and how to imagine a radical break?

KAI LUMUMBA BARROW: First of all, thanks for the opportunity to discuss these big questions. These times, they are a-changin'. And yet, they seem eerily familiar ... As a Queer Black liberationist, feminist, and abolitionist, I am working to think about this period through a lens of abundance—understanding that this moment is within a continuum of protracted struggle for liberation. We have an opportunity to learn from our victories and mistakes. In this sense, the present moment is bringing up many more questions for me than answers. However, when I am assaulted by media coverage (including of events tantamount to public executions) or confused by the strategies, goals, or current demands of our evolving movement, I think a few key points stand out for me: 1) We are in a crisis moment, and within conflict and crisis, change occurs. 2) Our response to state violence has become ritualized. We participate in a "spectacle of protest" that is strong on performance but lacks a generative strategy. 3) Our evolving movement is well resourced and has access to numerous platforms.

By using the phrase "spectacle of protest" I am specifically critiquing our movement's responses to the violence of the state. With almost ritualized precision, our movement's responses to exploitation and violence (for example, police murders of Black folks) span a pretty narrow spectrum of protest: 1) silence; 2) peaceful, nonviolent mobilizations; 3) community uprisings; 4) institutional support (from faith-based, government, and charitable/service-based organizations); and 5) state-approved sanctions for state-sponsored actors. After decades of work to stop police/police terror, I can almost predict the response from the people and the state, which leads to a few questions: Are our tactics and methods of dissent predictable? Do our tactics of disruption really heighten the contradictions between anti-Black violence and Black liberation?

Imagining a radical break, I think there are numerous opportunities and challenges before us right now that allow us to direct the crisis, disrupt the ritual, and perform in multiple spaces (from "firstspace" to "thirdspace," as Edward Soja theorizes).[1] The work to get there requires critical thinking, democratic

dialogue, experimentation, and improvisation. I see these as abolitionist practices and principles that allow us to develop praxis and strategies that sharpen the contradictions between the state and the rest of us.

Similarly, the act of constructing transformative futures allows us to imagine ourselves outside of the borders that define our values and our movements. What are our radical goals? And what makes them radical? Will our work result in a stronger, more fortified state, or will it shrink/dismantle/end the state? Who are we in addition to and beyond our identities? How do we see ourselves within the arc of history? Do we see ourselves as historical actors? And if so, what is our role? I would like to think of us as a band of disrupters. Any tactic or strategy that becomes too familiar turns stagnant—into a spectacle, so to speak. In this sense, I think we must always be willing to interrupt ourselves, even when we think we've got it "right." We need to ask ourselves: How do we intend to use the resources we have? What are our long-term strategies for moving our goals forward during the lull periods (for instance, when the state fights back)? How are we preparing for this response? Are we institutionalizing too soon? Too much? Are we too US-focused? Should we be thinking about "infrastructurally light" structures to implement our work? I raise these questions as a challenge to current organizers, as opposed to a set of "best practices" that I can draw from any particular experience.

KALANIOPUA YOUNG: The mainstream visibility of police killings, mass shootings, and transgender icons is not saving black, brown, and trans lives. In fact, things appear to be getting worse. Kai asks if we are institutionalizing too soon. I think so. For instance, while the prohibition of transpeople serving openly in the military can be legitimately contested in the interests of employment and basic civil rights concerns, in the US such an endeavor is simultaneously hijacked by a racist heteropatriarchal nation-state system that institutionalizes suppression and is built on hypocrisy and exploitation. It is as if one must appeal to a visibility logic that seeks to erase our very being. The right of transpeople to serve in the military emboldens a rationale for inhumane invasions under a pinkwashing campaign that marks other (mostly Islamic) countries as heteropatriarchal, backward, and hostile to the supposed security interests of trans folks. The irony of course is that the US is one of the most oppressive military regimes in the world. It regularly sells weapons to oppressive regimes, even those incredibly hostile to gender nonconforming folks. It operates on the assumption that bombing brown Muslim trans folks in the Middle East will somehow liberate trans folks in the US or anywhere. Obviously, this is a farce. It is exploitative and hypocritical. We must be critical of such a discourse that marks the nation-state

as a protector of the people rather than the very thing that puts bodies, especially trans bodies of color, at the forefront of imperial nation-building.

I am befuddled but sadly unsurprised that the US nation-state benefits more than any other country from a war machine that maims, kills, and abuses with impunity. Today, more than half of the federal discretionary spending in the United States goes to support military interests. To put this in context, the National Priorities Project—a research organization dedicated to making the federal budget transparent and accessible to the public—compares US spending to that of other countries such as China, which spends almost three times less than the US on its military expenditures.[2] What is to be done when the state's impunity from violence allows it to mark dissent and difference as criminal in a domestic context as well? "Not in my name!" "No justice, no peace!" We scream these chants in marches for Black Lives Matter to do more than burn systemic injustice down to the ground. As an indigenous trans woman, I recognize that I cannot stand idly by while my black brothers and sisters are being slain in the street.

Hannah Arendt's term the "banality of evil," which she uses in her scathing critique of Adolf Eichmann's administrative brutality by mindlessly following orders during the Holocaust, is speaking to me right now. The everyday bureaucracy of evil that Arendt suggests allowed Eichmann, the former vacuum salesman turned Nazi officer, to command the deaths of Jews with impunity is the same banality that prevents any personal accounting for the evil that police officers inflict upon black and brown bodies on the streets and in our neighborhoods. According to Arendt, the belief that one can do no evil provided one follows the script of a given institutionalized social order must be challenged, abolished, and remade.[3] Institutional thinking replicates hierarchy and puts power in the hands of the state in ways that problematically devalue community and place-based power. In order to bring transformation to fruition, we must allow ourselves space to think in struggle beyond the institution, to "git woke," to embrace the fact that there is something intrinsically valuable about fighting oppression in all of its forms.

SPADE: Kai asserts that "there are numerous opportunities and challenges before us right now that allow us to direct the crisis, disrupt the ritual." In the last few years, we have seen increased engagement with tactics of disruption, especially from Black Lives Matter and migrant justice activists. In my experience, these disruptions have been exciting, powerful conversation-changers at the local level and on national and international scales. At the same time, we see rapid co-optation and recuperation by the violent institutions (and their individual representatives) that were targeted. I am curious to hear how other people are thinking about the

relationships between disruption and the cultivation of the new worlds that abolition and critical trans politics imagine. Have your experiences in the last few years given you any insights into these relationships, or are there historical movements or moments you look to for thinking about this?

BARROW: Given the current political moment (as Dean eloquently identified in the opening remarks), I think it is important for our movement(s) to map our strengths and challenges, trends and contradictions over the past ten to twenty years in order to consider these logistical questions about how to move forward. I think it is important to look at our work within a broad frame and assess this work based upon a reading of our history. For example, as an abolitionist, I want to understand where the movement has been successful and weak from multiple vantage points: How many formal groups with intersectional and abolitionist agendas were birthed and dismantled in the past twenty years? What are the political legacies left by these groups, and how are these ideas and practices currently applied? Or, what have been the results of the paradigm shifts in popular narratives that now make visible police violence, mass incarceration, and the voices of prisoners and former prisoners? How has the stigmatization of prisoners shifted, and what has taken its place? I would love to participate in more of these dialogues—cross-organizational and identity-, geography-, and issue-specific.

YOUNG: I'd like to respond to Kai's remarks on the numerous opportunities and challenges that allow us to direct the crisis and disrupt the ritual. I do think that such opportunities exist. Along with Black Lives Matter and migrant justice activists, there are indigenous activists and accomplices taking part in social movements like Idle No More and fighting for sacred sites like Mauna Kea, Oak Flat, and Standing Rock. These activists are disrupting resource extraction logics of settler colonialism and rights discourses that disavow the claims of indigenous peoples to self-determination and earth justice resistance. Movements are created, developed by the hands of the afflicted from the ground up. I join these direct action marches, speak-outs, and rallies organized by the families and accomplices of the directly affected, particularly of those gunned down by police. Their memories are planted firmly on my shoulders as I fight to hold accountable a racist system that seeks to disappear us in the trenches of ecological devastation and economic austerity. In fact, I believe that it is precisely in these times of great sorrow, violence, and mourning that more of us continue to do this work from the ground up. "Hands up, don't shoot!" "Eric Garner, Sandra Bland, Trayvon Martin, Kollin Elderts, we speak your names!" Grassroots organizing

and mobilization are needed now more than ever to bring about a different world beyond the power of war machines and the increase in military and police violence. We need our boots in the street and our fingers on the digital pulse of disruption to fight powers built on the institutionalization of our very erasure.

However, as someone who has been involved in direct actions for Black Lives Matter in Seattle, I've seen little resolve in the national and municipal political arenas. A key takeaway from this abysmal state of affairs is that it takes much more than a movement for visibility, bureaucratic reform, and liberal empathy to transform the neoliberal police state and its continued attack on people of color, women, queer folks, and mother earth. In fact, I'd like to suggest that it is precisely in these moments that we think with and act toward an alterNative economy of solidarity beyond the institution itself, toward a radical reclamation of our bodies and our communities as sites of refusal and collaborative possibility.

BARROW: The familiarity of disrupting that which we know prevents us from engaging a true tactics of transformation in order to impact our daily ways of being and produce the "alternative" realities that Kalaniopua calls for. On the one hand, I agree with Dean's assessment that the current spate of disruptions has opened the door for broader and more nuanced conversations about dominant norms (e.g., prisons, policing, gender, borders). However, if disruption becomes the primary (or sole) strategy of a movement, we limit our potential to construct new worlds (and by extension, we create new problems).

I don't have the answers for what should be done, and by no means do I think we can reduce the complexity of colonization to a simple panacea/prescription/ solution. However, I would love to help bring to fruition a global movement that is networked and intentional about creating strategies and tactics for transformation. Movements that transform our relationships to power by creating or supporting self-determining, autonomous, culturally relevant, sovereign, and sustainable communities are critical to disrupt and dismantle systemic oppression. A "counterculture" (e.g., liberation schools, cooperatives, land sovereignty, cultural practices/mores, coded languages, harm reduction, and so forth) or dual power model would center the needs and desires of the people who are at the center of the problem.

To avoid a potential binary, let me say this differently: I think that our dissent must include disruptions designed to direct the oppressor's actions as well as transformative theories and practices that center experimentation, flexibility, and improvisation. A tactics of transformation allows us to move (and keep moving) like a spiral, outside of the lines—even the lines that we create for ourselves. This is a place for the artist or "trickster"—a cross-cultural figure, in art and

literature, who represents the playful, boundary-crossing, disruptive side of the imagination—to spin possibilities.[4] To play. To indulge in an ongoing game of "What's next?"

SPADE: The project of abolition can be narrowly construed as being specifically about getting rid of prisons and police, but for many of us it opens up broader questions, invites expansive imagining, and calls into question many more institutions and conditions beyond the formal apparatuses of racial punishment. What are the ways, spaces, or sites where abolition is important for you that might be surprising to people newly encountering prison and police abolition work, or perhaps to those who have been working with the idea of prison and police abolition for a while?

YVE LARIS COHEN: This spring one of my trans students at the Cooper Union organized a panel called "Black Femme Power" featuring black transfeminine organizer and abolitionist Joshua Allen. This student, Rio Sofia, along with a core group of fellow trans students and their cis accomplices, had just won a long and difficult battle with the school administration to degenderize campus restrooms. At one point during the panel, Allen spoke about the difference between radical strategies for trans liberation rooted in abolitionism and rights-based neoliberal projects focused on trans visibility. In the same breath as talking about trans inclusion in the military, Allen listed "bathrooms" as one such neoliberal concern. It was a quick mention—Allen didn't elaborate or revisit it later in conversation—but a meaningful one.

I recoiled a bit and could sense some discomfort among the passionate student bathroom organizers in the audience. I defensively thought through how working for bathroom safety for trans folks was so very different from imploring the Pentagon to participate in US imperialism. I then paused to examine how my position as a white transmasculine person mediated this defensive thinking. The bathroom is one of the primary sites where I've experienced violence as a trans person; I haven't been incarcerated or deported or homeless, for example. I can see how bathroom accessibility might be a very low or non-priority for many of my transfeminine and people of color comrades who experience regular, systemic threats to their lives through many other vectors. Additionally, waging an all-gender restroom campaign almost invariably involves heavy engagement with an institution—be it a school, a museum, or a local government. In many cases, heavy engagement means heavy begging (e.g., "Please allocate resources in next year's budget to build an all-gender restroom with wheelchair accessibility").

The intersection with disability is important and another reason why I was resistant to characterizing bathroom organizing as a neoliberal endeavor. During my teenage years as a queer youth organizer in the early 2000s, I strategically formed coalitions with disabled teens to fight for the building or remodeling of bathrooms to be both ADA-compliant and gender-neutral. High school administrations were much more responsive to demands for accessible all-gender restrooms when threatened with a lawsuit for noncompliance with landmark national legislation. This work was a formative experience in shaping my thinking around how transness is entangled with disability, or crip experience—how trans liberation must be cripped and crip liberation must be transed.

In the 1990s and early 2000s, trans bathroom organizing wasn't entwined with mainstream trans visibility and media representation in the way it's now become so deeply enmeshed in less than a year's time. We used to be on the offense, pushing for lasting architectural changes to our institutions. Now, anti-trans bathroom legislation is a de facto legal avenue for conservatives to go after us. And this is where we find ourselves in a neoliberal trap. We're on the defensive, asserting our *right* to use whichever existing gendered bathroom "fits" us best. The bathroom fight is no longer about willing a radical futurity, building new spaces for our shit and cum and piss that look and feel different from the old ones. We're assuring lawmakers and voters that we—particularly transwomen, who are *always* on the front lines—are not a threat to the safety of cis children in these shitty existing bathrooms. "Safety" has always been about the maintenance of white supremacy.

This is where I turn back to my incredible Cooper students and how abolition can lend the bathroom effort a radical break. At several points over the course of the two-and-a-half-year battle, administrators offered the student organizers a number of concessions: more single-stall all-gender bathrooms or opening up some all-gender faculty restrooms to students. The organizers didn't yield. The point had always been to remove *all* gender designations from *all* restrooms in the entire institution, rather than designating auxiliary "safer spaces" for trans and gender nonconforming students, faculty, and staff. This is abolition thinking. It's not incidental that several of these students are active in prison and police abolition work, such as Freedom To Live (F2L). It wasn't about reforming or upgrading or lessening the pain—it was about freeing everyone, cis and trans alike, from the oppressive architecture of gendered facilities.

BARROW: I am an abolitionist because I am committed to self-determination. The ways in which the social, cultural, political, economic, and, I think we can add, technological sectors intersect to control the ideas, values, and mobility of the

body politic form a violent carceral landscape that exists within our neighbor-hoods, households, institutions, and imaginations. I think an abolitionist process is both active and reflective. It is internal and external; it is within the "between space." State violence (perpetuated by police, prisons, jails, mental asylums, courts, and surveillance) works in accord with every other sector of systemic oppression—education, housing, finance, business, health, media, planning … There is no skirting the existence of this behemoth. A prison-industrial-complex abolitionist politic is, at its core, a politic that is in direct contradiction to systemic oppres-sion. We cannot reform the system; it is a system that must be dismantled.

Similarly, systemic oppression cannot exist without an agreement from the body politic. In what ways are we complicit with our own oppression? I think that to practice an abolitionist praxis requires that we work to decolonize our imagi-nations, push ourselves beyond borders, and demand aspirational thinking from ourselves and from each other. How do we provide safety for ourselves without calling on outside forces? How are we sustaining ourselves economically to pre-vent the intrusions of the state into our neighborhoods, communities, households, and minds? Where are these models? I think abolitionists have to keep asking ourselves these questions, compiling documentation, archiving the hell out of stuff, using all of the platforms available to us, and hunkering down … It's rough out here!

SPADE: It has been challenging to see both criminal punishment system reform and trans politics go mainstream in the last few years. As with all mainstreaming processes, much has been lost in the process, and it seems that a liberal, visibil-ity-centered version of these politics with weak surface reforms has emerged for mass consumption. What have you noticed about these mainstreaming projects? What about these processes and their impacts do we need to think through? Have you seen or participated in resistance to the creation of these liberal, digestible, legible trans and criminal punishment reform projects in ways that you think are effective?

YOUNG: Hinaleimoana Wong-Kalu, a very well-known and respected *māhūwahine* (a transgender woman of Hawaiian heritage), has described the term *māhū* as a place in the middle, a transitory and fluid gender construct that emerges, moves, and falls beyond the confines of "male" and "female."[5] This framing opens up (rather than forecloses) a shape-shifting gendered subjectivity that is radically inclusive and totally compatible with modern life. Why does journalist, activist, and TV personality Janet Mock—a fierce black Native Hawaiian role model of trans-survivance politics in the mainstream—not self-identify as *māhū*?

In her *New York Times* best seller *Redefining Realness*, Mock relegates this conceptual framing of gender liminality to a cultural term, defining it in a way that denies its move to the modern—consigning *māhū* to the past while emphasizing her chosen self-identification as a transwoman of color.[6] It is as if going mainstream means that she must negate the Native and participate in the settler-colonial erasure of indigenous terminology. Mock claims to be Native Hawaiian, but it isn't all that clear how that identification situates her political commitment to the real struggle that Hawaiian people, particularly *māhū*, face in our homeland. I think distancing oneself from the language of these struggles can delegitimize our power not only as Native Hawaiian transwomen, but as transwomen of color.

Hawaiian transwomen, that is, Hawaiian transwomen who are of Aboriginal ancestry, are of critical import to the work of prison abolition and a broadly envisioned collective movement for land, life, and self-determination. To mainstream is to liberalize, centerize, and consumerize what it means to be *māhū* in today's world. Within this context, Mock's incredible story of survival and flourishing gets inoculated in a monolithic narrative for what "girls like us" should implicitly aspire to be and prescriptions for how we should get there. I take issue with this. I know that this is beyond Mock. I know she isn't to blame for this, because I think this happens to the best of us in the process of going mainstream. Radical voices are inoculated in a model-minority characterization that measures success by capitalist and liberal values.

If Mock is going to be the new Oprah, I'm all for it. However, I know that this will not liberate "girls like us" from the prisons and homeless encampments in Hawai'i where Hawaiians comprise the largest segments of these populations. Having more money, a celebrity platform for liberal consumption, and a special television show will not help Hawaiians get our land back. If anything, a move toward the mainstream seems like a step away from liberation. Obama's election—an undeniable historical feat—was transformative but, as we have seen, was not radical. Though by becoming the first black president he has achieved something many thought impossible, and has even pardoned a number of criminal offenders, he has yet to pardon a single black liberation fighter or political prisoner. How does one transform settler colonialism without confronting it directly, without claiming one's Native language and culture as a site that refuses elimination? Mock's walk into the mainstream, while presenting an important new narrative for disenfranchised transwomen, is ill-equipped to support Hawaiian transwomen fighting on the frontlines for place-based de-occupation and decolonial lovemaking.

Now, while I can relate to Mock's love for Beyoncé and Oprah's *SuperSoul Sunday* programming as escapism at its best, I do not think celebrating under-

represented minorities, transpeople, and folks of color in the mainstream will make things better. In fact, it might inadvertently make things worse or even limit a capacity for transforming the status quo. The mainstream will not end prisons, nor will it help Aboriginal folks get our land back. However, it is true that many of us were raised on mainstream media images and that these images have allowed wider horizons for imagining the possible. Still, the limits of the mainstream must be subjected to critique.

For some, going mainstream is like using the master's tools to dismantle the master's house, and as Audre Lorde made clear, this cannot and will not liberate us.[7] Mainstreaming transpeople will not assuage the struggles of incarceration, displacement, and dispossession. I have a tremendous amount of respect for Mock's journey into the mainstream. She is doing something that no one else has done before, and she has done so brilliantly by being bold, black Hawaiian, and beautifully trans. However, her written positioning in the mainstream media seems to conflict with a more broadly imagined and lived frontier of decolonial homemaking beyond visibility campaigns that tell us *māhū*, in a somewhat condescending tone, that "it gets better."

SPADE: I'm curious, does the word "radical" work for you for thinking about the transformations you imagine, the method of critique you employ, or the intellectual and artistic traditions you are part of? What other terms are useful or have been useful to you in trying to describe your orientation to transformation and new worlds and ways of life?

LARIS COHEN: Lately, particularly with the unfortunate distraction of the upcoming presidential election, I've clung to "radical" with renewed vigor, but over the course of fifteen years of political organizing, my relationship to the term has moved through periods of both affinity and alienation. Although likely an effort to bring together multiple strands of leftist activity in coalition, subsuming such varied political strategies under one diffuse term can mask or eschew important political history. For example, many of us say "radical" when we mean "anarchist." We lose a clearly articulated position toward capitalism and the state when we avoid naming specific trajectories of leftist thought and action.

In thinking through the vagueness of "radical," I find it helpful to map out how the term is deployed in the contemporary US political landscape. The right wing mobilizes "radical" in three directions: in dismissing mainstream leftist work as fringe or ineffectual, in arousing racist and xenophobic hatred of "radical Islam," and in praising reactionary direct action such as Tea Party tactics (which co-opt leftist strategies) or "maverick" conservative politicians' rejection

of the conventional electoral playbook. (Neo)liberal Democratic co-optations of "radical" are more ambivalent and less about long-term political strategy than they are about temporary optics. This centrist project of evacuating "radical" of its political power is almost more dangerous than rightist adoptions of the term (all of which at least retain its connotations). Similarly, "radical" becomes neutralized and unspecific in some art discourses, particularly as we look back on art production in the 1960s and '70s and confine radicalism to political work of that era (and perhaps misdiagnose artworks as "radical").

That said, this summer I've found "radical" useful and necessary to differentiate my antistate, anticapitalist, abolitionist politics from those of Hillary Clinton voters.

BARROW: Exactly!

SPADE: Kai talks about building "countercultural" practices in our movements that "center the needs and desires of the people who are at the center of the problem." Where do you see this happening now?

YOUNG: As a tent city queen and anthropologist from Waiʻanae, I have returned home to work with a group of Native Hawaiian transwomen who are also *māhū*. We are collaborating on a film project from our tent village precariously nestled between a marina and a high school on nineteen acres of public land. We live in tents because we can't afford housing, under the conditions of possible eviction by a settler state that continues to make life difficult for us. Our people are routinely displaced from our homeland, and going mainstream is not helping the situation. The mainstream media's current obsession with the homeless in paradise is not creating social movement projects for the better.[8] Rather, such news reports reinforce state-centered control and domination in ways that criminalize homelessness and limit space for creative alterNatives. Nonetheless, I want people to know that there is a counter-mainstream experiment that is budding here in the village. Tent city queens are emerging from the ruins of settler hetero-paternalism and creating films that center the voices of our own people who are combating neoliberal forms of coloniality and dispossession in contemporary Hawaiʻi. The village is run by Native Hawaiian women of various queer orientations in extended family or *haus* arrangements that are critical to the global disruption of ecological destruction, displacement, and dispossession.

Taking back public land is, for a growing number of Hawaiians, the only viable solution to an unresolved land dispute between the US and the Kingdom of

Hawai'i. The contemporary revival of the *pu'uhonua* as a noncapitalist land sanctuary or decentralized zone of refuge serving to reconnect people to the values of *ka po'e kahiko* (the people of old Hawai'i) often involves a struggle for recognition limited by state sovereignty. However, restoring traditional land-based systems by building modern-day *pu'uhonua* provides a restorative and uniquely Hawaiian response to the crises of land and housing in Hawai'i. Historically, *pu'uhonua* offered a queer space that protected *maka'āinana* commoners, said to be the eyes of the land, from authoritarian abuses of power. Embattled war veterans, displaced family members, conscientious objectors, lawbreakers, and exiles collectively and responsibly governed these land zones. Forming an integral part of the precolonial land management system under a strict *kapu*, or law, that predates enclosures of the commons, *pu'uhonua* enabled people to access clean water and abundant food resources regardless of their class status. In exchange, people were expected to support the community through *aloha 'āina* (a deep love for the land and people).

Becoming "home-free," to borrow a term from my Aunty Bam, is to make possible an intimate reconnection to *'āina* (the land, or that which feeds) without having to choose between putting food on the table, economic needs, and shelter. However, it is also about ensuring that the multiple voices of people who are reclaiming, reconnecting, and remaking land-based relationships from a Hawaiian standpoint are valued and heard. The future-making goals of this expansive community are unified by alterNative lovemaking, a lovemaking that does not shun our kin, but rather brings Natives, settlers, and arrivants (that is, folks indigenous to another place who are forced to move away from home for work, life, etc.) into the home space with open arms.

SPADE: How do trans politics, survival, and experience, and/or abolition politics and critique, and/or trans abolition inform or shape how you think about radical futures?

YOUNG: Trans-survivance and abolition politics are an important part of my thinking about radical models of futurity. For me, this almost always entails an inclusive rethinking of Native belonging, that is, aboriginal notions of the self in the contemporary moment. Like Yve, I find the term "radical" useful in my own work because it demarcates a transformative praxis, toward a space/place outside the mainstream, beyond the quotidian and the status quo and into the alterNative, the *māhū*, and the abolition of prisons.

The many comings and goings of my life highlight the importance of centering place-based notions of radical belonging within my particular narrative of

trans survivance. Returning to Hawai'i for middle school, I elected to leave my immediate family in Washington state to reunite with my *ohana* (extended family) in Wai'anae, a Hawaiian stronghold on the leeward coast of Oahu. This experience reconnected me to a unique possibility beyond the suburbs outside of Olympia where the white majority lived in standardized housing units or apartment complexes.

Traveling back and forth between Olympia and Wai'anae is a part of my trans-survivance story of struggle. In Wai'anae, little distinction was made between those of us living in tents, ramblers, or tin shacks. The lack of such distinctions informs my thinking about models of futurity. For individuals struggling, unable or unwilling to abide by the standard of American housing defined by rent and mortgage payments, Wai'anae represented an important radical alterNative. *Ohana* in Wai'anae are known for pulling together when the state fails to support the people. They are also known for holding on to traditional Hawaiian beliefs and practices against the transit of missionization, capitalism, and assimilation. Anthropologist Wende Elizabeth Marshall refers to Wai'anae as "a space of resistance," where the abandoned have a safe place to lay their heads at night.[9]

Home is a journey. For Hawaiians, people of color, and trans folk alike, this journey often involves structural and settler forms of violence that continue to dispossess, oppress, divide, and eliminate life. In my current work, I examine alterNative economies of solidarity between Hawaiians, settlers, and arrivants at Pu'uhonua O Wai'anae (POW) through the *ohana* principle. Paying particular attention to its anarcha-indigenous homemaking capacity to resist Empire, settler domination, and the subsequent discourse of indigenous elimination, I situate POW as a home of belonging and resistance for the displaced, dispossessed, and abandoned outside of the dominant society. Borrowing from queer indigenous studies, post-Marxist philosophy, and science fiction texts, I articulate how villagers of POW perform and/or enact a kind of decolonial autonomy that is a non-cis-heteronormative, anti-oppressive, and non-statist form of self-determination in the nation's largest outdoor "homeless" encampment.

According to post-Marxist philosophers Antonio Negri and Michael Hardt, "the creative forces of the multitude that sustain Empire are also capable of autonomously constructing a counter-Empire, an alternative political organization of global flows and exchanges."[10] At POW, the multitude lives in tents. Tents are canoes expanding that dwelling place of social interconnection in an ocean of betweenness that Tongan anthropologist Epeli Hau'ofa refers to as "our sea of islands," a s/Pacific relational third space of connection between islands, places, people, seas, skies, and the imagination. "We are the sea, we

are the ocean, we must wake up to this ancient truth and together use it to overturn all hegemonic views. ..."[11]

BARROW: In *The Aesthetic Dimension*, the philosopher Herbert Marcuse upholds that the imagination is fundamental to the possibility of human liberation. Marcuse contends that the imagination has within it the regenerative abilities to resist the oppression of existing conditions, generate new ideas, and reconfigure the familiar.[12] Within the creative process is resistance. I am, like Marcuse, interested in the radical imagination as a site in the mind where the experience of freedom is (re)created and the rules that govern daily life are suspended. As an artist, I find that the process as well as the outcomes of making art allow my radical imagination an outlet for demonstrating the discoveries that exist within its geography. My interest in human geographies—specifically the relationship of Black populations to space, place, and psychic locations—is driven by the interplay between geographies of confinement and liberation. The psychic location allows us to exist within and move between sites of freedom and confinement. Our imaginations sustain us through harm and catalyze us to envision new possibilities. In imaginative space we have the freedom to create new worlds, counter-narratives, and new mythologies where daily realities are transformed, appropriated, subverted, destroyed, and refashioned. In this sense, opportunities to strategically and intentionally focus radical imagination are critical to developing movement-building strategies and concretizing our dreams and hopes.

I believe that the artist has a responsibility and a privileged role in movements for transformative, liberatory change. The artist can serve as a nomad transporting ideas, tools, visions, and strategies across physical and imaginative borders. Artists can guide us in the work of unleashing our collective imaginations. Artists can help answer questions such as: How do we nurture and protect our bodies, our communities, and our things when we are continually on the brink of displacement? And, as we twenty-first-century nomads are dislocated, how do we work with the communities we enter and/or displace? What are our roles and expectations? Where are the contradictions? And what obstacles are on the horizon for those who dare (from desire or necessity) to cross borders? My work aims to explore safety and risk-taking. I am particularly interested in the ways in which carceral landscapes are reinforced and rejected among oppressed groups.

Aesthetically and ideologically, I see my work as play, my discoveries as experimentation. I aim to place my work within the tradition of an art of liberation that is neither didactic (vanguardist in its charge) nor entertainment-driven (consumerist and vapid). I am influenced by artistic movements that intersect with liberation movements, and through genres, materials, concepts, and forms,

I inspire people to actualize and engage in possibility—from direct resistance and subversion to constructing new models of community accountability, design, and services.

I also hope to provoke paradigm shifts at the crossroads of cultural work, art practice, sustainability, and direct confrontation with power. In this sense, my work is rooted in a praxis approach. For me, this art is dialogic, inviting participation through investigation and/or physical interaction; oppositional, critical, bold, and embracing of contradictions; and erotic, emerging from the underground, passionate in its quest to transform. These characteristics are also fundamental to an intersectional politic that guides my organizing and activism. My aspirational desire is to merge these identities as a tool for liberation; my vocational work is to place my body in service to this mission.

..

This roundtable discussion was convened online in the summer of 2016 for this volume.

..

NOTES

1. See Edward Soja, *Thirdspace: Journeys to Los Angeles and Other Real-and-Imagined Places* (Oxford: Basil Blackwell, 1996).

2. "U.S. Military Spending vs. the World," National Priorities Project, accessed October 6, 2016, https://www.nationalpriorities.org/campaigns/us-military-spending-vs-world/.

3. Hannah Arendt, *Eichmann in Jerusalem: A Report on the Banality of Evil* (1963; repr., New York: Penguin Books, 1994).

4. See Lewis Hyde, *Trickster Makes This World: Mischief, Myth, and Art* (New York: Farrar, Straus and Giroux, 1998).

5. *Kumu Hina*, directed by Dean Hamer and Joe Wilson (Warren, NJ: Passion River Press, 2014).

6. Janet Mock, *Redefining Realness: My Path to Womanhood, Identity, Love & So Much More* (New York: Simon & Schuster, 2014), 102–03.

7. Audre Lorde, "The Master's Tools Will Never Dismantle the Master's House," in *Sister Outsider: Essays and Speeches* (Berkeley, CA: Crossing Press, 2007), 110–13.

8. Adam Nagourney, "Aloha and Welcome to Paradise. Unless You're Homeless," *New York Times*, June 3, 2016, http://www.nytimes.com/2016/06/04/us/hawaii-homeless-criminal -law-sitting-ban.html?_r=0.

9. Wende Elizabeth Marshall, "Waiʻanae: A Space of Resistance," in *Potent Mana: Lessons in Power and Healing* (Albany: State University of New York Press, 2011), 45–68.

10. Michael Hardt and Antonio Negri, *Empire* (Cambridge, MA: Harvard University Press, 2000), xv.

11. Epeli Hauʻofa, "Our Sea of Islands," in *We Are the Ocean: Selected Works* (Honolulu: University of Hawaiʻi Press, 2008), 39.

12. Herbert Marcuse, *The Aesthetic Dimension: Toward a Critique of Marxist Aesthetics* (Boston: Beacon Press, 1978).

ALL TERROR, ALL BEAUTY

Wu Tsang and Fred Moten in Conversation

Conducted on the occasion of the exhibition "Wu Tsang: The Luscious Land of God Is Sinking" at 356 S. Mission Road, Los Angeles, this conversation between Wu Tsang and Fred Moten took place in September 2016. Tsang and Moten collaborate and inhabit the roles of performance artist and poet, respectively. Their projects include the films *Miss Communication and Mr:Re* (2014) and *Girl Talk* (2015) and the sculptural performance *Gravitational Feel* (2016), commissioned by the Amsterdam-based organization If I Can't Dance, I Don't Want To Be Part of Your Revolution.

In this conversation, the two collaborators discuss Tsang's recent film *Duilian* (2016), which explores the life of Chinese poet and revolutionary martyr Qiu Jin. Highlighting the romantic relationship between Qiu, played by the artist boychild, and the calligrapher Wu Zhiying, played by Tsang, the film interlaces excerpts of Qiu's writing, historical references, and choreographed sequences of martial artists performing with swords. Set in the present day, *Duilian* was shot largely on a boat between Hong Kong and mainland China.

FRED MOTEN: So first of all, my experiences of seeing the performance, and then seeing the drawing, or let's say the transcript of the performance, and then this archive of materials that went into the performance and film [*Duilian*], and the film itself, and then recognizing the scale of it all—from something very large, like the canvas of the transcript, to the very small particularities of the materials in the archive—all combine in my mind to make me want to ask a question. There are two kinds of spans that I'm constantly thinking about with art: one is a span from lightness to density, and the other is from something more cosmological, in terms of its scope, to something really small. They're fourfold: lightness and density, largeness and smallness. The ones who can traverse and maintain

movement along those axes are those whom I end up thinking of as being great. Really the first question is: Do you know that you're great?

WU TSANG: Haha, Fred!

MOTEN: I wonder what it's like. It must be a difficult thing to have to deal with. Not so much in terms of living with your own brain, but being able to move on all those different planes and scales. It makes me think of a term Charles Rosen used in regard to Schoenberg's work: "chromatic saturation."[1] There are certain moments in a composition in which it feels like every note that could be played is being played, a tremendous marshaling of the possible musical material in a way that's still connected compositionally, without anything having to be left out. Rosen thinks about this with regard to music, but it also connects with color. Your film [*Duilian*] is just so colorful. There's this one particular moment where you and boychild are on a boat, and the boat is traversing this canal bordered by buildings with neon lights ... And there's another moment where the pattern on boychild's headband becomes almost like a flag and is waving and is almost fading or melding with the image of the water. That richness is what I would talk about in regard to density in your work.

TSANG: I appreciate what you're saying, because there are so many choices when it comes to moving image–making. Especially with all the available technologies and formats, it means that you can choose a lot of different ways to communicate. For example, when I made *Girl Talk* with you we ended up just shooting on an iPhone. I realize now, it was because I wanted the image to fall apart, or be barely there, and also to reference intimate daily communication. There's not a systematic way of working—I'm not just trying to make something look as fancy as possible by default. But definitely with *Duilian* there was a choice, at a certain point, to sort of ... go for it. What it meant to take on this subject matter in this context became about honoring the size of the material, even if it meant having to hustle to make it possible. There were certain things the material demanded: for example, filming on a boat in order to be floating between space-time and geography. Working collaboratively with many people to coalesce the poetry translations required a lot of time and energy. I wanted the film to feel like an exquisite corpse, to destabilize identities and narratives. We have talked about art in terms of an axis of lightness and density, but also in terms of an axis of beauty and horror. When I'm working, I'm always searching for a certain kind of pleasure and humor combined with devastation, and the stakes have to become high in order to make a decision.

Wu Tsang, *Duilian*, 2016. Installation view: "The Luscious Land of God Is Sinking," 356 S. Mission Rd., Los Angeles. Courtesy the artist; 356 S. Mission Rd., Los Angeles; and Galerie Isabella Bortolozzi, Berlin. Photo: Brica Wilcox

MOTEN: There are all these things that come into my mind in an obvious way, and that's what makes me not want to say them. It's not that they are not real and true, but you have to work for it a little bit. How do you do justice to someone's story? Somebody's story is always more than just theirs. You have to get into a whole bunch of stuff that you don't immediately have access to. If you're getting a story by way of one person, that means you have to do all this imaginative work to try to do justice to everything and everyone else. But even beyond the simple questions of one person's story, there are all these other things you could talk about under the rubric of intensity. It's like what you were saying: it has to be as beautiful, and it also has to be as terrible.

"The Luscious Land of God Is Sinking," 2016.
Exhibition view: 356 S. Mission Rd., Los Angeles.
Courtesy Wu Tsang; 356 S. Mission Rd., Los
Angeles; and Galerie Isabella Bortolozzi, Berlin.
Photo: Brica Wilcox

TSANG: Yes, totally.

MOTEN: It's not a balance of terror and beauty; it's all terror and all beauty.

TSANG: They are not separable.

MOTEN: But then you have to figure out a way to do it, and show it so that people can receive it in a way that does not immediately trigger a certain kind of impulse to reduce. You could be writing about some shit that's horrible, and

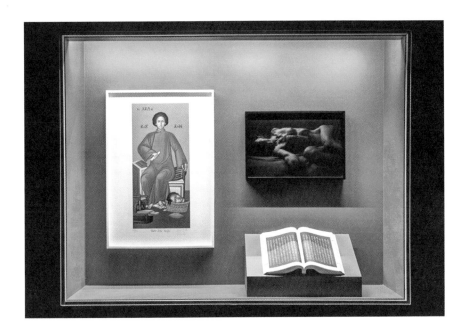

Wu Tsang, *The Prosopa Project* (left) and *Corpse* (right, rear), both 2016, displayed with Wu Zhiying's 1908 transcription of the *Surangama Sutra* (right, front). Installation view: "The Luscious Land of God Is Sinking," 356 S. Mission Rd., Los Angeles. Courtesy the artist; 356 S. Mission Rd., Los Angeles; and Galerie Isabella Bortolozzi, Berlin. Photo: Brica Wilcox

you write about it in a beautiful way, but you also write about how that horror is completely inextricably bound up with beauty. Especially in terms of the relationship between you, boychild, Wu Zhiying, and Qiu Jin. How do you create a way for people to be able to accept all of it, without having to reduce it?

TSANG: I'm aware of the critiques, or suspicions, that contemporary art has of narrative and also of beauty, which is something that I find myself wanting to push back on. If you look at it one way, there is a certain privilege to failure or incoherence, which I can't fully relate to. My experience has been about trying to

exist and to thrive, which is something I might relate to being trans. I'm not saying that I'm trying to translate myself into something that I'm not, or to make visible, to use my least favorite word. But for me and the realities that I'm inhabiting simply to exist, for those things to be communicated and communicable, it's not the same thing as reducing them. That's actually something I'm actively trying to do.

MOTEN: It makes me wonder if there must be actually some pretty intense and irreducible relationship between being trans and what it is to be communicable. What it is to be engaged in a general communicability that is beyond or outside of any restrictive and restricted economy of reduction. This is all about what it means to be working in a way that occupies or traverses these spaces and is defined by absolute intensities and densities at the same time as absolute richness and light.

That seems to me to be the goal, the task ... And I think that "trans" is one word for it that is not just one word among others. You know what I'm saying? I have all these shorthand ways of putting shit that I steal from other people, but what I mean is that there are other words that one could use, but none of those words is replaceable. Not only are they not replaceable, they are not substitutable.

TSANG: Right. One could say "brown."

MOTEN: Our friend José [Esteban Muñoz] would say "brown."[2] It's another word for it, but it, too, is not just any other word. Like you say, I think the privilege comes from feeling like you could kind of slack off.

TSANG: There's a position from which some can assume legibility, as a point of departure.

MOTEN: It's not about achieving some absolute success or something like that. The absoluteness is in the attempt, not in the achievement. The privilege that you're talking about is the privilege to fail to try hard! Our lives are lived in the context of an absolute brutality, and your recourse to beauty, someone might say, is a way of deflecting that brutality. But there's no way for us to understand anything like the intensity of the brutality, if you slack off on the beauty. Each one makes the other possible to see or to know. I look at what you've done, and I can tell with each individual piece that attempt is there. But also the range of material, the range of things that you make across these different genres, it all feels like a massive attempt at doing justice to this whole field of life that you're a part of, embedded in.

TSANG: I hope I'm not reducing it to something simplistic like "our pain is beautiful," but it does make me think of ways I want to challenge critical practices that try to separate these things. Maybe beauty falls into the category of pop, or maybe trying hard gets conflated with succeeding, but I think art should be challenging and make people uncomfortable, and there is a certain safety or even, let's say, problem with focusing only on the struggle. Only people who have not actually struggled would see others as downtrodden.

MOTEN: Artists are always working with different levels of awareness of this problem. Another technical term would be the necessity of refusing reductiveness. It's a mathematical problem on a certain level, but it's not something you can get at by way of these sort of rote calculations. It moves by trial and error, and improvisation.

TSANG: Maybe this is a way to talk about artistic process. It reminds me of a conversation we recently had about how writing and performance are inseparable in your poetry. Specifically, you were talking about how, when you're working on a new poem, you read it out loud over and over again. If you stumble, it's not a mistake; it means the language is not right. You rework it until there are no stumbles, until it comes out of you or you're able to get out of the way of it, as you said. So your performance is a rigorous process, but it doesn't come from performing that rigor, it comes from an openness and attentiveness, and of course repetition. I can relate to that process, because I'll spend forever researching for a film, even though by the time it actually becomes a film, most of the material is not there. The research becomes embedded, but not necessarily on the level of the image or the story. Actually with *Duilian*, it was specifically a language thing. Because I was working with five languages—four of which I don't speak, and I can't read Chinese characters. So I was fumbling through so much memorization in order to arrange the script and edit the film. When I edit, I usually prefer to start over from scratch, rather than rework a scene. The process feels almost closer to musical improvisation than filmmaking.

MOTEN: In regard to music or the spoken word, people would say that it all seems so effortless. But effortlessness is not a quality that accrues due to lack of effort.

TSANG: That gets back to the lightness and density thing, because effort does not culminate in something rehearsed or memorized. Each time you read a poem, it comes out completely different.

Wu Tsang, *Female Hero*, 2016. Installation view:
"The Luscious Land of God Is Sinking," 356 S.
Mission Rd., Los Angeles. Courtesy the artist; 356
S. Mission Rd., Los Angeles; and Galerie Isabella
Bortolozzi, Berlin. Photo: Brica Wilcox

MOTEN: The difference emerges that way. It's just like in the martial arts practice in your film [*Duilian*]. There's one cool moment where one of the martial artists is showing boychild a particular way of standing and holding the sword. And then it cuts to another moment where the other four women [the martial artists] are all in formation, about to begin an exercise in a specific position. What was amazing was the absolute nonidentical nature of each performer's perfect occupation of the proper position. That's something that only emerges not just from work or effort, but also from a certain kind of ritual practice. I think about this more so with regard to blackness than I do with regard to transness, but I'm beginning to think that these things converge in an irreducible way. They can't be thought separately from one another, because both manifest themselves in regard to ritual practice. I don't think about blackness as an identity. I think about blackness as a ritual practice, and I feel like I should think this about transness too.

TSANG: If I have to say something about identity, I also think of ritual practice. I was recently asked to write something about identity for a publication, and the first thing that came to my mind was that identity is the act of putting yourself together each day.

MOTEN: If identity is the ritual practice of putting yourself together every day— the ritual and jurisgenerative practice of putting yourself together every day— then it manifests on the most specific level under the rubric of dis-identification, as José taught us.[3] The way you put yourself together every day is the way that you take yourself apart every day. In other words, dis-identification is this practice by tearing oneself apart. You can see it precisely in that interplay between the fighting and dance that is such a big part of your film [*Duilian*]. These modalities of dancing and fighting are really about a ritualized activity of ripping your body apart. It almost feels like …

TSANG: Like your limbs are coming off!

MOTEN: Like you're slicing your own limbs off. In that opening scene, you see the first swordswoman and this tremendous twirling and flash of the sword, accentuated by its flexibility and thinness—it's as if you have a whirling circle of matter that keeps slicing parts of itself off that almost immediately recoalesce. So, putting oneself together every day is inseparable from tearing oneself apart every day.

TSANG: In that opening scene, the voice-over recites a famous line of Qiu Jin's poetry, but it was translated and performed in Ilocano [a language spoken by the Ilocano people in the Philippines]: "My body will not allow me to mingle with men, but my heart is far braver than that of a man." I'm just thinking about what it could mean to segment the body into parts, and how those parts would measure up to one's assessment of power. What limbs can we sever, or momentarily conjure, to constitute our place in this world?

..

This conversation between Wu Tsang and Fred Moten was conducted in September 2016 on the occasion of the exhibition "Wu Tsang: The Luscious Land of God Is Sinking" at 356 S. Mission Rd., Los Angeles. It was originally published on 356 S. Mission Rd.'s website.

..

NOTES

1. Charles Rosen, *Arnold Schoenberg* (Chicago: University of Chicago Press, 1996), 57–63.

2. José Esteban Muñoz, "Feeling Brown: Ethnicity and Affect in Ricardo Bracho's *The Sweetest Hangover (and Other STDs),*" *Theater Journal* 52, no. 1 (2000): 67–79.

3. José Esteban Muñoz, *Disidentifications: Queers of Color and the Performance of Politics* (Minneapolis: University of Minnesota Press, 1999).

Stamatina Gregory and Jeanne Vaccaro

Una nueva artista necesita usar el baño (2011) is a photo-performance by Argentinian conceptual artist Elizabeth ("Effy") Mia Chorubczyck (1989–2014), a trans woman who committed suicide while studying for her MFA at IUNA Universidad Nacional de las Artes in Buenos Aires. We observe a woman entering a room and opening a door marked with the schematic drawing (a circle atop a triangle resting on two parallel rectangles) we recognize as "woman," a symbol that, immediately and without words, constrains the possibilities of access. The image registers the banal and intractable discrimination and violence trans people experience in public bathrooms. Although the work, whose title translates into English as "A new artist needs to use the bathroom," is a staging of a potential public action, Effy constructed the performance in the bedroom in her childhood home. It recalls a practice of feminist artists making domestic and interior spaces public and political. We can read the names of thirteen women artists, drawn on her body in black marker, who collectively compose a canon of feminist art in modern and contemporary art history: Marina Abramović, Judy Chicago, Tracey Emin, VALIE EXPORT, Sylvie Fleury, Barbara Kruger, Ana Mendieta, Yoko Ono, Méret Oppenheim, Adrian Piper, Carolee Schneemann, Cindy Sherman, and Hannah Wilke. As Effy enters the bathroom and brings with her the names and histories of a feminist art world, she performs a self-portrait and inscribes the need for a transfeminine and transfeminist arts praxis.

An artist must always locate herself in history. *Una nueva artista* wrestles with something as precarious and polemical as "women's experience," mining the history of 1970s feminist art and its experimental pedagogies to understand and claim the identities of "woman," "artist," and "woman artist." Having "quit the great privilege: being male,"[1] Effy began to negotiate the intersections of these categories. Moving in public spaces in which trans women—and all

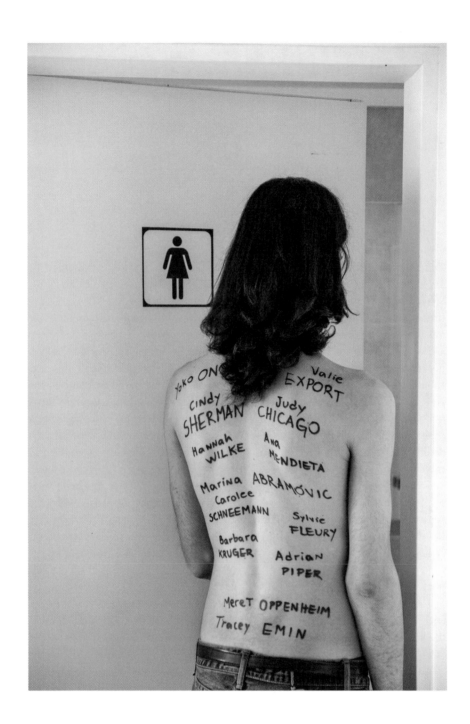

STAMATINA GREGORY AND JEANNE VACCARO

Elizabeth ("Effy") Mia Chorubczyck, *Una nueva artista necesita usar el baño* (A new artist needs to use the bathroom), 2011. Photo-performance; digital photograph, 7 ⅞ × 11 ⅞ in (20 × 30 cm). Courtesy María Laura Voskian. Photo: © María Laura Voskian

women—are both threatened and invisible mobilized her commitment to transfeminism as both a physical and a conceptual geography. Her performances, digital diaries, photo collages, videos, and drawings animate the demanding force of second wave feminist art and also critique the essentialist ideas about the female body we associate with those works and movements. In different methods and contexts, the thirteen artists whose names Effy scrawled on her body work with the symbolism of "woman" as an object of inquiry and frustration. In *Una nueva artista*, Effy sutures her transfeminine history to cisfeminine artists, retaining and building upon these efforts to deconstruct women's experience, while signaling her desire for active, embodied participation in an evolving landscape of feminist art.

Many of Effy's radical and didactic public interventions asked, "From where do you build your own acknowledgment as a woman and as an artist?" Taking inspiration from feminist art history to remake iconic works of feminist performance, she turned to performance and public intervention as alternatives to exhibition practices and spaces, such as museums and galleries, that are less accessible to women and minoritarian artists.

Nunca serás mujer, or "You will never be a woman" (2010), comprised one such set of performances undertaken outside exhibition spaces. Over the course of one year, Effy performed thirteen separate "actions" of menstruation in various public and semipublic spaces, including a classroom, a Catholic church, a public square, an underground metro station, and her family's home. She described the work thus:

Someone once told me that even if you feel like a woman, and your tits grow, and you take hormones, and you operate on your genitals, you will never be a woman because you don't menstruate and you don't know what being a woman means. In April 2010 I started hormonal reassignment treatment. Since then, my body supplies the same amount of hormones as a woman born with female genitals. Exactly one year later, I extracted all the blood that I would have menstruated in that year, meaning the same amount of blood a woman loses every year that she bleeds, which is approximately half a liter. I divided the blood into thirteen doses, representing thirteen menstruations, and made a series of actions with them related to what I experienced each month regarding the construction of my gender identity. The actions are all performative in nature: some are specifically urban interventions and some are photo-performances.[2]

In a time of "postfeminism," Effy made the identity politics and pedagogies of 1970s feminist art into objects and methods for reconstruction. *Nunca serás mujer* draws out the tensions born of biological essentialism, evoking works like *Loving Care* (1993) by Janine Antoni, *Menstruation Bathroom*, made by Judy Chicago as part of the *Womanhouse* project (1972), and *Vagina Painting* (1965) by Fluxus artist Shigeko Kubota. Works like *Una nueva artista* and *Nunca serás mujer* performatively revive the constative grammar of essentialist feminist legacies, as Effy saw value in feminist pedagogies of consciousness-raising and identitarian inquiries into the experience of being a woman, an artist, and a woman artist.

Genital Panic: Cortala! (2011) re-presents *Genital Panic* (1968), a performance by VALIE EXPORT, in which she exposed herself in pants with a triangle cutout. Effy's *Cortala!* (a command meaning "Cut it!') was a performance in the streets of Buenos Aires during a lesbian and gay parade (EXPORT performed her work in a Viennese experimental cinema). Like EXPORT, Effy wore a bustier and pants with cutouts. She also carried a pair of hedge-trimming shears and would provocatively place her genitals between the blades. While EXPORT holds a machine gun in *Action Pants: Genital Panic* (1969)—the series of posters she produced to commemorate her performance—Effy replaced the gun with shears, thereby presenting her body as both desirous and threatening, if only to herself.

For EXPORT, the site of contestation is the cinematic representation of women; she said of the performance:

I didn't want to perform in a gallery or a museum, as they were too conservative for me, and would only give conventional responses to

STAMATINA GREGORY AND JEANNE VACCARO

my experimental works. It was important for me to present my works to the public, in the public space, and not within an art-conservative space, but in the by then so-called underground ... I wanted to provoke, because I sought to change the people's way of seeing and thinking ... If I hadn't been provocative, I couldn't have made visible what I wanted to show. I had to penetrate things to bring them to the exterior.[3]

In Effy's iteration, the site of contestation is the public space of the street. A site of harassment and violence for trans women, the street also retained an audience for whom a defiant trans body held radical potential. In performing movements that were simultaneously assertive and self-harming, she created an image—an image that reflected prevailing and distorted assumptions about trans women back onto public viewers, but which also revealed itself as both a manipulation and a public demand. Public interventions, outside the university art space, became a critical form of her practice.

Effy was an enormously prolific artist, and yet no archive—formal or informal—contains her creative output of performance documentation, photo works, drawings, or essays, or her collaborations with other artists and students at IUNA.[4] Looking at documentation of her practice on scattered websites, speaking with friends and family, and reconstructing performances made in the streets, in the privacy of her home, or in the laboratory of the university art school, it is difficult to access and put together an archive, and we can imagine that much has been lost. Undertaking an archival reconstruction requires negotiating these disparate forms of liminality as they intersect with borders, translations, and migrations (of language, concepts, and identities).

Art history's methods and disciplinary norms too rarely account for truncated forms of cultural production by artists like Effy. Transgender art is vulnerable; Effy's work is singular, extraordinary, and also symbolic of the precarity of trans practices and the imminent loss of its histories. The ubiquity of this precarity demands an engagement with the archival—a way of making that both engages with earlier histories and acts with and through its own self-preservation. Effy consciously and strategically scaffolded origins as a structure for her practice, making radical alterations to second wave feminist art and constructing an intergenerational, transfeminist dialogue that makes claims and spaces of artistic recognition inclusive, while throwing into relief the obstacles in assembling a transgender art history.

A thinking through of these kinds of necessarily textured strategies informed our curatorial approach to organizing "Bring Your Own Body: transgender between archives and aesthetics," an exhibition including the work of Effy and sixteen

other contemporary artists, which opened at the Cooper Union in October 2015. The exhibition spanned archival responses and practices across six decades, acknowledging generational influences and the sometimes ephemeral/precarious state of contemporary archives in formation. Framing the encounter with the archive as one that demands that you bring your own body is to suggest that archives, in particular those collections housing materials related to marginalized communities, require continual intervention and reinterpretation. The title "Bring Your Own Body" ("BYOB") comes from an unpublished manuscript written in 1971 by intersex pioneer Lynn Harris, which performance artist Zackary Drucker revisited in a multimedia performance in 2012 at the ONE National Gay and Lesbian Archives at the USC Libraries. Our appropriation of Harris's and then Drucker's title acknowledges the intergenerational and archival debts of our research and emphasizes artists who work with and reanimate historical collections for new genealogies.

Despite recent and unprecedented visibility in popular culture and media, transgender is neither new nor finished, and a return to the archive offers a timely historical perspective. "BYOB" explored the way transgender is formed in the space between an archive and an aesthetic, between historical taxonomies and creative resistance. Accordingly, it looked to archival collections to tell us something new about our present moment, while simultaneously presenting critical interventions by contemporary artists who must negotiate a set of inherited representations of gender identity. Bridging these two fields of inquiry was a theoretical interrogation of the politics of representation and difference.

Taking this question of historical precedent seriously, not only as a method of art historical inquiry but as a foundational question for conceptualizing the exhibition, "BYOB" presented objects, ephemera, and artifacts from collections including the Kinsey Institute. Dr. Alfred Kinsey was the first North American sexologist to record sex histories, beginning in 1948, and to collect data from self-identified trans people. His collections include what he termed "visual data": photographs categorized into behaviors and identities such as "petting," "fetish," "homosexual," "male," and "female." The archive's often-violent capturing of identity is especially evident in the Institute's "TV" (transvestite) files, a collection of images of anonymous subjects whose self-identification is impossible to know.[5] Also included were ephemeral objects from sexologists Harry Benjamin, who authored *The Transsexual Phenomenon* (1966), and John Money, who founded the first North American gender identity clinic at Johns Hopkins University in 1967. Taken together, these rarely seen lecture slides, correspondence, drawings, and doodles gestured to the embattled subjectivity of the sexologist and illustrated the contested forms of agency inherent to the

formation of archives, undermining previously fixed notions of scientific objectivity. Making these materials publicly available as part of "BYOB" allowed for a destabilizing of their secrecy and the tacit naturalness of trans medicalization. Given the various problematics of the original conditions of data collection and taxonomic categorization, a careful ethical consideration of the processes of historical recovery guides the research and stakes of curatorial intervention for contemporary queer politics.

These sexological archives also provide evidence of transformative agency among subjects and actants within and through these histories. Archives compiled by artists and communities illustrate the efforts of pre–Stonewall era LGBT groups to self-narrate, define, and document their evolving understandings of gender and sexuality. Virginia Prince's self-published journal *Transvestia* (1960–80), generously on loan from the Transgender Archives at the University of Victoria, features firsthand accounts of gender crossing, practical advice, and resource-sharing, as well as heated political debates about the differences among men, heterosexual cross-dressers, and trans women. Self-determined projects like *Transvestia* were essential in enabling the formation of communities—both local and geographically disparate—through highly choreographed, pre-digital networks, making these ephemeral objects critical to histories of media and queer organizing.

Early radical artists working in and around gender and performance signal new forms of transgender archives: namely, those that are self-determined and those that are in continual formation. The archive of legendary drag queen Flawless Sabrina includes ephemera from her long-running, multicity "Miss All-America Camp Beauty Pageant," whose final event was documented in the 1968 film *The Queen*, shot at New York's Town Hall and attended by Richard Pryor and Andy Warhol. Contemporaneously, Surrealist outlier Pierre Molinier used photography, collage, and a collection of props and maquettes to construct a complex and multigender subjectivity, recuperable into early histories of trans identity formation. Molinier's practice inspired a generation of artists, including Genesis Breyer P-Orridge, whose experiments with photo-collage, performance, and surgery span over forty years and include interdimensional collaborations with h/er partner Lady Jaye Breyer that form alternative structures of kinship and belonging.

These early photographic and performative practices provide historical precedents for a contemporary generation of trans artists using strategies of performance, historical recuperation, and restaging to explore nonbinary trans subjectivity. Justin Vivian Bond, for example, constructs an intimate study of beauty and the search for the "transchild" in watercolor diptychs of the artist

and model Karen Graham in *My Model / MySelf* (2014). And in *DISCOTROPIC / Alien Talk Show* (2015), niv Acosta seizes on an elementary medium of transgender exposure—television and the confessional culture of the talk show—to explore the relationships between science fiction, disco, astrophysics, and Black American experience. Contemporary works in performance, sculpture, and new media complicate disciplinary formations of trans experience beyond the singular category of gender to engage histories of feminism, race and geography, artistic authorship, and the origins of identity and difference.

Several of the artists whose work was featured in "BYOB" engage directly with archival objects and images, reconstructing and reassembling them to produce works that transform historical positions into speculative futures. Chris E. Vargas's quasi-fictional Museum of Transgender Hirstory and Art (MOTHA) mounts collections of artworks and archival objects in temporary spaces, resurfacing little-known histories and radical practices.[6] In a commissioned work for "BYOB," Vargas repurposed, through collage, sensational headlines of gender deviance from the scrapbooks of trans woman Louise Lawrence, whose correspondence with Kinsey demonstrates the agency of trans self-determination within limiting diagnostic structures. Using Lawrence's scrapbooks dating from the 1940s to the 1970s, Vargas created a newsprint takeaway—*Transvestism in the News* (2015)—that draws an immediate parallel between mid-century trans panic and the contemporary media fascination with transgender. *Transvestism in the News* reflects Vargas's ongoing, appropriative, and tactical relationship to institutions and institutionality, positing an institutional critique through the use of established conceptual tactics in Western art (among others, one might think of Marcel Broodthaers's "fake museum").[7] MOTHA intentionally nurtures an ongoing contradiction: it is a project aimed at acquiring institutional legitimacy for trans and gender nonconforming artists who do not yet have and are foreclosed from establishing an exhibition history outside of local and community-centered contexts.

The collaboration with MOTHA represented an important conceptual question informing the research and organization of "BYOB," which sought to enfold and recognize a wider set of genealogical origins for transgender art and art history: Given the absence of formal canons and precedents and the liminality of trans works and makers, who historically lack institutional investment, market interest, and representation in established museums and galleries, how can we work both with and against earlier efforts around gender and contemporary art?

Assembling a history of art practices that prioritizes gender exploration, plasticity, and self-determination becomes even more challenging when applied to exhibition histories. While there is no historical trans art "field," there are stakes

STAMATINA GREGORY AND JEANNE VACCARO

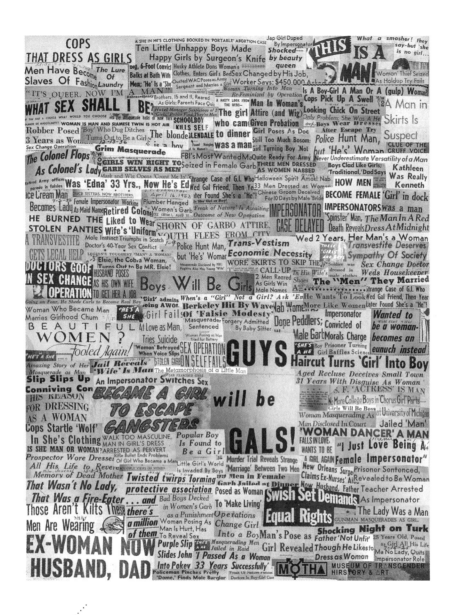

Chris E. Vargas, *Transvestism in the News*,
2015. Newsprint broadside, 22 ¾ × 30 in
(57.8 × 76.2 cm). Courtesy the artist

in the deconstruction of historical approaches to gender representation where they do exist. We were wary, for example, of appropriative attempts at trans cultural production, most notably evident in the 1974 exhibition "Transformer: Aspekte der Travestie" at Kunsthalle Zürich. While the catalog made an attempt to assess transsexual subjectivities and drag practices in terms of both labor and aesthetics, the exhibition itself was overwhelmingly comprised of the work of cisgender, heterosexual male artists and pop musicians (such as Mick Jagger), with the work of Molinier arguably that of the only gender nonconforming artist,[8] although Jürgen Klauke's *Selbst-performance* series (1972–73) was a self-conscious hybrid of Molinier's photographic self-constructions and popular appropriations of femininity by male performers. Works by David Bowie, Andy Warhol, and the Cockettes capitalized on the popular zeitgeist of drag and glam-androgyny. Ultimately, the exhibition conceptualized trans as an affectation—often to produce a kind of uncanny destabilizing of gender—but deployed it without actually troubling gender politics or divesting it from the privileges of cis-centric heterosexuality. "Transformer" raises identitarian and categorical claims about trans art as being separate from trans artists and reveals the deep power imbalances inherent in an exhibition of the work of cisgender artists who abandoned politics and represented trans purely as an aesthetic. The relatively uncritical restaging of "Transformer" in 2014 at Richard Saltoun Gallery in London with many of the same artists (but a different set of works) reveals a similar disinterest in the stakes of transcultural participation in contemporary art production, instead capitalizing on contemporary discourse around gender representation.[9]

Jürgen Klauke, *Selbst-performance*, 1972–73 (detail). Thirteen black-and-white C-prints, 22 ½ × 16 ½ in (57 × 42 cm) each. Courtesy the artist, Galerie Anita Beckers, Frankfurt, Germany, and VG-Bildkunst

STAMATINA GREGORY AND JEANNE VACCARO

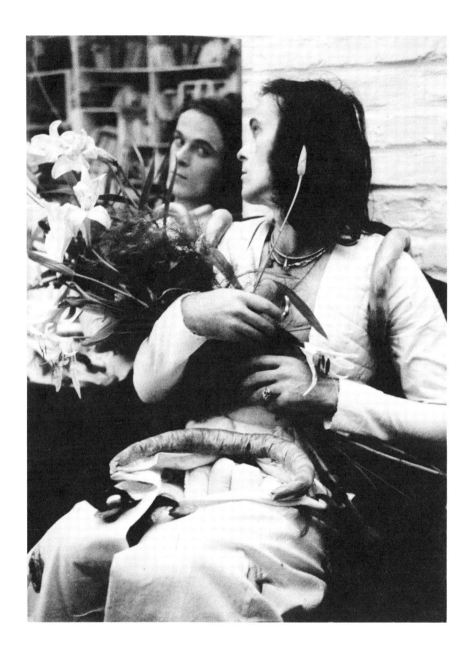

How can we can begin to write a transgender art history, one that asks foundational questions about the categories of transgender art and aesthetics, unless we both recognize and confront the vulnerability of trans life? Effy's diverse practice wrestled with questions about field location and framing through a conceptual structure that invited her audience to revisit the stalled promises of representation demanded by historic feminist art. Similarly, the category of transgender art opens out onto some of those same well-worn questions about the identity politics of art and artists. Thus, theorizing a trans exhibition and its history requires making a number of delimitations: historical, identitarian, aesthetic, institutional. Given that trans is an evolving category that continues to unfold along the lines of history, etymology, community speech, the law, and politics, and given the temporal continuum of trans, how does one make art historical demarcations? How do these demarcations shift before, during, and after the different historical periods in which "trans" is recognized variously as an identity category? Thinking through Effy's practice as both exceptional and representative in transgender art history is one way of imagining the conditions of possibility for both an archive and an art history of transgender art that are self-reflexively in formation, undoing as they rebuild histories.

In this moment of heightened hyper-visibility for transgender representation in mainstream media, it may be fair to say that the relationship of trans art and art history to the institution must necessarily be an appropriative and parasitical one. MOTHA's tactical flirtation with a kind of institutional mimesis is a model for anchoring trans art histories within established cultural spaces; it is also a response to a prevailing model in which institutional representation is the only gauge of political progress within the art world and the categories of transgender art and artist are problematically collapsed. On the other hand, an exhibition like "Transformer" performs an aesthetic of "transgender-ness" without accounting for a politics of representation. Effy's practice transcends this conflation through a set of works and a methodology that interrogate the possibilities of categories like "woman," "women's experience," and "artist" and demonstrate the inadequacy of the identity politics of collective representation. Both Effy and Vargas's MOTHA tap into and deconstruct institutional and canonical models and thereby create space for critical practices in the seeming absence of history.

While "Bring Your Own Body" gathered work under an expanded umbrella of transgender, it did so without making identitarian claims. Elaborating transgender through an expanded field of the visual doesn't simply generate an alternative canon; it offers a new methodological apparatus, one that allows us to understand gender as a category that is formed through multiple fields and aesthetic strategies. Mining the archive's often violent capture of identity and the

STAMATINA GREGORY AND JEANNE VACCARO

persistent burdens of diagnosis, "Bring Your Own Body" looked to the work of contemporary artists who both mediate those histories and performatively animate the sexological imaginary of transgender. An excavation of previously overlooked trans exhibition histories both widens canonical understandings of queer art history and pushes disciplinary conversations about gender difference beyond the sociological and narratological. A curatorial exploration of sexological and artistic collections doesn't yield any one history of transgender, but assembles objects and works that can constitute an alternative archive.

...

"Canonical Undoings: Notes on Trans Art and Archives" was coauthored by curator and art historian Stamatina Gregory and writer and curator Jeanne Vaccaro in 2016 for this volume.

...

NOTES

1. María Cafferata, "El adiós a una revolucionaria trans," *Publicable: El diario de Tea*, April 1, 2014, http://www.diariopublicable.com/sociedad/2245-adios-revolucionaria-trans-effy.html.

2. Effy, "El proyecto," *Nunca Serás Mujer*, blog post, accessed June 22, 2016, http:// nuncaserasmujer.blogspot.com/p/el-proyecto.html. "Una vez una persona me dijo: aunque vos te sientas mujer, te crezcan las tetas, tomes hormonas, te operes los genitales, nunca serás mujer porque no menstruás ni sabés lo que eso significa. En Abril del 2010 inicié el tratamiento de reasignación hormonal. Desde entonces mi cuerpo suministra la misma cantidad de hormonas que una mujer nacida con genitales femeninos. En Abril del 2011, exactamente un año después, extraigo de mi cuerpo toda la sangre que debería haber menstruado desde entonces, es decir, la misma cantidad de sangre que pierde por año la mujer que menstrua (½ litro aproximadamente). Reparto la sangre en 13 dosis representando las 13 menstruaciones desde abril del 2010 a abril del 2011, y realizo con cada una de ellas una serie de acciones relacionada con lo que viví cada mes respecto a la construcción de mi identidad de género. Las acciones son performáticas en su totalidad, aunque algunas en particular son también intervenciones urbanas, y foto-performance."

3. VALIE EXPORT, quoted in Tom Seymour, "Feminist Actionism—Friedl Kubelka and Valie Export," *British Journal of Photography*, April 16, 2014, http://www.bjp-online.com/2014/04 /richard-saltoun-friedl-kubelka-valie-export/.

4. Matías Rodríguez, "Effy: cultura, performance y sentido" (master's thesis, Universidad Nacional de La Plata Facultad de Periodismo y Comunicación Social, 2015), http://sedici.unlp .edu.ar/handle/10915/49703.

5. Materials were drawn from the Archives of the Kinsey Institute at Indiana University, Bloomington. For an overview of the Archives' holdings, see "Archival Collections," Kinsey Institute, Indiana University, accessed October 1, 2016, http://www.indiana.edu/~kinsey /library/archives.html.

6. For further discussion of MOTHA, see Chris E. Vargas, "Introducing the Museum of Transgender Hirstory and Art" on page 121, and Jeannine Tang, "Contemporary Art and Critical Transgender Infrastructures" on page 363 of this volume.

7. Marcel Broodthaers's *Museum of Modern Art, Department of Eagles* was a conceptual work, a fictional museum created in Brussels in 1968. Between 1968 and 1971, the museum appeared in "sections" at locations including the artist's studio/home and Kunsthalle Düsseldorf, but had no permanent collection or location. Sections of the piece were recently restaged at "Marcel Broodthaers: A Retrospective" at the Museum of Modern Art, New York (2016), and are discussed in the show's catalog. See Christophe Cherix and Manuel J. Borja-Villel, eds., *Marcel Broodthaers: A Retrospective* (New York: Museum of Modern Art, 2016).

8. Jean-Christophe Ammann, *Transformer: Aspekte der Travestie* (Lucerne, Switzerland: Kuntsmuseum Luzern, 1974), 13. "Mehr oder weniger verbindet alle Künstler-Transvestite eine aktionistische-schauspielerische Aneignung der extensiven und intensiven Ausdruckwirklichkeit der Koerperbewegungen, der leibgebundenen Expressionen Effeminierter […] Nur im Falle Moliniers laesst sich mit Bestimmtheit sagen, dass hier die authentische Biografie eines Transvestiten unter der aesthetische Darstellungsakt des Koerper-Auteurs in der Visualisierung ganz zussamenfallen." ["More or less, what connects all artist-transvestites is an active appropriation of the extensive and intensive realness of bodily movement, the embodied expressions of effeminates. … Only in the case of Molinier is it possible to say with certainty that the authentic biography of a transvestite, and the aesthetic act of representing the artist's body, totally coincide."]

9. In discussions of this period in photography, performance, and gender, the work of Ulay (as well as his work with Marina Abramović) are sometimes seen as foregrounding a heterosexual duality while attempting to push gendered boundaries through costume, montage, and relational performance, such as continual evocations of a Freudian mirror stage that ostensibly prefigures gender difference.

CONTEMPORARY ART AND CRITICAL TRANSGENDER INFRASTRUCTURES

Jeannine Tang

Under what gendered conditions are contemporary art and life improvised here in the United States? How are systems of living and systems of culture enmeshed within the life of a person, as they negotiate these systems' racialized, classed, and gendered effects? What infrastructures hinge cultural systems and systems of life together, and how do artists in the field of contemporary art move through them to transform the very trajectories and fabric of infrastructure itself? I ask these questions because of two sets of phenomena that both myself and others have informally observed. These phenomena point to a paradoxical disparity experienced by those claimed by society and culture as transgender—on the one hand receiving artistic recognition or acceptance, while simultaneously navigating greater difficulty in living life under racial capitalism on the other.

The first set of phenomena is an accumulation of my personal observations, based on living in New York City from 2009 to the present, as a participant within some of the city's contemporary art institutions and communities. I have noticed increasing incidents of cultural recognition whereby the work and identities of publicly transgender, genderqueer, gender diverse, and gender variant artists are validated within the field of contemporary art. These artists have received attention by way of inclusion in major group and survey exhibitions, solo exhibitions, programmed events, and various discursive contexts; some have even had their work acquired and collected by prominent cultural institutions and museums. These artists have discussed their identities as transgender and/ or their work in relationship to issues defined as transgender in readily available published interviews, writings, and publicly attended, recorded, and broadcast panels and lectures. Consequently, the conversations around these artists' works have reiterated their identities in discursive and publicity materials, not only produced by the institutions and curators who exhibit their art, but also by

the critics, curators, bloggers, and various public spheres that respond to both artists' works and utterances.

This recognition is often perceived as a positive step toward the greater socio-cultural acceptance of transgender people and has notably increased over the past three years: for example, in 2012, works by transgender artists were included in film programs at the New Museum and off-site programs at the Museum of Modern Art in New York; by 2013, artworks by transgender artists were included in the Whitney Biennial; and in 2014, transgender artists participated in several public programs at the Studio Museum in Harlem.[1] Comparatively, 2015 was a banner year: The Whitney Biennial featured work by Yve Laris Cohen and Zackary Drucker and Rhys Ernst; the New Museum's Triennial included contributions from niv Acosta and Juliana Huxtable; and the Brooklyn and Whitney Museums both included work by Gordon Hall in their public programs. Art criticism in more mainstream contemporary art journals and mainstream magazines, from *Art Journal* and *Artforum* to the *New York Times* and the *New Yorker*, also took special note of work by transgender artists between 2014 and 2015.[2] Additionally, art fairs began taking interest: Art Basel, for example, organized a panel on the highly criticized rubric of transgender artists and a putative mainstream.[3] These facts all highlight the growing critical reception, institutional inclusion, and narrativization of the work of transgender artists, potentially indicating new markets for both their work and their identities within the field of contemporary art, including its discourses, institutions, labor force, and economies.

The second set of phenomena that I mentioned previously is drawn from the results of population-level public health studies conducted in the US, in which pools of individual responses were solicited, then statically organized, described, and generalized, to capture—however imperfectly—a transgender person's putative chances of living a life.[4] According to the report "Lesbian, Gay, Bisexual, Transgender, Queer, and HIV-Affected Hate Violence" compiled by the National Coalition of Anti-Violence Programs, homicides increased by over 11 percent in 2014; 80 percent of that increase could be traced to the rise in murders of LGBTQ people of color, primarily individuals who were black or African American.[5] And more than half of those homicide victims were transgender women of color—in spite of the fact that transgender women of color represented only 19 percent of all reports.[6] In general, transgender people of color, especially transgender women of color, were far more likely to experience physical and sexual violence, discrimination, threats, harassment, and intimidation. Transgender women of color were also far more likely to experience police and hate violence in public areas and to require medical attention, while crimes against them and the brutality impacting their lives were less likely to be classified as hate violence.[7] The

JEANNINE TANG

violence experienced by transgender women of color is disproportionately high, and the systemic attacks on their lives are estimated to be even more extreme than the available data suggests due to the many uncounted, undocumented, unclassified, and unidentified lives that never enter the realm of statistical visibility.[8]

The recent intensification of violence against transgender people—especially women of color—has been widely noted. The Trans Murder Monitoring project, which is run by Transgender Europe and tracks reported killings of trans and gender diverse people internationally, found that between January 2008 and April 2014, 141 trans and gender nonconforming people were reported killed in the US—and these numbers continue to rise. The reported murders of transgender and gender diverse people in the first four months of 2016 were higher than in the early months of each of the previous years since 2008.[9] In 2015, the estimated suicide rate for transgender people was listed as approximately four out of ten—which means that 40 percent of trans people in the US are at risk of taking their own lives.[10] The average life expectancy for a transgender woman of color is less than thirty-five years;[11] and, at the time of this writing, *Advocate* has just announced that 2016 is the most dangerous year on record for transgender people.[12] In February 2015, it was reported that 125 anti-LGBT bills had been introduced in the US—with twenty-one of these specifically targeting transgender people. These pieces of legislation police the access of trans people to gender-appropriate restrooms and other public spaces ranging from coffee shops to city halls and refuse trans people access to medical services and the ability to change identity documents, thereby effectively legalizing discrimination against transgender people.[13] The prevalence of such anti-transgender legislation has dramatically increased: of the 175 anti-LGBT bills under consideration in February 2016, forty-four specifically targeted transgender people.[14]

.

These cultural and social, personal and statistical facts suggest that the rise in recognition—especially in recent years—for transgender artists in the culture industry has not been matched by an extension of their life chances at a population level. Instead, running parallel to this rise in visibility is the heightened vulnerability of transgender people to forms of state-sanctioned violence and murder and to slow deaths from chronic isolation, poverty, and mass incarceration. I begin where these two sets of facts, two regimes of study, and multiple sociocultural systems converge: in the lives of artists as they move through multiple worlds, where relationships between contemporary artistic recognition and survival at the demographic or population level are linked in the daily labors

of living. It is the oeuvre, or the conjunction of life and art, that is my subject here—the fabric that folds artists into cultural systems of identity management, reproducing both the circulation of art and the life of the artist.

This essay considers how the lives of transgender artists—particularly those who identify as transfeminine and transgender people of color—persist under impossible conditions, while certain artists are made increasingly prominent in the cultural sphere and are upheld as exceptional. The personal, mundane, and quotidian character of this paradox is my subject, as are the everyday aspects of cultural transphobia that reinforce this paradox, which manifests in methodologies of writing, curating, and administration. Consequently, even as I refer to artists who have claimed or been claimed by the term transgender, my object of inquiry is ultimately a cultural system that reproduces cisgender supremacy. In other words, and to quote artist Zackary Drucker, "Artists aren't trapped in the wrong body. They're trapped in the wrong world."[15]

To theorize the gendered contours of this wrong world—which nonetheless includes within it latent, immanent, residual, and emergent *other* worlds that artists have created—I draw from earlier feminist social histories of art as working models for revision today. I ask myself: How might a feminist social history of art account for transfeminine life and participate in a broader critical transfeminist politics? How might a feminist social history of art continue to learn from black feminisms, some of which, to quote theorist and activist Che Gossett, are "always already trans"?[16] In this essay, drawing from early feminist art histories, I will trace not only the gendering effects of contemporary cultural institutions, but also the ways that artists, in their art and in their lives, have sought to counteract these effects by attending to aesthetics and infrastructure.

TOWARD TRANSFEMINIST SOCIAL HISTORIES OF ART

In "Why Have There Been No Great Women Artists?" (1971), a principal text of feminist art history, Linda Nochlin famously interrogates a question asked by many art historians and curators who doubt the capacity of women to produce great art. Nochlin does not seek to answer this question; rather, she examines the very institutional structures of the art historical canon and the terms on which the historical recovery of art by women is pursued. Examining the canon's production of major and minor masters, and its historical determination of purportedly innate genius, Nochlin rhetorically poses the question "Why have there been no great women artists?" precisely to reject its biases and principal

JEANNINE TANG

focus on individual artists and their art. Instead, Nochlin argues, the problem of women's exclusion from both the museum and the canon lies in the gendered criteria, institutions, and cultural assumptions by which artistic greatness is socially produced: the conditions of which include kinship structures such as the artist's family; the gendered access of artists to spaces of education and production such as the studio, the art academy, and the salon; as well as hierarchies of genre that distinguish the greater from the lesser arts—distinctions that were themselves dependent on training and education.[17]

In the years since Nochlin's essay, many of the institutions that engender artistic life have changed radically. Indeed, there are numerous curators, writers, educators, and artists who have unflaggingly supported the work and lives of transgender artists over the last few decades.[18] The institutions that engender artistic life in capacious and vital ways include spaces of sociality, work, and pleasure: nightclubs and parties that have been historically welcoming and supportive of trans people and artists (the Clit Club, Monster, Julius, and parties such as Judy, Color me Queer, and others in New York City among them). These spaces of queer and transgender nightlife provide what Che Gossett has called "temporary autonomous and temporary fabulous zones [of] eroto-politicized desire."[19] For Che Gossett, these are countervailing spaces against "anti queer/trans necropolitical violence."[20] Such spaces exist alongside others that provide community organizing, health care, and legal services to prioritize and affirm transgender lives.[21] These lives are also made possible by countless artistic, familial, and sexual relationships, without which we might not have the opportunity to glimpse the art of Justin Vivian Bond, Wu Tsang, Tuesday Smillie, Ryka Aoki, micha cárdenas, and many others.

The recent prominence of transgender artists has, in fact, emerged because of decades of transgender community and infrastructural support that has often involved the work of artists themselves that is utterly personal, social, situated, and spatial. This support has counteracted the ongoing infrastructural and institutional regulation of gender that reproduces functions of artistic identity to favor the social mobility of people who aren't transgender or gender nonconforming. This cultural infrastructure distributes access—more specifically, the institutional recognition, economic resources, and access to a public sphere by which one's work might be received, affirmed, and amplified in ways that do not endanger one's life but enhance it—based on the subject *position* of the artist. Since the 1940s, artistic education has shifted toward prioritizing speech, writing, discourse, and social situations such as studio visits. Artistic greatness no longer depends on establishing technical mastery within hierarchies of genre.

Instead, graduate students learn to position themselves within what art historian Howard Singerman calls "the disciplinary coherence of the art world."[22]

This positioning might be understood by way of what sociologist Pierre Bourdieu calls the habitus of art—the conditioning of one's "capacity to produce classifiable practices and works, and the capacity to differentiate and appreciate these practices and products."[23] The habitus manifests in an aesthetic disposition, an array of inclinations and attitudes assumed by participants in the field of culture.[24] For Bourdieu, the habitus is necessarily classed; it is also deeply racialized and gendered, encompassing the field of culture and the social character of aesthetic education—seminars, office hours, studio visits, evaluations—that validate or diminish the collegial support required to sustain an artistic practice. I have seen firsthand how assessments can reproduce cultural transphobia when faculty are too preoccupied with the grammatical uses of "they" to analyze the art in front of them; how transgender students are frequently hyper-visible in classroom discussions, displacing attention from their work and onto their bodies, beliefs, and identities. And even before students make it through the door, narratives of coherent gender covertly regulate the purportedly neutral "achievements" required for admission, as well as how gender is managed during the admissions process.

What legal scholar and activist Dean Spade has described as "identity management" in the university's socializing processes particularly burdens those of nonconforming gender identity or expression.[25] Students attempt a "trans 101" during interviews, and letters of recommendation can contradict or out students' sexual or gender identities. The administration of gender variance dictates how and why students' gender identities and professional capacities are received by the field, often becoming painfully illegible, unspeakable, misunderstood, and rejected. During transgender students' entry into and exit from professional education, records such as student loans, transcripts, and certificates follow them, potentially disrupting their identity profiles as artists. Access to forms of employment, artist visas, and rights to residency all rely on such documentation, which often depends on forms of legal identification that can be costly or impossible to acquire or change. Many US states and cities require medical diagnoses or surgery to process gender changes on identification documents, and many universities and institutions require these very state or federal forms of identification to process name changes or disbursements of scholarships, remuneration, and loan relief.

Today's institutions of contemporary art demonstrate a convergence of artistic position and information profiling, in which the administrative systems of artistic professional support and the production of artistic identity are reliant on forms of biopolitical population management that distribute professional

JEANNINE TANG

life chances along gendered, racialized, national, and economic lines. The disparities of this distribution are themselves racialized patterns of systemic transphobia with which cultural infrastructures are fully interdependent. When we consider that transgender youth—especially transgender youth of color—are disproportionately homeless and experience higher levels of violence, eviction, deportation, and incarceration, we can better understand the comparatively small number of trans artists of color applying to, being admitted to, and completing art school—and subsequently gaining mainstream visibility—as symptomatic of institutional and systemic transphobia and racism.

The production of artistic positions and profiles also emerges through social techniques of reception and recognition such as studio visits, grant proposals, artist interviews, and artist statements. Chris E. Vargas and Greg Youmans's series of single-channel webisodes, *Falling in Love ... with Chris and Greg* (2008–13), parodies this system at work. The series follows the trials and tribulations of two constructed personae: Chris, who is transgender, and Greg, who isn't, an odd couple navigating numerous queer quandaries of relationship maintenance. One episode from Season Two, "Work of Art! Reality TV Special," utilizes original footage from the Bravo reality television series *Work of Art*, specifically an episode in which artists are challenged to make a work of art influenced by Andy Warhol.[26] Vargas and Youmans splice the characters Chris and Greg into this appropriated program footage and edit the "challenge" topic, turning it into an exercise in "making a successful piece of queer art about failure." In a cutaway, Chris and Greg describe their strategy through queer theory's examination of failure and difficulty, with Chris confidently observing how "queer artists have been failing successfully for so long, at least since Jack Smith." The duo also receives critiques from Simon de Pury and China Chow, the hosts of the Bravo show, whose voices are overdubbed to emphasize classed and transphobic projections: de Pury relentlessly presumes an intrinsic failure of trans identity as he scrutinizes the people in Chris's video for determining traces of not passing as cisgender ("You can tell by the feet, yes?"). Ultimately, Chris and Greg are eliminated—Chow pronounces that their "queer work of art was a failure, and not in a good way."

As "Work of Art! Reality TV Special" suggests, failing successfully—as opposed to just plain failing—is utterly gendered and socially adjudicated in the sphere of one's critical reception. Art historians such as Anna Chave have pointed out that artists of marginalized gender or sexual identity are more likely to receive biographical readings of their work, while work made by those of "unmarked" subject positions is more frequently addressed in terms of its formal characteristics and place in aesthetic debates.[27] The reception of Wu Tsang's

Chris E. Vargas and Greg Youmans, "Work of Art!
Reality TV Special," 2012 (stills), from the series
Falling in Love ... with Chris and Greg, 2008–13. HD
video, sound, color; 14 min. Courtesy the artists

JEANNINE TANG

Wildness (2012) is a case in point. *Wildness* is a feature-length documentary focusing on Silver Platter, a Los Angeles bar frequented by transgender and queer people of color.[28] This artist-directed film has been screened in multiple cities in the US, where critics have consistently ignored the film's use of montage, its Brechtian distancing techniques, and the scripted voiceover in which the bar is anthropomorphized as the film's first-person narrator.[29] Instead, writers have fixated on Tsang's voice, biography, dress, and gender identity in sensationalizing and judgmental ways.

As the example of *Wildness*'s critical reception demonstrates, art criticism that addresses the work of transgender artists often creates a double-bind of professional validation and violent recognition underpinned by the presumption of a socially sanctioned, stable, and coherently gendered author. The effects of such assumptions appear in critics' misgendering of artists, confusing of personae with identity, and use of given rather than chosen names. Naming is among the most basic of artistic functions, reproducing the modern concept of the "original" work of art whose provenance can be authenticated and traced to its "genius" creator. It is a convention that both provides and prohibits access to forms of exhibition and discourse, and the effects of misnaming are the misunderstanding or loss of massive sections of an artist's oeuvre.[30] Artists have sought to counteract this: for instance, the bio section of Justin Vivian Bond's website previously used "v" as the artist's preferred pronoun and "Mx" as v's chosen prefix.[31] Yet critics have ignored these easily available sources of information. For instance, Carl Swanson's 2011 article on Bond in *New York* magazine was manifestly transphobic in its rampant misgendering, its emphatic policing of "acceptable" and "unacceptable" forms of drag and transgender, its sensationalizing use of salacious description, and the authorial fallacy of presuming access to Bond's "inner life" and intentions.[32]

Such instances of biographical determinism in art writing are a part of broader cultural patterns of transgender narrativization that include both the teleological accounts of transitioning experiences and the normalizing redemption stories that define the putative "transgender experience." These narratives of "wrong body" life histories are typically developmental and linear in nature, and their reproduction often regulates the access of trans people to diagnoses and gender-affirming forms of health care, resources, and services. The teleological logic of such accounts arises from the modern art industry's narratives of life or life's work, which presume artists to possess singular identities through which one's oeuvre can be neatly categorized into early, mature, and late phases. Such underlying biographical assumptions structure the reception of an artist's

work through solo exhibitions and retrospectives, the accessioning of work into museum collections, and the valuation of art on the market.

Many art historians before me have pointed out that "periodizing" narratives—in which the artist's oeuvre is organized into youth, prime, and elder phases of production—do few favors to any artists. However, the effects of these narratives are particularly damaging to transgender artists, first because such developmental narratives presume consistent identity markers, which are not always possible to sustain for artists who have changed names or pronouns. Further, since artwork is only seen to be "mature" or sufficiently "resolved" at later phases of development, work produced in youth is often judged more harshly; given that the lives of many transgender artists have ended all too early due to systemic violence, their contributions may not be sufficiently (if at all) registered in history. In order to attune ourselves to their art, we might instead follow Edward Said's example: rather than assuming the affinity of early work with experimentation, understanding mature work as culmination, synthesis, and definition, and assuming that late style is resolved and reflective, we might consider the maturity and precocity of early work or the experimentation, dissonance, and discordance evident in the art of elders.[33] Further, if names change between early and late work, our writing might relinquish the proper name to recognize artists' self-determination. Rather than write oeuvres as histories of identities, perhaps we could write histories of identifications, acknowledging in our work the ungrounding of given names by names chosen and changing. In this reconceived mode, writing about an artist reckons with the unmooring of the sovereign subject and adopts a concept of the self that is multiple, mutable, and indebted to others—or, as theorist Stefano Harney and poet Fred Moten describe it, as "(*more* and *less than*) *one.*"[34]

Today, the works and lives of artists are gathered up and made legible by browser searches, corporate digital repositories, and algorithmic rankings. Consequently, narratives of a life's work are fully enmeshed with networked systems of policing and surveillance that are reliant on data profiles—in which identities are tracked and required to be consistent, coherent, and transparent. These values are presumed and proliferated by a liberal media and cultural public sphere and frequently assumed by institutions, curators, and critics, who copy and reproduce outdated gender identity information from the internet for their catalog essays, magazine and journal articles, and marketing, press, and publicity materials. Even as many artists openly discuss being transgender, there are still more who do not wish to have their transness mentioned, outed, or emphasized in certain contexts.

An artist's decision to claim or avoid a transgender identity is complex and often competes with the desires of other cultural workers, such as writers and curators, who sometimes wish to stress their inclusion of transgender embodiment in order to signal their program's or institution's commitment to queer and transgender diversity. Such desires worry me, both in how they are materialized within an age of digital and networked surveillance and in how they express a valuation of cultural recognition and transgender proximity that does not always consider—and sometimes seems to values *less*—the material reproduction of transgender social life. The consequences of the above-mentioned forms of information proliferation fall upon those bodies deemed gender nonconforming, racialized, and without citizenship, who risk loss of employment, housing, physical safety, and social inclusion because of such forms of outing. Indeed, even as we negotiate available forms of visibility and representation, we might also utilize the strategies of respectful, patient opacity already at play in activist and cultural forms of writing and organizing and not demand untimely and hazardous disclosures of personal information for those whose lives are still unfolding.

CULTURES OF CRITICAL TRANSGENDER POLITICS

Spade has theorized a critical transgender politics in response to how "[g]ender is an organizing principle of both the economy and the seemingly banal administrative systems that govern everyone's daily life, but have an especially strong presence in the lives of poor people."[35] People whose lives and presentations do not, cannot, or will not fit the forms of these systems are constantly exposed to social exclusion and criminal punishment. As a result, their lives are institutionally and systemically structured to be impossible. In these impossibilities, and within the everyday improvisations of survival that people imagine and enact, Spade locates the potential for another politics that exceeds the empty neoliberal promises of safety and opportunity that are themselves underwritten by "settler colonialism, racist, sexist, classist, xenophobic imprisonment, and wealth disparity."[36] Drawing from Spade's theorization of a critical trans politics, we might also ask how the cultural sphere participates in these conditions of impossibility and possibility, as artists navigate forms of cultural opportunity and alternative living.

For many transgender artists, their first interpellation[37] into the cultural sphere is often through putatively queer and feminist exhibitions that seek to

establish themselves as both queer *and* transgender, or feminist *and* queer. Although these exhibitions, spaces, and events can afford an opportunity to pursue transfeminist questions and to undo the historical violence of the gender binary, they can also uphold and reproduce sexual segregation through forms of gender policing. I've noticed how frequently gender binaries—when employed by curators and institutions—inhibit identifications of artists as genderqueer or transgender; consequently, I find myself constantly questioning how curators and organizers deploy and narrate genres of exhibition, monographic study, or collective organizing long associated with feminist politics, such as the all-women exhibition, the women-only monograph, and the separatist community event. It increasingly appears to me that these forms of presentation risk foreclosing more multiple gendered identifications—for instance, artists who are genderqueer might be forced to take on a female pronoun in order to be included in an exhibition and written about in its catalog.

Rather than presuming that these curatorial genres of presentation are intrinsically feminist forms, we might keep in mind how transgender artists have pushed back against exhibitions and screening events that seek to establish the notion of "women-born-women" as a rubric for admission, thereby restricting the ability of transgender women not only to attend events or enter spaces as audience members, but also to be considered as producers, organizers, or leaders of culture. In a published conversation, artists Tuesday Smillie and Reina Gossett theorize the relationship between social exclusion on an interpersonal scale and more overtly violent attacks on transgender people. Drawing on theorist and activist Eric A. Stanley's theorization of how the murdered bodies of transgender people are especially mutilated, Smillie and Reina Gossett postulate that it is not only the life force but the symbol and meanings of being transgender that are targeted. They link the spectacular destruction of life and meaning to everyday acts of sociocultural "exclusion, isolation and violence" toward transgender women that occur in "tiny little ways," even within the very queer spaces that would putatively shield transgender people from them.[38] Such "tiny" acts of violence occur in the instances "where we're deciding who of us belongs in this dyke space, who belongs in the queer women/trans men space—and doing it by gendering a body without consent."[39] The labors of such transfeminine and trans women artists, who have continually negotiated and sought to transform the biological determinism and gynocentrism of cultural and artistic spaces, are often invisible but necessary acts of resistance that challenge the foreclosures inherent in essentialist feminisms. These foreclosures are sometimes inherent even within "queer and trans" cultural spaces, against which transfeminist artists enact what T. L. Cowan calls "the transfeminist kill/joy," or "a set of proliferating

dialectics expressed as the rage that comes into being through living the violent effects of transphobia and transmisogyny and the practice of transformational love as a struggle for existence."[40]

These transfeminist acts of resistance also include curatorial and historical alternatives that have taken the form of curatorial experiments and alternative modes of historicization. Works by transgender artists, artist-curators, and their colleagues and friends have not only prioritized and contextualized work in profound ways, but also reinvented the capacities of exhibition spaces, discursive spaces, and presentation models to respect self-determination and creative experimentation alike.[41] One such example of world-making is the Museum of Transgender Hirstory and Art (MOTHA), founded by artist Chris E. Vargas.[42] MOTHA reimagines the world of the museum and its role in the reproduction of social life. It is an imagined multi-platform entity that sometimes pursues concrete projects hosted in physical museum spaces, with propositions whose prefigurative possibilities appear simultaneously realist and ludic. Its founding activities included a MOTHA Resident Artist Program, which "takes into account the hectic life of the struggling, yet dedicated, trans artist and makes no demands or promises on their time."[43] Like the museum itself, MOTHA's residency has no actual physical site, but rather acts parasitically in other museums.

While Vargas's museum engages the production, exhibition, and acquisition of artworks, the accumulation of cultural value is not its primary purpose. In an age of museums designed by celebrity architects as tourist destinations, MOTHA's primary architecture is instead "one giant bathroom," a gender-neutral but full-spectrum series of toilets from which a visitor can self-select or, if they cannot yet commit to an identity or pronoun, explore their uncertainty—thereby opening the museum as a space for unlimited gender exploration. MOTHA also features a café called Compton's Café (in honor of the 1966 uprising at Compton's Cafeteria in San Francisco, where trans women revolted against police brutality and harassment) that serves "top notch affordable queer and transgender food" aimed at complementing herbal or pharmacological transitions, in addition to sliding-scale community options.[44] MOTHA, at present, plans to expand by way of a themed restaurant in Cherry Grove, the queer and trans artist colony on Fire Island, New York. Additional satellite locations, themed restaurants, and casinos are destined to multiply around the world.

MOTHA's hyperbolic reimaging of the museum cannibalizes the post-1990s expansionist project of so many globalizing museums and their entanglement with luxury markets, entertainment, and mass commerce. Theorist Thomas Keenan and curator John Hanhardt have discussed this contemporary state of affairs as marking the end of the museum as a democratic project of the Enlightenment.

Chris E. Vargas, *MOTHA Executive Address,*
Chapter 2, 2014. HD video and performance;
5 min. Courtesy the artist

They describe the ends, aspirations, and ethos of the contemporary museum as
riven with internal conflicts, and complicities with capitalism and colonization
as the museum's foundational premise.[45] Vargas joins this fray, conceptualizing
MOTHA's history of art as a history written not only by victorious men but by
various peoples, animals, and beings of planetary experience. As a promotional
poster for MOTHA states, it is a museum of "... brownstory gaystory earthstory
... meowstory ..."[46] This range of geologic, racialized, gendered, and animal sig-
nifiers implicitly refutes the discourse of the museum as a sovereign humanist
enterprise, instead proposing that the life of the museum is fundamentally con-
nected to all forms of animate existence across spectrums of human experience
and nonhuman sentience.

JEANNINE TANG

"Pronoun Showdown" poster, MOTHA, 2015.
Digital graphics, 11 × 17 in (27.9 × 43.2 cm).
Courtesy Chris E. Vargas

While MOTHA is, in part, concerned with the production and acquisition of culture, it is especially concerned with the domains of social reproduction on which cultural work depends—cafés, residencies, and bathrooms—that are systems of subsistence, care, support, and waste. If art historians Alexander Alberro and James Meyer referred to art of the 1990s as a way out of institutional critique—theorizing art that operated on dual fronts, immanently critiquing a moribund cultural apparatus while simultaneously engaging other institutions of the public sphere[47]—artists such as Vargas dissolve this very distinction between cultural and other institutions, working in the wake of earlier feminist forms of institutional critique that would emphasize the dependence of cultural production on social reproduction.[48] When MOTHA explicitly addresses museological practices and concerns, it redefines the traditional modes of exhibition and collection. For instance, MOTHA's blog warns other museums of its upcoming intervention into their collections built on colonial seizure, stating: "Other museums be warned: MOTHA is evolving, and soon no collection will be safe from our Acquisitions & Repatriations Department—which we will establish any day now."[49] MOTHA points to the difference that feminist political scientist Kathy E. Ferguson has discerned between bureaucracy (the reproduction of the organization) and administration (devoted to the reproduction of social life chances).[50] With this distinction, we might not imagine the institution as a closed or discursive entity, but as an assemblage that is internally differentiated and constituted by multiple infrastructures of relation.

TOWARD TRANSFEMINIST INFRASTRUCTURES AND AESTHETICS

To conceptualize the role of infrastructure in the critical transgender politics of contemporary art, I turn to theorist Angela Mitropoulos's definition of infrastructure as a form of social relation. For Mitropoulos, infrastructure comprises not only forms of transportation, communication, and logistics, but also everyday forms and patterns of contact and access.[51] Infrastructures are, in her words, "how worlds are made, how forms of life are sustained and made viable."[52] Mitropoulos's turn toward infrastructure offers a different model of relation from liberal-democratic regimes (that prioritize "identity, demands, promises, rights and contracts"); instead, infrastructure points to how "knots of attachment, adherence, care or fondness" are tied, but never incontestably, by kinship, race, money, sexuality, nationality, and other assemblages.[53] Infrastructures are pliable and not static; they scaffold how we attach or adhere to, or care or

experience fondness for, one another. We flex, reinterpret, and scale these infra-structures to the needs of those we encounter and, in so doing, change the very weave of infrastructures themselves. As Mitropolous puts it, "Infrastructure is the undercommons—neither the skilled virtuosity of the artisan, nor regal damask, nor the Jacquard loom that replaced, reproduced and democratised them, but the weave."[54]

The intimacies of our experiences and the capaciousness of our desires expand upon and rework infrastructure itself, rescript it away from intimate self-management under capitalism. However, Mitropolous points out how even intimate infrastructures may issue from possessive individualism, based on lib-eral notions of equality and hierarchy that constitute "*oikonomia*, the law of the household."[55] An effect of this is the scripting of agreements between peoples as "properties-in-self" (contracts, for instance, are exemplary of the management of relational uncertainty and allocation of risk). Instead of a politics based on re-lationships of contract, or a politics based on modern divisions of the household—such as separations between *oikos* and politics, male and female, slave and free, man and animal—Mitropoulos proposes a politics of infrastructure that would queer these relationships, render them promiscuous, a politics in which infra-structure is produced for and by subalterns within the tissue of their sociality.

I summon this notion of infrastructure in light of how cultural institutions and their infrastructures often are not scaled for prioritizing the lives, work, and memory of transgender individuals (to which projects by Vargas and others re-spond). The valences of trans social reproduction have been incisively articulated by Reina Gossett in her work as a community historian of pivotal drag queens and transgender individuals around the 1969 rebellion at the Stonewall Inn in New York City. This recovery is, by its nature, a difficult process: she emphasizes "the physical violence that stops some trans women from ever becoming elders. This historical violence elevates some lives, names them as important to know through their tragic deaths while erasing the lives & legacies of others."[56] Reina Gossett's research has made increasingly clear how both Marsha P. Johnson and Sylvia Rivera were fundamental to the founding of the Gay Liberation Front, before being forced out by conservative liberalizing impulses in the movement. Johnson and Rivera's foundational antipolicing, anti-prison, welfare and shelter organizing were replaced with more conservative LGB organizing that focused on legal rights rather than structural economic reforms. The artifacts that Reina Gossett draws on to reconstruct this history are often limited; she has critically observed how public and LGB-specific repositories rarely prioritize saving ma-terials related to transgender artists. Rather, these materials are, in her words,

"accidentally archived"[57]—sometimes within the records of people who, in life, opposed the efforts of the trans people involved.

How, then, does one work with these scant traces of trans elders within the conditions of neglect and alienation that shaped their lives and the surviving artifacts of their cultural heritage? Reina Gossett's work points to a way forward, as a project that does not constitute a reparative impulse that would seek to insert, repair, and replace absences within a historical narrative that is structured by evictions. Instead, her polymath art embodies a *transformative* impulse: working across numerous platforms and genres, her efforts have included podcasts, lecture performances, and Tumblrs such as *40 Days* and *The Spirit Was ...* that excavate trans and cultural histories, provide critical views on contemporary trans political issues, and distribute collectively sourced funds to trans people who are experiencing violence and need resources, support, and care. Her art is the work of a public intellectual that, in Stanley's words, forms an "insurgent trans study that refuses its own complicity in the brutality of exclusion."[58]

In doing so, the collectivizing and activist aspects of Reina Gossett's work lie alongside other transfeminist projects that battle brutality to emphasize the critical need to care for other trans people in rich and variant ways. micha cárdenas importantly called for a "free safety movement"—adapting the "free software movement"—in the wake of many people's recognition that the "Internet era has not brought about more safety, but less."[59] cárdenas's call to "hack safety" encompasses collaborations between artists, designers, activists, and hackers to produce networked technological devices that enable people to summon their own personal networks for help and empower bystanders to step in to avert the onset of violence. Crucially, these safety devices would be affordable, maintain the privacy of both their users and the persons involved, and center the needs of those most targeted and most intensely affected by violence—namely, transgender women of color, sex workers, and people living with disabilities.[60] Or we might also consider the crowdsourcing platform organized by Grace Dunham, Blaine O'Neill, and Rye Skelton to raise money for incarcerated transgender people.[61]

These pragmatic, infrastructural interventions have aesthetic effects, working upon our sense of what lives might be desirable, possible, cherished, and loved. They are dually aesthetic in their visual dimensions, in their attention to color, fashion, and beauty, dimensions not opposed to infrastructure but fundamental to it. It is important to note that, since the nineteenth century, the aesthetic and the infrastructural have been entangled in the US in ways that perpetuate modern state violence. Earlier laws against cross-dressing justified the arrest and incarceration of people for wearing clothing not of their presumed and assigned gender identity. Some of these same techniques persist in

contemporary policing tactics that violently target trans people based on perceptions of sexualized flamboyance and gender nonconformity.[62]

These techniques of surveillance and criminalization depend on the perception of aesthetic effects. Therefore, it is important that artists such as Gossett do not refute the aesthetic in their pragmatism, but embrace it as a space of improvisation, feeling, and glamour, including it within—rather than evicting it from—forms of institutional and infrastructural critique.[63] I emphasize this in light of how sections of the art world dismiss glamour for its allure and putative deceptiveness: such judgments interpret certain kinds of performances (quoting forms of entertainment, utilizing pleasure, or engaging the body explicitly) as pornographic or superficial; denigrate the explorations of surface, style, and fascination as trivial, frivolous, or irrelevant; and disdain queer and transgender glamour as dissonant, deceitful, monstrous, or contradictory, particularly within more refined spaces of high art.

We might instead continue to learn from transfeminist art practices such as Gossett's that foreground the vastly different structural conditions for trans and queer aesthetic embodiment. Her work points to how the improvisation of aesthetic genres of glamour might be a site of historical quotation and experiment, audacious pleasure, pragmatic necessity, community recognition, and interpretation. Dwelling with glamour is often denigrated by forms of Marxist critique (which prioritizes defamiliarization, distance, and the anti-aesthetic), but such dismissals risk reproducing a dangerous and transphobic discourse of erotophobia as critique. Such forms of analysis exist even within feminism—in feminist suspicions of artifice and in transphobic metaphors of transvestism as a signifier of deception and falsity—when critics try to differentiate the truly critical position or person from imposters.[64]

This discourse of erotophobia is lived to violent effect within the gallery, at school, and on the street. It participates in the broader stigmatization of survival sex work, poverty, nonnormative gender presentation, access to wearable clothing, and the pursuit of complex forms of desire. Against such punitive forms of critique, I wish to consider the most bewitching of aesthetic genres—glamour—as a critical modality by way of *Happy Birthday, Marsha!* (2018), a film by Reina Gossett in collaboration with Sasha Wortzel. The film narrates the hours prior to the famous 1969 rebellion at the Stonewall Inn, where drag queens and trans women fought back against the protracted forms of police brutality they endured, barricading the cops in the bar. Legend has it that the first shot glass was thrown by Marsha P. Johnson, a longtime activist who, with Sylvia Rivera, notably forged the resistance that surrounded this event. *Happy Birthday, Marsha!* imagines the hours before Sylvia and Marsha's appearance at the Stonewall Inn,

after a birthday party for Marsha that nobody attends. Disheartened, Marsha goes to the bar as the historic event unfolds.

Reina Gossett and Wortzel's film actively adopts the language of glamour circa 1969 through its use of cinematography, soft-focus and tinted camera filters, period typography and costuming, and score by artist Geo Wyeth. Gossett and Wortzel set out, from the very beginning, to make a luscious film as a form of aesthetic resistance to the ways in which trans bodies are so frequently featured on camera as mangled and murdered, their scenes often captured with lower production values, their characters presented as caricatures, tropes, or scenography. In opposition to such depictions, in *Happy Birthday, Marsha!* the camera lingers on the faces of its characters; its slow pans focus lovingly on the grace of each gesture and capture the beloved objects and animals of a household.

Depicting the social familiarities of transfeminine friendships, Gossett and Wortzel's film details an affective landscape of intimate transgender social life. Its glamour quotes and reworks the street queens' own grammar of flamboyant femininity, wordplay, and camp, which constituted their liberation aesthetics. These aesthetics have been consumed as pageantry and spectacle in films such as *Paris Is Burning* (1990), but, when lived on the street rather than on the screen, such aesthetics were violently rejected by conservative impulses within LGB movements in the 1990s and 2000s and, in the last few years, have been increasingly used as a justification for murder when embodied by trans people. As Gossett has pointed out, "Those of us on the receiving end know what glamour as a slur is meant to do, who accusations of glamour are used against."[65]

Happy Birthday, Marsha! is not glamour used against but for: glamour as an optics of loving looks between queer and trans women. Indeed, even as Gossett and Wortzel worked with costume specialists, the lead actresses playing the various roles had input into the stylization of their characters. The film offers glamour as an event and an opening into how aesthetic embodiment sutures acts of complex signification, while moving across domains of street space and psychic life, fiction and history. Here, glamour is a set of operations upon forms of life and living: its aesthetics of allure, mutability, gorgeousness, and fascination are notably invoked by the film's exploration of visual splendor. Yet the film also resonates with how glamour has been historically entwined with language, transmission, and knowledge (whether in bohemian cafés, underground clubs, or books of sorcery), endowed with the powerful capacity to, in the words of Judith Brown, "shape and reshape the objects before us."[66]

The glamour of this film is pedagogical, an affective mapping of what Ruth Gilmore has termed "an infrastructure of feeling," which describes the affects emerging from the prison industrial complex—such as expectations of safety and

JEANNINE TANG

protection—that also serve to hold its material domains in place.[67] The operative infrastructure of trans feeling in *Happy Birthday, Marsha!* might offer a response to José Esteban Muñoz's crucial question—"How does the subaltern feel? How might subalterns feel each other?"—by considering what Muñoz describes as the different "frequencies on which certain subalterns speak and are heard or, more importantly, felt."[68] Most of the film consists of quiet, conversational scenes between trans women in groups or pairs, who are rarely shown in art and cinema within structures of kinship and familial affection (in this regard, *Happy Birthday, Marsha!* provides a decisive contribution to the history of trans cinema). In a pivotal scene in which Marsha realizes that nobody showed up to her birthday party, the camera cuts back and forth between Johnson in her cozy living room and Rivera on the telephone in a gray stairwell. She soothes Marsha's wounded feelings, even as she herself seems exhausted and crabby from having endured a long day. The tone of the scene is amplified by the anchor setting of Johnson's living room, decorated with party accoutrements, trinkets, and cats—artifacts of cherished femininity and festivities that are lovingly beheld by the camera. We are drawn proximate to the nuances of the characters' weary, bitchy, affectionate conversation, as the camera's close-ups solicit the interiority of kinship striated by fatigue, forgetfulness, disappointment, forgiveness, and immense tenderness.

Morgan Bassichis, Alexander Lee, and Dean Spade have argued that "[i]n an age when thousands of people are murdered annually in the name of 'democracy,' millions of people are locked up to 'protect public safety,' and LGBT organizations march hand in hand with cops in Pride parades, being impossible may just be the best thing we've got going for ourselves: *Impossibility may very well be our only possibility.*"[69] *Happy Birthday, Marsha!*'s heightened moods of glamour make us feel the impossible as something present, tender, and viable, bringing abolitionist desires for alternatives to imprisonment and debt one step closer, by way of what Bassichis, Lee, and Spade have called "the nourishing possibilities dreamed of and practiced by our ancestors and friends."[70] The glamour of Sylvia and Marsha is here a kind of affective mapping of what it's like to hold on to life and stay with it: each promise kept, each phone call answered, each gesture of forgiveness and staying with is a moment of aesthetic transformation within the natal alienation that structurally underpins black and transgender lives under racial capitalism. In this infrastructure of feeling, chosen family is sutured, seam by seam, into a discourse of impossible love that is lived every day, up close and at a distance.

Reina Gossett and Sasha Wortzel, *Happy Birthday,
Marsha!*, 2018 (still). Video, sound, color.
Courtesy Reina Gossett and Sasha Wortzel. Image:
© Reina Gosett and Sasha Wortzel

JEANNINE TANG

Reina Gossett and Sasha Wortzel, *Happy Birthday,*
Marsha!, 2018 (still). Video, sound, color.
Courtesy Reina Gossett and Sasha Wortzel. Image:
© Reina Gosett and Sasha Wortzel

"Contemporary Art and Critical Transgender Infrastructures" by art historian Jeannine Tang was first delivered as a lecture titled "Aesthetic Infrastructures: Contemporary Art and Critical Transgender Politics" at Goldsmiths, University of London, on February 23, 2016, and was revised and expanded for publication in this volume.

NOTES

1. The works, programs, and artists I am referring to here are: the performance of Antony and the Johnsons' *Swanlights* (2010), commissioned by the Museum of Modern Art, New York, and presented at Radio City Music Hall, January 26, 2012; the screening of a version of Eric A. Stanley and Chris E. Vargas's film *Criminal Queers* that was presented by Jeannine Tang and Reina Gossett with Stanley and Vargas as part of "Love Revolution, Not State Collusion," a public program at the New Museum, New York, June 7, 2012; Wu Tsang's screenings and the installation *GREEN ROOM* at the 2013 Whitney Biennial, New York; Geo Wyeth's participation in Studio Lab (May 16, 2014) and niv Acosta's performance program *Courtesy the Artists: Songs of the Civil War* (June 7, 2014), both at the Studio Museum in Harlem.

2. A sampling of this attention includes: Holland Cotter, "The Artist and the Work, Both Intricate and Fluid: 'Greer Lankton,' a Retrospective at Participant Inc.," *New York Times*, December 4, 2014, http://www.nytimes.com/2014/12/05/arts/design/greer-lankton-a-retrospective-at-participant-inc.html; David Getsy and Jennifer Doyle, "Queer Formalisms: Jennifer Doyle and David Getsy in Conversation," *Art Journal*, March 31, 2014, http://artjournal.collegeart.org/?p=4468; and Grace Dunham, "The 'Terrorist Drag' of Vaginal Davis," *New Yorker*, December 12, 2015, http://www.newyorker.com/culture/culture-desk/terrorist-drag-vaginal-davis.

3. "Salon: Transgender in the Mainstream," panel, Art Basel, Switzerland, December 5, 2015, https://www.youtube.com/watch?v=zsHXmS1jJYE. The panel was moderated by William J. Simmons and featured presentations by Kimberly Drew, David Getsy, Gordon Hall, and Juliana Huxtable. All panelists criticized the panel's presumption of a link between transgender and the concept of a mainstream; for instance, Huxtable remarked, "On one hand, you have the idea of transgender or gender variance being more emergent. ... But I don't think that necessarily goes hand-in-hand with what being in the mainstream signifies— which is power, financial resources, presence, institutional influence, dialogues ..."

4. Artist and archivist Leeroy Kun Young Kang included an earlier version of these statistics in his introduction to a program of Christopher Lee's films at UnionDocs Center for Documentary Art in New York on July 22, 2015, connecting Lee's individual film practice and circumstances to broader systemic patterns of queer and transgender health. This essay runs parallel to such forms of analysis. See "Through His Documents: Remembering Christopher Lee," UnionDocs, accessed July 23, 2016, http://www.uniondocs.org/2015-07-22-remembering-christopher-lee/.

5. Osman Ahmed and Chai Jindasurat, "Lesbian, Gay, Bisexual, Transgender, Queer, and HIV-Affected Hate Violence in 2014," National Coalition of Anti-Violence Programs, accessed July

23, 2016, http://www.avp.org/storage/documents/Reports/2014_HV_Report-Final.pdf. My thanks to Dani Hefferman for these statistics and for discussing them with me.

6. Ibid., 9–10, 35–36.

7. Ibid., 9–10.

8. Ibid., 8–9.

9. See "IDAHOT 2016—Trans Murder Monitoring Update," *Trans Murder Monitoring Project*, May 12, 2016, http://transrespect.org/en/idahot-2016-tmm-update/.

10. Ibid.

11. Jen Richards, "Op-Ed: It's Time for Trans Lives to Truly Matter to Us All," *Advocate*, February 15, 2015, http://www.advocate.com/commentary/2015/02/18/op-ed-its-time -trans-lives-truly-matter-us-all.

12. Dawn Ennis, "REPORT: 2016 Is the Most Dangerous Year for Transgender Americans," *Advocate*, February 22, 2016, http://www.advocate.com/transgender/2016/2/22/report -2016-most-dangerous-year-transgender-americans.

13. Summer Luk, "New Report Shows Rise in Anti-Transgender Legislation in 2016," *GLAAD*, February 23, 2016, https://www.glaad.org/blog/new-report-shows-rise-anti-transgender -legislation-2016.

14. Stephen Peters, "New HRC Report Reveals Unprecedented Onslaught of State Legislation Targeting Transgender Americans," *Human Rights Campaign*, February 22, 2016, http://www .hrc.org/blog/new-hrc-report-reveals-unprecedented-onslaught-of-state-legislation-targeti.

15. Zackary Drucker with A. L. Steiner, "Destabilizing a Destabilized Existence," panel, Shares & Stakeholders: The Feminist Art Project, College Art Association Annual Conference, Museum of Contemporary Art, Los Angeles, February 25, 2012, accessed July 23, 2016, https://vimeo.com/49815420.

16. For Che Gossett—and the history of black feminism that they cite—feminism and transgender politics are joint projects of resistance toward antiblackness, anti-transness, and capitalism. These projects of world-building cultivate forms of relation that are defined neither by logics of incarceration nor by settler-colonial concepts of innocence and safety. Che Gossett and Reina Gossett, "Interview with Che Gossett and Reina Gossett," *Mask*, no. 15: The Crossing Paths (April 2015), http://www.maskmagazine.com/the-crossing-paths -issue/life/che-and-reina-gossett.

17. Linda Nochlin, "Why Have There Been No Great Women Artists?," in *Woman in Sexist Society: Studies in Power and Powerlessness*, ed. Vivian Gornick and Barbara Moran (New York: Basic Books, 1971), 480–510.

18. In particular, I am thinking of Lia Gangitano's gallery PARTICIPANT INC; curators such as Thomas Lax and artist-curators Emily Roysdon and Tobaron Waxman (the latter working on a book of interviews with trans women artists such as Nina Arsenault and Raafat Hattab); hybrid artist-documentarian projects such as Amos Mac's Original Plumbing and Chris E. Vargas's Museum of Transgender Hirstory and Art; theorists and historians such as Johanna Burton, Jennifer Doyle, David Getsy, Dominic Johnson, Tirza Latimer, Tavia Nyong'o, Julia Bryan-Wilson, and the late José Esteban Muñoz; artist-teachers such as Gregg Bordowitz, Vaginal Davis, Andrea Geyer, Sharon Hayes, and Mary Kelly; and art schools such as Parsons School of Design, the Cooper Union, UCLA, and the School of the Art Institute of Chicago.

19. Che Gossett, "Pulse, Beat, Rhythm, Cry: Orlando and the queer and trans necropolitics of loss and mourning," blog post, *Verso*, July 5, 2016, http://www.versobooks.com/blogs/2747 -pulse-beat-rhythm-cry-orlando-and-the-queer-and-the-trans-necropolitics-of-loss-and-mourning.

20. Ibid.

21. Here I refer to organizations such as APICHA Community Health Center, Callen-Lorde Community Health Center, Sylvia Rivera Law Project, Audre Lorde Project, the Trans Justice Funding Project, and others whose services have—quite literally—kept many artists alive.

22. Howard Singerman, *Art Subjects: Making Artists in the American University* (Berkeley: University of California Press, 1999), 204.

23. Pierre Bourdieu, *Distinction: A Social Critique of the Judgment of Taste*, trans. Richard Nice (Cambridge, MA: Harvard University Press, 1984), 170.

24. Ibid., 12.

25. Dean Spade, "Be Professional!," *Harvard Journal of Law and Gender* 33, no. 1 (Winter 2010): 71–84.

26. Chris E. Vargas and Greg Youmans, "Work of Art! Reality TV Special," *Falling in Love … with Chris and George*, 2012, HD video, sound, color; 14 min, accessed July 24, 2016, http:// fallinginlovewithchrisandgreg.com/pages/WorkofArt.html.

27. Anna Chave, "Minimalism and Biography," *Art Bulletin* 82, no. 1 (March 2000): 149–63.

28. Silver Platter opened in 1963, and anecdotal accounts have traced the transgender patronage of the bar to the 1970s. See Jamilah King and Jorge Rivas, "At SXSW, an Honest Look at a Latina Transgender Bar in Transition," *Colorlines*, March 9, 2012, http://www .colorlines.com/articles/sxsw-honest-look-latina-transgender-bar-transition.

29. There have been a small number of insightful scholarly treatments of this film. See, for example, the consideration of *Wildness*'s cinematic context in Eve Oishi, "Reading Realness: *Paris Is Burning*, *Wildness*, and Queer and Transgender Documentary Practice," in *A Companion to Contemporary Documentary Film*, ed. Alexandra Juhasz and Alisa Lebow (Malden, MA: Wiley-Blackwell, 2015), 252–70; and Dean Spade, "*Wildness*," *make/shift: feminisms in motion*, no. 9 (Spring–Summer 2011): 28–29. Spade notably presents *Wildness* as an alternative to other documentaries that purportedly define "transgender experience," the latter presenting transgender subjectivity in normative ways that Spade criticizes for being "sensationalist, individualizing, depoliticizing redemption narratives."

30. As art historian Thomas E. Crow notes in his writing on artistic life in the eighteenth century (when reception and publicity for one's work became crucial—facts that still resonate today), "artists today live on critical attention—and can die professionally from the lack of it." Thomas E. Crow, "The Salon Exhibition in the Eighteenth Century and the Problem of its Public," in *Painters and Public Life in Eighteenth-Century Paris* (New Haven, CT: Yale University Press, 1985), 11.

31. Earlier incarnations of Bond's website included a "User's Guide" for critics and curators that listed the artist's chosen prefix as "Mx," chosen pronoun as "v," and gender as "trans" (not "trans man," nor "trans woman," but "trans") Bond's website has since been updated and no longer features this guide. However, the guide was an important document that inspired many other artists and critics; see, for example, Chris Mosier, "My Inspiration: A User's

JEANNINE TANG

Guide," *Original Plumbing*, accessed February 12, 2013, http://www.originalplumbing.com /index.php/society-culture/surviving/item/458-my-inspiration-a-users-guide; and Johanna Burton, "Justin Vivian Bond at Participant Inc," *Artforum* (February 2012): 227–28. For v's current website, see http://www.justinvivianbond.com/.

32. Carl Swanson, "The Story of V," *New York* magazine, May 8, 2011, http://nymag.com /arts/popmusic/features/justin-bond-2011-5/. Bond's critical corrective to Swanson's article, "Notes on the Story of V," was previously posted to v's website on May 10, 2011, but it is no longer available. For coverage of Bond's response to Swanson, see "Justin Bond on Why Else That New York Story Pisses V Off," *Papermag*, May 10, 2011, http://www.papermag.com /justin-bond-on-why-else-that-new-york-story-pisses-v-off-1425752662.html.

33. For his account of Beethoven's late work, see Edward Said, "Timeliness and Lateness," in *On Late Style: Music and Literature Against the Grain* (New York: Vintage Books, 2007), unpaginated.

34. Stefano Harney and Fred Moten, *The Undercommons: Fugitive Planning & Black Study* (Brooklyn, NY: Autonomedia, 2013), 112. See also Moten's formulation of this concept in the context of blackness and nothingness as a project of black optimism; Fred Moten, "Blackness and Nothingness (Mysticism in the Flesh)," *South Atlantic Quarterly* 112, no. 4 (Fall 2013): 737–80 (esp. 737–38 and 774).

35. Dean Spade, *Normal Life: Administrative Violence, Critical Trans Politics and the Limits of Law* (Boston: South End Press, 2009; repr., Durham, NC: Duke University Press, 2015), 11.

36. Ibid., 41.

37. Here I follow Louis Althusser's use of the term "interpellation" as "the constitutive process where individuals acknowledge and respond to ideologies, thereby recognizing themselves as subjects." Louis Althusser, "Ideology and Ideological State Apparatuses (Notes towards an Investigation)," in *Lenin and Philosophy and Other Essays* (New York: Monthly Review Press, 1972), 174.

38. Reina Gossett and Tuesday Smillie, "In Conversation: Reina Gossett and Tuesday Smillie," *Randy*, no. 3 (2012): 14–15. The text to which they refer is Eric A. Stanley, "Near Life, Queer Death: Overkill and Ontological Capture," *Social Text* 107 (Summer 2011): 1–19.

39. Gossett and Smillie, "In Conversation: Reina Gossett and Tuesday Smillie." While the spaces to which they refer include spaces of activism and historically lesbian cultural spaces (such as the New York City Dyke March or the Lesbian Herstory Archives), contemporary art spaces form a subtext of their conversation.

40. T. L. Cowan, "Transfeminist Kill/Joys: Rage, Love, and Reparative Performance," in "Trans Cultural Production," special issue, *Transgender Studies Quarterly* 1, no. 4 (November 2014): 501, doi: 10.1215/23289252-2815201.

41. For example, in the 1990s at the Clit Club in New York City, Julie Tolentino and Clit Club organizers befriended trans women who came to the bar, crafting a space that was simultaneously a sex club, a performance space, a safe haven for minors and youth, and a shield for sex workers during police raids. For accounts of the curatorial work of Jordy Jones and others, see Julian B. Carter, David J. Getsy, and Trish Salah, eds., "Trans Cultural Production," special issue on cultural production, *Transgender Studies Quarterly* 1, no. 4 (November 2014), doi: 10.1215/23289252-2815183; and Jeanne Vaccaro and Stamatina

Gregory, *Bring Your Own Body: transgender between archives and aesthetics* (New York: Cooper Union, 2015), accessed July 23, 2016, http://cooper.edu/sites/default/files/uploads/assets /art/files/2015/BYOB-catalogue_sm.pdf, catalog to the exhibition of the same name curated by Vaccaro with Gregory at 41 Cooper Gallery, The Cooper Union, New York, from October 13 through November 14, 2015. See also Stamatina Gregory and Jeanne Vaccaro, "Canonical Undoings: Notes on Trans Art and Archives," on page 349 of this volume.

42. For more on MOTHA, see Chris E. Vargas, "Introducing the Museum of Transgender Hirstory and Art," on page 121 of this volume.

43. "Announcing MOTHA Resident Artist: Tuesday Smillie," SFMOTHA, September 17, 2014, http://www.sfmotha.org/post/97758155025.

44. Chris E. Vargas, *MOTHA Executive Director Address, Chapter 5*, video, 4:14 min, *vimeo*, accessed August 14, 2016, https://vimeo.com/148670214.

45. John G. Hanhardt and Thomas Keenan, eds., *Els límits del museu* (Barcelona: Fundació Antoni Tàpies, 1995). This catalog accompanied the exhibition "The End(s) of the Museum," curated by Hanhardt and Keenan, at Fundació Antoni Tàpies, Barcelona, from March 15 to June 4, 1995.

46. "Pronoun Showdown" (poster for Museum of Transgender Hirstory and Art), SFMOTHA, September 5, 2015, http://www.sfmotha.org/image/128423492400.

47. See Alexander Alberro, "Institutions, Critique, and Institutional Critique," in *Institutional Critique: An Anthology of Artists' Writings*, ed. Alexander Alberro and Blake Stimson (Cambridge, MA: MIT Press, 2010), 2–19; and James Meyer, *What Happened to the Institutional Critique?* (New York: American Fine Arts, Co. and Paula Cooper Gallery, 1993), reprinted in *Kontext Kunst*, ed. Peter Weibel (Cologne: Dumont, 1993), 239–56.

48. For earlier work engaged with institution and infrastructure, production and reproduction, see Mierle Laderman Ukeles, "Maintenance Art Manifesto, Proposal for an Exhibition, '*CARE*,'" in *Conceptual Art: A Critical Anthology*, ed. Alexander Alberro and Blake Stimson (Cambridge, MA: MIT Press, 1999), 122–25; and Andrea Fraser, "*Psychoanalysis* or *Socioanalysis*: Rereading Pierre Bourdieu," *Texte zur Kunst* (December 2007): 139–50.

49. Chris E. Vargas, "Disembodied States: PRESS RELEASE," *Open Space*, San Francisco Museum of Modern Art, April 27, 2016, http://openspace.sfmoma.org/2016/04 /disembodied-states-press-release/.

50. Kathy E. Ferguson, *The Feminist Case Against Bureaucracy* (Philadelphia: Temple University Press, 1985).

51. Angela Mitropoulos, "Infrastructure, Infra-Politics," in *Contract and Contagion: From Biopolitics to Oikonomia* (Wivenhoe, UK, and New York: Minor Compositions, 2012), 116.

52. Ibid., 118.

53. Ibid.

54. Ibid.

55. Ibid., 30.

JEANNINE TANG

56. Reina Gossett, "Happy Birthday Marsha 'Pay It No Mind' Johnson!," *Crunk Feminist Collective*, accessed July 23, 2016, http://www.crunkfeministcollective.com/2013/06/27 /happy-birthday-marsha-pay-it-no-mind-johnson/.

57. "A lot of the lives of trans people of color—specifically trans women of color, drag queens of color, people who identified as transvestites, transsexual—were only accidentally archived." Reina Gossett, quoted in Thomas Page McBee, "Why Tumblr Is Perfect for the Trans Community," *Buzzfeed*, May 31, 2013, https://www.buzzfeed.com/thomaspagemcbee /why-tumblr-is-perfect-for-the-trans-community/.

58. Tom Boellstorff, Mauro Cabral, micha cárdenas, Trystan Cotten, Eric A. Stanley, Kalaniopua Young, and Aren Z. Aizura, "Decolonizing Transgender: A Roundtable Discussion," in "Decolonizing the Transgender Imaginary," special issue, *Transgender Studies Quarterly* 1, no. 3 (August 2014): 425–26, doi: 10.1215/23289252-2685669.

59. micha cárdenas, "From a Free Software Movement to a Free Safety Movement," *Mute*, July 10, 2013, http://www.metamute.org/editorial/lab/free-software-movement-to-free -safety-movement.

60. Ibid. For more on cárdenas's project #stronger, see micha cárdenas, "Dark Shimmers: The Rhythm of Necropolitical Affect in Digital Media," on page 161 of this volume.

61. Diana Tourjee, "The People Making a Crowdfunding Platform for Incarcerated Trans People," *Vice*, July 11, 2016, https://broadly.vice.com/en_us/article/the-people-making-a -crowdfunding-platform-for-incarcerated-trans-people?utm_source=broadlytwitterus.

62. For the history of how criminal profiling has targeted gender nonconforming and transgender people, see Joey L. Mogul, Andea J. Ritchie, and Kay Whitlock, eds., *Queer (In) Justice: The Criminalization of LGBT People in the United States* (Boston: Beacon Press, 2010); and Susan Stryker, *Transgender History*, Seal Studies (Berkeley, CA: Seal Press, 2008).

63. "Official Trailer for *Happy Birthday, Marsha!*," *Happy Birthday Marsha*, accessed July 23, 2016, http://www.happybirthdaymarsha.com/.

64. See, for example, Craig Owens, "Outlaws: Gay Men in Feminism," in *Beyond Recognition: Representation, Power, and Culture*, ed. Scott Bryson, Barbara Kruger, Lynne Tillman, and Jane Weinstock (Berkeley: University of California Press, 1992), 218–38.

65. Reina Gossett's Facebook page, posted February 12, 2016, https://www.facebook.com /reinagossett/.

66. Judith Brown, *Glamour in Six Dimensions: Modernism and the Radiance of Form* (Ithaca, NY: Cornell University Press, 2009), 9.

67. Ruth Gilmore, introduction to *Prison/Culture*, ed. Sharon E. Bliss, Kevin B. Chen, Steve Dickison, Mark Dean Johnson, and Rebeka Rodriguez (San Francisco: City Lights Foundation Books, 2009), unpaginated. Gilmore outlines the infrastructure of feeling thusly: "Infrastructure: labor, land, financing, and the general organizational capacity to combine these things in order to make other things, in general, easier to make. While not always public, it is the form of most public wealth. Prisons are a monumental aspect of the ghastly public infrastructure underlying a chain of people, ideas, places, and practices that produce premature death the way other commodity chains crank-out shoes or cotton or computers. Why don't our heads burst into flames at the thought? Why is the prison-industrial complex so hard to see? The many structures that make carceral geographies disappear (which is to say, become ordinary) depend, for their productive capacity, on the

infrastructure of feeling. To affect what lies beneath these structures, wherever it might be in space and time, requires radical revision. By turning what becomes ordinary towards the extraordinary, our expressive (and explanatory) figurative works cause what disappears to be visible, palpable, present here and now."

68. José Esteban Muñoz, "Feeling Brown, Feeling Down: Latina Affect, the Performativity of Race, and the Depressive Position," in "New Feminist Theories of Visual Culture," special issue, *Signs* 31, no. 3 (Spring 2006): 677. "Affect is not meant to be a simple placeholder for identity in my work. Indeed, it is supposed to be something altogether different; it is, instead, supposed to be descriptive of the receptors we use to hear each other and the frequencies on which certain subalterns speak and are heard or, more importantly, felt. This leaves us to amend Gayatri Chakravorty Spivak's famous question, 'Can the subaltern speak?' (1988, 1999) [*sic*] to ask How does the subaltern feel? How might subalterns feel each other?"

69. Morgan Bassichis, Alexander Lee, and Dean Spade, "Building an Abolitionist Trans and Queer Movement with Everything We've Got," in *Captive Genders: Trans Embodiment and the Prison Industrial Complex*, ed. Eric A. Stanley and Nat Smith (Oakland, CA, and Edinburgh: AK Press, 2011 and 2015), 36.

70. Ibid.

PUBLICATION HISTORY

The following list includes publication histories for the essays in this volume that have been reprinted from other sources.

"AN AFFINITY OF HAMMERS" BY SARA AHMED

Ahmed, Sara. "An Affinity of Hammers." In "Trans/Feminisms, edited by Talia M. Bettcher and Susan Stryker. Special issue, *Transgender Studies Quarterly* 3, no. 1–2 (May 2016): 22–34.

"EVERYWHERE ARCHIVES: TRANSGENDERING, TRANS ASIANS, AND THE INTERNET" BY MEL Y. CHEN

Chen, Mel Y. "Everywhere Archives: Transgendering, Trans Asians, and the Internet." *Australian Feminist Studies* 25, no. 64 (June 2010): 199–208.

"SPIDERWOMEN" BY EVA HAYWARD

Hayward, Eva. "Spiderwomen: Notes on Transpositions." In *Transgender Migrations: The Bodies, Borders, and Politics of Transition*, edited by Trystan T. Cotten, 92–104. New York: Routledge, 2012.

Hayward, Eva. "Spider City Sex." *Women & Performance: a journal of feminist theory* 20, no. 3 (November 2010): 225–51.

"PROXIMITY: ON THE WORK OF MARK AGUHAR" BY ROY PÉREZ

Pérez, Roy. "Her Proximity: On the Work of Mark Aguhar." In *Platforms: Ten Years of Chances Dances*, edited by Aay Preston-Myint, 176–84. Chicago: Chances Dances, 2015.

"CONTEMPORARY ART AND CRITICAL TRANSGENDER INFRASTRUCTURES" BY JEANNINE TANG

Tang, Jeannine. "Aesthetic Infrastructures: Contemporary Art and Critical Transgender Politics." Talk presented at Goldsmiths, University of London, February 23, 2016.

"ALL TERROR, ALL BEAUTY" BY WU TSANG AND FRED MOTEN

Tsang, Wu, and Fred Moten. "Interview with Wu Tsang and Fred Moten." *356 S. Mission Rd.* Accessed October 8, 2016. http://356mission.tumblr.com/post/150698596000/interview -with-wu-tsang-and-fred-moten.

LEXI ADSIT is a fierce and femme Trans Latina woman, troublemaker, and groundbreaker. Lexi has been a part of many historic projects, including but not limited to: founding the Queer Yo Mind Conference at San Francisco State University (2010); cofounding and co-coordinating the International Trans Women of Color Network Gathering in Detroit, Michigan (2014); and producing Brouhaha: Trans Women of Color Comedy Storytelling in Oakland, California (2015). Her articles "24 Actions You NEED to Take to Help Trans Women of Color Survive" and "Stonewall Is in Our Blood" were featured on *Autostraddle* and *Salon*, respectively. Lexi retired from the nonprofit sector after nine years and began a new career in cosmetology in January 2017.

SARA AHMED is an independent feminist scholar, writer, and activist. She has previously held academic appointments at Lancaster University and Goldsmiths, University of London. Her books include *The Cultural Politics of Emotion* (Routledge, 2004, and Edinburgh University Press, 2014) and *Queer Phenomenology: Orientations, Objects, Others* (2006), *The Promise of Happiness* (2010), *On Being Included: Racism and Diversity in Institutional Life* (2012), and *Willful Subjects* (2014), all published by Duke University Press. Her most recent book, *Living a Feminist Life*, was written in tandem with her blog, *feministkilljoys*, and was published by Duke University Press in 2017.

NICOLE ARCHER, PhD, is Assistant Professor of the History and Theory of Contemporary Art (HTCA) at the San Francisco Art Institute, where she also serves as chair of the HTCA program and Liberal Arts Department. Archer researches contemporary art and material culture, with an emphasis on modern textile and garment histories. She is also interested in critical and psychoanalytic theory, corporeal feminism, and performance studies. Archer is currently writing a book entitled *A Looming Possibility: Toward a Theory of the Textile*, which considers how textiles are used to produce and maintain the limits of "legitimate" versus "illegitimate" forms of state violence. Recently her work has appeared in *Women & Performance: a journal of feminist theory* and *Textile: The Journal of Cloth and Culture*. Archer is a regular contributor to *SFAQ/NYAQ/AQ: International Arts and Culture*, where she writes and edits "Style Wars: Critical Reflections on the Power of Style."

KAI LUMUMBA BARROW has grounded her work in efforts to end structural oppression and state violence for the past thirty-five years. She is also an emerging visual and performance artist working to transgress the borders of both the art and the organizing worlds. As an abolitionist, she is interested in mining imaginative space as a site for exploring radical and sustainable outcomes in the dismantling of the prison industrial complex. She has played a leadership role in developing strategies, actions, tools, and techniques that are used in movement-building organizing. In this capacity, Barrow has worked with international, national, regional, and local organizations to coordinate and design convenings, trainings, mass mobilizations, nonviolent direct actions, and guerrilla theater performances. In 2010, Barrow formed Gallery of the Streets, an evolving network of artists, activists, organizers, scholars, and community supporters committed to exploring radical possibilities within Black geographies. Using Black Feminist Theory as a point of departure, Gallery of the Streets works from a principle of "revolutionary nomadism" to create temporary site-specific installations and performances that are rooted in community collaboration and democratic processes. In this sense, Barrow's work aims to demonstrate how imaginative play can challenge and expand movement-building.

JOHANNA BURTON is Keith Haring Director and Curator of Education and Public Engagement at the New Museum in New York and the series editor for the Critical Anthologies in Art and Culture. An art historian, a critic, and a curator, she has contributed articles and reviews to numerous journals—including *Artforum*, *Art Journal*, *October*, and *Texte zur Kunst*—as well as to exhibition catalogs for institutions throughout the world. Among other projects, Burton has curated or co-curated exhibitions including "Sherrie Levine: Mayhem" at the Whitney Museum of American Art, New York, in 2011 (with Elisabeth Sussman); "Anti-Establishment" at the Center for Curatorial Studies at Bard College, Annandale-on-Hudson, NY, in 2012; "Take It or Leave It: Institution, Image, Ideology" at the Hammer Museum, Los Angeles, in 2014 (with Anne Ellegood); and, at the New Museum, "XFR STN" in 2013, "Wynne Greenwood: 'Kelly'" in 2015 (with Stephanie Snyder), "Cheryl Donegan: Scenes + Commercials" in 2016, "Simone Leigh: The Waiting Room" in 2016 (with Shaun Leonardo and Emily Mello), and "A. K. Burns: Shabby but Thriving" in 2017 (with Sara O'Keeffe). She is the editor of *Cindy Sherman* (October Files, MIT Press, 2006) and coeditor (with Shannon Jackson and Dominic Willsdon) of *Public Servants: Art and the Crisis of the Common Good* (New Museum and MIT Press, 2016). Prior to her work at the New Museum, Burton was Director of the Graduate Program at the Center for Curatorial Studies at Bard College (2010–13) and Associate Director and senior faculty member at the Whitney Independent Study Program (2008–10).

MICHA CÁRDENAS, PhD, directs the Poetic Operations Collaborative, a design research lab at the University of Washington Bothell, where she also serves as Assistant Professor of Interdisciplinary Arts & Sciences and Interactive Media Design. The Poetic Operations Collaborative applies technological creativity to advance social justice. cárdenas is an artist/theorist who creates mobile media to reduce violence and increase health. cárdenas's forthcoming book, *Shifting Poetics*, uses practice-based research to understand trans of color movement—including migration, performance, and mobility—in digital media. She completed her PhD in Media Arts + Practice in the School of Cinematic Arts at the University of Southern California. She is a member of the artist collective Electronic Disturbance Theater 2.0. Her solo and collaborative artworks have been presented in museums, galleries, and biennials, including CECUT, Centro Cultural Tijuana, Mexico (2009); the California Biennial, the Orange County Museum of Art, Newport Beach (2010); Los Angeles Contemporary Exhibitions

(2011); the ZERO1 Biennial, San Jose, California (2012); ZKM | Zentrum für Kunst und Medientechnologie, Karlsruhe (2014); the Art Gallery of Ontario, Toronto (2014); the Museum of Modern Art, New York (2015); and Centro Cultural del Bosque, Mexico City (2015). cárdenas's coauthored books *Trans Desire/Affective Cyborgs* (2010) and *The Transreal: Political Aesthetics of Crossing Realities* (2012) were published by Atropos Press.

MEL Y. CHEN is Associate Professor of Gender & Women's Studies and Director of the Center for the Study of Sexual Culture at the University of California, Berkeley. Chen's 2012 book *Animacies: Biopolitics, Racial Mattering, and Queer Affect* (Duke University Press; winner of the MLA Alan Bray Award) explores questions of racialization, queering, disability, and affective economies in animate and inanimate "life" through the extended concept of animacy. Chen's second book project concerns the relationships among the conceptual territories of toxicity and intoxication and their involvement in histories of the shared interanimation of race and disability. Chen's writing on cognitive disability and method, the racialization of pollution, and other topics can be found in *Journal of Literary and Cultural Disability Studies*, *Transgender Studies Quarterly*, *Discourse*, *Women & Performance: a journal of feminist theory*, *Australian Feminist Studies*, *Medical Humanities*, and *GLQ: A Journal of Lesbian and Gay Studies*. Chen coedits, with Jasbir K. Puar, the book series Anima, which highlights scholarship in critical race and disability post/in/humanisms and is published by Duke University Press.

GRACE DUNHAM is a writer and prison abolition activist from New York. They have written about abolition, trans justice, and histories of trans resistance for the *New Yorker*, the *Village Voice*, and anthologies published by Vienna Secession and by ONE National Gay & Lesbian Archives at the USC Libraries, among other publications. Their first chapbook of poetry, *The Fool*, is available at thefool.us. Their current project, Support. FM, is a crowdfunding platform to help trans and gender nonconforming people in jail and detention centers raise money for bail and bond. They live in Los Angeles, where they are developing Support. FM with JODI.

TREVA ELLISON is Assistant Professor of Women's, Gender, and Sexuality Studies and Geography at Dartmouth College. Treva's research revolves around the prison industrial complex (and its abolition), urban geopolitics, political praxis, and queer history. They are currently working on the book *Toward a Politics of Perfect Disorder: Queer Criminality, Carceral Geographies, and Other Ways to Be,* a multicity examination of articulations and strategies of queer criminality and grassroots responses to police efforts to contain queer criminality in the 1970s and '80s. The cities covered in *Toward a Politics of Perfect Disorder* include Detroit, Los Angeles, New Orleans, and Philadelphia.

SYDNEY FREELAND is an Emmy Award–nominated filmmaker. Her debut feature film, *Drunktown's Finest*, premiered at the 2014 Sundance Film Festival and went on to win a number of awards, including the Grand Jury Prize and the HBO Outstanding First Feature award at Outfest Los Angeles in 2014. It received a GLAAD Media Award nomination for Outstanding Feature in 2016. Freeland directed the web series *Her Story* (2016), which was nominated for an Emmy Award for Outstanding Short Form Drama. Sydney is also a recipient of a 2004 Fulbright Scholarship, a 2009 Sundance Native Lab Fellowship, a 2010 Sundance Screenwriting and Directing Labs Fellowship, a 2014 Time Warner Fellowship, a 2015 Women at Sundance Fellowship, a 2015 Fox Global Directors Initiative appointment, and a 2015 Ford Fellowship. Her other projects include the Netflix original film *Deidra and Laney Rob a Train*, released in 2017. She currently lives and works in Los Angeles.

CHE GOSSETT is a Black trans femme writer and para-academic theory queen. They are the recipient of the 2014 Gloria E. Anzaldúa Award from the American Studies Association and the 2014 Sylvia Rivera Award in Transgender Studies from the Center for Gay and Lesbian Studies at the City University of New York. They have published work on blackness and animality on the *Verso* blog and have also contributed to anthologies including *Captive Genders: Trans Embodiment and the Prison Industrial Complex* (AK Press, 2011 and 2015), *The Trans Studies Reader Volume II* (Routledge, 2013), and *Queer Necropolitics* (Routledge, 2014), among other projects.

REINA GOSSETT is an activist, writer, and filmmaker. Along with Sasha Wortzel, Reina wrote, directed, and produced *Happy Birthday, Marsha!* (2018), a short film about legendary trans activist Marsha P. Johnson, starring Independent Spirit Award–winner Mya Taylor with cinematography by Sundance Award–winner Arthur Jafa. As the 2014–17 Activist Fellow at Barnard College's Center for Research on Women, Reina produced and directed *No One Is Disposable*, a series of cross-media platform teaching tools used to spotlight the ways oppressed people are fighting back, surviving, and building strong communities in the face of enormous violence. She is currently working on the short animated film *The Personal Things*, which is about iconic black trans activist Miss Major. Reina has recently presented work at Tramway in Glasgow, Scotland (2014), and the New Museum (2012), the Brooklyn Museum (2014), the Cooper Union (2015), and Bard College (2016) in New York. Her work has been supported by Open Society Foundation, Art Matters Foundation, Astraea Foundation's Global Arts Fund, and the Trans Justice Funding Project. Reina is a participant in the Lower Manhattan Cultural Council Workspace program, and she was a 2012–13 Fellow in filmmaker Ira Sachs's Queer/Art/Mentorship.

STAMATINA GREGORY is Associate Dean of the School of Art at the Cooper Union. A curator and an art historian, she focuses primarily on the interrelationship of photography and politics. Together with Jeanne Vaccaro, she is the co-curator of "Bring Your Own Body: transgender between archives and aesthetics," which opened at the Cooper Union in 2015 and traveled to Glass Curtain Gallery at Columbia College, Chicago (2015), and the Cantor Fitzgerald Gallery at Haverford College, Pennsylvania (2016). In 2013, she organized a retrospective of the work of New York photographer and activist Brian Weil, "Brian Weil, 1979–95: Being in the World," that was shown at the Institute of Contemporary Art at the University of Pennsylvania (2013) and the Santa Monica Museum of Art, California (2015), and was accompanied by a catalog published by Semiotext(e) (2014). Her other recent projects include an exhibition of the work of Tavares Strachan for the inaugural pavilion of the Bahamas at the 55th Venice Biennale (2013) and "Monument to Cold War Victory," an exhibition and book project on imagined and unrealizable public monuments, with an upcoming iteration at the Wende Museum, Los Angeles (2018).

MISS MAJOR GRIFFIN-GRACY has been responsible for nurturing her two biological sons and whole communities of trans people in New York, San Diego, and San Francisco for many decades. Major participated in New York's Stonewall uprising in June 1969 and was politicized by a veteran of the Attica Prison uprising while she was incarcerated in the 1970s. She has worked and has spoken hundreds of times on behalf of trans, anti-prison, HIV, and sex-worker movements across the Americas and Europe. Her incredible life story is depicted in the biographical documentary *Major!* (directed by Annalise Ophelian, 2015).

ROBERT HAMBLIN is an artist based in Cape Town, South Africa. He launched his fine arts career with an exhibition in 1993. At that time, he was practicing as a freelance commercial photographer working largely within the creative arts scene, from which he drew the subjects for the works included in his exhibition. Hamblin maintained his commercial career while

simultaneously exhibiting his personal work nationally and internationally. In 2004, he was awarded a fellowship from the Houston Center for Photography in Texas, and by 2012 he had become a full-time fine arts photographer. Hamblin's work examines one main issue: gender theory within the context of human rights and masculinity. His focus on masculinity and, more specifically, on white maleness and power is evident throughout most of his personal work.

EVA HAYWARD is Assistant Professor in the Department of Gender & Women's Studies at the University of Arizona, Tucson. She has taught at the University of California, Santa Cruz; the University of New Mexico; Uppsala University, Sweden; Duke University, North Carolina; and the University of Cincinnati, Ohio. Her research focuses on art and aesthetics, animal studies, and sensation studies. She has recently published articles in *Transgender Studies Quarterly*, *Cultural Anthropology*, *Parallax*, *differences: A Journal of Feminist Cultural Studies*, *Women's Studies Quarterly*, and *Women & Performance: a journal of feminist theory*.

JULIANA HUXTABLE is a New York–based artist who explores the intersections of race, gender, queerness, and identity. She uses a diverse set of means to engage these issues, including self-portraiture, text-based prints, performance, nightlife, music, writing, and social media. In 2015, she performed *There Are Certain Facts That Cannot Be Disputed* as part of Performa 15 at the Museum of Modern Art, New York. Her work has also been featured in group presentations, including the White Columns Annual, White Columns, New York (2014); "Take Ecstasy with Me," the Whitney Museum of American Art, New York (2014); Frieze Projects, London (2014); and the 2015 Triennial: "Surround Audience," the New Museum, New York (2015); among others. Huxtable studied art, gender studies, and human rights at Bard College, Annandale-on-Hudson, New York.

YVE LARIS COHEN is an artist whose work incorporates visual art and dance practices and often deals with the body as a medium. He frequently draws upon classical ballet and utilizes sculptural and architectural elements in his performances. His works have been performed in many New York venues, including *Waltz* at Thomas Erben Gallery (2012); an untitled work, created with Park McArthur, and *Coda* at SculptureCenter (both 2012); *Seth* and *Fine* at the Kitchen (2013 and 2015); *D.S.* at the Whitney Museum of American Art, as part of the 2014 Whitney Biennial; *D.C.* at Murray Guy (2014); *Platform and Patron* at Danspace Project, as part of "Dancers, Buildings and People in the Streets" (2015); and in exhibitions such as "Landing Field: Vito Acconci and Yve Laris Cohen" at the Hessel Museum of Art, Center for Curatorial Studies, Bard College (2013). Laris Cohen's work has also been presented and commissioned by Judson Church (2009 and 2011), Dance Theater Workshop (2010), the Abrons Arts Center (2011), and Company Gallery (2015) in New York; the Institute of Contemporary Art in Philadelphia (2012); and other organizations. Laris Cohen graduated with a BA in Dance & Performance Studies/Art Practice from the University of California, Berkeley, in 2008, and earned an MFA in Visual Arts from Columbia University in 2011.

ABRAM J. LEWIS is a postdoctoral fellow in the Sexualities Project at Northwestern University. His writing on magic and madness in 1970s queer activist cultures has appeared (or is forthcoming) in *Radical History Review*, the *Journal of the History of Sexuality*, and *Angelaki: Journal of the Theoretical Humanities*. He is also a founder of the NYC Trans Oral History Project, a community archive that works in partnership with the New York Public Library.

HEATHER LOVE teaches English and gender studies at the University of Pennsylvania. She is the author of *Feeling Backward: Loss and the Politics of Queer History* (Harvard University Press, 2009); the editor of "Rethinking Sex," a special issue of *GLQ: A Journal of Lesbian and Gay Studies* on Gayle Rubin (2011); and the coeditor of "Description Across Disciplines," a special issue of *Representations* (2016). She is currently completing a book project on practices of description in the humanities and social sciences.

PARK MCARTHUR is an artist living in New York who works mostly in sculpture around questions of dependency and autonomy. McArthur and Constantina Zavitsanos coauthored the article "Other Forms of Conviviality," published in *Women & Performance: a journal of feminist theory* in 2013. Their collaborative projects have also included workshops and performances as part of "Arika Episode 7: We Can't Live Without Our Lives" at Tramway, Glasgow, Scotland (2015); and "*Still Life*, a workshop" and "*Vanitas*, a rehearsal" at the New Museum, New York (both 2015).

CECE MCDONALD became the face of the crusade against trans imprisonment in 2010, when she was incarcerated in a Minnesota men's prison for defending herself against a racist, transphobic attacker. She now speaks regularly about trans/queer liberation and racial justice issues. The film *Free CeCe!* (directed by Jac Gares, 2016) illustrates her singular strength as a black trans woman, as well as the strength of the large movement of people who organized for her cause before and during her nineteen months of imprisonment. McDonald says her hope is that viewers will "fight with me towards a world where we all can thrive and survive and live together."

TOSHIO MERONEK is a San Francisco–based journalist who focuses on politics, the Bay Area, disability, LGBT/queer issues, and prisons. He covers Silicon Valley for *Truthout* and has reported for Al Jazeera, *In These Times*, and the *Nation*. His work appears in anthologies including *Captive Genders: Trans Embodiment and the Prison Industrial Complex* (AK Press, 2011 and 2015).

FRED MOTEN is the author of *In the Break: The Aesthetics of the Black Radical Tradition* (University of Minnesota Press, 2003), *Hughson's Tavern* (Leon Works, 2008), *B Jenkins* (Duke University Press, 2010), *The Feel Trio* (Letter Machine Editions, 2014), *The Little Edges* (Wesleyan University Press, 2015), and *The Service Porch* (Letter Machine Editions, 2016). He is the coauthor, along with Stefano Harney, of *The Undercommons: Fugitive Planning and Black Study* (Compositions/Autonomedia, 2013). He lives in Los Angeles and teaches at the University of California, Riverside.

TAVIA NYONG'O is Professor of American Studies and Theater Studies at Yale University, where he teaches courses in aesthetic and affect theory, cultural studies and cultural history, and black and queer studies. He writes on art, popular music, politics, culture, and theory. His first book, *The Amalgamation Waltz: Race, Performance, and the Ruses of Memory* (University of Minnesota Press, 2009), won the Errol Hill Award for best book in African American theater and performance studies. He is completing a study of fabulation in black aesthetics and embarking on another project on queer wildness. Nyong'o has published in venues such as *Radical History Review*, *Criticism*, *GLQ: A Journal of Gay and Lesbian Studies*, *TDR*, *Women & Performance: a journal of feminist theory*, *Women's Studies Quarterly*, the *Nation*, *Triple Canopy*, the *New Inquiry*, and *n+1*. He is a coeditor of the journal *Social Text* and co–series editor of the Sexual Cultures book series published by New York University Press. He regularly blogs at *Bully Bloggers*.

MORGAN M. PAGE is a multiple award–winning performance and video artist, writer, activist, and Santera who is based in Canada. Her work focuses on issues related to trans history, sex work, and HIV/AIDS. She also is an organizer and a social services provider, having worked with individuals and organizations across Canada and the United States. Her podcast, *One from the Vaults*, tells trans history in a fun, conversational way.

ROY PÉREZ is Associate Professor of English at Willamette University in Salem, Oregon. His writing has appeared in *Narrative, Race, and Ethnicity in the United States* (Ohio State University Press, 2017), *Women & Performance: a journal of feminist theory*, *FENCE* magazine,

Platforms: Ten Years of Chances Dances (Chances Dances, 2015), and *The Best of Panic!* (Fireking Press, 2010), and on the blogs *Glitter Tongue*, *THEthe Poetry*, and *Bully Bloggers*. Pérez is a coeditor, with Kadji Amin and Amber Musser, of "Queer Form," a special issue of *ASAP/Journal* on queer politics and aesthetics. His book in progress, *Proximities: Queer Configurations of Race and Sex in Latina/o Literature and Performance*, forwards a relational account of *latinidad* by examining sexuality and cross-racial representation in US Latina/o narrative, visual art, and performance.

DEAN SPADE is Associate Professor at the Seattle University School of Law. In 2002, he founded the Sylvia Rivera Law Project, a nonprofit collective that provides free legal help to low-income people and people of color who are trans, intersex, and/or gender nonconforming and works to build trans resistance rooted in racial and economic justice. He is the author of *Normal Life: Administrative Violence, Critical Trans Politics, and the Limits of Law* (Duke University Press, 2015). In 2015, he released *Pinkwashing Exposed: Seattle Fights Back!*, an hour-long documentary that follows a local queer community controversy and examines the concept of "pinkwashing."

ERIC A. STANLEY is Assistant Professor in the Department of Gender and Sexuality Studies at the University of California, Riverside. They are an editor of *Captive Genders: Trans Embodiment and the Prison Industrial Complex* (AK Press, 2011 and 2015) and, along with Chris E. Vargas, a director of the films *Homotopia* (2006) and *Criminal Queers* (2016).

JEANNINE TANG is an art historian who teaches art history and exhibition history. Tang currently holds the position of Senior Academic Advisor and LUMA fellow at the Center for Curatorial Studies, Bard College, Annandale-on-Hudson, New York. She received her PhD from the Courtauld Institute of Art, London, and was previously a fellow at the Smithsonian American Art Museum, Washington, DC, and a participant in the Whitney Museum of American Art's Independent Study Program. Her writing has appeared in numerous exhibition catalogs and books, and in periodicals including *Art Journal*, *Artforum*, and *Theory, Culture & Society*. Her current projects include co-curating the first major exhibition on the art and activities of New York galleries Pat Hearn and American Fine Arts, Co. (Hessel Museum of Art, Center for Curatorial Studies, Bard College, 2018); coediting an anthology on art, affect, and power; and writing a book on information profiling in the 1970s.

WU TSANG is a visual artist, filmmaker, and performer. Her films, installations, performances, and sculptures move fluidly between documentation, activism, and fiction. Her projects have been presented at museums and film festivals internationally, including SANFIC 8, Santiago, Chile (2012); Hot Docs Festival, Toronto (2012); SXSW Film Festival, Austin, Texas (2012); Tate Modern, London (2013); the Stedelijk Museum Amsterdam (2014); the Museum of Contemporary Art Chicago (2014); the Hiroshima City Museum of Contemporary Art, Japan (2015); and the Berlinale Festival (2016). Tsang's 2012 film *Wildness* premiered at the Museum of Modern Art's Documentary Fortnight, and her work was also featured in the 2012 Whitney Biennial, the Whitney Museum of American Art, and the 2012 Triennial: "The Ungovernables," the New Museum, both in New York; "Made in L.A.," the Hammer Museum, Los Angeles (2014); and the Berlin Biennial (2016). Her solo exhibitions include "Not in my language," Migros Museum für Gegenwartskunst, Zurich (2014); "Duilian," Spring Workshop, Hong Kong (2016); and "Devotional Document (Part I)," Nottingham Contemporary, United Kingdom (2017). She has received grants from the Andy Warhol Foundation for the Visual Arts (2011), the Louis Comfort Tiffany Foundation (2012), the Foundation for Contemporary Arts (2013), and Creative Capital (2015). Tsang was named a Guggenheim Fellow in 2016.

JEANNE VACCARO is a writer and curator working at the intersection of performance, visual culture, feminist art and archives, histories of the body, and queer studies. She is the curator of "Bring Your Own Body: transgender between archives and aesthetics," organized for the Cooper Union (one of *artnet News'* most memorable museum shows of 2015) and editor of "The Transbiological Body," a special issue of *Women & Performance: a journal of feminist theory* dedicated to transgender reproductive ecologies. Her book in process, *Handmade: Feelings and Textures of Transgender*, looks at the felt labor of identity in soft sculpture, fiber art, dance, and film. With Reina Gossett and Abram J. Lewis, she co-organizes the New York City Transgender Oral History Project for the New York Public Library.

CHRIS E. VARGAS is a video-maker and interdisciplinary artist currently based in Bellingham, Washington. His work deploys humor and performance in conjunction with mainstream idioms to explore the complex ways that queer and trans people negotiate spaces for themselves within historical and institutional memory and popular culture. From 2008 to 2013, Vargas collaborated with Greg Youmans on the web-based trans/cisgender sitcom *Falling in Love ... with Chris and Greg*. Episodes of the series have been screened at numerous film festivals and art venues, including MIX NYC; the Ann Arbor Film Festival, Michigan; and Tate Modern, London. Vargas codirected the movie *Homotopia* (2006) and its feature-length sequel, *Criminal Queers* (2016), with Eric A. Stanley. Both films have been screened at Palais de Tokyo, Paris; Los Angeles Contemporary Exhibitions; Centre for Contemporary Arts, Glasgow, Scotland; and the New Museum, New York; among other venues. Vargas is also Executive Director of the Museum of Transgender Hirstory and Art (MOTHA), a conceptual arts and *hir*story institution highlighting the contributions of trans art to the cultural and political landscape.

GEO WYETH is an artist who works with music, performance, installation, and video. Wyeth has presented work at La MaMa Experimental Theater Club, New York (2012); Joe's Pub, New York (2012); Kate Werble Gallery, New York (2013); Human Resources, Los Angeles (2013); the Studio Museum in Harlem, New York (2014); New York Live Arts' Live Ideas festival (2015); the Institute of Contemporary Art, Boston (2015); the Museum of Contemporary Art, Los Angeles (2015); the New Museum, New York (2015); the Stedelijk Museum Amsterdam (2016); and MoMA P.S.1, New York (2016); among other venues. S/he was in residence at the Rijksakademie van beeldende kunsten, Amsterdam, from 2015 to 2016.

KALANIOPUA YOUNG is a radical Native Hawaiian *māhu* transgender woman scholar-activist of color, a more-than survivor of cis-sexist racial violence, and a former community organizer with United Territories of Pacific Islanders Alliance (UTOPIA) in Seattle, Washington. As a doctoral candidate in the Department of Anthropology at the University of Washington, she is currently working on her forthcoming dissertation, "Re-Making the Passage Home." This project is a critical ethnography that examines the daily lived experiences of frontline Kanaka Maoli (Native Hawaiians), particularly *māhu* Hawaiian transgender women who are houseless and home-free in Waianae, Oahu, a critical site for observing ongoing US settler colonialism, indigenous resistance, and survivance in the nation's largest outdoor homeless encampment.

CONSTANTINA ZAVITSANOS is an artist living in New York who works in sculpture, performance, text, and sound, and with issues of debt, dependency, inconsequence, and speculation. Zavitsanos and Park McArthur coauthored the article "Other Forms of Conviviality," published in *Women & Performance: a journal of feminist theory* in 2013. Their collaborative projects have also included workshops and performances as part of "Arika Episode 7: We Can't Live Without Our Lives" at Tramway, Glasgow, Scotland (2015); and "*Still Life*, a workshop" and "*Vanitas*, a rehearsal" at the New Museum, New York (both 2015).

INDEX

Newsletters. *See* Erickson Educational
Foundation: *Newsletter*; Piers newsletter;
Radical Queens, Philadelphia: *Radical
Queen* newsletter; Transexual Action
Organization: *Mirage* newsletter;
Transexual Action Organization:
Moonshadow newsletter; Transvestite
Legal Committee, Chicago: *Newsletter*
Newton, Huey, 62
New York City, 363
 Christopher Street, xvii, 60; illus. 72, 100
 police, xvi, xix
 See also Legislation: INTRO 475;
 Legislation: INTRO 554; Stonewall
 Inn riots
New York City Dyke March, 389n39
New Yorker magazine, 364
New York Supreme Court ruling (1977), 59
New York Times, 364
Nightlife, 51–53, 367
Nochlin, Linda, 366–367
Nonprofit organizations, 94, 97–99
 See also Audre Lorde Project; Black & Pink;
 BreakOUT!; FIERCE; Southerners On
 New Ground; Sylvia Rivera Law Project;
 Transgender, Gender Variant, and Inter-
 sex Justice Project
Norman, Tracey "Africa," 40
Nussbaum, Emily, 216
Nyong'o, Tavia, xxii, 41, 387n18, 400
 "Representation and Its Limits," 191–200

Oakland, California, 174, 264
Obama, Barack, 18
OFTV. See *One from the Vaults*
Okazawa-Rey, Margo, 188n2
One from the Vaults (*OFTV*, podcast), 136,
 137, 138, 142, 144
O'Neill, Blaine, 380
ONE National Gay and Lesbian Archives,
 USC Libraries, Los Angeles, 20n33, 87n3,
 131, 133, 134n1, 136, 145n7, 354
Ono, Yoko, 349
Ophelian, Annalise, 33, 37n3; illus. 25
Opie, Catherine, 211, 213–214; illus. 215
Oppenheim, Méret, 349
Oprah Winfrey Show, The, 147, 148, 149, 151,
 156–157

Orange Is the New Black (series), 203
Orlando. *See* Pulse nightclub
"Orlando 49," 167, 172
 See also Pulse nightclub
Owens, Craig, 293, 295, 314n3

Page, Morgan M., xxi, 402
 "*One from the Vaults*: Gossip, Access, and
 Trans History–Telling," 135–146
Paranormal phenomena, 64
Paris Is Burning (1990), 40, 382
Parker, William H., illus. 99
Parsons School of Design, New York,
 387n18
Participant Inc., New York, 387n18
Pastoureau, Michel, 299
Pattern, 298, 301, 303, 316n12, 318n23,
 318n26, 319n31
 camouflage, 317n19
 dazzle, 317n19
 and Decoration movement, 315n8
 -jamming, 312, 318n25, 319n31
 stripes, 299–300, 303, 305, 317n19
Peacock Rebellion, San Francisco Bay Area,
 194, 197, 198–199
 Brouhaha (2014–2016), 194, 199
Pentagon, ends transgender ban (2016), 170,
 315n10
Pérez, Roy, xxi, 393, 400–401
 "Proximity: On the Work of Mark Aguhar,"
 281–291
Periodizing artist's oeuvre, 372
Perkins, Grace Rosario, 310
Perkins, Olen, illus. 311
Petrisko, Anna Luisa, 310
Phillips, Lisa, "Director's Foreword," xi–xiv
Phillips, Trevor, 223
Photography, 93, 130, 355
Phytohormonal ingredients, 127
Piers, The. *See* West Side Piers
Piers newsletter, 93–94, 98; illus. 92
Pine, Seymour, xvi, xxvin4
Pines, the, Fire Island, New York, 127
 Botel disco, 128
 "Invasion of the Pines" (1976), 128
Piper, Adrian, 349
Poetic Operations Collaborative, University
 of Washington Bothell, 175, 176
Policansky, David, 260

Stubblefield, Anna, 236, 250n2
Studio Museum in Harlem, New York, 364, 386n1
Suicide, 203, 289–290, 365
Swanson, Carl, 371
SWEAT. *See* Sex Workers Education and Advocacy Taskforce
Syjuco, Stephanie, 317n19
Sylvia Rivera Law Project (SRLP), New York, 87n2, 94, 388n21; illus. 109, 110

Takahashi, Ginger Brooks, 303
Tambor, Jeffrey, 216
Tang, Jeannine, xx, xxi, 386n1, 393, 401
 "Contemporary Art and Critical Transgender Infrastructures," 363–392
TAO. *See* Transexual Action Organization
Tate Modern, London, 317n19
Tava, illus. 92
Taylor, Mya, xix
Tenderloin, San Francisco, 126, 257, 259
Tesori, Jeanine, 201, 206, 208
Thomas, Mickalene, 318n25
356 S. Mission Road, Los Angeles, 339; illus. 341, 342, 343, 346
Thresholds, 265, 286
Time magazine, 26, 37n1, 133
TLC. See Transvestite Legal Committee
Tolentino, Julie, 389n41
Tomkins, Silvan, 166
Towers, Randy, 65
Trans activism, 57
Trans* aesthetics, 314
Trans community, 42–43
Trans Day of Action, New York, 96; illus. 103
Trans, discrimination against, xii, 10, 60, 95
Trans-exclusionary policy, 216
Trans-exclusionary radical feminism (TERF), xxii, 88n11, 222, 224, 229, 230, 233n11
Transsexual Action Organization (TAO), Los Angeles/Miami Beach, 57, 60, 61, 62, 63, 64, 65; illus. 58, 74–75
 Mirage newsletter, 64; illus. 82, 83, 86
 Moonshadow newsletter, 64; illus. 58, 83
Transfeminism, 63
"Transformer," Richard Saltoun Gallery, London (2014), 358, 360

"Transformer: Aspekte der Travestie," Kunsthalle Zürich (1974), 358
"Transgender," 60
 as invention of postwar era, 138
Transgender Europe, 365
Transgender, Gender Variant, and Intersex Justice Project (TGIJP), San Francisco, 33, 94, 95, 96, 97, 194–195, 199; illus. 102, 107, 108
"Transgender Hirstory in 99 Objects: Legends & Mythologies," MOTHA, 133
Transgender identity, 373
"Transgender in the Mainstream," Art Basel (2015), 44, 364, 386n3
Transgender pride flag, 132
"Transgender Tipping Point," xvi, 2, 6, 12, 133, 142
Transgender troops, 315n10
Transgender women of color, 199, 364
 life expectancy, 365
 violence and murder, 364–365, 380
TransGriot (blog), 41
Trans history, 137–138, 140
Trans Justice Funding Project, 388n21
Trans liberation/trans* liberation, 98, 314
Transmale pregnancy, 148
Trans Murder Monitoring Project, 365
Transparent (series), 203; illus. 217
Trans people of color/People of Color, 17n1, 199
Transphobia, 222–223, 224
Transpositioning, 255, 256, 265, 266, 267, 269, 273
Transsexuality, 256, 275n1, 276n8
Transsexual surgery. *See* Gender-affirming surgery
Trans subjectivity/trans* subjectivity, 279n32, 298
"Transvestite and Transsexual Liberation," illus. 74–75, 76–77
Transvestite Legal Committee (TLC), Chicago, 57, 61, 62
 Newsletter, illus. 67, 80
Trans visibility/trans* visibility, 15, 39, 170, 183, 297, 314
Trans women of color/Women of Color, 23, 194, 197, 199
 See also Transgender women of color